ALL _the_ SAINTS of the CITY of the ANGELS

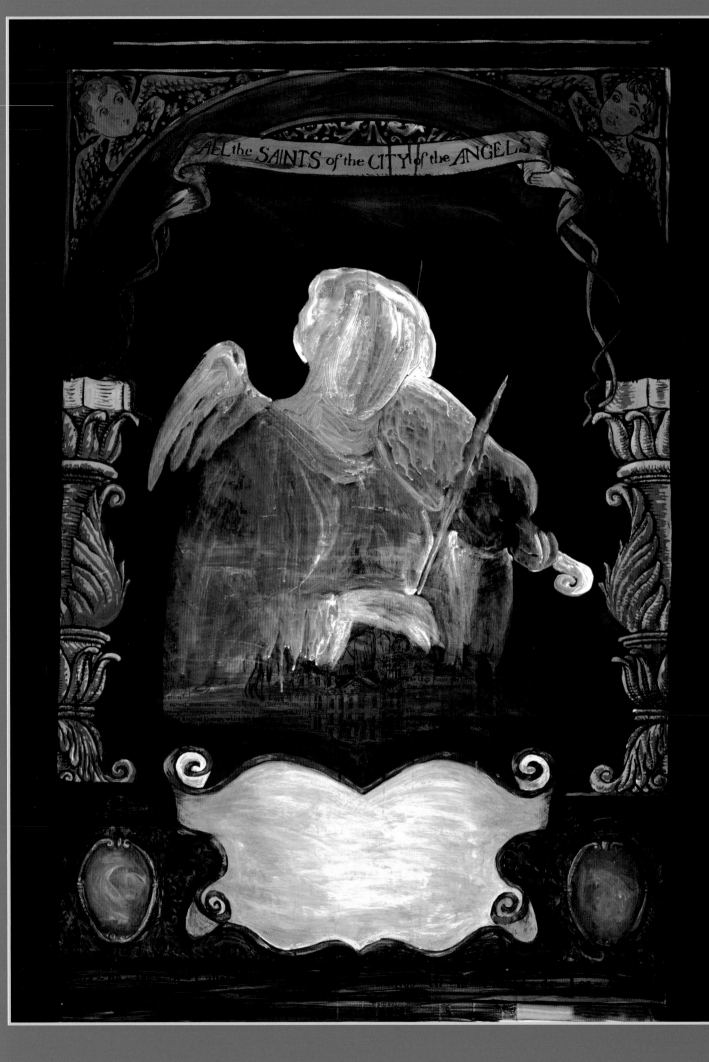

ALL the SAINTS of the CITY of the ANGELS

Seeking the Soul of L.A. on Its Streets

Stories and Paintings by

J. Michael Walker

Autry National Center, Los Angeles, California

Heyday Books, Berkeley, California

Library of Congress Cataloging-in-Publication Data
Walker, J. Michael.
All the saints of the city of the angels : seeking the soul of
L.A. on its streets : paintings and stories / by
J. Michael Walker.
 p. cm.
 Includes bibliographical references and index.
 ISBN 978-1-59714-075-1 (pbk. : alk. paper)
 1. Walker, J. Michael. 2. Streets in art. 3. Los Angeles
(Calif.)—In art. 4. Street names—California—Los Angeles—
History. 5. Los Angeles (Calif.)—History. I. Autry National
Center. II. Title.
 ND237.W312A4 2008
 759.13—dc22

2007035248

Front Cover Art: *St. Moritz*
Back Cover Art: *The Holy Family Watches Over My Neighborhood*
Cover and Interior Design/Typesetting by Lorraine Rath
Printed in Singapore by Imago

All the Saints of the City of the Angels was copublished by the Autry National Center and Heyday Books. Orders, inquiries, and correspondence should be addressed to:
 Heyday Books
 P. O. Box 9145, Berkeley, CA 94709
 (510) 549-3564, Fax (510) 549-1889
 www.heydaybooks.com

10 9 8 7 6 5 4 3 2

For Mimí and Jacobo,

for Eulalia and Rogerio,
for Jevona, Natalie, and Stephanie,
for the people of Kinkingna and Kuruvungna,
and
for all the Santa Susanas, Santa Ynezes,
and San Ysidros
of the City of the Angels

CONTENTS

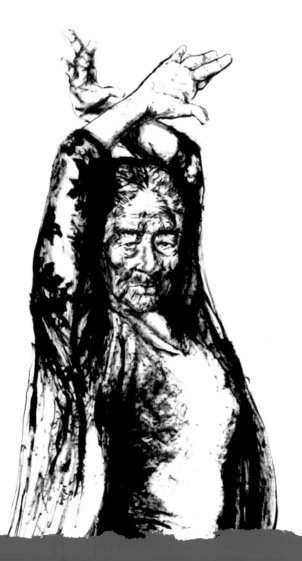

TODOS-LOS SANTOS-DE-LOS ANGELES

ALL the SAINTS of the CITY of the ANGELS

" We find ourselves threatened
by hordes of Yankee immigrants
who have already begun to flock into our country,
and whose progress we cannot arrest. "

~ California Governor Pio Pico,
Los Angeles, 1846

Los Angeles
from
the first known sketch

1853.

La
Historia
De un Lugar
Reside en
sus
Nombres

The
History
Of a Place
Resides
In Its
Names

INTRODUCTION

i. The Sacred Geography of Los Angeles

Away back in 1769, on the first Wednesday in August, some thirty Spanish soldiers clad in leather jackets dismounted their horses in the parking lot of *La Playita* Seafood Restaurant, just east of the Golden State Freeway, north of Downtown; and six or eight "heathen from a good village" down by the railroad tracks crossed the freeway into Lincoln Heights to greet them.

The Tongva natives brought offerings of coiled baskets, pinole, and shell necklaces, which they exchanged for Spanish gifts of glass beads and tobacco. Taking due notice of the Spaniards' three dozen Guaycuran and Cochimí Indian servants, the Tongva then retreated to their "delightful place among the trees on this river"—a village called Yang-Na, near Chinatown.

All along the Spaniards' journey up from Baja, their spiritual guide and chief diarist, Fray Juan Crespí, the man whose words are quoted here, had enfolded virtually every significant piece of geography into the care of God's elect: a river for San Dionisio, defender of the Faith; a pond for St. Elmo, protector of sailors; a marsh for St. Isabel of Hungary, lover of the poor and infirm. The saints fell into place and became landmarks—as vivid to a Franciscan as a field of poppies to a native.

The days, too, were named for saints. The year began with the Feast of Circumcision and moved reverently forward, filling the calendar with grace: January 2nd for St. Macarius of Alexandria; January 3rd for the Blessed Name of Jesus; January 4th for Blessed Angela of Foligno; and so on, through time.

Saints provided the framework and served as veritable coordinates for the Spaniards' space-time axis. Twenty days prior to this meeting with the Tongva, the Spaniards had set out on the Feast of St. Bonaventure, the Franciscan theologian, from the mission of St. Didacus of Alcalá, a Franciscan lay brother. Passing through the Valley of Blessed Simon of Lipnica, a Franciscan artist, they rested on the Feast Day of St. Margaret, slayer of dragons. After crossing the stream of San Francisco Solano, missionary to Peru, on the Day of St. Anne, mother of the Virgin Mary, they endured a trio of earthquakes beside the River of the Sweetest Name of Jesus (one quake, Father Crespí recorded, as long as the Creed, two shorter than a Hail Mary).

And then, three leagues beyond the River of St. Michael the Archangel, they descended upon the greenest lush valley they had yet to tread: a full-flowing river of fresh pure water framed by sycamore, cottonwood, giant live oak, and willow. Green grass tall and billowing like ripening corn; grapevine, sage, and rosebush carpeting the banks; thrush, quail, and turtledove songs filling the air; wolves and antelope, coyote and hares, in untold numbers and uneasy truce.

In other words: the City of Los Angeles, as it was then, before *La Playita* Seafood Restaurant and the Golden State Freeway.

ii. To Live and Drive in L.A.

Like many people in Los Angeles—like, perhaps, too many people in Los Angeles—I get where I'm going by car. Thousands of streets spread tentacles across this city, yet fewer than a hundred take me almost anywhere I go.

Whenever this limited vocabulary of mine fails, I rely on maps for guidance. In the days before MapQuest and Global Positioning came into our lives, this meant turning to the spiral-bound reference guide Southern California motorists have relied on since the 1950s: *The Thomas Guide to Los Angeles County Streets*, a compendium of some two hundred street maps that lies tattered and cherished, like a much-abused teddy bear, on the rear floorboard of many an L.A. car.

I was thumbing through the index of the *Thomas Guide*, as it is familiarly known, one such pre-MapQuest day in early 2000, seeking some street beginning with the letter "S," when I was diverted and struck by column upon column of streets that begin with "Saint," "San," "Santa," or "Santo."

"All these saints in Los Angeles!" I thought to myself, a phrase which soon crystallized, in Spanish, as *"Todos los Santos de Los Angeles,"* and in English as "All the Saints of the City of the Angels."

I knew that Spanish explorers and Mexican settlers conferred saints' names on sites to seek their protection. Had something similar happened with Los Angeles' streets? What connection, I wondered, might exist between the histories of these streets and the stories of the saints whose names they bear—even if those names were given, not by explorers or rancheros, but by real estate developers and city planners.

Launched along my path by a small grant from the Cultural Affairs Department of the City of L.A., and driven by an artist's intuition that there might be some meaning here to discover, I set off on this journey—this metaphorical road trip through the City of the Angels—in the early fall.

iii. There Be Saints among Us

The streets and saints, I have found, intersect in interesting ways.

San Julian Street sits in the heart of Skid Row, where it has evolved over the past twenty-five years into the principal gathering place for the city's homeless, and where most of the area's clinics and single-occupancy hotels are also stationed. Laid out in the 1870s, its name commemorates the patron saint of wanderers and those who proffer them refuge.

Twenty miles across town, a world away from Skid Row, San Ysidro Drive flows aside the fine homes of Bel-Air. Named for a poor Spanish farmer who supported his family by working on the lands of the wealthy, the drive features gardens maintained today by Mexican gardeners doing the same thing.

And so it goes. Santa Clara Street, evoking its namesake's vow of poverty; San José Street, arrayed with the telltale signs of a working-class dad; San Rafael Avenue, where this guardian angel volunteers as a crossing guard for the neighborhood school; and St. Elmo Drive, where St. Elmo's Fire burns at St. Elmo Village.

The saints can be a contrary lot, speaking uncomfortable truths, broaching inconvenient subjects. Prickly contradictions of humility and certainty, they insert their convictions into otherwise polite conversation, reminding us of accounts yet left unsettled.

St. Moritz Drive seems a simple entrance to a gated Tarzana community, but it also serves as portal to a Eurocentric world's discomfort at portraying black males as role models.

Santa María Road appears to be a welcoming Topanga dirt path, but discomfitingly reminds us of a history of Church-sanctioned anti-Semitism.

One may then well wonder: who are these saints, and why are they saying such painful things about us?

iv. Not Quite as Expected

The day the Spaniards arrived at the intersection of the Golden State Freeway and Yang-Na, August 2nd, was a Franciscan day of reflection to commemorate St. Francis of Assisi's holy chapel, *Nuestra Señora de los Angeles* ("Our Lady of the Angels"), and the hovel where St. Francis lived and died, *la Porciúncula* ("the Little Portion").

As he gazed into the south-coursing river, which nourished the stand of cottonwood and alder which in turn sheltered the welcoming Tongva, Father Crespí's thoughts flowed back to his order's founder; and with the prayerful hope that something of the humble and impoverished saint's essence would befall his namesake site, he dedicated the land to the chapel and the river to the hovel; thus christening *El Pueblo de Nuestra Señora de los Angeles de la Porciúncula*.

As it happened, the Tongva were soon herded from their "good village" into forced labor under the successors to Father Crespí and his leather-clad soldiers; the cottonwood and alder became firewood and lumber for the imminent Spanish-Mexican settlers; the surrounding land was transformed, first into agricultural plots and grazing fields, then into industrial yards and humble housing; and the unwieldy river was cemented and tamed.

This transformation, from a "delightful place among the trees" into the grimy gas stations, freight yards, freeways, and auto salvage lots today rimming the Los Angeles River, suggests that Father Crespí's invocation of St. Francis' vow of poverty and humility had, at best, certain unforeseen consequences.

Again: saints can be a contrary lot.

v. The Saints Come Marching In

Following Father Crespí's baptism of the California landscape, the first saints summoned to work here were assigned to the missions, to aid in converting the native peoples. But the saints were soon dismayed with the conquerors' tactics. Santa Ynez, the martyr, identified with her neophyte rebels and prisoners; San Gabriel, angel of the Annunciation, wondered just what his arrival was meant to announce; San Diego, who tended the sick, was overburdened with native women suffering from the soldiers' *mal gálico*; and San Fernando, patron of rulers and paupers, found himself incapable of serving both.

Few roads were named for saints before the Americans took over. There was the road to San Pedro Bay; the road to Mission San Fernando Rey; the road to Rancho San Vicente y Santa Mónica (the beginnings of Santa Monica Boulevard); and the road to Mission San Gabriel, known simply as Mission Road.

It was only after the railroads connected El Pueblo with the then-western borders of civilization (think: Kansas City) in the 1870s and 1880s that the first great wave of saints came to town. Those trains brought thousands of Anglo settlers who descended, locust-like, on the groves and grasslands here, and set about recreating the ordered communities they had left behind.

Conveniently ignoring that the spirit, traditions, and peoples of El Pueblo were all but crushed by their arrival, Anglos soon proclaimed themselves "Pioneers" and "Native Sons," and dressed in Mexican regalia for annual pageants celebrating El Pueblo's founding, with scant acknowledgment of the bitter irony inherent in their choices.

As the city grew, the Anglo real estate developers directing that growth—first in the 1880s and then periodically throughout

the twentieth century—sought to embellish their newly paved streets with a patina of history and romance. By ennobling these streets with the (generally Spanish) names of saints, developers laid claim to Southern California's amber-cast history; or, less often, to the more venerable, elegant cities of Europe.

vi. Call and Response

Whatever developers' motives, the tradition of naming Los Angeles streets for saints carries tacit acknowledgment of the profundity of spiritual beliefs among the city's Spanish and Mexican forebears (to say nothing of the native peoples who preceded them). Singing morning songs to the Virgin; baptizing infants with the names of patron saints; signing important documents before homemade altars; even naming fruit for saints' feast days (*las peras de San Juan*): these intimate, quotidian gestures bear testimony to the saints' pervasive presence in Southern California during the Spanish-Mexican era.

And the called-upon, put-upon saints, summoned to aid real estate developers' get-rich-quick schemes, have responded by demonstrating their prickly, contrarian nature.

Still smarting, perhaps, from their initial misuse and misrepresentation at the missions, they frequently criticize those who invoke them: certainly they speak their minds. Like any immigrant, they arrive with a history and point of view, and with stories to tell.

What follow in these pages are those stories—the spirits of the saints on their namesake streets—as best I can transcribe them: the stories of All the Saints of the City of the Angels.

ONE: The Journey Begins

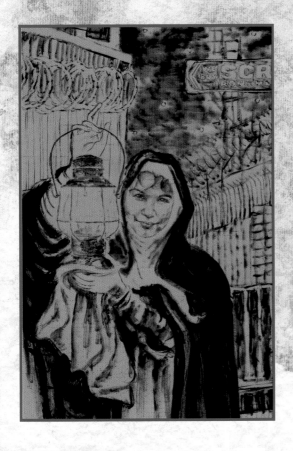

hen I embarked on this pilgrimage across the City of the Angels, the first significant saint-street I encountered was San Julian Street—which is wholly appropriate, because the original St. Julian, after years of wandering, offered his home as a refuge for pilgrims.

Physically located along the southeastern rim of Downtown, San Julian Street also lies at the existential intersection of saintly legend and social reality, thereby providing a mythic matrix for the lives of society's dispossessed.

San Julian provided me an introduction to a fellow habitué of his world, Santa Ynez. A young woman harangued by ill-suited suitors, she daily struggled (struggles still?) to maintain her dignity and her autonomy against great odds.

Santa Clara, too, resides near San Julian, and her impoverished little street opposes, both physically and philosophically, the ostentatious cathedral (named for the chapel where she took her vows) which parades along Downtown's northern border.

Of similar disposition as San Julian and Santa Clara, St. Vincent's miniscule Court and Place embrace both humility and the humbled, in perfect imitation of this meek saint's personality.

Close to these three in geography and countenance is St. Joseph's Place, which rises in resurgent testament to the ability to face great loss with quiet resolve.

Santa Mónica, a strong woman of limitless love and patience, has seen her resolve tested time and again, through harrowing spirals of pain and loss. Although she generally wanders the western side of the city, here she visits her sisters in nearby Boyle Heights for support.

Her neighbor, St. Stephanie de los Niños, a meditation on the response to loss, could almost be Mónica's adopted daughter. Stephanie floats like an angelic butterfly above the streets of her Boyle Heights home, while providing a human face for this City of the Angels.

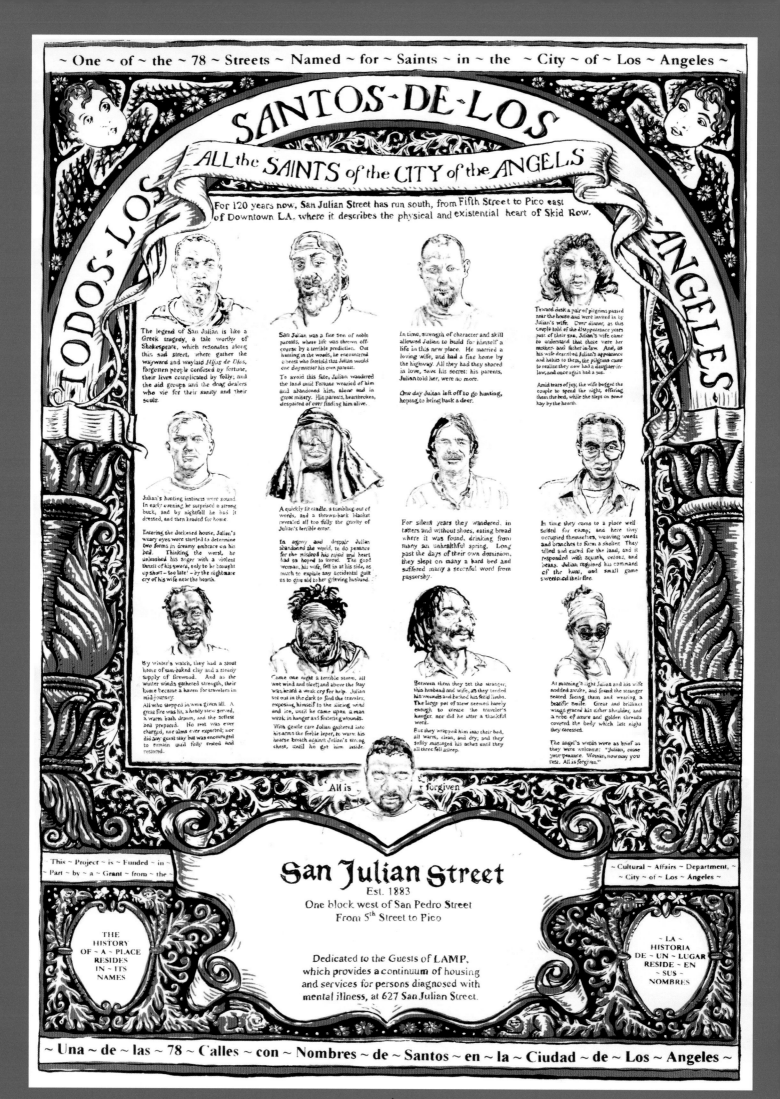

SAN JULIAN STREET and PLACE

Southeast Downtown, Skid Row

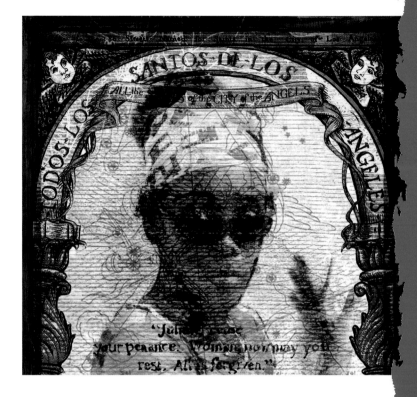

Few places in Los Angeles concentrate so much palpable loss, deadened pain, and inexorable challenge as does the northern half of San Julian Street. Running along the transitional southeastern rim of Downtown—long abandoned by the city, but now impacted by gentrification and commerce—San Julian Street, founded in 1883, has over the past twenty years come to describe the physical and existential heart of Skid Row.

The legend of San Julian is like a Greek tragedy, a tale worthy of Shakespeare, and it resonates on this sad street where gather the wayward and waylaid *hijos de Dios*—forgotten people confused by fortune, their lives complicated by folly—and the aid groups and drug dealers who vie for their souls and sanity.

The fine son of noble parents, San Julian's life was thrown off course by a terrible prediction. Out hunting in the woods one day, Julian encountered a beast who foretold that one day he would murder his parents. To avoid this fate, Julian wandered the land "until Fortune wearied of him," and left him alone and in great misery. His parents, heartbroken, despaired of ever finding him alive.

In time, strength of character and skill allowed Julian to build for himself a life in this new place. He married a loving wife and had a fine home by the highway. All they had they shared in love, save his secret: his parents, Julian told her, were no more.

One day Julian left home to go hunting, hoping to bring back a deer.

Toward dusk a pair of pilgrims passed near the house and were invited in by Julian's wife. Over dinner, as this couple told of the disappearance years past of their son, Julian's wife came to understand that these were her mother- and father-in-law. And, as his wife described Julian's appearance and habits to them, the pilgrims came to realize they now had a daughter-in-law, and once again had a son. Amid tears of joy, the wife begged the couple to spend the night, offering them the bed, while she slept on some hay by the hearth.

Julian's hunting instincts were sound. In early evening he surprised a strong buck, and by nightfall he had it dressed and then headed for home.

Entering the darkened house, Julian's weary eyes were startled to determine two forms in dreamy embrace on his bed. Thinking the worst, he unleashed his anger with a violent thrust of his sword, only to be brought up short—too late!—by the nightmare cry of his wife near the hearth.

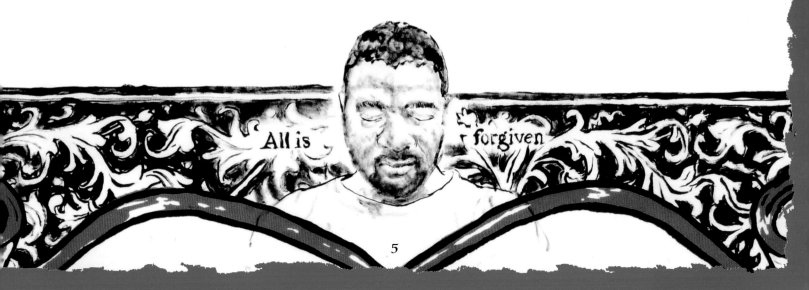

All is forgiven

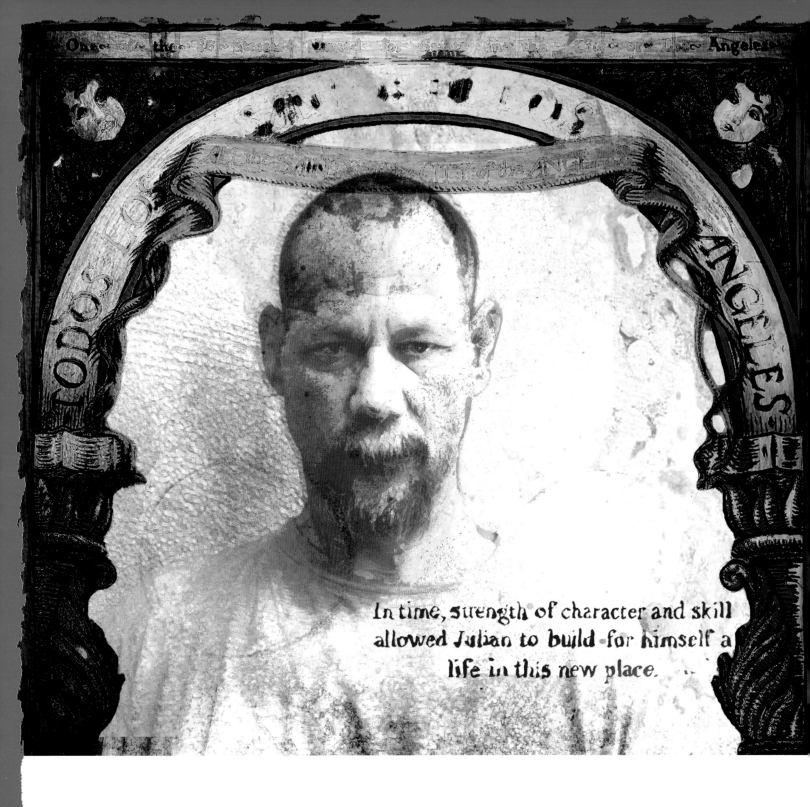

In time, strength of character and skill allowed Julian to build for himself a life in this new place. ...

{ The legend of San Julian is like a Greek tragedy...and it resonates on this sad street where gather the wayward and waylaid *hijos de Dios*—forgotten people confused by fortune, their lives complicated by folly... }

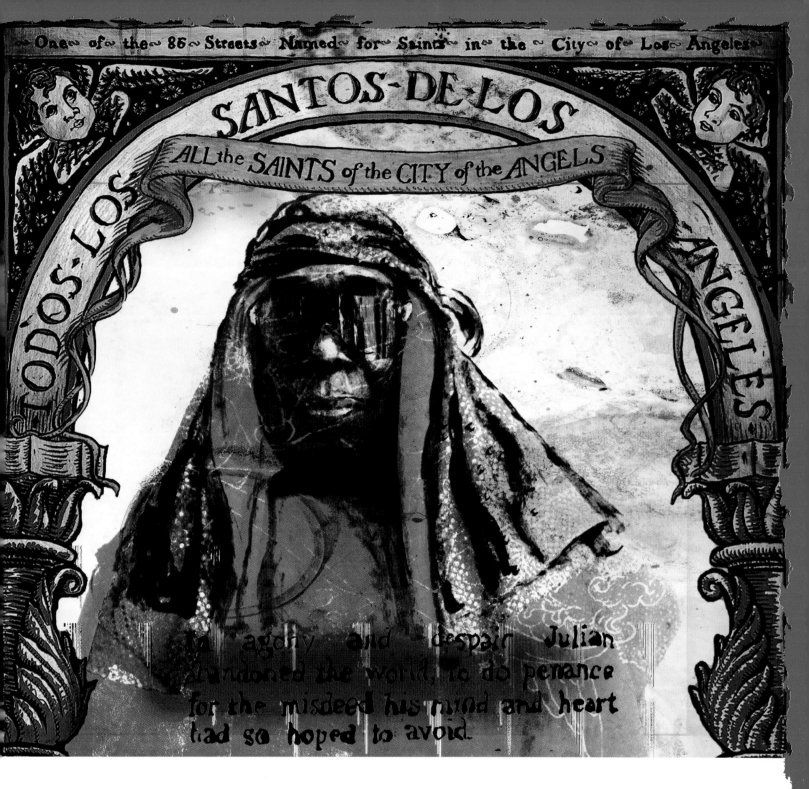

SANTOS-DE-LOS

ALL the SAINTS of the CITY of the ANGELS

TODOS-LOS

ANGELES

In agony and despair Julian
abandoned the world, to do penance
for the misdeed his mind and heart
had so hoped to avoid.

A quickly lit candle, a tumbling-out of words, and a thrown-back blanket revealed all too fully the gravity of Julian's terrible error.

In agony and despair, Julian abandoned the world to do penance for the misdeed his mind and heart had so hoped to avoid. The good woman, his wife, fell in at his side, as much to expiate any accidental guilt as to give aid to her grieving husband.

For silent years they wandered, in tatters and without shoes, eating bread where it was found, drinking "from many an unhealthful spring." At misfortune's beck and call, they slept on many a hard bed and suffered many a scornful word from passersby.

In time they came to a place well suited for camp; and here they occupied themselves, weaving weeds and branches to form a shelter. They tilled and cared for the land; and it responded with squash, onions, and beans. Julian regained his command of the hunt, and small game sweetened their fire.

By winter's watch, they had a stout home of sunbaked clay and a steady supply of firewood. And as the winter winds gathered strength, their home became a haven for travelers in mid-journey.

All who stopped in were given all. An inviting fire was lit, a heady stew served, a warm bath drawn, and the softest bed

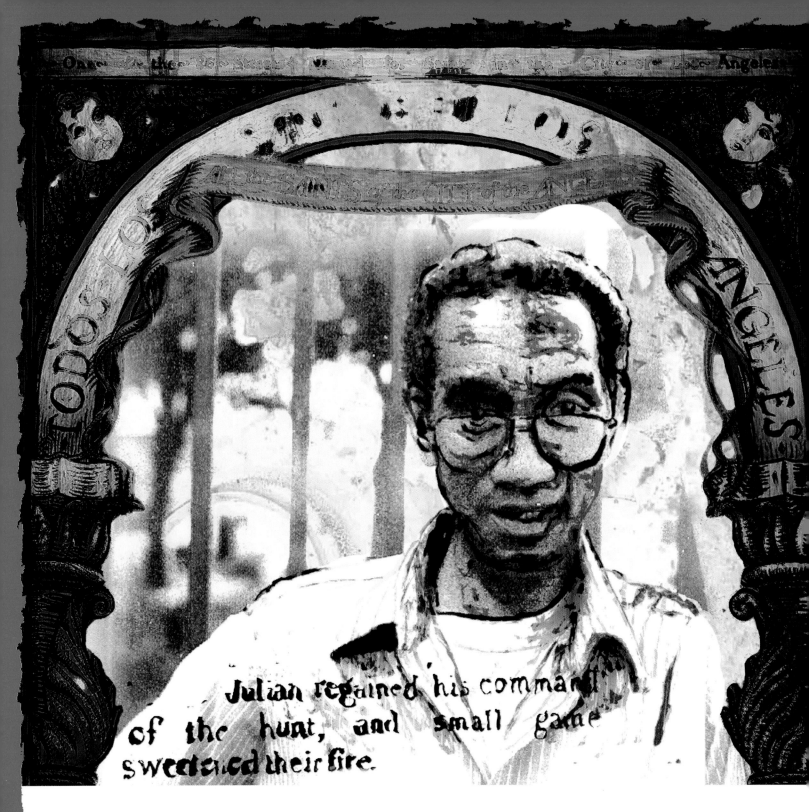

Julian regained his command of the hunt, and small game sweetened their fire.

prepared. No rent was ever charged, nor alms expected; nor did any guest stay but was encouraged to remain until fully rested and restored.

Came one night a terrible storm, all wet wind and sleet; and above the fray was heard a frail cry for help. Julian set out in the dark to find the traveler, exposing himself to the slicing wind and ice, until he came upon a man weak with hunger and festering wounds.

With gentle care Julian gathered into his arms the feeble leper, to warm his hoarse breath against Julian's strong chest, until he got him inside. Between them they set the stranger, this husband and wife, as they tended his wounds and bathed his fetid limbs. The large pot of stew seemed barely enough to crease the traveler's hunger, nor did he utter a thankful word. But they wrapped him into their bed, all warm, clean, and dry; and they softly massaged his aches until they all three fell asleep.

At morning's light Julian and his wife nodded awake, and found the stranger seated facing them and wearing a beatific smile. Great and brilliant wings graced his either shoulder, and a robe of azure and golden threads covered the body which last night they had caressed.

The angel's words were as brief as they were welcome: "Julian, cease your penance. Woman, now may you rest. All is forgiven."

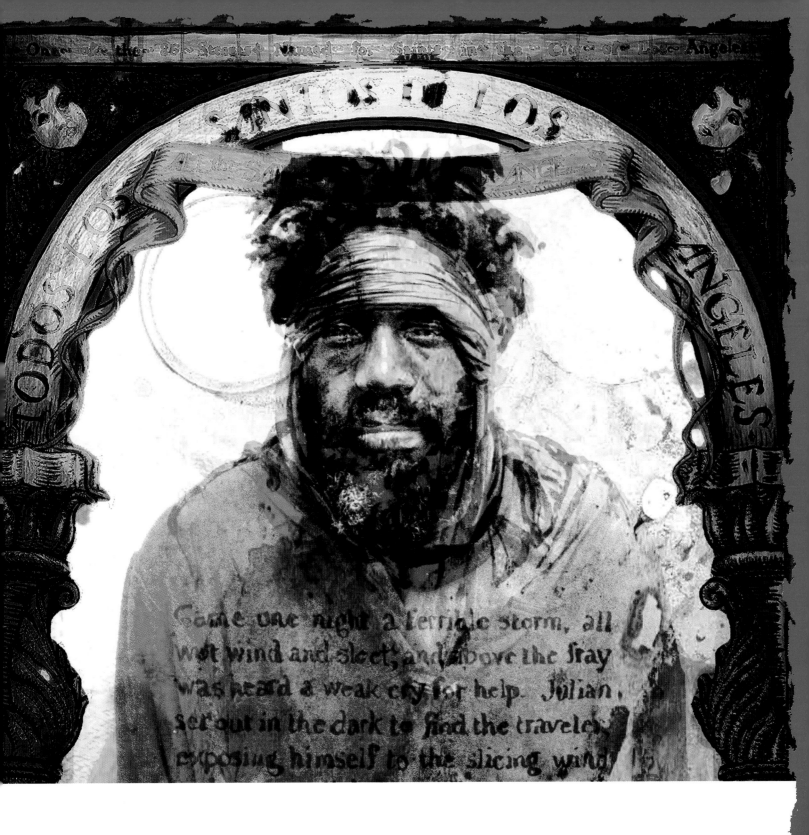

At misfortune's beck and call, they slept on many a hard bed and suffered many a scornful word from passersby.

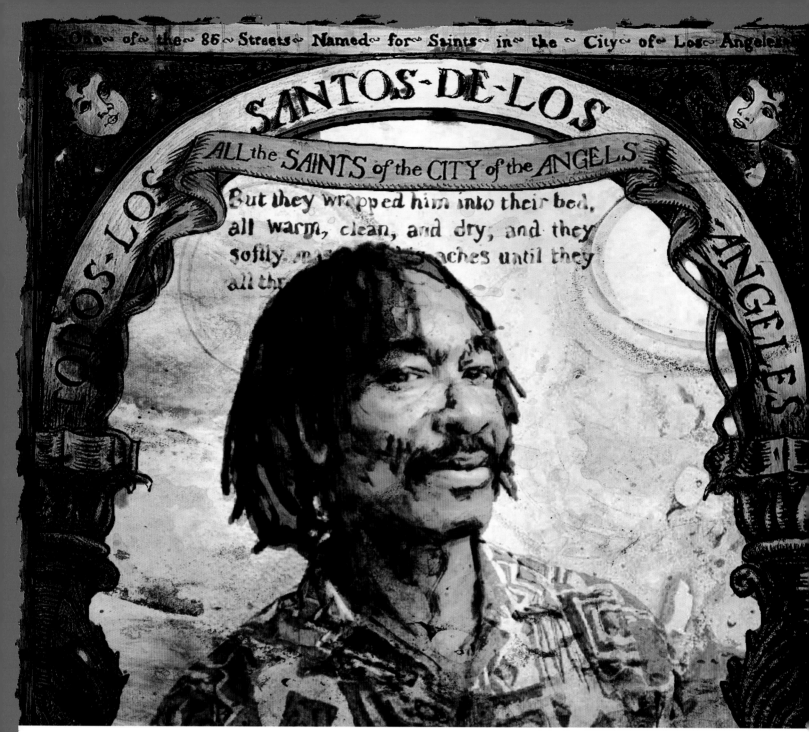

SANTOS·DE·LOS

ALL the SAINTS of the CITY of the ANGELS

But they wrapped him into their bed,
all warm, clean, and dry, and they
softly ... aches until they
all thr...

When I first walked down San Julian Street I was welcomed into LAMP, one of a number of clinics serving the thousands of homeless who have been drawn to this three-block netherworld. Not only does LAMP offer much-needed refuge from the madness outside its doors; many of its counselors are, like San Julian, former wanderers themselves.

LAMP focuses its services on the mentally ill homeless: a sizeable, growing population. It occurred to me during my visits here that this also echoes San Julian's legend, for mental illness befalls people unsought, and strikes people as unexpectedly—and unmerited—as San Julian's curse.

Another similarity to San Julian's tale is that LAMP staff members refer to those they serve not as patients or clients, but as guests. The first day I arrived, a number of these guests lined up for me to take their portraits, as contemporary San Julians, for my painting.

We later installed a large print of the painting in LAMP's lobby, and I have been back any number of times to visit. Seven years after I painted their portraits, a few of the guests I portrayed are still here and a few have moved on and up; a few drop in from time to time and a few have been claimed, more or less permanently, by prison or the street.

As Julian experienced, while living on the street one endures "many a hard bed" and "many a scornful word." Patience and sympathy are in short supply.

But on this street named for the patron saint of wanderers and those who provide them shelter, at least one friendly door is open. It is not enough, by far—we must, as a city and a people, do better—but fittingly, LAMP's light is both bright and a welcome sign of hope.

10

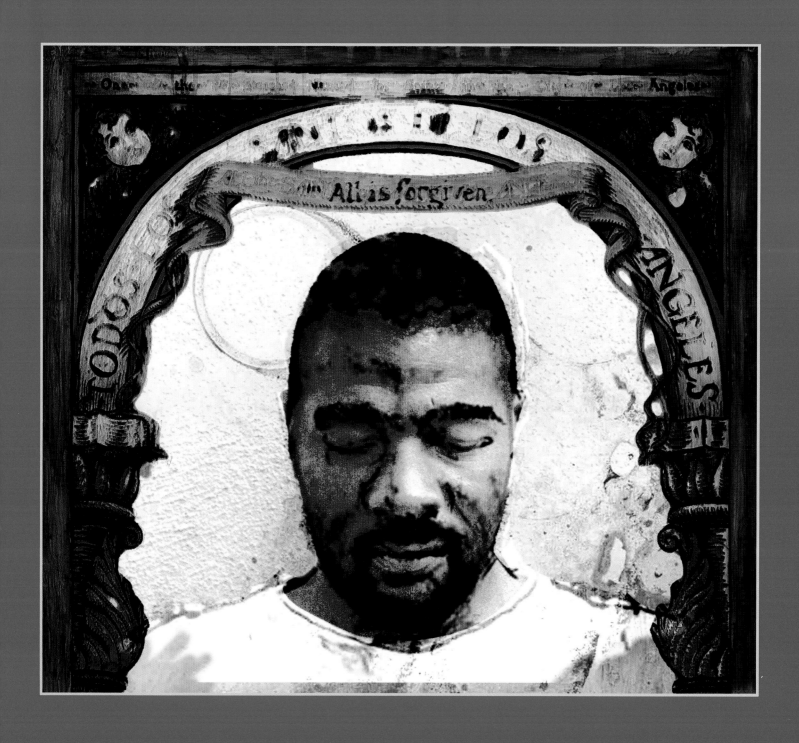

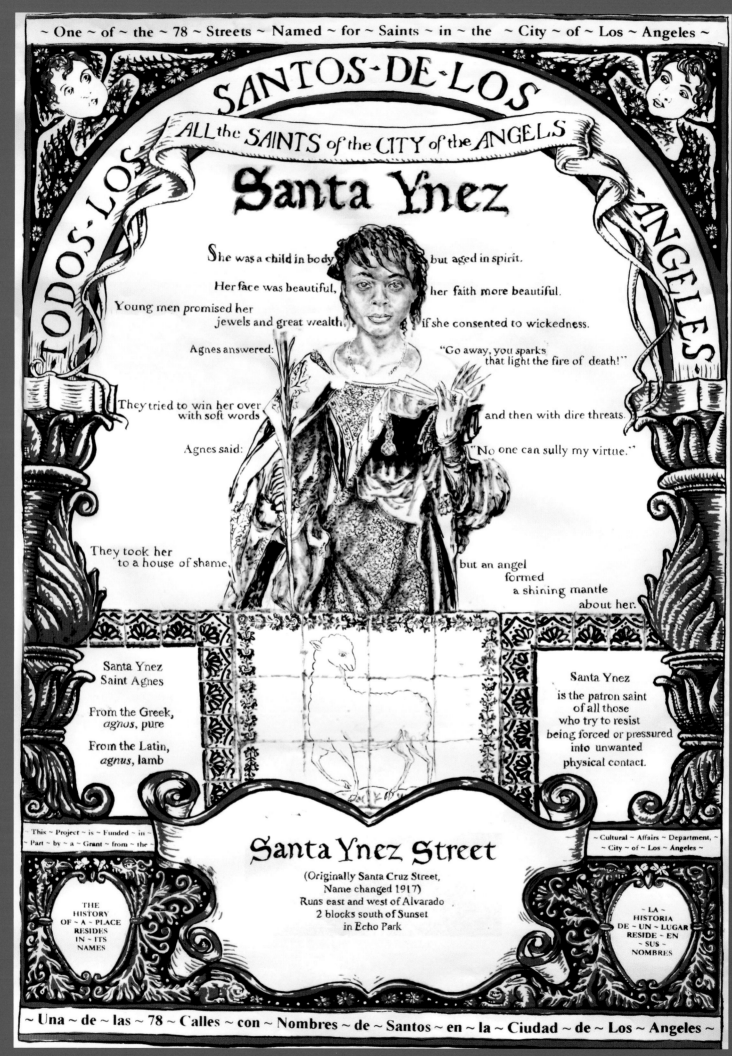

SANTOS · DE · LOS
TODOS · LOS
ANGELES

ALL the SAINTS of the CITY of the ANGELS

Santa Ynez

She was a child in body but aged in spirit.

Her face was beautiful, her faith more beautiful.

Young men promised her jewels and great wealth, if she consented to wickedness.

Agnes answered: "Go away, you sparks that light the fire of death!"

They tried to win her over with soft words and then with dire threats.

Agnes said: "No one can sully my virtue."

They took her to a house of shame, but an angel formed a shining mantle about her.

Santa Ynez
Saint Agnes

From the Greek,
agnos, pure

From the Latin,
agnus, lamb

Santa Ynez
is the patron saint
of all those
who try to resist
being forced or pressured
into unwanted
physical contact.

~ This ~ Project ~ is ~ Funded ~ in ~
~ Part ~ by ~ a ~ Grant ~ from ~ the ~

~ Cultural ~ Affairs ~ Department,
~ City ~ of ~ Los ~ Angeles ~

Santa Ynez Street

(Originally Santa Cruz Street,
Name changed 1917)
Runs east and west of Alvarado
2 blocks south of Sunset
in Echo Park

THE
HISTORY
OF ~ A ~ PLACE
RESIDES
IN ~ ITS
NAMES

~ LA ~
HISTORIA
DE ~ UN ~ LUGAR
RESIDE ~ EN
~ SUS ~
NOMBRES

SANTA YNEZ STREET

Echo Park

i.

I was standing in the lobby of a drop-in shelter for the mentally ill homeless in the heart of Skid Row.

She was sitting in one of the gray plastic chairs lining the wall, dressed in a black blouse and beads. Frail and small with delicate features, she had the eyes of a doe.

I had come to deliver the photographs I had taken for my San Julian Street painting, so they could be distributed to the homeless guests who had posed for me.

I noticed her immediately: she looked far too young and vibrant to be in this place, as though she had somehow confused it with the bus station a few blocks away. Perhaps she was still new at "being homeless" and not yet beaten down by it. Perhaps this was why her eyes seemed fixed on something far away—to shut out her mistaken surroundings.

"Excuse me," I approached her. "Would you mind if I took your photograph?"

Her eyes brightened, a broad smile appeared, and she replied, as though I had happened by at the most opportune moment, "I've been waiting for someone to take a good picture of me."

I couldn't help imagining that one could wait a very long time in a shelter for the mentally ill homeless for such a moment to occur—and yet here I was, my camera in my backpack.

We were permitted to pass through LAMP's dining room (which was transformed each evening into a cot-filled dormitory) to enter the small, sheltered patio out back. If LAMP's lobby provided a buffer from the harsh life outside its doors, this small wedge of green, hemmed in by wire fence and concrete, offered a further gift. Here one could conceivably forget for a moment, under the sycamore's shade and free of the sights and sounds of the street, that one was still mired on Skid Row.

Jevona immediately struck photogenic pose after pose. Wrapping her arms around the sycamore's low branches she smiled into the camera and told me her story.

ii. *She was a child in body, but aged in spirit: her face was beautiful, her faith more beautiful* (from *The Golden Legend*)

How long had she been here? It was never very clear to me, but it had not been long.

Her pathway from childhood in the Carolinas to adulthood in L.A. followed a time-honored story line. Jevona, "the Young Innocent," had come to Hollywood to "Make It Big," only to be subjected to the avaricious whims of those to whom she turned for aid. It was a tale at least as old as silent film melodramas; but really, it was as ancient—and as contemporary—as the plight of the powerless everywhere.

She had hoped to find work as a model or performer: she could sing and dance, Jevona assured me. Like models and performers, though, she would need head shots and fashion photos to show around, so her boyfriend at the time found someone who would photograph her at no cost. Well, almost no cost.

All she needed for the exchange was to pose for "other" photographs first.

iii. *Young men promised Agnes jewels and great wealth if she consented to wickedness*

How does it begin? When does a woman—or a girl, actually—realize that men see her body as a commodity, to be purchased and possessed, desired and discarded?

What is the cost of seeing yourself as two beings: the inner you, comprised of your ideas and abilities; and the outer you, comprising your appearance? And what is the effect when you see that the outer you is valued more highly than the inner you?

Jevona consented to the trade; she saw no other options. She agreed to pose for the photographer so she could get her head shots, in hopes of getting some work. With her boyfriend present the modeling session began.

She didn't mind at first, she told me; the photos weren't too bad or too uncomfortable.

But as the poses became increasingly explicit, and as the photographer demanded she do more and more things she was uncomfortable with doing, her discomfort grew.

The point came when she found herself unable to continue: "I couldn't help myself," she explained. "My feelings just came bubbling up to the surface and I started to cry."

Her boyfriend got angry and the photographer became exasperated, but Jevona kept crying. Her boyfriend yelled at her and the photographer threatened her, but she couldn't stop.

Finally, the photographer tore up the roll of film and the session was over. No more uncomfortable modeling, but also no head shots or fashion photos, and so no hope of work either. And then the boyfriend was gone, too.

Santa Ynez

As she related this story her voice had been calm, at most a little wistful. It was, after all, just one step along the path that had led her here.

iv. *They tried to win her over with kind words and then with dire threats; Agnes said, "No one can sully my virtue"*

When I had my film developed and reviewed the images in my studio, I was struck again by Jevona's off-kilter beauty and her wavering between youthful innocence and world-weary experience.

The next saint-street I needed to portray was Santa Ynez—St. Agnes; and it was quickly obvious to me as I read the saint's legend that, although Jevona's life was unfolding three miles from Santa Ynez Street, their stories converged in important ways.

Extracting passages from St. Agnes' *Golden Legend*, and marrying Jevona's face to the saint's regal, five-hundred-year-old portrayal by the Master of the St. Bartholomew Altarpiece, I created my painting—her portrait—that evening.

The next day Jevona pored over the photographs I brought her, arranging and rearranging them, carefully storing them in the only bag she possessed, and then removing them to view the pictures again.

We went upstairs, and in one of LAMP's offices I was able to share with her the finished painting.

"What do you think of it, Jevona?" one of the counselors asked.

Her eyes brimmed with tears; "It makes me think of grace," she said.

v. *They took her to a house of shame, but an angel formed a shining mantle about her*

I saw Jevona a handful of times after that.

Once I invited her to accompany me on an errand—she was eager to explore the city—and when we stopped for a bite to eat and the food was set in front of her, she lost her composure—a look I still remember. When I dropped her off at the shelter it was early evening: the shelter gates were being locked, San Julian Street was teeming, and the noise level was rising ominously. As I drove away I saw her through the gate: she looked like a frightened deer.

Another morning I found her seated along the wall where we had first met, listening to really loud music on her headphones ("It's to drown out the voices in her head," the staff explained). She was gazing apprehensively into the middle distance. I sat next to her and watched her for a long time, wishing I could see what she saw and hear what she heard that was so hard to escape.

The last time I saw her at the shelter there was music in the air. A celebration of some sort was going on; the dining room tables and chairs were pushed aside and a boom box was playing hits from the 1960s and '70s. Men and women—the regulars—were laughing, talking, and dancing.

A small circle of men had gathered around Jevona, trying to attract her attention: "C'mon over here, baby." She would have none of it. She was in her own world now, laughing and talking with invisible companions, enjoying a private party with the voices in her head.

The music hadn't stopped, but Jevona started toward the front door, her gaze fixed on the world inside her head. As she walked, the floor seemed to be a moving target, as if she was on a small boat on very high seas. Just as she passed by, looking ahead, she spoke very softly, "Hi, Michael." And then she was gone, stumbling out the door into the street. Given her condition and the effort it took, her words were probably the highest compliment she could have paid. Not long after that she was gone for good—or for worse. No one at the homeless shelter ever saw or heard from her again.

vi. *O, she is rich in beauty, only poor / That when she dies with beauty dies her store* (from *Romeo and Juliet*)

Where is the saint in all this?

When I first came home from the shelter with my photographs of Jevona and read the legend of St. Agnes, I thought the moments where their stories converged were the dramatic ones: where an angel protects Agnes at the "house of shame" and where Jevona's crying stops the photographer from coercing her to expose herself.

But real life is far less tidy. Jevona once told me that men were always after her; that if she was willing to sell her body she wouldn't have to be homeless. It may be a transaction she finally chose to make. Women do that, when they find their options reduced.

Jevona was really fighting a trio of demons: the mental illness that gnawed away at her serenity, the societal illness that commodifies a woman's body, and the poverty that deprived her of options for resisting either one. In the face of all that, where was she supposed to find peace?

Instead of some dramatic moment that would define her as a saint, her accomplishment came in just getting through each day with a modicum of tranquility and her self-esteem intact.

I hadn't asked Jevona for her story the day we met; I had only asked for her picture. The story had tumbled out between the photographs. But what the story had done was create a bridge between us, one of Jevona's construction.

In a sense, of course, I had asked for the outer Jevona—which she had freely given in exchange for my also accepting the inner Jevona.

She had been waiting, as she said, for a "good photograph." But everyone so far had insisted on bartering for it, on unequal terms.

By quietly insisting that I see the "inner her" and not just her face, Jevona set the terms of our exchange—and gave me far more than I had hoped for in return.

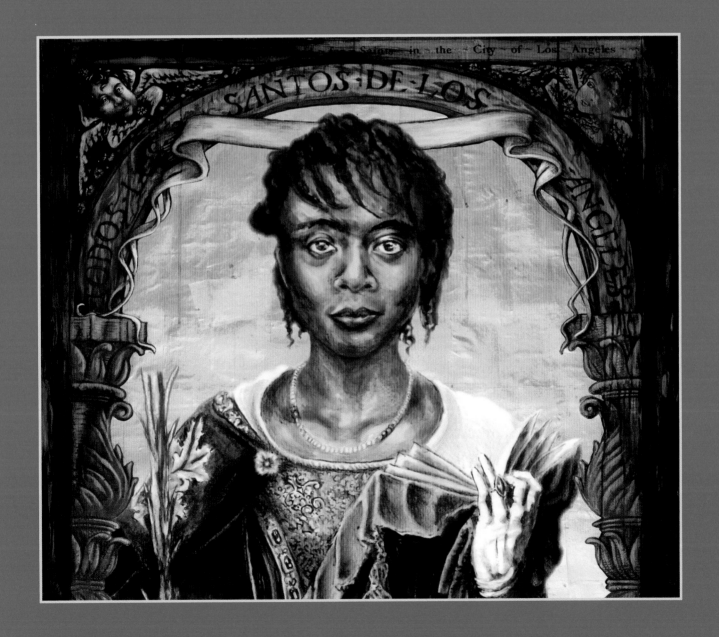

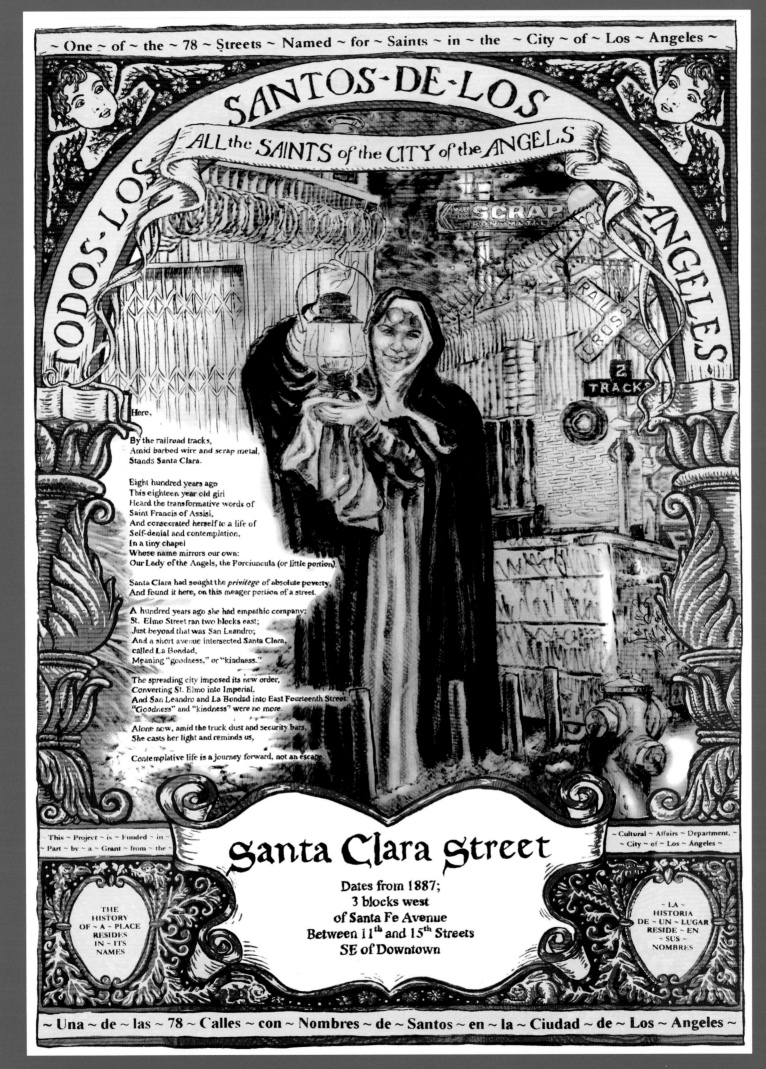

SANTOS · DE · LOS

TODOS · LOS

ANGELES

ALL the SAINTS of the CITY of the ANGELS

Here,

By the railroad tracks,
Amid barbed wire and scrap metal,
Stands Santa Clara.

Eight hundred years ago
This eighteen year old girl
Heard the transformative words of
Saint Francis of Assisi,
And consecrated herself to a life of
Self-denial and contemplation,
In a tiny chapel
Whose name mirrors our own:
Our Lady of the Angels, the Porciuncula (or little portion).

Santa Clara had sought the *privilege* of absolute poverty,
And found it here, on this meager portion of a street.

A hundred years ago she had empathic company:
St. Elmo Street ran two blocks east;
Just beyond that was San Leandro;
And a short avenue intersected Santa Clara,
called La Bondad,
Meaning "goodness," or "kindness."

The spreading city imposed its new order,
Converting St. Elmo into Imperial,
And San Leandro and La Bondad into East Fourteenth Street:
"Goodness" and "kindness" were no more.

Alone now, amid the truck dust and security bars,
She casts her light and reminds us,

Contemplative life is a journey forward, not an escape.

~ This ~ Project ~ is ~ Funded ~ in ~
~ Part ~ by ~ a ~ Grant ~ from ~ the ~

~ Cultural ~ Affairs ~ Department, ~
~ City ~ of ~ Los ~ Angeles ~

Santa Clara Street

Dates from 1887;
3 blocks west
of Santa Fe Avenue
Between 11th and 15th Streets
SE of Downtown

THE
HISTORY
OF ~ A ~ PLACE
RESIDES
IN ~ ITS
~ NAMES

~ LA ~
HISTORIA
DE ~ UN ~ LUGAR
RESIDE ~ EN
~ SUS ~
NOMBRES

SANTA CLARA STREET

Southeast of Downtown

Here
By the railroad tracks,
Amid barbed wire and scrap metal,
Stands Santa Clara.

Eight hundred years ago
This eighteen-year-old girl
Heard the transformative words of
St. Francis of Assisi,
And consecrated herself to a life
Of self-denial and contemplation,
In a tiny chapel
Whose name mirrors our own:
Our Lady of the Angels, the Porciúncula.

Santa Clara had sought the privilege of absolute poverty,
And found it here, on this meager portion of a street.

A hundred years ago, she had empathic company:
St. Elmo Street ran two blocks east;
Just beyond that was San Leandro;
And a short avenue intersected Santa Clara—
La Bondad, meaning "goodness" or "kindness."

Then the spreading city imposed its new order,
Converting St. Elmo into Imperial,
And creating East Fourteenth Street
Out of both San Leandro and *La Bondad*:
Goodness and kindness were no more.

Alone now amid the truck dust and security bars
She casts her light and reminds us:

Contemplative life is a journey forward, not an escape.

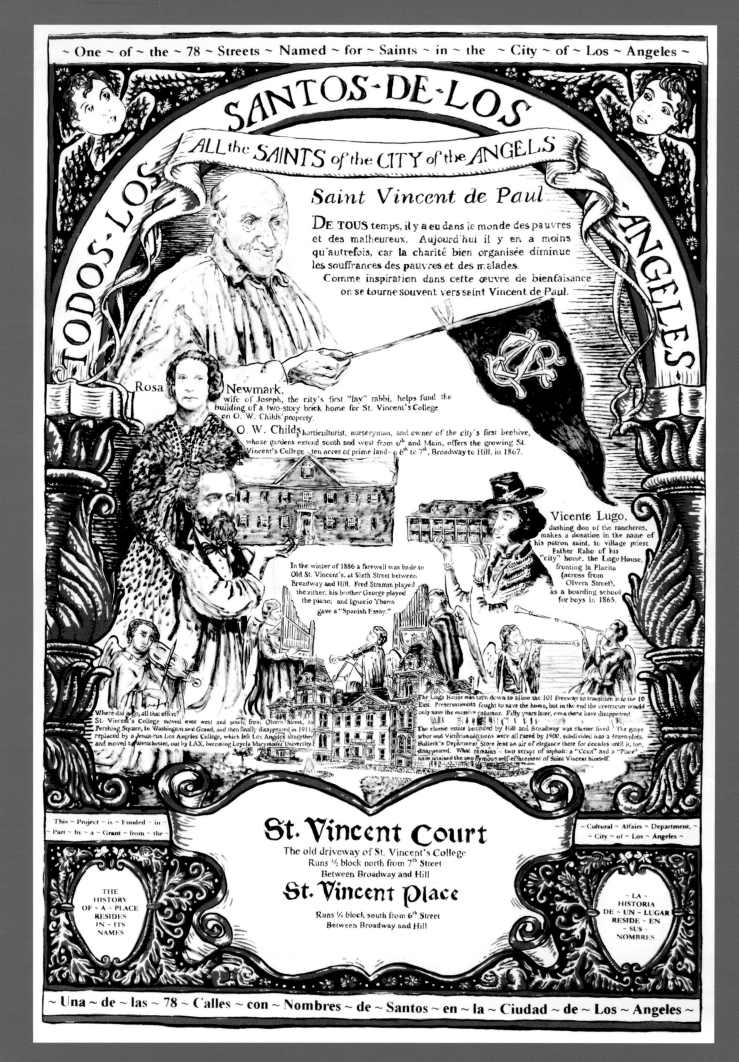

ST. VINCENT COURT and PLACE

Downtown L.A.

Vicente Lugo probably felt he could use a blessing in 1865.

After watching his cattle suffer through alternating years of drought, floods, and Yankee interest rates, with his ranchlands selling for a sad dollar an acre, the dashing don of the ranchos was well poised to receive Father Raho's request to convert the family adobe fronting the plaza into a boarding school for boys.

Thus did St. Vincent's College, the first institution of higher learning in El Pueblo de los Angeles, begin its hopeful life in what passed for a skyscraper in those days: one of the few two-story buildings in what was then a dusty small town.

By the time St. Vincent's outgrew the Lugo Adobe two years later, Protestant O. W. Childs, a prominent horticulturist and future founder of the city's first opera house, was feeling flush and philanthropic enough to donate his land, which lay between today's Sixth and Seventh, Hill and Broadway Streets, as the replacement site.

Rosa Newmark, wife of Los Angeles' first "lay" rabbi, helped with the fundraising (a pleasant reminder, her nephew Harris Newmark would later remark, "of the charming tolerance then existing among Los Angeles citizens of different convictions and beliefs"); and the college blossomed over time into a graceful Victorian estate, replete with grape arbor and fountain.

Such ecumenical philanthropy gave honor to the college's namesake, the sixteenth-to-seventeenth-century French priest Vincent de Paul, who spent his long life helping the less fortunate.

But, what became of all this civic multicultural effort?

When the infamous real estate "boom" hit in 1887, St. Vincent's directors caught the fever, selling off and moving west, to Washington and Grand, where they went belly-up in 1911. Reforming as Los Angeles College, the school moved twice more before landing at its current site near LAX, in Westchester, where it transformed into present-day Loyola Marymount University.

The Lugo Adobe was transformed as well, even becoming part of the old Chinatown on the plaza's east side, until it was torn down in 1951 to facilitate access to the Hollywood Freeway from Alameda and Los Angeles Streets. Preservationists fought to save the venerable century-old home, but in the end the contractor would save only its massive columns: fifty years later, even these have disappeared.

The classic Victorian estate bounded by Hill and Broadway, Sixth and Seventh was even shorter lived: razed by 1900 and subdivided into a dozen plots. Bullock's department store lent an air of elegance to the spot for decades until it, too, disappeared, replaced by a jewelry mart and offices.

At the core of St. Vincent de Paul's life was a love of humility; so perhaps it is, in the end, not to be lamented that all that remains of his great school downtown are fragments of the college's driveways: two anonymous and largely unnoticed scraps of asphalt, which run south from Sixth Street and north from Seventh in the shadows of high-rises and office buildings. Indeed, one of these buildings is the egregiously named St. Vincent Jewelry Mart, the very antithesis of all St. Vincent stood for. Miniscule St. Vincent Place and St. Vincent Court, however, exhibit the very self-effacement of the saint himself.

It may be on the Sixth Street side, at St. Vincent Place, between Hill and Broadway, where St. Vincent de Paul has found his true Los Angeles home. For each night, in this tiny alley's dead end, after all the businesspeople and merchants have packed their things and headed home, the man who wrote "We must serve the poor, especially outcasts and beggars...our masters and patrons" enfolds his homeless masters in his welcoming, sheltering arms.

Where did it go, all that effort?

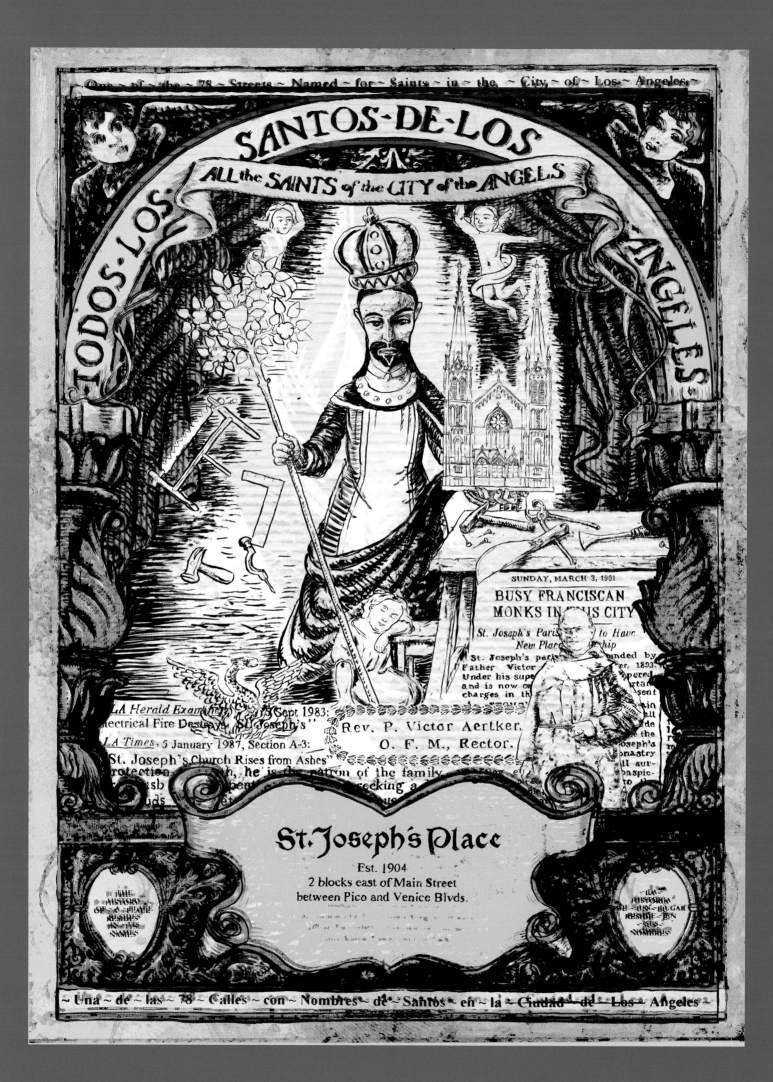

ST. JOSEPH'S PLACE

Downtown Garment District

It all came from hard work, the sort of determined effort St. Joseph knows well. Carpenter by trade and man of skill, he found the cathedral plans ambitious, glorious, slightly daunting, but entirely manageable.

Twin cross-tipped steeples one hundred seventy feet tall; a large rosette window centering a pure gothic façade; three naves and seven altars within; and stained glass throughout—it would be grand and graceful.

The lovely structure, which rose from 12th and Los Angeles Streets in 1903, was all that and more, elegantly supplanting the modest frame building that preceded it a block to the east, and dominating the southern downtown skyline for decades to follow.

A school, some gardens, a rectory and monastery—all served to create a community around the great church. There was much to build, much to maintain. The church even had its own little street: St. Joseph's Place, off Pico just south of the estate, and leading right up into the property.

The altars within the church were ornate and baroque; and handsome handwrought sculptures adorned their many niches.

German families filled the pews to hear Mass in their native tongue. But as the decades passed, both Downtown's and the city's demographics changed.

On Labor Day 1983, as St. Joseph and his fellow workers rested, an electrical fire struck the fruit of his years of labor. All that glorious woodwork turned to firewood; the blaze was great and utterly destructive.

His son is known for rising phoenix-like from the dead, but St. Joseph does not concede easily, either.

After he swept up the ashes and hauled off the shambles, he strapped on his tool belt, brought in fresh, clean material, and set back to work.

You don't give in or up, St. Joseph knew. You rebuild. Maybe more modest this time, maybe *en Español*. But you're a carpenter, so you rebuild.

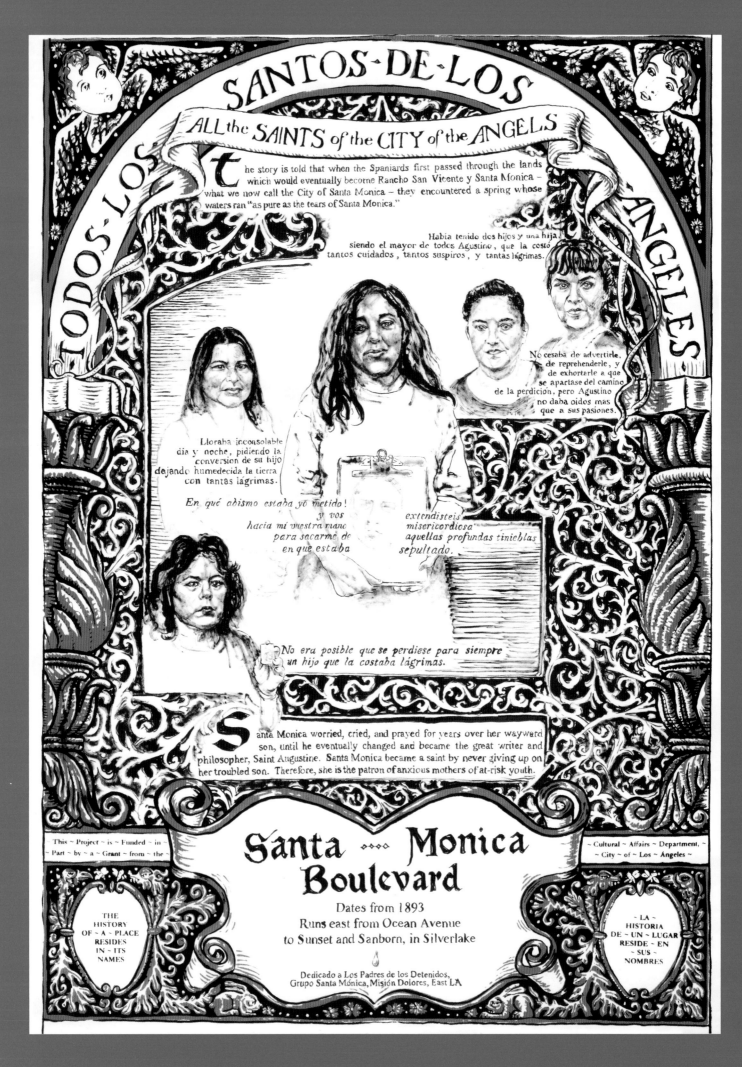

SANTOS·DE·LOS

TODOS·LOS

ANGELES

ALL the SAINTS of the CITY of the ANGELS

The story is told that when the Spaniards first passed through the lands which would eventually become Rancho San Vicente y Santa Monica – what we now call the City of Santa Monica – they encountered a spring whose waters ran "as pure as the tears of Santa Monica."

Había tenido dos hijos y una hija, siendo el mayor de todos Agustino, que la costó tantos cuidados, tantos suspiros, y tantas lágrimas.

No cesaba de advertirle, de reprehenderle, y de exhortarle a que se apartase del camino de la perdición, pero Agustino no daba oídos mas que a sus pasiones.

Lloraba inconsolable día y noche, pidiendo la conversion de su hijo dejando humedecida la tierra con tantas lágrimas.

En qué abismo estaba yo metido! y vos hacia mí vuestra mano para sacarme de en que estaba

extendisteis misericordiosa aquellas profundas tinieblas sepultado.

No era posible que se perdiese para siempre un hijo que la costaba lágrimas.

Santa Monica worried, cried, and prayed for years over her wayward son, until he eventually changed and became the great writer and philosopher, Saint Augustine. Santa Monica became a saint by never giving up on her troubled son. Therefore, she is the patron of anxious mothers of at-risk youth.

~ This ~ Project ~ is ~ Funded ~ in ~
~ Part ~ by ~ a ~ Grant ~ from ~ the ~

~ Cultural ~ Affairs ~ Department, ~
~ City ~ of ~ Los ~ Ángeles ~

Santa ···· Monica Boulevard

Dates from 1893
Runs east from Ocean Avenue
to Sunset and Sanborn, in Silverlake

THE HISTORY OF ~ A ~ PLACE RESIDES IN ~ ITS NAMES

~ LA ~ HISTORIA DE ~ UN ~ LUGAR RESIDE ~ EN ~ SUS NOMBRES

Dedicado a Los Padres de los Detenidos,
Grupo Santa Mónica, Misión Dolores, East LA

SANTA MONICA BOULEVARD

From Silver Lake to the Pacific Ocean

The story is told that when the Spaniards first rolled across the land which would one day become Rancho San Vicente y Santa Mónica—the present-day city of Santa Monica—they encountered a natural spring whose waters, it is said, ran "as pure as the tears of Santa Mónica."

But, who was Mónica, and why was she weeping?

Mónica was a fourth-century widow and the mother of three children. Her eldest son, Agustín, was a bright fellow of great promise who was forever given, instead, to rabblerousing, carousing, and falling into trouble. Although Mónica counseled and pleaded daily with her son to change his ways and seek the right, Agustín would neither listen nor change. Neither, however, would his mother give up hope that his hard heart would soften.

Mónica's years of pleading and praying, of worrying and crying—"until the ground was damp with her tears"—finally bore fruit: one day her wayward son repented, eventually becoming the famed writer and philosopher St. Augustine, a theologian whose books, such as *City of God,* are still studied more than fifteen hundred years after they were written.

Mónica became a saint for continuing to love her son even when he did wrong, and for never abandoning hope for his redemption. Indeed, Agustín himself attributed his conversion to his mother as much as to divine inspiration.

The indestructible love and immovable faith of Santa Mónica are exemplified by the dozen or so women who gather monthly at an Eastside church, Dolores Mission, to share their setbacks, challenges, small victories, hopes, and pain. These mothers have sons in prison; sons whose wayward course has wrought untold suffering and loss on a spiraling circle of loved ones, acquaintances, and strangers.

I was studying the legend of Santa Mónica when I learned of this support group, and the parallels between the saint and these women's lives hit me forcefully. Because of my previous work in the community, they invited me to attend their meetings and share stories.

These mothers had much to share: how difficult, and rare, it is to be permitted to see their sons; how public transportation stops a mile from prison, leaving families to walk the final heavy mile on foot; how their other children—the ones who haven't "messed up"—grow resentful of the attention shown their imprisoned sibling; and how strangers reflexively criticize, rather than empathize with, mothers of prisoners.

Yet these women continue to love their sons and hold out hope that they will change and be freed—if not in body, then at least in mind and spirit. Then these mothers, like Santa Mónica, their eyes hollowed by tears and worry, can find peace, too.

In his *Confessions,* St. Augustine writes, "In what abyss was I buried? And you extended...toward me your merciful hand, to bring me out of that profound darkness."

Here in the City of the Angels, where so many mothers weep for sons who are victims of violence or perpetrators of violence; where so many families are connected by prisons and hospitals, courtrooms and morgues; it is that merciful hand, like the optimistic, long-suffering love of Santa Mónica, that can help us out of the darkness, that can help us to heal.

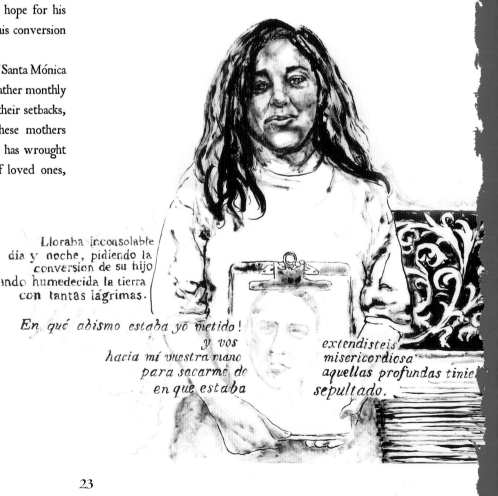

Lloraba inconsolable
dia y noche, pidiendo la
conversión de su hijo
ndo humedecida la tierra
con tantas lágrimas.

En qué abismo estaba yo metido!
y vos extendisteis
hacia mí vuestra mano misericordiosa
para sacarme de aquellas profundas tinie
en que estaba sepultado.

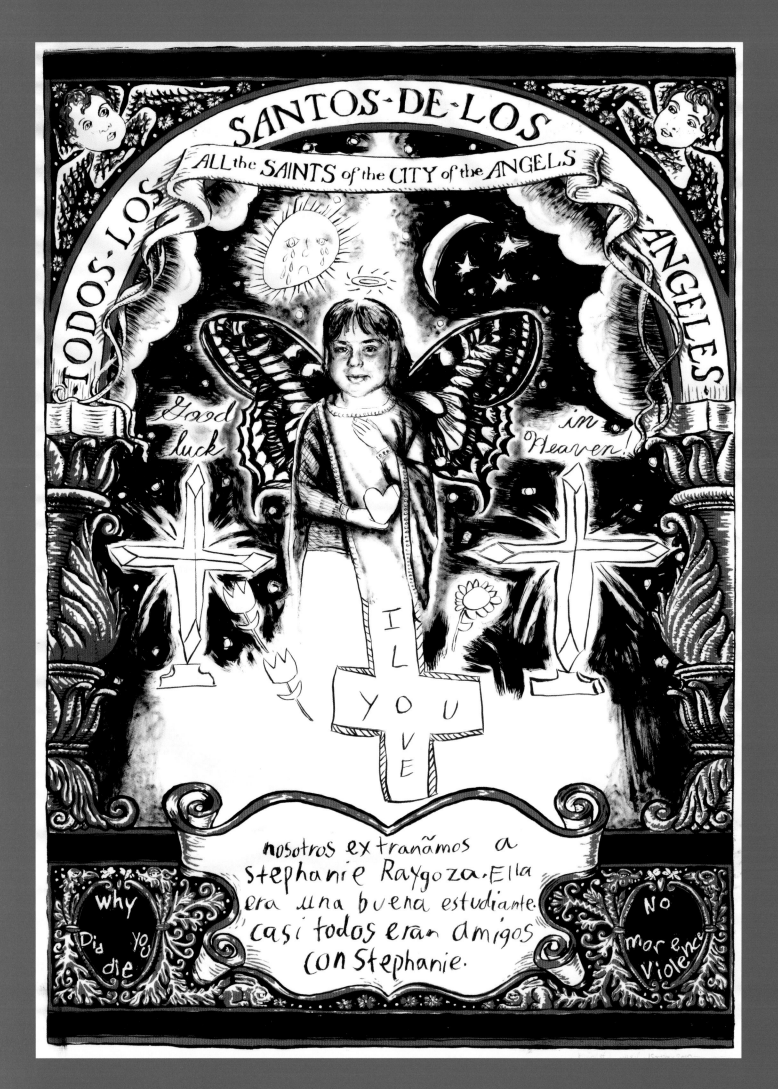

ST. STEPHANIE
de los NINOS

Boyle Heights

Stephanie's father, Gilberto, was begging her to hold on until they made it to the hospital, but already Stephanie was sprouting butterfly wings.

It was a late Sunday afternoon in Boyle Heights, a block away from Dolores Mission Church, shortly before evening Mass, on a quiet side street sandwiched between the L.A. River and the 101 and Golden State Freeways.

The scene had seemed so suburbanly serene: a teenage boy washing his car in the afternoon sun, while down the street a girl traced front-yard circles on her scooter.

If the boys from the other gang hadn't found Raymond there washing his car, would they have kept rolling down Clarence Street, looking for the first young man or boy they could find?

Or was everything immutable, predetermined? The shots fired, the screams from inside the house, the teenage boy falling by his car, the blood mixing with water?

And a half-block down the street, that irretrievable bullet ricocheting toward Stephanie on her scooter—as she played in her yard because her folks knew the street was too dangerous.

If only she had been riding or standing maybe just a foot to the left or the right; if only she had lost her balance and stopped, or fallen off her scooter at that very moment; if only she had stopped for a second to scratch her nose; or, maybe, if she had just gotten hungry and gone inside for a snack, or gone to the bathroom, or remembered a television show she wanted to watch, or been doing her homework, or taking a nap, or lived somewhere else...

But the bullet did find her; and from that moment to her last were the final thirty-five minutes of her third-grade life.

On the Saturday after Gilberto Raygoza rushed his dying daughter to White Memorial Hospital, I got a phone call from the parochial priest of Dolores Mission, Father Mike Kennedy, asking if I could help the family and the community by creating something for her funeral Mass, to be held the next evening—a week, exactly, after she died. I had already collaborated with the community on several art projects, and it was here that I had met with and portrayed the mothers of incarcerated youths for my Santa Monica Boulevard piece.

I drove over and Father Mike shared with me dozens of precious handmade cards Stephanie's classmates had made to give to her parents. I wondered about a world in which children make one another sympathy cards as readily as get-well cards. The images and sentiments expressed equally the children's attempts to cope with senseless loss and their ability to grasp the moment's core issues. "Good luck in heaven" read one message; another asked, "Stephanie, why did you die?"

I was painting my "All the Saints of the City of the Angels" series at the time, so I said I would paint a portrait of Stephanie within one of those frames, and work into the painting some of her classmates' images and words. But I needed a picture of Stephanie to refer to, so we walked around the block to the house where she had lived.

The sidewalk in front of the Raygozas' home was marked with an all-too-familiar collection of flowers, notes, stuffed animals, and lighted candles, around which gathered silent neighborhood children. Passing through the gate and across the tiny yard where Stephanie and her scooter had been six eternal days ago, we entered the family kitchen, filled with matronly women making tamales.

I thought about how marvelous a tradition it is, among Latino families, that the grieving family makes the food, rather than its being brought over by others, because this helps the family focus on something "constructive" and welcoming. One of the seated women was Stephanie's mom, Norma; and she invited me to borrow one of Stephanie's framed photographs from the sidewalk altar out front.

I selected a studio portrait and some dozen or so of the children's cards and came home, shutting myself into my studio, to contemplate what to create. The role of the artist has rightfully become an elective one of self-expression and, often, of responsibility to nothing and no one more than the artist's own muse. But I also knew that everyone had a task to fulfill for Stephanie's memorial the next day—making, stringing, and hanging hundreds of white paper flowers; gathering the helpers, ingredients, and paper plates, and overseeing the cooking so that everyone would be fed; practicing the songs and composing the prayers for the service; typing and printing and folding the programs. Mine was one task among many that together would form the community's response to an awful event by focusing, instead, on celebrating a wonderful child.

Poring over the children's cards, I was impressed with the regularity with which her classmates referred to Stephanie as being an angel now; and how they depicted her with wings—but butterfly wings, not bird wings. A little boy named Javier had drawn a wonderful sun crying copious tears. There were sweet renditions of tulips, sunflowers, hearts, and crosses. And there were the children's words, expressing a range of emotions, in English and Spanish.

I painted through the night, beginning with Stephanie's face, settling on the pose of an angel by Fra Angelico to complement her gaze; then trying to decide which elements from the children's cards to work into the painting as well; changing the music on my CD player from Alan Hovhaness to Phillip Glass to Joseph Arthur to Joni Mitchell's "Job's Lament" and keeping myself alternately fueled with coffee and mezcal. I stumbled into bed shortly before dawn, hopeful I had created something useful.

Just before noon I took the finished painting to Dolores Mission and was invited to sit in with the support group of parents of incarcerated youth; they felt the piece worked, and loved seeing the children's words and images integrated into it. Afterwards I marvelled at the generous, empathic heart of this community, which welcomes and aids the parents of the victims and of the perpetrators of violence; a heart that recognizes how connected they—we—all are.

son. Indeed, it seemed that Stephanie's whole life had been circumscribed by a triangle a mere six blocks long: from her home, at Second and Clarence, to her school, just north of First; then a block east to Gless and down to Second for Mass; and one block west again, to her home at Second and Clarence.

But when Stephanie grew those butterfly wings, and the sun shed those copious tears, the community that supported her was transformed as well.

The Catholic Church has changed its position, over the centuries, on how one becomes, or is recognized as, a saint. The first saints were all martyrs: like St. Stephen or St. Paul, they were killed because of their beliefs. By the fourth century, there were added as saints those whose holy lives demonstrated an unexcelled degree of sanctity—people such as St. Martin of Tours and the Desert Fathers. Over the next millennium and a half, not surprisingly, the procedure for being declared a saint

...when Stephanie grew those butterfly wings, and the sun shed those copious tears, the community that supported her was transformed as well.

That evening was Stephanie's funeral Mass. As if to underscore how insane it was to be burying a child, it was also her First Communion. The church was packed to well beyond capacity, with many teachers and students attending from her school two blocks away. Stephanie's portrait formed part of a procession, followed by her family carrying lighted candles, that entered the dark and humble church as the choir sang. The painting also stood in for Stephanie during her first communion, and Father Mike pointed out (as I had asked him to) how many of the picture's elements had originated in her classmates' images and words.

When Stephanie passed away, in October 2000, her contribution to the world had been the same we ask of any ten-year-old: to be a loving, thoughtful, vibrant child. There was no reason to expect her loss to resonate beyond the sorrow and heartbreak that accompany the passing of any daughter or

has undergone a number of further changes. Still, it remains a constant that one must attribute two miracles to any candidate for sainthood.

On behalf of Stephanie I offer you three.

First, on that mid-October evening a week after the gunfire, a prayer written by her cousins was recited in the darkened church: "Pray for those who killed Stephanie," it said. "May we forgive them; may they find peace." How, save by a miracle, do we explain such compassion in the hearts of those who might easily thirst for blood?

Second, the murdering stopped. Not immediately, it's true; and perhaps not for good (to imply otherwise would be boastful and vain). But still, since July 2004 up to the day this was written, there have been no homicides in Stephanie's neighborhood—for three months shy of three years. For thirty-three months the

mothers have gone to bed trusting their children are safe, and have awakened in the morning to find that it was not just a dream. For thirty-three months children have played safely in their yards and on their streets. In some places this would simply be life as usual; but here the mothers can appreciate each moment shared with their children for the miracle of life that it is—a miracle largely explained by the third one.

Miraculously, this shunted and marginalized community, the mothers in particular, came together after Stephanie's death—and, they say, because of her death—to protest the conditions that made Stephanie's killing so easy. After years of seeing their requests for anti-drive-by speed bumps denied and ignored, they threatened to throw blankets on the asphalt and sleep on the street until City Hall relented (it relented). Mothers who have never raised their voices in public now demand after-school programs, job training, and more—and more humane—policing. To impress upon police and city officials how seriously they take their commitments, they have given them public

blessings and continue to meet with them monthly. And in a program called "Safe Passage," mothers train teams of volunteers to walk each other's children safely home from school.

The Church, of course, is unlikely to declare Stephanie a saint. Not that it matters: her classmates instinctively declared her an angel just days after she died.

The children, with their poetic sense, probably have it right: Stephanie, the angel with the butterfly wings, floats above her old neighborhood while, on the streets below, the mothers—true saints—place themselves daily in harm's way to protect their community.

Read as saintly legend, it might have been more impressive had Stephanie stopped the killing and made the streets safe all by herself. But as lived experience, to have inspired and empowered the mothers of her community to take charge of their neighborhoods and bring about positive, concrete change—that is far more valuable. In fact, it is all one can ask of anyone, from a saint to a ten-year-old girl.

TWO:

False Moves

A visitor to Los Angeles might notice, more than a native Angeleno would, the profusion of streets named for saints in Southern California. A natural assumption would be that they are a relic of our Spanish-Mexican heritage: well, they are and they aren't.

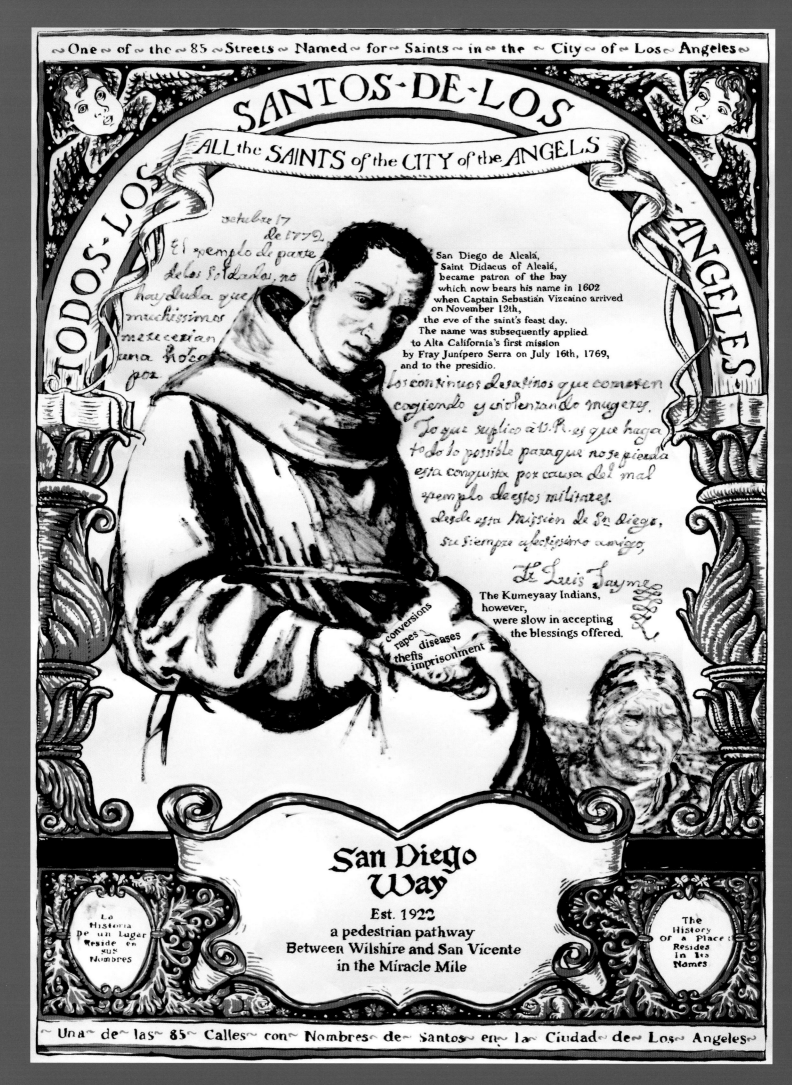

SANTOS·DE·LOS

TODOS·LOS· ANGELES

ALL the SAINTS of the CITY of the ANGELS

San Diego de Alcalá,
Saint Didacus of Alcalá,
became patron of the bay
which now bears his name in 1602
when Captain Sebastián Vizcaíno arrived
on November 12th,
the eve of the saint's feast day.
The name was subsequently applied
to Alta California's first mission
by Fray Junípero Serra on July 16th, 1769,
and to the presidio.

The Kumeyaay Indians,
however,
were slow in accepting
the blessings offered.

conversions
rapes
diseases
thefts
imprisonment

San Diego Way

Est. 1922
a pedestrian pathway
Between Wilshire and San Vicente
in the Miracle Mile

La Historia De un Lugar Reside en sus Nombres

The History Of a Place Resides In Its Names

ALL the SAINTS of CARTHAY CIRCLE

San Diego Way, San Gabriel Way, and Santa Ynez Way

In central Los Angeles, squeezed in between Fairfax and La Cienega, straddling the four or five streets that separate Wilshire and Olympic Boulevards, three modest sidewalks—pedestrian pathways, really—bear the burden of our refusal to confront the past.

San Diego Way (three short blocks long), Santa Ynez Way (two blocks), and San Gabriel Way (one block) were created, in the 1920s, to do two things: to bisect the otherwise broad east-west blocks of Carthay Circle, and to call to mind the Franciscan missions whose names they bear.

In much of America, the "transition" from Native American stewardship to United States ownership occurred in the seventeenth and eighteenth centuries. Here in Los Angeles, however, this transition—mediated first by Spanish and then Mexican possession—was not officially consummated until 1850; and even then it took decades to play itself out. As a result, the city's cultural battle scars are of relatively recent vintage; and for many people here—native peoples and Chicanos among them—the wounds are still fresh.

The Anglos who came to dominate Los Angeles politics, commerce, and culture from the 1870s onward sought to bolster their self-esteem by associating themselves with some grand, laudable "golden past"; and they found one by selectively interpreting the work of the Franciscan padres who created and ran the California mission system from the end of the eighteenth century until the 1830s. The fact that the forced end of the padres' reign could be blamed on the Mexicans, whom the Americans had recently defeated, was a bonus.

Something of the flavor of the mission narrative, as it came to be accepted and passed down in schools, pageants, art, and legend, can perhaps best be gleaned from the writings of local author John Steven McGroarty, best known for his *Mission Play*, which offered the mission narrative as a colorful three-hour pageant. The same year, 1911, that his *Mission Play* was published, and shortly before it was first performed—at his own "Mission Playhouse," adjacent to San Gabriel Mission—McGroarty also released *California: Its History and Romance,* which declares:

Very few of the California Indians occupied a plane of civilization higher than that of beasts when the white men first found them...They had no names for themselves, no traditions and no religion. They were lazy and indolent to a degree and made no attempt whatever to till the soil...It was from this ignorant mass that the Padres brought forth skilled artisans, husbandmen, painters, craftsmen and musicians.

Lest these reprehensible words be thought extreme for their time, it should be noted that the *Mission Play* ran for twenty years, and was seen by some two million patrons; and that McGroarty was chosen, at the end of the play's run, first, as California's poet laureate, in 1933, and then as its Congressman two years later.

What this "mission fantasy" provided for the Anglo-Americans in power was not only a poetic heroic past to claim, but a historical metaphor for their attitudes toward other communities: the padres were celebrated, not for their spirituality, but for their organizational skills; the Protestant work ethic applied to interethnic relationships. The Mexicans who followed the Indians and padres could be celebrated for their festive gaiety—"there is a feeling of regret in the heart that the color and the splendid, happy idleness of it ever passed away"—but clearly their lifestyle was never going to create a civilization on a par with that of the padres, nor with the padres' organizational heirs, the Anglo-Americans.

This was the cultural landscape when, in 1922, Los Angeles developer J. Harvey McCarthy conceived the grand-scale project which would be his own great historical and commercial monument to "the glories of California South": Carthay Circle, named (somewhat creatively) for his father, Daniel O. McCarthy, a forty-niner who had died three years previously.

J. Harvey saw his housing development as a way to honor not only Daniel O., but other persons and locales significant to nineteenth-century California history. His community chapel, for example, was named the Amanda Chapel, as "a memorial to a woman of beautiful character who was one of the Pioneers of California"; in other words, Amanda Anderson McCarthy: Daniel O.'s wife, J. Harvey's mom.

To help name his streets for people other than his parents, J. Harvey designated a committee of three fellow members of the Native Sons of the Golden West—the same fraternal organization to which he, his architect, and his engineer belonged.

The Native Sons, founded in San Francisco in 1875, were dedicated to celebrating and preserving California history—or at least California history as it was understood in 1875. This meant that, like many Californians of their day, and indeed like the creator and two million patrons of the *Mission Play*, they saw

of Southern California's recent past provided the example that McGroarty and others would follow for decades to come.

H. H. Jackson's novel springs from an admirable goal: to call attention to the shameful historical treatment and contemporary predicament of California's native peoples. Her method, however, of constructing a fiction around the ill-fated love affair between a mestiza heroine and her Indian lover, set in the fantasy twilight of the mission era, enabled her avid readers to focus on the melodrama and romance at the expense of any implicit social commentary.

Indeed there is almost a parallel love story in *Ramona*, and that is its author's love for a romanticized vision of the Franciscan missions, and a resulting nostalgic yearning for a golden (if fictional) past.

local history as the forward march of civilization, from Indian to Spanish-Mexican to American; from the darkness to the light.

The Native Sons' membership initially comprised men who had been born in California, "under the American flag." However, with the rarest of still-well-connected ex-ranchero exceptions, membership was exclusively Caucasian. There were no blacks; certainly no Asians (the Native Sons campaigned heavily against Asian immigration); and in the clearest contradiction possible, there were no Native Americans—and, hence, no true "native" sons.

That J. Harvey, his architect, his engineer, and his naming committee all belonged to the Native Sons of the Golden West simply reflects, on one level, the professional composition of fraternal organizations of the day.

But it also speaks to a central issue that affects our connection to the land: Who gets to interpret our past? Who gets to tell the stories? As we have seen from J. S. McGroarty's framing of the relationship between the Franciscans and Native Californians, this is not a minor concern.

The local chapter of the Native Sons, to which J. Harvey et al. belonged, was known as the Ramona Parlor and had been founded in 1887, twelve years after the mother organization's founding and three years after publication of the seminal novel from which it takes its name: *Ramona*, by Helen Hunt Jackson.

In a very real sense, everything flows from *Ramona*. This misunderstood novel inadvertently launched a cottage industry (of Mission design, of course) of souvenirs, tourism, movies, music, and even its very own pageant play. The author's recast

This yearning, of course, was not Jackson's alone: it came to infuse the popular culture of its day with an almost trademark twinge of regret. Yet by focusing on the superlative friars (as they were portrayed), adherents could maintain opposing opinions—as McGroarty, for one, did—of the very natives the Franciscans came to "save," and Jackson wrote to honor (and save).

It is not surprising, therefore, that when the Ramona Parlor named Carthay Circle's streets for important nineteenth-century figures—such as Ygnacio del Valle and Abel Stearns—they also christened the walkways with mission names: San Diego Way, San Gabriel Way, and Santa Ynez Way. The path leading from *Ramona* to the Ramona Parlor to Carthay Circle is fairly direct, and each stop along the way meshes truth, social benevolence, and fantasy.

The same may be said for the missions as well. The friars, understandably, believed they represented the Truth. They also sought to do well by the natives, as they understood things. But, of course, their sense of what was appropriate here on the natives' home turf, and even their sense of whom the natives fully were— these were, perhaps unavoidably, faulty and fantastic.

The sad thing is that, in each case, someone meant well: Helen Hunt Jackson, with her novel of social justice that was read as nostalgic melodrama; the Native Sons of the Golden West, who sought to preserve California history, from a narrow, ethnocentric perspective; J. S. McGroarty, who, in praising the friars, blasphemed the natives they came to help; and the mission friars, who sought to save the natives through methods that ultimately led to their destruction.

It may seem too much to saddle three concrete walkways with the burden of California's mission fantasy. But this was, in essence, the purpose of naming them in the first place. J. Harvey McCarthy and his Ramona Parlor colleagues wanted residents and visitors to associate their housing development, their streets, and yes, even their sidewalks with California history.

The walkways are dedicated to the first and last of the Southern California missions (San Diego and Santa Ynez), and to the mission closest to Los Angeles (San Gabriel). The natives at San Diego and Santa Ynez were subjected to continual abuse from the soldiers posted nearby: in San Diego it was principally sexual; in Santa Ynez it was principally economic. In both places these abuses led natives to revolt against the injustices they experienced—revolts which came at great price to the natives.

Seen in this context, and bearing in mind the disease-born suffering and cultural disruption that the natives experienced throughout the mission system, one may well ponder—given that San Gabriel Mission is dedicated to the Angel of the Annunciation—just what the missions' arrival was meant to announce.

Amanda Chapel is gone and Daniel O.'s park is reduced to a sliver of land in the middle of San Vicente Boulevard—neither a quiet nor a safe place to sit and think.

But we do have these three pathways still, named for Southern California missions, where we can stroll and consider our storied past. The three saints of Carthay Circle serve as conduits for thought and reflection on the chasm between dream and reality, on the distance between reach and grasp; and as reminders, once again, that the road to hell is sometimes paved with good intentions.

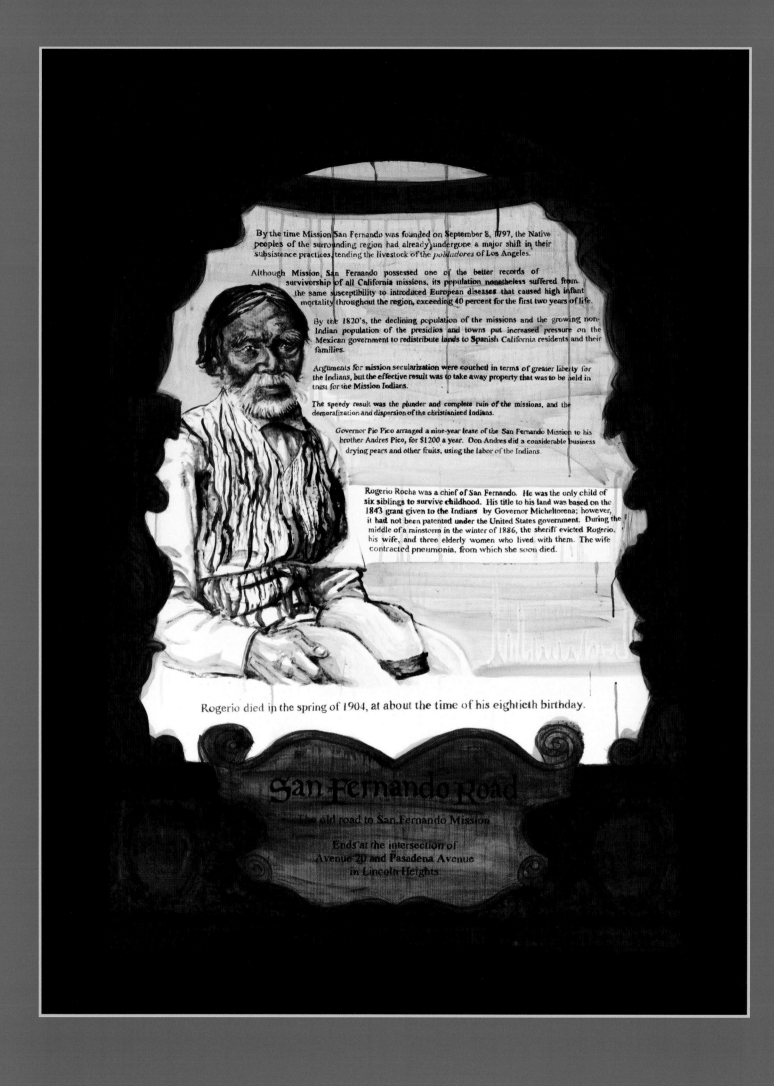

By the time Mission San Fernando was founded on September 8, 1797, the Native peoples of the surrounding region had already undergone a major shift in their subsistence practices, tending the livestock of the *pobladores* of Los Angeles.

Although Mission San Fernando possessed one of the better records of survivorship of all California missions, its population nonetheless suffered from the same susceptibility to introduced European diseases that caused high infant mortality throughout the region, exceeding 40 percent for the first two years of life.

By the 1820's, the declining population of the missions and the growing non-Indian population of the presidios and towns put increased pressure on the Mexican government to redistribute lands to Spanish California residents and their families.

Arguments for mission secularization were couched in terms of greater liberty for the Indians, but the effective result was to take away property that was to be held in trust for the Mission Indians.

The speedy result was the plunder and complete ruin of the missions, and the demoralization and dispersion of the christianized Indians.

Governor Pio Pico arranged a nine-year lease of the San Fernando Mission to his brother Andres Pico, for $1200 a year. Don Andres did a considerable business drying pears and other fruits, using the labor of the Indians.

Rogerio Rocha was a chief of San Fernando. He was the only child of six siblings to survive childhood. His title to his land was based on the 1843 grant given to the Indians by Governor Micheltorena; however, it had not been patented under the United States government. During the middle of a rainstorm in the winter of 1886, the sheriff evicted Rogerio, his wife, and three elderly women who lived with them. The wife contracted pneumonia, from which she soon died.

Rogerio died in the spring of 1904, at about the time of his eightieth birthday.

San Fernando Road

The old road to San Fernando Mission

Ends at the intersection of
Avenue 20 and Pasadena Avenue
in Lincoln Heights

SAN FERNANDO and SAN FERNANDO MISSION ROADS

From Lincoln Heights Northwest to Mission San Fernando Rey

Two centuries on, the San Fernando Valley still bears marks of its troubled, sainted heritage: El Camino Real, buried 'neath Ventura Boulevard, runs like a swordsman's scar across its face; and San Fernando Mission rests near the Valley's western heart, the well-dressed wound of an historic campaign; but really, there are bruises here everywhere.

The pain and unease stem from competing, conflictive aspects of the Valley's namesake's personality. Ferdinand III of Castile—one of several similarly named monarchs—was a just ruler and man of faith, the patron saint of both paupers and governors. Known as *Fernando el Santo* in his native Spain, this thirteenth-century King Fernando is best remembered for his decades-long crusade against the Moors.

It was Franciscan Father Fermín Lasuen who, in 1797, summoned Fernando el Santo's return, some seven and a half centuries after his death, to reign over a "very pleasant and spacious valley" a day's ride from then-tiny El Pueblo de Nuestra Señora de los Angeles.

By the time Friar Fermín dedicated Mission San Fernando Rey in the canonized king's honor, the valley's natives had already weathered sixteen years of cultural disruption, as imported livestock—which they were herded into tending—invaded their fertile lands, courtesy of El Pueblo's vaunted *pobladores*, or settlers.

Fernando el Santo was dropped into this moving tableau and hit the ground running, guessing the key players and their relative positions.

A lay member of the Order of St. Francis, Fernando naturally gravitated to the friars and assisted in realizing their missionary dream. Under his command (after all, he had led the Spaniards to victory against the Moors), hundreds of Chumash and Tongva were brought onto mission property (not long ago free land, open to all); required to work and live in conditions alien to them; forced to abandon diets and beliefs that had served their peoples for millennia; and subjected, however inadvertently, to disease and infection for which they possessed no defense.

No doubt, from the vantage point of the Church all seemed fair, just, even noble and incontrovertibly progressive—save the fact that the natives kept dying, or trying to escape. Indeed, mortality was such that two of every five infants died before their second birthdays (sadly, this was better than survivorship at other California missions).

Regrettably, Fernando el Santo may have unwisely focused his attention on the padres and their catechism, to the neglect of the military; for the record is fairly clear on the continual abuses heaped upon the natives—particularly the women—by insatiable, corrupt soldiers.

Then again, perhaps memory of his ancient crusade against the "heathen" Moors proffered Fernando a too-ready excuse to turn a blind eye to such excess.

In any case, Fernando el Santo was not to rule over the San Fernando Valley for very long. Other outsiders were swarming in, pressuring the temporarily ascendant Mexican government to dethrone the old king and the friars, and to offer the lands not to the beleaguered natives who had always been here—and for whom the land was said to be held in trust—but to these self-same outsiders and their governmental cronies.

It would take another dozen years for Fernando's bond with the friars to fully unravel, but by 1836 most of the natives found themselves evicted from the only land they had ever known and either joined the handfuls of Indians still living free in isolated pockets in the hills, or drifted into Los Angeles' first slums, where hard liquor and hard labor awaited them.

As Eulogio de Celis took possession of the mission property, having purchased the lands from the Pico brothers for twelve cents an acre, Fernando el Santo found himself drifting as well. Toppled from power, no longer counseled by his Franciscan brethren, all the old king had left was his anti-infidel crusade. As Anglo-Americans took possession of California, unattached to the culture and traditions that preceded them, Ferdinand III of Castile cast his lot with the interlopers and bided his time.

He met his match in spring 1874, when ex-Senator Charles Maclay steamed into San Pedro, rolled up the Cahuenga Pass, gazed out over the Valley, and fell deeply, speculatively, and lucratively in love with its progressive promise of subdivided real estate.

Turning to the now-freelance former King of Spain, Maclay murmured, "This Valley, my friend, is the Garden of Eden. *[dramatic pause]* Let's chop it up and sell it."

Stifling any misgivings his Franciscan conscience should have suggested, Fernando el Santo shook hands on a sweetheart deal: he would aid Maclay and his cronies in acquiring the land from

de Celis; and he would reap a new kingdom: the city of San Fernando.

With a loan from the president of the very railroad that would make Maclay's land explode in value—the railroad which would run through the Valley on tracks dearly paid for by the city of Los Angeles—things soon fell into place for Maclay and Co.

Over the next decade business was brisk: their chopped-up lots and arable land sold quickly; the Southern Pacific Railroad chugged into town as promised; and whatever native plants survived fell beneath the plow to English wheat and barley.

There remained one messy bit of business, however, and it was here that Fernando el Santo faced his greatest test.

Not long after the century's birth, when Mission San Fernando Rey was yet young, a Tongva infant named Rogerio Rocha was born and baptized there, the lone survivor among six siblings. In time Rogerio grew up to become a chief among his people and had resided on the mission lands, even after secularization, all of his life.

Although Eulogio de Celis had guaranteed Rogerio and his family "possession of the lands they occupied for the length of their lives"; and although Rogerio had had his land surveyed and registered in city archives—and even paid taxes on it—Charles Maclay wanted that land for himself.

Thus Fernando el Santo, patron saint of paupers and governors, found himself in a tight spot: Rogerio Rocha was certainly a pauper, but Charles Maclay was an ex-senator, his lawyer was a judge, and his financial backer—the president of the Southern Pacific Railroad—was California's ex-governor. Faced with protecting the interests of one side or the other, paupers or governors, Fernando el Santo, man of his times, responded as people are wont to do: by erring on the side of power.

On November 1, 1886, when Rogerio Rocha was in his seventies, a pair of sheriff's deputies was called in by Maclay's attorney to evict Rogerio, his wife, and three other elderly women living in their home. As the deputies would later testify, they were bidden "to hasten our work, and [the attorney] would give us $5.00 extra if we should get them off [the property] that afternoon."

Everyone and everything was tossed onto a wagon and dumped by the side of a road, from which spot Rogerio set off walking towards El Pueblo in a fruitless search for justice.

What Rogerio knew as he walked to town that day was that it was raining very hard, as it would continue to do for another four days. What Rogerio did not know, but would later learn (to what sorrow we can only imagine), was that Anglo citizens would stop by the spot where the women sat in the rain, awaiting his return, and steal their meagre possessions; and that the extreme cold and constant rains would give his wife a serious case of pneumonia, from which she would soon die.

This small matter of eviction successfully concluded—a devil's bargain really, nothing more—Charles Maclay sold off Rogerio's fifteen acres, in a wondrous bit of sacrilege, to fund the establishment, a mile away, of the Charles Maclay School of Theology.

It was said of Fernando el Santo, when he was King of Spain, that he "feared the curse of an old woman more than a whole army of Moors." We must await the day, then, when old accounts are settled; when Rogerio's cold-killed wife is permitted to speak; for that fearsome curse at long last to be uttered.

Fernando el Santo showed himself incapable of serving both the powerful and the powerless: he showed himself, alas, to be a man of his times. And the real men of his time with whom he allied himself bear real responsibility for egregious deeds in his Valley: deeds for which history must hold them accountable.

Charles Maclay's legendary words a century and a third ago were true: the Valley had indeed been a Garden of Eden, or something very much like it, for the native peoples who lived there. Just as surely, however, the arrival of San Fernando and his colleagues converted the natives' experience into a century-long passage through the Valley of the Shadow of Death.

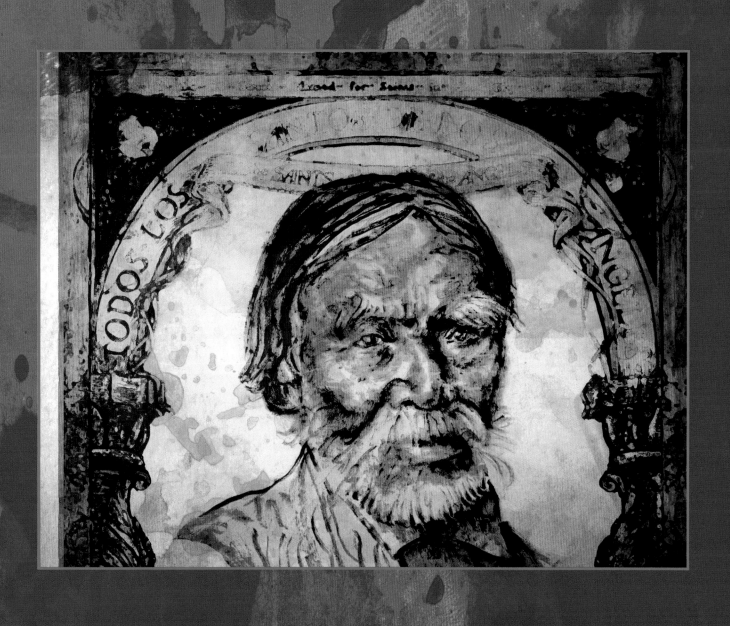

THREE:

Puro Eastside

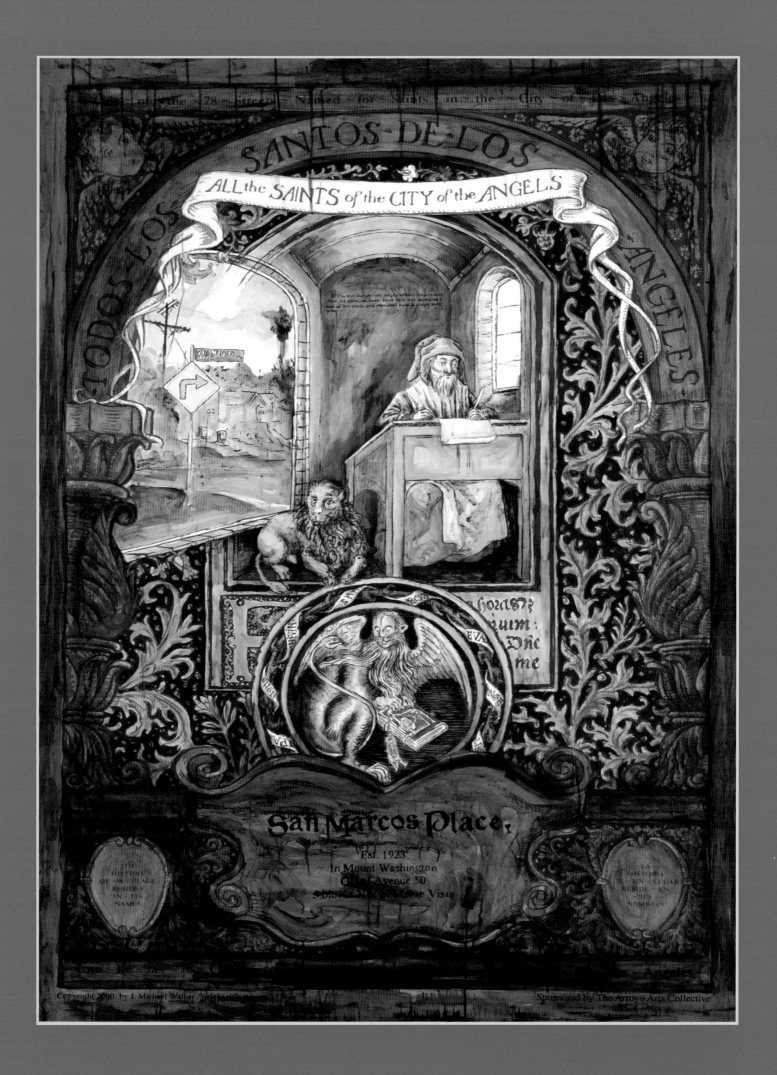

SAN MARCOS PLACE

Mt. Washington

The humble Gospel writer sits at his desk, his faithful emblematic lion at his feet. Perhaps he's been kept after school in hopes his writing will improve.

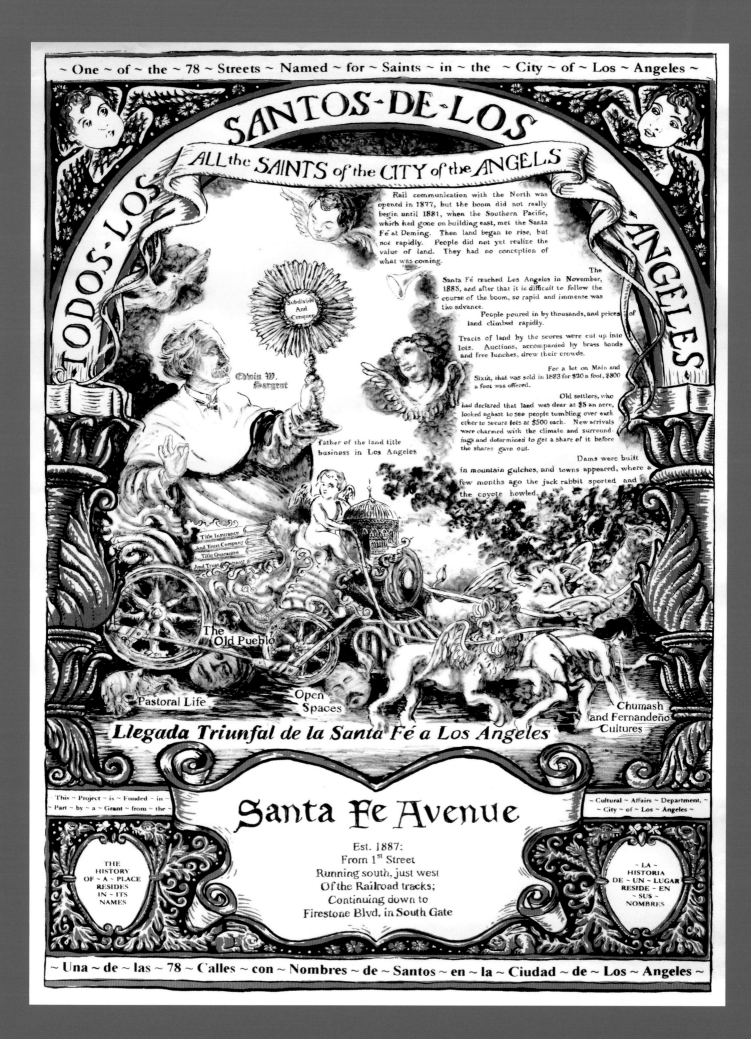

SANTA FE AVENUE

Along the Eastern Rim of Downtown

Born at the signing of the Treaty of Cahuenga, Anglo L.A. in the 1870s was in the throes of a slow-birthing adolescence, weary of its backwater Mexican parentage, ashamed to be seen in the company of its humble, stodgy *madre*.

Like a twelve-year-old in sore need of cable TV and a cell phone, it demanded communication, direct and immediate, with the outside world.

Up the coast San Francisco was hosting grand parties and having friends over from back east—why couldn't L.A.?

The sure thing to do, it seemed, was to open up a train route between the two cities, send out the invites, and hoist a shingle reading "Wide Open for Business."

Not to say it didn't tax the coffers of the City Fathers or require the sacrifice of Chinese pickax slingers to make the Southern Pacific Railroad connection happen. But still, something was lacking, something less circuitous, something—how shall we say?—more lucrative.

Extending the Santa Fe Railroad west to Los Angeles was just the ticket (so to speak), and cutting the price of admission aided as well. By the time the twin trains (Southern Pacific and Santa Fe) were steaming and streaming into Los Angeles in 1886, the fare from back east had plummeted from a reasonable $125 to a don't-even-think-about-it $15, and even on down to a brief but legendary "one-dollar one-way" ticket to California sunshine, with money left over for real estate.

Anglo L.A. had found the way to get folks' attention for sure. The fliers announcing "Party at Our House" had all been distributed; the bartenders and con men were in place; and the only thing left to do was to get dressed, sit back, and welcome the crowd as it debarked at the station on the newly and aptly named Santa Fe Avenue.

It was Anglo L.A.'s finest hour so far, and she stepped smartly to the music, all bright smiles, warm weather, and fertile fields, as suitors snapped up easy dreams of sunsets and citrus trees on swell three-hundred-dollar lots.

Such a good time was being had by all—save by those who, prey to con men, were simply being had—that it took a while to realize the party was overbooked.

Some of the partygoers were getting out of hand—the old character of El Pueblo was being crushed and crumbled left and right—rather like teens at a birthday party playing Frisbee with

the good china while the parents are away.

By the time the dust settled a few years later, Anglo L.A. had sobered up a notch and realized there really *was* something to its Mexican heritage (*Mamá* was right!); something valuable (and, if properly packaged, saleable), even if no one understood what exactly that might be.

The transition out of adolescence is never painless, nor is it immediate; but Anglo L.A. would spend a considerable amount of its new adulthood reflecting on its rejected *madre*, trying to understand her, searching for her face in old images—or painting her portrait from untrustworthy memory.

The irony of the loss comes from what should have been a grand union: the Santa Fe Railroad (ultimately named for the Holy Faith of St. Francis of Assisi) and the City of Los Angeles (named for Our Lady of the Angels, the chapel that St. Francis built to honor that holy faith).

Anglo L.A. had chafed at its *madre*'s Mexican apron strings for so long; but when they finally gave way, it found itself in free fall, untethered to the good earth that had nourished it.

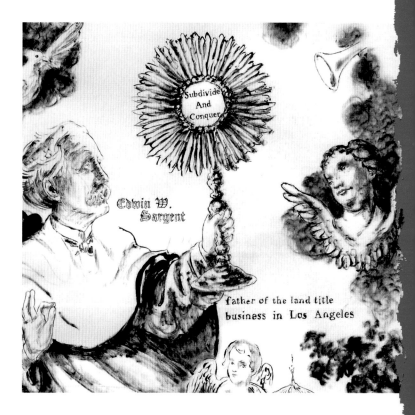

Subdivide And Conquer

Edwin W. Sargent

father of the land title business in Los Angeles

SANTOS · DE · LOS

the SAINTS of the CITY of the ANGELS

Alone, forgotten, and incongruous,
Left to fend for itself amid factory weeds and
The rusty recollect of an ancient reservoir,
San Pablo Street rises,
South and

Up;

Away from the railroad tracks along old Eastlake (now Lincoln) Park,
Mattie McCormack's twenty-five acres long ago became
A child's rendering of a factory,
Leonides Bates' 16 acres sprouted tiers of concrete, and
Became a parking structure;
And the Biggy Tract and the Flannagan and Lambie Subdivisions were
Swallowed up by County General.

Here, where one might expect to find St. Jerome,
Or that other St. Paul - the Hermit -,
San Pablo (converted, Saul-like, from Saint Paul)
Wanders uphill, relic of another age,
Feisty but constant,
Argumentative but true.

He dead-ends at hilltop,
All chain-link and dirt,
Looks out over the City,
And sends forth his Epistles.

Listening up from Marengo Street,

If you get past the carhorns and the anger,
There's some real poetry there.

THOUGH I speak with the tongues of men and of angels, and have not charity, I am become as sounding brass, or a tinkling cymbal.

SAN PABLO ST
1889

San Pablo Street

Originally St. Paul Street, 1889
Name changed 1893
Runs south from Valley Blvd.
Between Soto and Mission Road

SAN PABLO STREET

Lincoln Heights

Alone, forgotten, and incongruous,
Left to fend for itself amid factory weeds and
The rusty recollect of an ancient reservoir,
San Pablo Street rises,
South and

Up.
Away from the railroad tracks along old Eastlake (now Lincoln) Park:
Mattie McCormack's twenty-five acres long ago became
A child's rendering of a factory;
Leonides Bates' sixteen acres sprouted tiers of concrete and
Became a parking structure;
And the Biggy Tract and the Flanagan and Lambie Subdivisions were
Swallowed up by County General Hospital.

Here, where one might expect to find St. Jerome,
Or that other St. Paul—the Hermit,
San Pablo (converted, Saul-like, from St. Paul)
Wanders uphill, relic of another age,
Feisty but constant,
Argumentative but true.

He dead-ends at hilltop,
All chain-link and dirt,
Looks out over the city,
And sends forth his Epistles.

Listening up from Marengo Street,

If you get past the car horns and the anger,
There's some real poetry there.

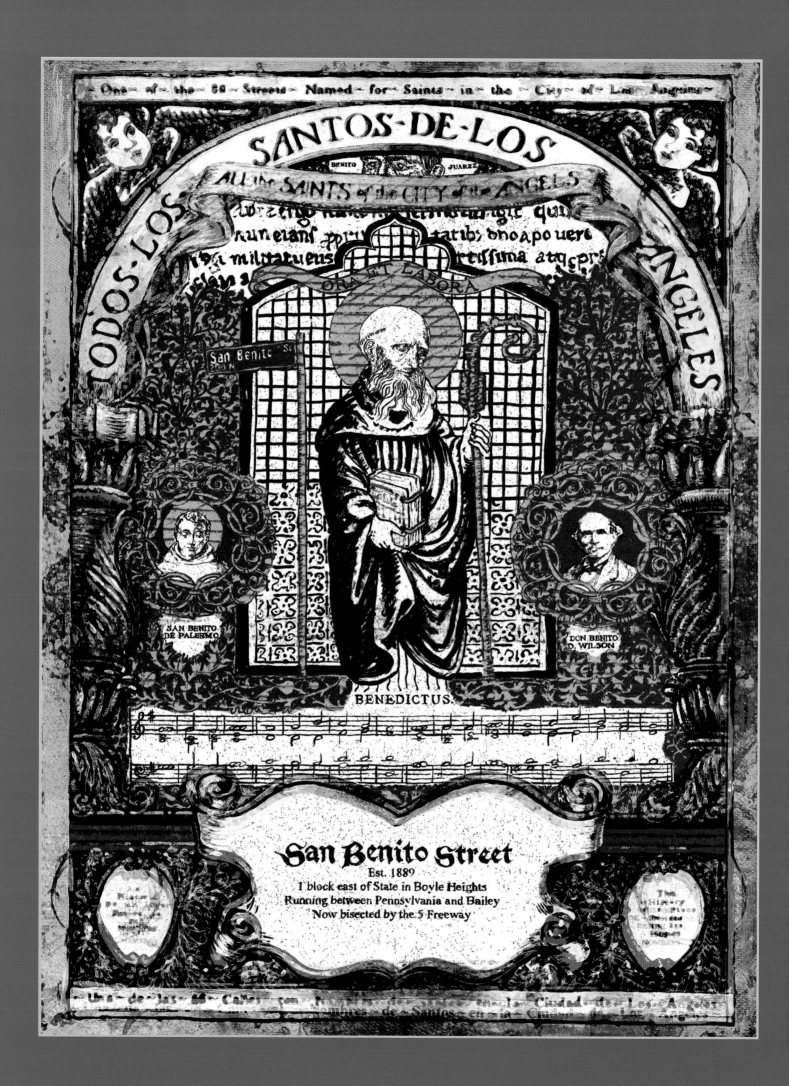

SANTOS·DE·LOS

BENITO · JUAREZ

ALL the SAINTS of the CITY of the ANGELS

TODOS·LOS

ANGELES

ORA ET LABORA

San Benito St

SAN BENITO DE PALERMO

DON BENITO D. WILSON

BENEDICTUS.

San Benito Street

Est. 1889

1 block east of State in Boyle Heights
Running between Pennsylvania and Bailey
Now bisected by the 5 Freeway

SAN BENITO STREET

Boyle Heights

Which Benito do we choose? Benedictine founder or Moorish saint? Yankee land baron or Zapotec president? Let us (work and) pray on it.

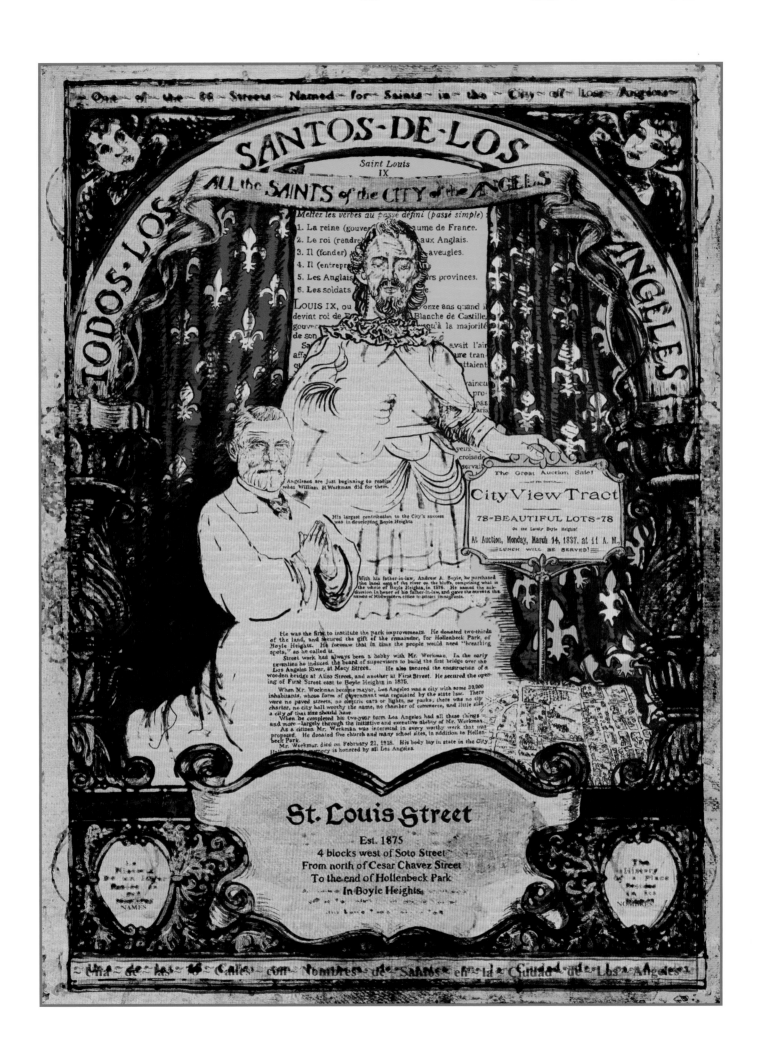

SANTOS·DE·LOS

TODOS·LOS

ANGELES

Saint Louis
IX

ALL the SAINTS of the CITY of the ANGELS

Mettez les verbes au passé défini (passé simple)

1. La reine (gouver...) ...aume de France.
2. Le roi (rendre... ... aux Anglais.
3. Il (fonder) ... aveugles.
4. Il (entrepr... ...
5. Les Anglais... ...rs provinces.
6. Les soldats ...

LOUIS IX, ou ...onze ans quand il
devint roi de F... ... Blanche de Castille,
gouv... ... qu'à la majorité
de son ...

Angelenos are just beginning to realize
what William H. Workman did for them.

His largest contribution to the City's success
was in developing Boyle Heights.

The Great Auction Sale!

CityView Tract

78=BEAUTIFUL LOTS=78

On the Lovely Boyle Heights!

At Auction, Monday, March 14, 1887, at 11 A.M.

LUNCH WILL BE SERVED!

With his father-in-law, Andrew A. Boyle, he purchased
the land east of the river on the bluffs, comprising what is
the whole of Boyle Heights, in 1876. He named the sub-
division in honor of his father-in-law, and gave the streets the
names of Midwestern cities to attract immigrants.

He was the first to institute the park improvements. He donated two-thirds
of the land, and secured the gift of the remainder, for Hollenbeck Park, of
Boyle Heights. He foresaw that in time the people would need "breathing
spots," as he called it.
Street work had always been a hobby with Mr. Workman. In the early
seventies he induced the board of supervisors to build the first bridge over the
Los Angeles River, at Macy Street. He also secured the construction of a
wooden bridge at Aliso Street, and another at First Street. He secured the open-
ing of First Street east to Boyle Heights in 1875.
When Mr. Workman became mayor, Los Angeles was a city with some 30,000
inhabitants, whose form of government was regulated by the state law. There
were no paved streets, no electric cars or lights, no parks, there was no city
charter, no city hall worthy the name, no chamber of commerce, and little else
a city of that size should have.
When he completed his two-year term Los Angeles had all these things
and more—largely through the initiative and executive ability of Mr. Workman.
As a citizen Mr. Workman was interested in every worthy work that was
proposed. He donated five church and many school sites, in addition to Hollen-
beck Park.
Mr. Workman died on February 21, 1918. His body lay in state in the City
Hall, ... mory is honored by all Los Angeles.

St. Louis Street

Est. 1875

4 blocks west of Soto Street
From north of Cesar Chavez Street
To the end of Hollenbeck Park
In Boyle Heights.

NAMES

NOMBRES

ST. LOUIS STREET

Boyle Heights

St. Louis Street is one of the rare examples we have of a street named for a saint, where we know not only when it was named and for what reason, but also by whom.

This residential street, which runs from just above César Chávez Avenue down to the southern edge of Hollenbeck Park, in Boyle Heights, bears the imprimatur of its designer—the man who invented Boyle Heights, an unsung grand character of late-nineteenth-century Los Angeles: William Henry Workman.

William H. was born and raised in Missouri, at a time when that was the stopping-off place for what most easterners considered to be "western civilization." Nonetheless, in the early 1850s, following the lead of William H.'s uncle William (yes, it is slightly confusing), he and his family moved out west; and our young hero and his brother Elijah set up shop in the saddlery business along El Pueblo de los Angeles' Main Street, where cattle hides, sometimes referred to as "leather dollars," still served as legal tender.

In a few years Workman had amassed enough leather (and silver) dollars to feel financially comfortable enough to propose marriage with María, the daughter of fellow businessman Andrew Boyle. William H. and his father-in-law went into business together on one of those foolhardy go-for-broke schemes that seem to typify nineteenth-century Yankee enterprises in California: they purchased the largely barren land on the bluffs east of the Los Angeles River, with an eye to turning it into a garden spot of wealthy residences.

Although Los Angeles was no desert, spotty winter rains could not be counted on to support either crops or gardens on the highlands; thus, cultivation had been restricted to the banks of the fickle, vagabond Los Angeles River. To convince people to build the fine estates he envisioned for Boyle Heights (named in honor of his father-in-law), William H. had to show that gardens and orchards were possible. This he did by underwriting much of the cost of bringing in water, via an aqueduct of his own design, which he argued through the city council.

The resulting water fed great acres of exotic plants and trees that Workman imported to his enclave, which he then divided into plots, christening the resulting streets with the names of midwestern and eastern cities and states, in a bid to attract immigrants from those areas—hence Brooklyn (now César Chávez) Avenue, and Pennsylvania, Chicago, and St. Louis Streets.

Workman's enthusiasm for building extended across various civic realms: getting the first bridge across the L.A. River built; initiating the parks improvement program by donating much of the land for Hollenbeck Park; donating land for a number of schools and at least five churches; and, during his two-year term as mayor, pushing for Los Angeles' first paved streets, electric cars, and streetlights, and its first impressive city hall.

Clearly, Workman's last name was appropriate: he got things done. Appropriate as well is his connection to the saint from whom his St. Louis Street ultimately received its name: St. Louis IX, for whom the city of St. Louis was named, is patron saint of construction workers, masons, and builders.

Here's to William H. Workman, the builder of Boyle Heights and of much of that which is to be celebrated in late-nineteenth-century Los Angeles.

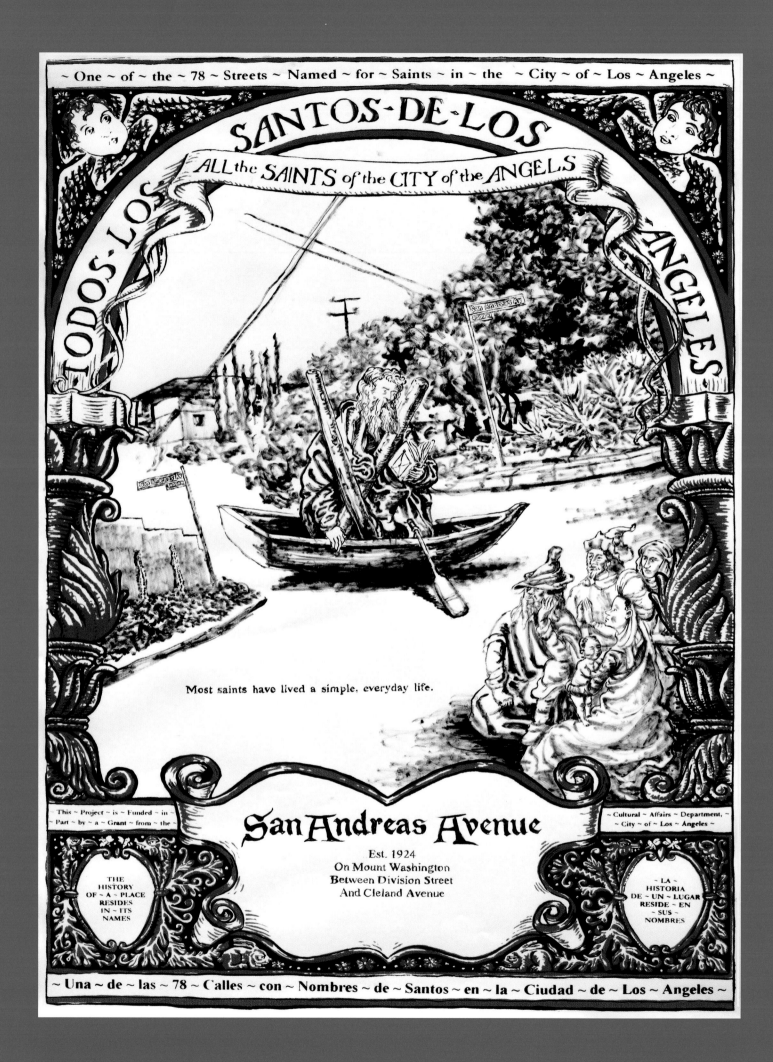

SANTOS·DE·LOS

TODOS·LOS

ANGELES

ALL the SAINTS of the CITY of the ANGELS

Most saints have lived a simple, everyday life.

·This ~ Project ~ is ~ Funded ~ in ~
~ Part ~ by ~ a ~ Grant ~ from ~ the ~

~ Cultural ~ Affairs ~ Department, ~
~ City ~ of ~ Los ~ Angeles ~

San Andreas Avenue

Est. 1924
On Mount Washington
Between Division Street
And Cleland Avenue

THE
HISTORY
OF ~ A ~ PLACE
RESIDES
IN ~ ITS
NAMES

~ LA ~
HISTORIA
DE ~ UN ~ LUGAR
RESIDE ~ EN
~ SUS ~
NOMBRES

SAN ANDREAS AVENUE

Mt. Washington

Along Mt. Washington's western hillside sits a fairly nondescript street named for a rather nondescript saint—a real fish out of water in this interesting neighborhood.

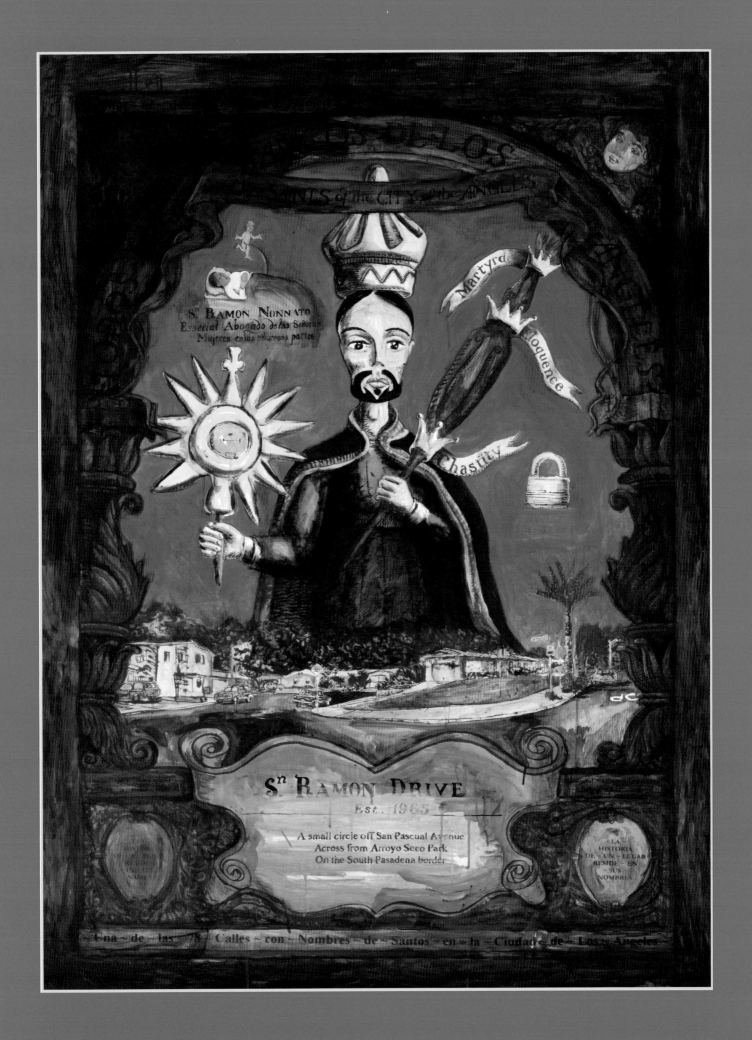

SAN RAMON DRIVE

Garvanza, Northeast L.A.

San Ramón may be just about the most intimate of saints, a semi-sisterly father confessor to women in their assorted hours of need.

His full name—San Ramón Nonato (Saint Raymond Unborn)—alludes to his birth by Caesarean section, an early experience which led him to become the empathic patron saint of women facing difficult childbirth.

San Ramón is often depicted bearing a padlock and chain: the Church says this is because he was improperly imprisoned. But throughout Mexico women know it is because he can be trusted to keep secrets. And, indeed, one sometimes finds the mouth in his portrait rubbed bare of paint by countless women touching their finger to his lips to seal a promise of secrecy.

Clearly, it would not do to set this kitchen confidante on a major, public thoroughfare, so the City Fathers (and mothers) showed *San Ramón*esque restraint by attaching his name to a tiny side street off of Avenue 64, at Los Angeles' northeastern border with South Pasadena.

And there San Ramón remains, hidden away like so many of the secrets entrusted to him, his tiny street an enclosed circle: a womb full of promise, a depository of promises (and secrets) kept.

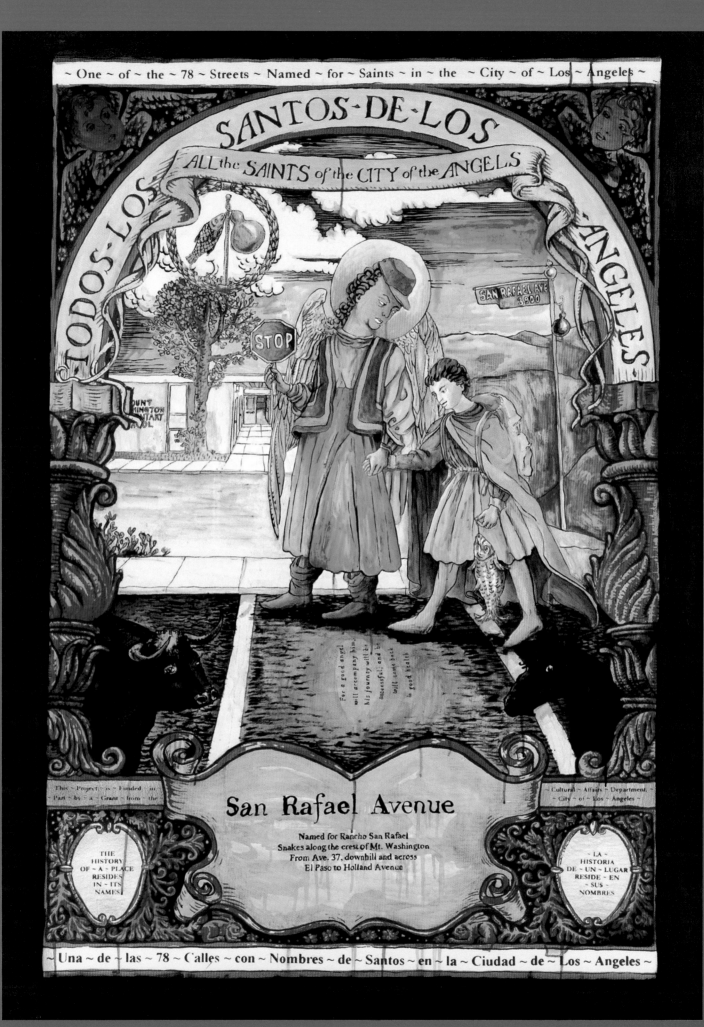

SANTOS·DE·LOS

TODOS·LOS

ALL the SAINTS of the CITY of the ANGELS

ANGELES

SAN RAFAEL AVE 3900

For a good angel
will accompany him,
his journey will be
successful, and he
will come back
in good health

This ~ Project ~ is ~ Funded ~ in ~
Part ~ by ~ a ~ Grant ~ from ~ the

~ Cultural ~ Affairs ~ Department ~
~ City ~ of ~ Los ~ Angeles ~

San Rafael Avenue

Named for Rancho San Rafael
Snakes along the crest of Mt. Washington
From Ave. 37, downhill and across
El Paso to Holland Avenue

THE
HISTORY
OF ~ A ~ PLACE
RESIDES
IN ~ ITS
NAMES

~ LA ~
HISTORIA
DE ~ UN ~ LUGAR
RESIDE ~ EN
~ SUS ~
NOMBRES

~ Una ~ de ~ las ~ 78 ~ Calles ~ con ~ Nombres ~ de ~ Santos ~ en ~ la ~ Ciudad ~ de ~ Los ~ Angeles ~

SAN RAFAEL AVENUE

Mt. Washington

Its two-lane twister of a snaking curve-hugger the city's only humble reminder of its storied antecedent, San Rafael Avenue concentrates myth and legend in a single simple crosswalk.

Long centuries before King James' translators completed their biblical masterwork, a delightful coming-of-age tale was making the rounds among Hebrew, Greek, and Aramaic storytellers.

Eventually enfolded into the Catholic canon and Protestant Apocrypha, the Book of Tobit tells how a young son, Tobias, goes on a journey to collect on a debt, cure his father's blindness, get the girl, and become a man.

Tobias is accompanied on his journey by a mysterious companion who offers advice and wisdom, saves his life, leads him to the girl, recovers the money, gets everyone home safely, and reveals his identity at the end as the archangel Rafael.

Archangels being lofty beings, it is not uncommon to find their names attached to high places; and so it was that by the turn of the eighteenth century, San Rafael's name had been given to a cluster of hills north of Los Angeles: the San Rafael Hills.

In time these hills formed part of a large land grant given by Governor Pedro Fages to a fast-rising corporal who had served throughout the Californias, José María Verdugo.

Rancho San Rafael, as it came to be called, encompassed over thirty-five thousand acres: from Cypress Park and Mt. Washington to Eagle Rock, Burbank, and La Cañada Flintridge; and its rolling hills and grasslands provided ample roaming room for Don José's cattle, mules, and wild horses.

Unfortunately, the corporal's patron saint was not St. William, for Don José suffered mightily from dropsy (which is St. William's concern)—suffered so much, in fact, that in 1828 he deeded his substantial lands to his "two favourite children."

The fertile southern half—just aching for wheat, barley, corn, and hay—was worked vigorously by Don José's son Julio and Julio's thirteen sons; whereas the picturesque northern half—filled with canyons, streams, wild bears, and on occasion, the infamous bandit Tiburcio Vásquez—was given, in an ironic twist, to Don José's blind daughter, Catalina.

As must ever be the case with narratives of nineteenth-century California ranchos, the tale takes a sad turn as mid-century arrives and the financially astute Yankees come to power. When the droughts of the 1860s hit Julio Verdugo's land and cattle-dependent bank account, he made a fateful pact with the devil: a $3500 loan at 3 percent interest, due quarterly.

History books at this point in the narrative usually pause to castigate the frivolous rancheros for their profligate lifestyle: fine *caballero* attire, fancy fandangos, and outsized hospitality—just the sort of gaiety and *savoir faire* that Angelenos would celebrate (and imitate) thirty years after its demise.

The point is well taken, but still it must be underscored: in eight years Julio Verdugo's loan had ballooned to an exorbitant seventeen times its original value.

By decade's end, Alfred Chapman had bought out poor Julio's troubled twenty-thousand-acre rancho at auction, tossing two hundred acres of it back to him "out of pity for the once proud ranchero"—acreage which was promptly pounced upon and gobbled by other creditors.

Litigation soon carved up Catalina's northern ranch as well; the bears died out, Tiburcio Vásquez was caught and hanged, and the cities of Glendale and Burbank were surveyed, subdivided, filed, and incorporated.

There remains an adobe rancho here and there (mainly there, three of them, in the city of Glendale) as testament to the Verdugos' hay-harvesting heyday, but for a once-prominent archangel, San Rafael is notably inconspicuous.

Perhaps it is because he didn't cure Catalina Verdugo's blindness the way he did for the apocryphal Tobit. Whatever the reason, he is reduced in L.A. to a roundabout road tumbling down Mt. Washington's northern face to Avenue 50 and a wee bit beyond.

No wild bears roam the roundabout road and environs now: only the nightly perambulations of raccoons, opossums, and the occasional "honey-I'm-home" coyote.

But, of course, wherever one lives in L.A., life is uncertain, as relatives back east are wont to remind us; thus a bit of protection is desirable. It is comforting, then, to find San Rafael still on the job, Monday through Friday, where the crossing guardian angel shepherds children across the San Rafael Avenue crosswalk to Mt. Washington Elementary School.

At moments like these, anxious parents dropping their children off in the morning can find comfort in the Book of Tobit's sagacious assurance:

For a good angel will accompany him; his journey will be successful, and he will come back in good health.

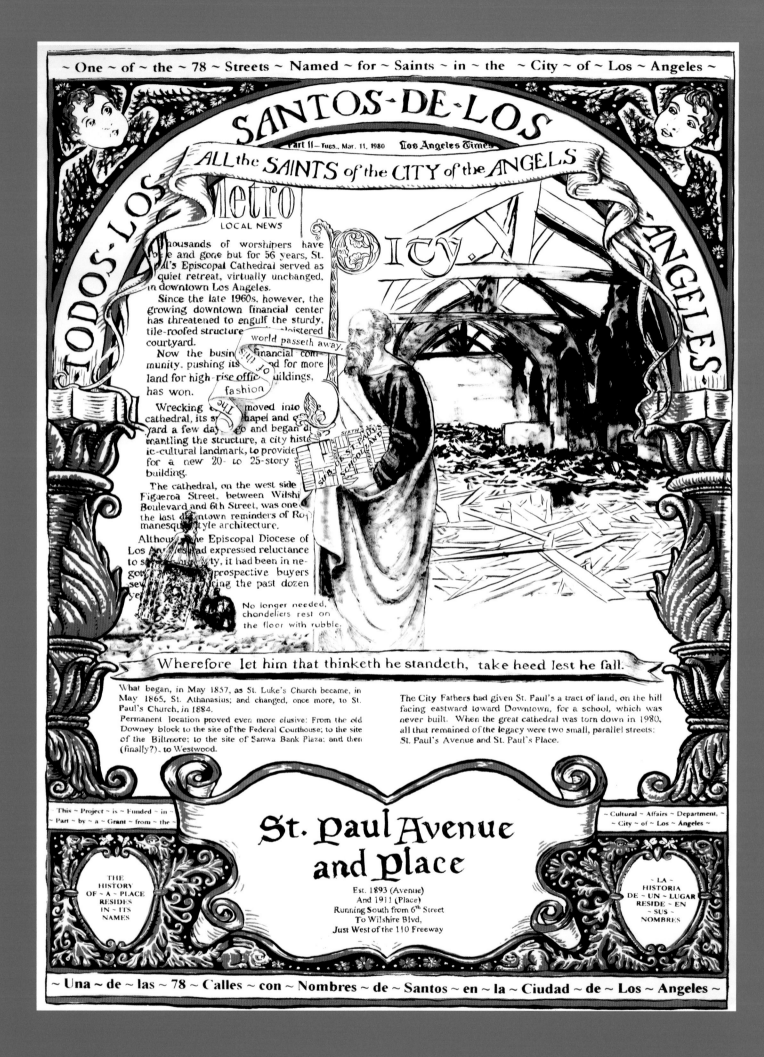

ST. PAUL AVENUE and PLACE

Just West of Downtown

Now, by Saint Paul, this news is bad indeed.
—King Richard III

St. Paul may well have been obstinate and cantankerous, condescending and overbearing; still he—and Downtown—deserved better.

What began, in August 1857, as St. Luke's Church became, in May 1865, St. Athanasius; then changed once more, to St. Paul's Episcopal Church, in 1884.

Permanent location proved even more elusive, as the congregation moved from Court and Spring Streets to the old Downey Block to Pound Cake Hill; and then, in late 1883, to Olive Street between Fifth and Sixth Streets.

There on Olive Street, for several turn-of-the-century decades, St. Paul's Church and School shared the block fronting tree-filled Central Park (now Pershing Square), commanding the space where the Biltmore Hotel now stands.

In response to the church's growth and in sympathy with its aims, the City Fathers, in a fit of community largess, bestowed upon St. Paul's the lands on the sloping hill just west of Downtown to accommodate a new church and school; but none were ever built there.

Instead, in 1924 St. Paul's moved four blocks west, astride Figueroa between Wilshire and Sixth Street, where its Romanesque-style cathedral welcomed the world-weary for over half a century.

In later years this western fringe of Downtown grew decidedly less neighborly and more severely modern. And, although the Episcopal Diocese publicly "expressed reluctance to sell the property," it was quietly in negotiations throughout the 1970s to do just that.

Finally, in fall 1979, the diocese decided to sell the cathedral property—by then a city historical landmark—for some four million dollars, and to move several miles away to Echo Park, where the diocese now has its headquarters.

After the wrecking crews descended on the cathedral's "rubble-filled shell" and its cloistered courtyard; and after Matsui Fudosan's contractors set to building the cathedral's commercial replacement; all that remained of St. Paul's century-long connection to the city's historic core lay just west of Downtown, on that sloping hill watching over the cathedral's destruction. There, two tiny parallel streets—St. Paul Avenue and St. Paul Place—hug a cement parking lot where the school never got built.

It may be true that, as the *L.A. Times* reported, "the growing downtown financial center [had] threatened to engulf" St. Paul's for some time. However, Paul, battered and beaten, ever relished long odds and a righteous fight to the end.

One pictures him gazing down now—dazed, wizened, and worse for wear—at his former abode from his concrete parking lot as he recalls, with not a little irony, a verse he penned long ago:

Wherefore let him that thinketh he standeth, take heed lest he fall.

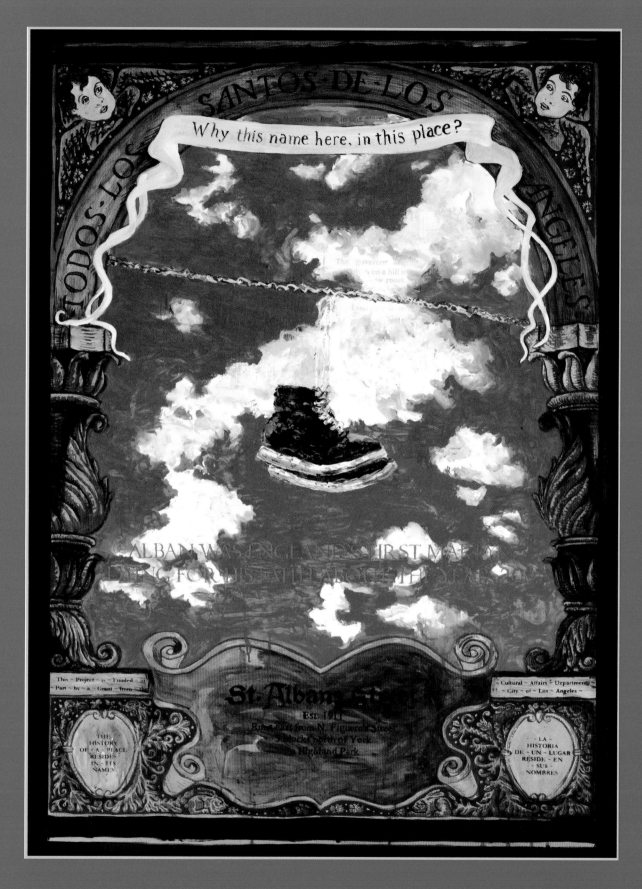

ST. ALBANS STREET

Garvanza, Highland Park

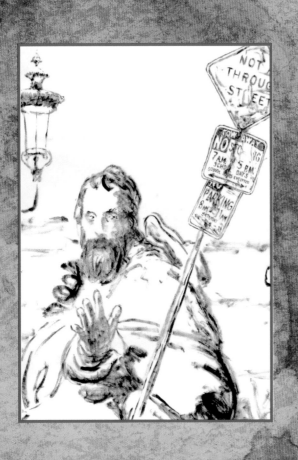

FOUR:

The City Spreads West

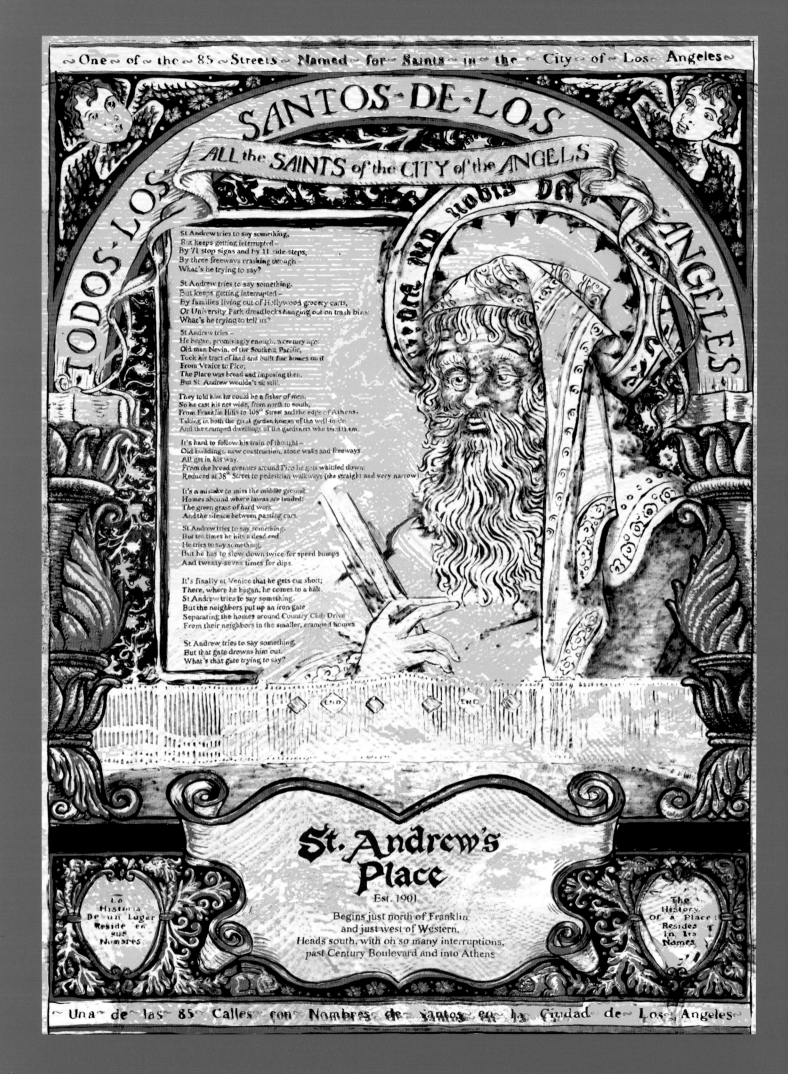

SANTOS·DE·LOS

ALL the SAINTS of the CITY of the ANGELS

TODOS·LOS

ANGELES

St Andrew tries to say something,
But keeps getting interrupted –
By 71 stop signs and by 11 side steps,
By three freeways crashing through –
What's he trying to say?

St Andrew tries to say something,
But keeps getting interrupted –
By families living out of Hollywood grocery carts,
Or University Park dreadlocks hanging out on trash bins:
What's he trying to tell us?

St Andrew tries –
He began, promisingly enough, a century ago.
Old man Nevin, of the Southern Pacific,
Took his tract of land and built fine homes on it
From Venice to Pico;
The Place was broad and imposing then,
But St Andrew wouldn't sit still.

They told him he could be a fisher of men.
So he cast his net wide, from north to south,
From Franklin Hills to 108th Street and the edge of Athens,
Taking in both the great garden homes of the well-to-do
And the cramped dwellings of the gardeners who tend them.

It's hard to follow his train of thought –
Old buildings, new construction, stone walls and freeways
All get in his way.
From the broad avenues around Pico he gets whittled down:
Reduced at 38th Street to pedestrian walkways (the straight and very narrow).

It's a mistake to miss the middle ground:
Homes abound where lawns are tended:
The green grass of hard work
And the silence between passing cars.

St Andrew tries to say something,
But ten times he hits a dead end.
He tries to say something,
But he has to slow down twice for speed bumps
And twenty-seven times for dips.

It's finally at Venice that he gets cut short;
There, where he began, he comes to a halt.
St Andrew tries to say something,
But the neighbors put up an iron gate
Separating the homes around Country Club Drive
From their neighbors in the smaller, cramped homes

St Andrew tries to say something,
But that gate drowns him out.
What's that gate trying to say?

St. Andrew's Place

Est. 1901

Begins just north of Franklin
and just west of Western,
Heads south, with oh so many interruptions,
past Century Boulevard and into Athens

La Historia De un Lugar Reside en sus Nombres

The History Of a Place Resides In Its Names

ST. ANDREWS PLACE

From Hollywood South to Athens, 1901

St. Andrew tries to say something,
But he keeps getting interrupted—
By seventy-one stop signs and by eleven side-steps,
And by three freeways crashing through—
What's he trying to say?

St. Andrew tries to say something, but keeps getting interrupted—
By families living out of Hollywood grocery carts, or
University Park dreadlocked drifters hanging out on trash bins.
What's he trying to tell us?

St. Andrew tries - - -
He began, promisingly enough, a century ago:
Old man Nevin of the Southern Pacific
Took his tract of land and built fine homes on it,
From Venice to Pico;
The Place was broad and imposing then,
But St. Andrew wouldn't sit still.

They told him he could be a fisher of men,
So he cast his net wide, from north to south,
From Franklin Hills to 108th Street and the edge of Willowbrook,
Taking in both the great garden homes of the well-to-do
And the cramped apartments of the gardeners who tend them.

It's hard to follow his train of thought—
Old buildings, new construction,
Stone walls and freeways all get in his way.
From the broad avenues around Pico he gets whittled down:
Reduced at 38th Street to pedestrian walkways
(the straight and *very* narrow).

It's a mistake to miss the middle ground, though:
Homes abound where lawns are tended;
The green grass of hard work
And the silence between passing cars.

St. Andrew tries to say something,
But ten times he hits a dead end.
He tries to say something,
But he has to slow down twice for speed bumps,
And twenty-seven times for some major dips.

It's finally at Venice that he gets cut short,
There, where he began, he comes to a halt;
St. Andrew tries to say something,
But the neighbors put up an iron gate
To separate the fine homes around Country Club Drive
From their neighbors in the smaller, cramped homes to the south.

St. Andrew tries to say something,
But that gate drowns him out.
What's that gate trying to say?

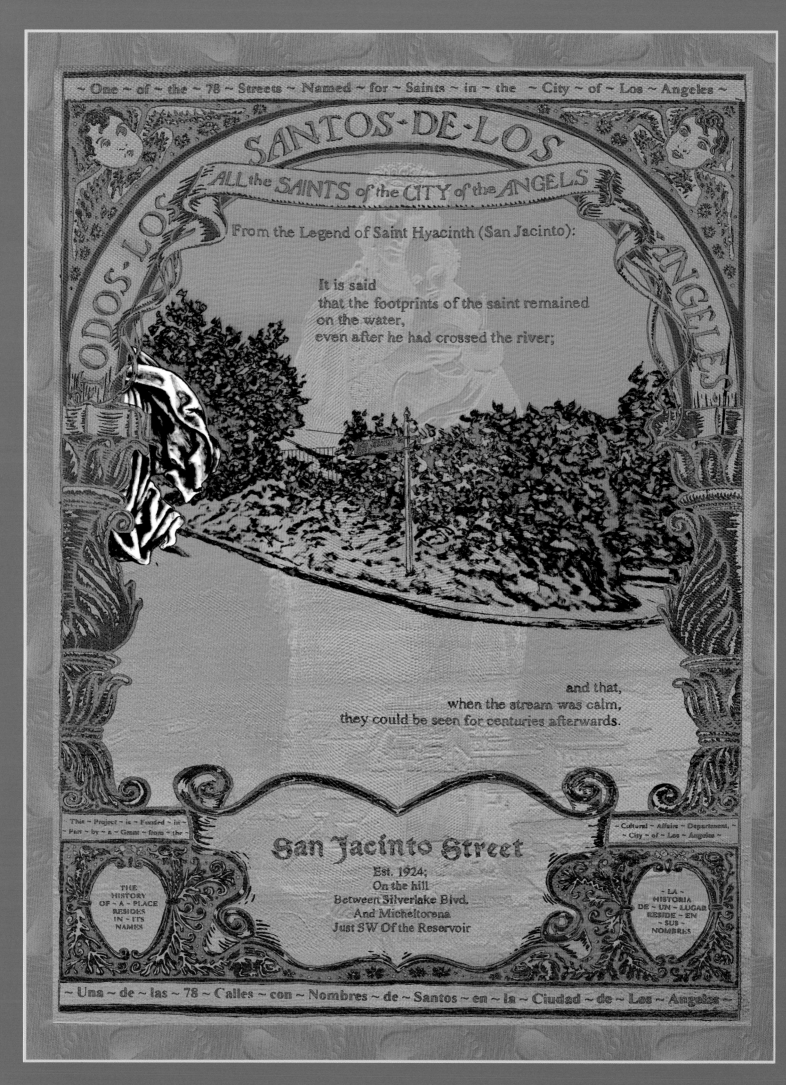

SANTOS · DE · LOS

TODOS · LOS

ANGELES

ALL the SAINTS of the CITY of the ANGELS

From the Legend of Saint Hyacinth (San Jacinto):

It is said
that the footprints of the saint remained
on the water,
even after he had crossed the river;

and that,
when the stream was calm,
they could be seen for centuries afterwards.

This ~ Project ~ is ~ Funded ~ in ~
~ Part ~ by ~ a ~ Grant ~ from ~ the ~

Cultural ~ Affairs ~ Department, ~
~ City ~ of ~ Los ~ Angeles ~

San Jacinto Street

Est. 1924;
On the hill
Between Silverlake Blvd.
And Micheltorena
Just SW Of the Reservoir

THE
HISTORY
OF ~ A ~ PLACE
RESIDES
IN ~ ITS
NAMES

~ LA ~
HISTORIA
DE ~ UN ~ LUGAR
RESIDE ~ EN
~ SUS ~
NOMBRES

SAN JACINTO STREET

Silver Lake

There are two schools of thought about holy men:

One holds that the purity of divine vision and the steadfast heart at the spiritually transcendent man's center will focus such luminosity on his features and movements as to make the holy palpably visible.

Another, equally compelling, contends that the true holy man will, through the exercise of humility and restraint, become almost imperceptible, so utterly "average" in appearance (which, after all, is mere illusion), that he will move among us unheralded and unnoticed.

San Jacinto has chosen to shoulder this latter yoke, challenging us to question our expectations of sainthood.

He ambles lightly about the Silver Lake hills, tracing a circumscribed path: two hundred paces downhill, south by southwest. Turn. Then two hundred paces uphill, north by northeast. Repeat. A sacred Zen dance, good for the heart and legs.

A broken glimpse of the silver lake below, and of the fantasy castle at mid-block; but apart from these, you'd pass this simple saint by on your way to something more interesting—like perhaps one of the Neutra or Schindler homes nearby.

But think on this. It is recorded in the *Acta Sanctorum* that when San Jacinto had crossed the River Dnieper in the Ukraine, his footprints remained on the water's surface "and that, when the stream was calm, they could be seen for centuries afterwards."

So, pass this average street by. Ignore him if you like. Our silent saint, *Zen* Jacinto, has time on his side:

Centuries later
after crossing the Dnieper—
footprints of the saint!

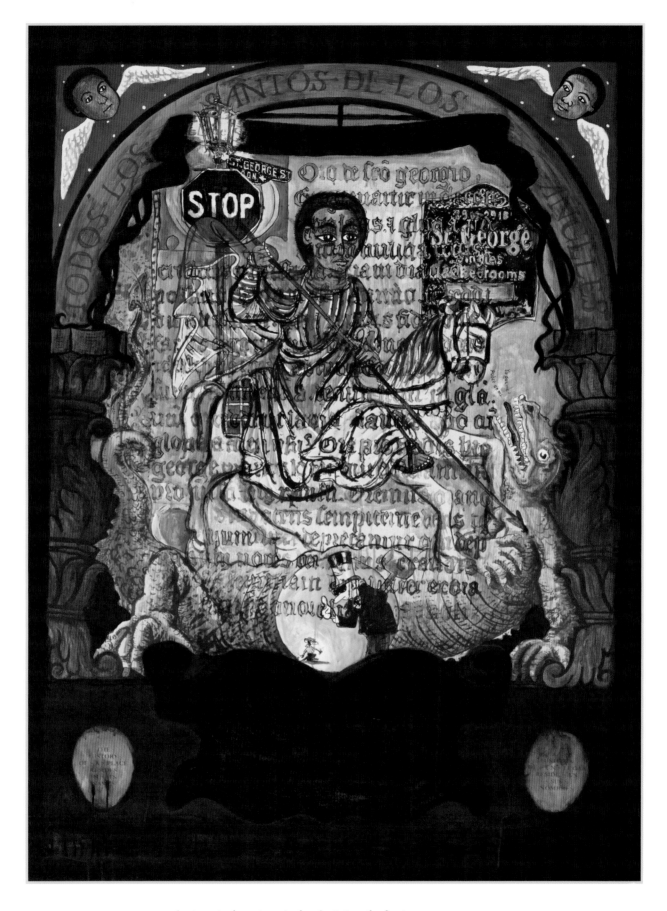

ST. GEORGE STREET *Los Feliz*

An Ethiopian patron saint—the forefather of modern exterminators—battles a dragon along a Los Feliz residential street. I'd step aside if I were you.

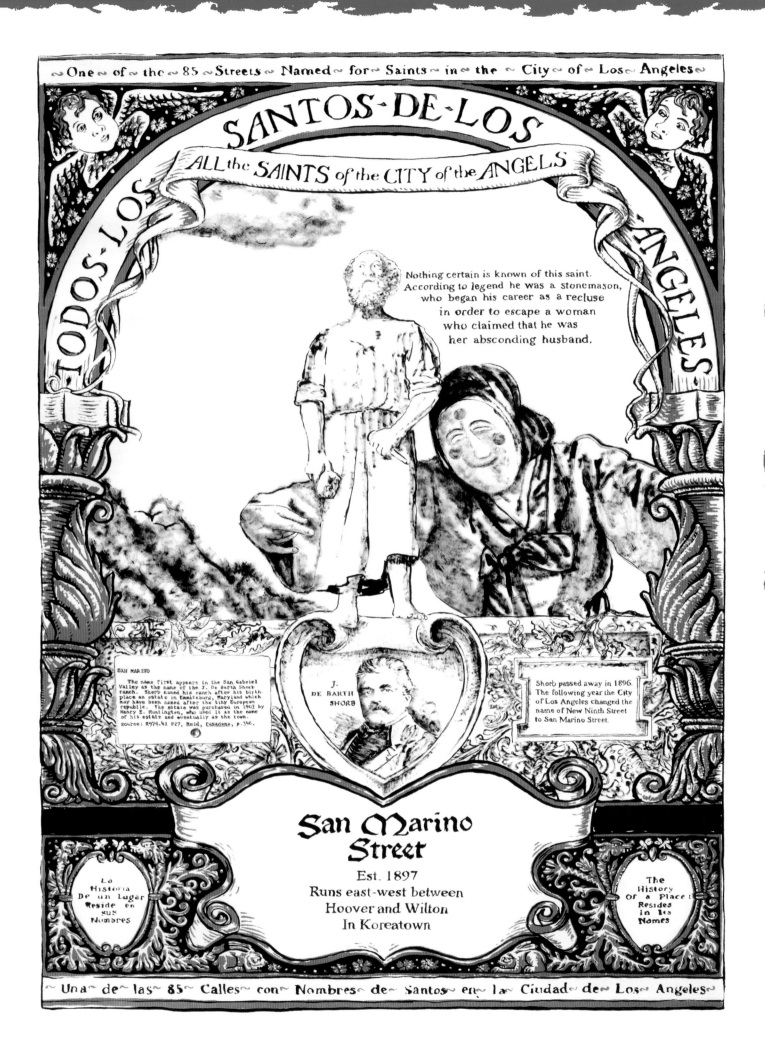

SANTOS·DE·LOS

TODOS·LOS·

ALL the SAINTS of the CITY of the ANGELS

·ANGELES·

Nothing certain is known of this saint. According to legend he was a stonemason, who began his career as a recluse in order to escape a woman who claimed that he was her absconding husband.

SAN MARINO

The name first appears in the San Gabriel Valley as the name of the J. De Barth Shorb ranch. Shorb named his ranch after his birthplace an estate in Emmitsburg, Maryland which may have been named after the tiny European republic. The estate was purchased in 1903 by Henry E. Huntington, who used it as the name of his estate and eventually as the town.

source: R979.41 P27, Reid, Pasadena, p.346.

J. DE BARTH SHORB

Shorb passed away in 1896. The following year the City of Los Angeles changed the name of New Ninth Street to San Marino Street.

San Marino Street

Est. 1897
Runs east-west between
Hoover and Wilton
In Koreatown

La Historia De un Lugar Reside en sus Nombres

The History Of a Place Resides In Its Names

SANTOS · DE · LOS

TODOS · LOS

ANGELES

ALL the SAINTS of the CITY of the ANGELS

{ All the riffraff is gone now, alas... }

ST. JAMES PARK and PLACE

North University Park

In 1885 Judge Silent came to town and went to work.

He formed the Silent Company, brokering real estate, and practically overnight transformed the Nathan Vale ranch, off Adams Boulevard, into a magnificent gaslit park of broad shade trees and enormous palms.

Little by little he carved away at the perimeter, great mansions sprouting along paved drives, leaving only the fountain and reflecting pool at the park's heart.

To honor his son James and to enhance his development's aura, Judge Silent christened the spot St. James Park, after the oldest of the British royal parks, which skirts both Buckingham Palace and the Houses of Parliament.

St. James Park, in turn, took its name from a thirteenth-century lepers' hospital dedicated to St. James the Greater and founded for "fourteen poor leprous maidens."

Henry VIII, he of the short temper, tossed aside the poor maidens and used the sylvan site to hunt deer.

Subsequent royalty used St. James for: a bowling green; a residence for crocodiles and wine-imbibing elephants; a rendezvous for clandestine lovers and prostitutes; and a gathering place for cattle and their aficionados, where one might order up a fresh cup of milk, straight from the cow.

All the riffraff is gone now, alas, replaced by a more refined yet still quite picturesque nineteenth-century design centered on a duck pond. Still an important center of British social and political life, St. James hosts formal receptions and government conferences.

Here in Los Angeles, St. James Park took an opposite turn, from refinement to decline. All its fine homes save one are now gone, its park forlorn, and the occasional tree grafittied, as the whole site slowly recovers from decades of decay and neglect.

There is one bright spot, however, set along the park's northeastern rim: Frank D. Lanterman High School. One of eighteen special education schools within the Los Angeles Unified School District, Lanterman serves students with moderate to severe physical and mental impairments, or disabilities.

Its population—bearing challenges ranging from autism and seizures to Down's syndrome, cerebral palsy, and more—brings St. James Park of Los Angeles full circle to the beginnings, eight hundred years ago, of St. James Park of London with one important, progressive difference: no one views this park's charges as outcasts.

The site may not be quite sylvan or the structure an architectural jewel; but special needs students discover here a safe, supportive, empowering, and peaceful refuge—which, after all, is just what we seek in a park.

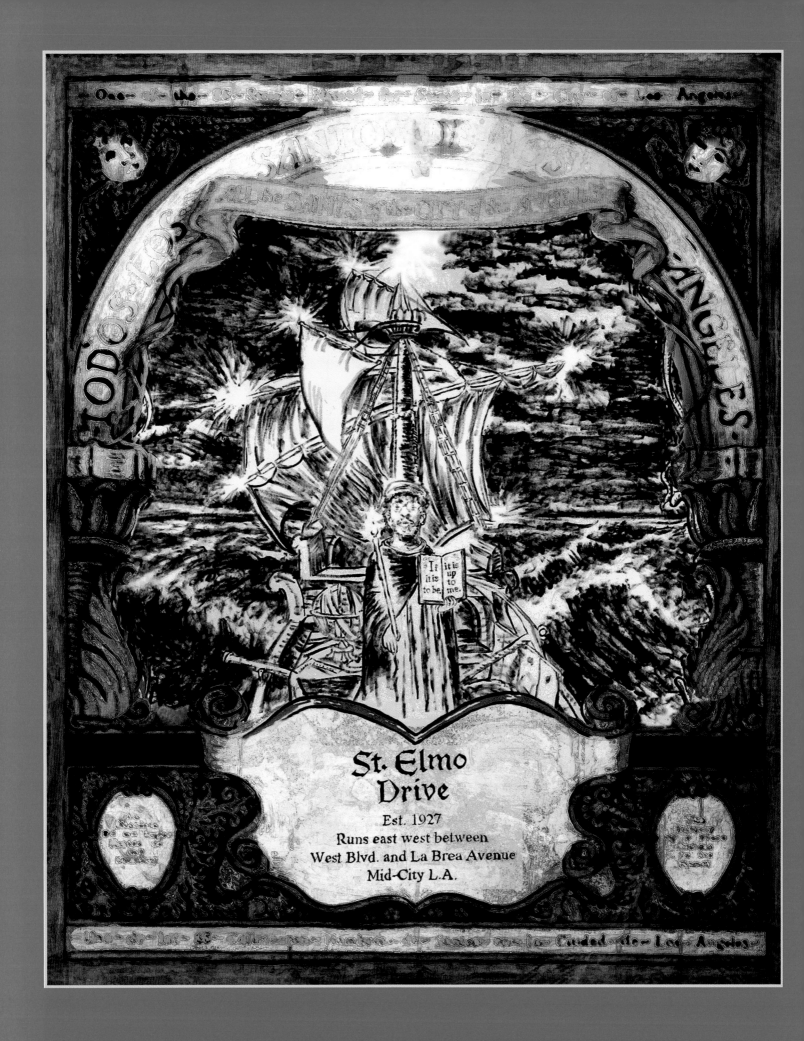

One of the 85 Streets Named for Saints in the City of Los Angeles

SANTOS
All the SAINTS of the CITY of ANGELES
TODOS LOS ANGELES

If it is to be, it is up to me.

St. Elmo
Drive

Est. 1927
Runs east west between
West Blvd. and La Brea Avenue
Mid-City L.A.

Uno de los 85 Calles para santos de seria en la Ciudad de Los Angeles

70

ST. ELMO DRIVE

Mid-City

Some stories take time to tell themselves: time for the details to cohere like coral forming beneath the waves; for the blanks to fill in like pools between the tides.

Sailors have ever been at risk at sea, encountering forces over which they have little control, and responding with discipline, strength, and imagination to the challenges that nature presents at a moment's notice.

Tales of seafaring peril are at least as old as Jonah and the Whale, or Noah and his Ark. Saints, too, have adventured at sea: Nicholas calming a storm, Brendan venturing to new lands, Clement dragged down to a watery grave.

Two such saints have become as entwined in history and legend as inseparable strands of seaweed: Peter González, a thirteenth-century Spanish roving priest, and Erasmus of Formiae, a largely apocryphal third-century hermit on Mount Lebanon.

Peter preached to sailors, shunned honors, and lived among the poor. Erasmus, atop Mount Lebanon, preached to nonbelievers, shunned most everyone, and survived on "what the ravens brought him to eat."

Peter is depicted holding a blue candle, while Erasmus is shown preaching, undeterred by a thunderbolt striking the ground where he stands.

Over time both became patron saints of sailors; and, as stories of their nautical patronage were passed down, they became, for many followers, one and the same person, whose name drifted from Erasmus to Erarmo to Elmo.

Out at sea thunderstorms can erupt with violent swiftness; and sometimes strange electrical discharges, blue in tint, dart about the ship's masthead. Since the time of Columbus sailors have seen these as signs that their protector, St. Elmo, is nearby.

"The thunder and rain being very violent," Columbus wrote on his second journey, in 1493, "St. Elmo appeared on the top-gallant mast with seven lighted tapers...those fires which the sailors believe to proceed from the body of the saint."

Seamen believed these "lighted tapers" were auspicious signs: "The sailors hold it for certain," Columbus continued, "that as soon as St. Elmo appears, the danger of the tempest is over." Sailors termed these occurrences "St. Elmo's Fire."

Alas, here on land, St. Elmo Drive, established in 1927, appeared for a long time unanchored to its namesake; and the community it traversed floundered rudderless, in economic, social, and cultural malaise.

Then, in the mid-sixties, Rozelle and Roderick Sykes, uncle and nephew artists, made port in a cluster of old bungalows and garages along St. Elmo Drive just west of La Brea, and the tides began to turn.

Entwined in their commitment to community, Roderick and Rozelle in 1969 christened their outpost "St. Elmo Village, a place to, as Roderick explained, "nurture the positive aspects of life," a place which shows that art is "not just your painting or your poem," but is rather "the art of living and is your whole environment."

There is much of St. Elmo's spirit afloat in the colorful, vibrant village that bears his name: the shunning of honors, the preference for the common man, and the trusting reliance on the goodwill of others. There are even, appropriately, a fountain and pond.

But most significantly, there burns here St. Elmo's Fire: it is the creative spark of the soul's unquenchable fire, evidenced in the village's motto, "If it is to be, it is up to me." And when that fire alights, one knows all will be well.

For Rozelle (now in the heavens), for Roderick carrying on the work, and for all who seek shelter from life's storms at St. Elmo Village, Shakespeare's description of St. Elmo's Fire from *The Tempest* rings true:

> *"I flamed amazement."*

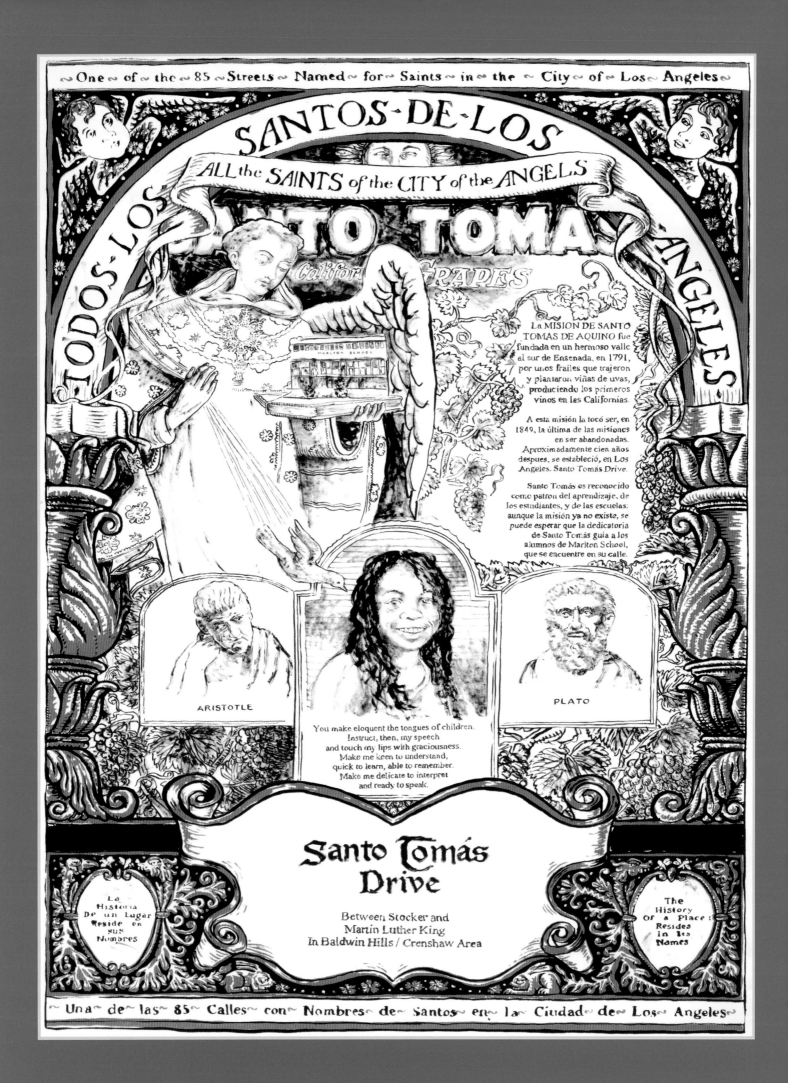

SANTOS·DE·LOS

ALL the SAINTS of the CITY of the ANGELS

TODOS·LOS SANTO TOMAS ANGELES

California GRAPES

La MISION DE SANTO TOMAS DE AQUINO fue fundada en un hermoso valle al sur de Ensenada, en 1791, por unos frailes que trajeron y plantaron viñas de uvas, produciendo los primeros vinos en las Californias.

A esta misión la tocó ser, en 1849, la última de las misiones en ser abandonadas. Aproximadamente cien años despues, se estableció, en Los Angeles, Santo Tomás Drive.

Santo Tomás es reconocido como patron del aprendizaje, de los estudiantes, y de las escuelas; aunque la misión ya no existe, se puede esperar que la dedicatoria de Santo Tomás guia a los alumnos de Marlton School, que se encuentre en su calle.

ARISTOTLE

You make eloquent the tongues of children.
Instruct, then, my speech
and touch my lips with graciousness.
Make me keen to understand,
quick to learn, able to remember.
Make me delicate to interpret
and ready to speak.

PLATO

Santo Tomás Drive

Between Stocker and
Martin Luther King
In Baldwin Hills / Crenshaw Area

La Historia De un Lugar Reside en sus Nombres

The History Of a Place Resides In Its Names

SANTO TOMAS DRIVE

Baldwin Hills/Crenshaw

The Baldwin Hills Crenshaw Plaza in southwest Los Angeles is the oldest regional shopping center in the country. When it opened in November 1947, as the Broadway-Crenshaw Center, a housing development sprang up along its western borders, curving up into the southern hills.

Many of the streets in this housing development were given Spanish names, such as Milagro (Miracle) Drive and Don Quixote Drive. Two of the streets bear the names of Baja California missions—Santo Tomás Drive, named for Misión Santo Tomás de Aquino, and Santa Rosalía Drive, named for Misión Santa Rosalía de Mulegé.

In 1791, a scant two years after El Pueblo de Los Angeles' founding, the Dominican priest José Loriente founded Misión Santo Tomás de Aquino in a lovely valley south of Ensenada, in Baja California. There, in the homelands of the Kumiai Indians, with transplanated European vines, the mission produced the first Californian wines.

Misión Santo Tomás outlasted all the other missions of either Baja or Alta California and was abandoned, finally, in 1849, a short year before the lands to the north came under U.S. control.

The mission buildings quickly fell into ruin, but the native peoples, the Kumiai (or Kumeyaay, as the group is known in the United States), have prospered, uniting with their native sisters and brothers, the Paipai, Cucapá, and Kiliwa, for cultural and political strength.

Here in Los Angeles the name of Santo Tomás de Aquino reappeared, a near-century after his mission's demise, as Santo Tomás Drive on the hill overlooking the Baldwin Hills Crenshaw Plaza.

This Drive, like the Baja mission before it, honors St. Thomas of Aquinas, the great philosopher, translator of Plato and Aristotle, and patron saint of students and academics.

How appropriate it is that we should find a school on the street named for the patron saint of learning. More appropriate still, and particular to Marlton School, is St. Thomas' "Student Prayer," which reads, in part:

> You make eloquent the tongues of children
> Instruct, then, my speech
> And touch my lips with graciousness.
> Make me keen to understand,
> Quick to learn,
> Able to remember.
> Make me delicate to interpret
> And ready to speak.

For it so happens that, alone of the more than one thousand schools comprising the Los Angeles Unified School District, Marlton is the only public school for the deaf; and its four hundred students "speak" with the graceful movements and symbols of American Sign Language, interpreting our world—as Santo Tomás had hoped—with eloquence and delicacy.

Santo Tomás Drive

Between Stocker and Martin Luther King In Baldwin Hills / Crenshaw Area

SANTOS · DE · LOS

ALL the SAINTS of the CITY of the ANGELS

TODOS · LOS

ANGELES

{ Some time before they were invaded by Europeans, the Cochimí living near what became Mission Santa Rosalía left cave paintings that speak of their natural and spiritual world. And in the seventeenth century, Van Dyck left us his portrait of Santa Rosalía, painted from musty bones and fervent spirit. }

SANTA ROSALIA DRIVE

Baldwin Hills/Crenshaw

In 1624 the Flemish artist Anthony Van Dyck traveled to Sicily at the invitation of the Spanish viceroy. While he painted portraits of the Genoese aristocracy, the Black Plague raged across the countryside.

At the same time, a hunter, lost on the mountain above Palermo, saw the vision of a young woman who told him her name was Rosalía and that she had died in a nearby cave 464 years ago.

Rosalía's remains were brought into Palermo, her hometown, and the plague ended; she was declared a saint and named patroness of the region; and Van Dyck was commissioned to paint her portrait.

Eighty years later, in 1705, Jesuit priest Juan María Basaldúa came upon a lush, stream-fed valley in Baja California, and founded there a mission in Santa Rosalía's honor: La Misión Santa Rosalía de Mulegé—"Mulegé" being a corruption of a Cochimí Indian term for the area, meaning "large ravine of white mouth."

There may have been ten thousand Cochimí living in Baja at the time of Mission Santa Rosalía's founding, but a century of European disease and violence sheared their number to mere hundreds; and the mission itself was abandoned in 1828.

In the late 1940s, a Los Angeles developer, casting about for Spanish names for his new neighborhood, named two streets for Baja California missions—one, we have seen, was Santo Tomás Drive, named for Misión Santo Tomás de Aquino; the other was Santa Rosalía Drive, named for Misión Santa Rosalía de Mulegé.

In the thirteenth century, Santa Rosalía left a message on the wall of her cave telling of her resolve to live as she saw fit. Some time before they were invaded by Europeans, the Cochimí living near what became Mission Santa Rosalía left cave paintings that speak of their natural and spiritual world. And in the seventeenth century, Van Dyck left us his portrait of Santa Rosalía, painted from musty bones and fervent spirit.

Apart from the Baja mission, which has crumbled into ruin, all else endures: Santa Rosalía's body in a Palermo shrine; Van Dyck's portrait at the Metropolitan Museum of Art; even a community of strong-willed Cochimí—once written off by the Mexican government as "extinct"—now fighting for official tribal recognition.

Santa Rosalía Drive in Los Angeles runs through one of the city's more economically challenged neighborhoods. Here survival is rarely a given, but the spirit of Santa Rosalía gives hope that its residents may not only survive, but thrive—for, like the residents of seventeenth-century Palermo, saved by Santa Rosalía's intervention, we may one day find ourselves in need of their aid.

TODOS·LOS·SANTOS·DE·LOS·ANGELES

ALL the SAINTS of the CITY of the ANGELS

EL ◆ CORRIDO ◆ DE SANTA ◆ SUSANNA

Con su permiso, voy a cantarles la historia
De una mujer de muy corta vida,
Les aseguro que ahorita está en la Gloria,
La señorita, una santa desconocida.

(Dicen) que era guapa y muy independiente,
Y que por nombre Susanna se llamaba;
Cerca de Sawtelle, en un parquecito enfrente
Encontrarás su calle, en un círculo cerrado.

De mala suerte fue en un país pagano
Donde a Susanna le tocó nacer creyente,
Y de mala suerte y también en vano
Se enamoró de ella un hombre rico y prepotente.

Por sus creencias el juez se molestaba,
Y por negarse a casar con el ahijado;
Por sus creencias ella fue condenada,
Por no querer casarse Susanna fue inmolada.

Pasan los años y hay hombres que no entienden
Que las mujeres también derechos tienen
A vivir como cómodas se sienten,
A creer lo que creen y a pensar lo que piensen.

Dile a la Madre que junte muchas flores,
Dile al Padre que toque la campana,
Que prendan velas e incienso de olores;
Que al campo santo llevan a la Santa Susanna.

St·Susan Place

Est. 1969
A tiny cul-de-sac
South of Palms Boulevard
In Mar Vista

La Historia De un Lugar Reside en sus Nombres

The History Of a Place Resides In Its Names

ST. SUSAN PLACE

Mar Vista

From the earliest times, the Church has marked the passing of women who suffered violent, needless deaths. Individual names may vary—Agnes or Apollonia, Lucy or Susan—but the gist of the tale, shorn of religious adornment, remains tragically common and constant: A woman who spurns a man's advances pays with her life.

In the telling, the woman is invariably young and beautiful, well-to-do and chaste; but these we may regard as attributes bequeathed in flowery tribute.

The life of the St. Susan commemorated on this street, the *Catholic Encyclopedia* informs us, "has been rightly questioned" (even as it continues to tell the tale). Thus St. Susan remains much like the Place that bears her name: a circular cipher, an enclosed street—a virtual dead end.

And yet, the very telling of her story, her very remembrance in art or song—or her appearance on a street sign—stands as affirmation, a reclamation of a life lived and lost; a rebuke to the folly of man.

EL ✦ CORRIDO ✦ DE SANTA ✦ SUSANNA

El Corrido de Santa Susana

The Ballad of St. Susan Place

Con su permiso, voy a cantarles la historia
De una mujer de muy corta vida,
Les aseguro que ahorita está en la Gloria,
La señorita, una santa desconocida.

(Dicen) que era guapa y muy independiente,
Y que por nombre Susana se llamaba;
Cerca de Sawtelle, en un parquecito enfrente
Encontrarás su calle, en un círculo cerrado.

De mala suerte fue en un país pagano
Donde a Susana le tocó nacer creyente,
Y de mala suerte y también en vano
Se enamoró de ella un hombre rico y prepotente.

Por sus creencias el juez se molestaba,
Y por negarse a casar con el ahijado;
Por sus creencias ella fue condenada,
Por no querer casarse Susana fue inmolada.

Pasan los años y hay hombres que no entienden
Que las mujeres también derechos tienen
A vivir como cómodas se sienten,
A creer lo que creen y a pensar lo que piensen.

Dile a la Madre que junte muchas flores,
Dile al Padre que toque la campana,
Que prendan velas e incienso de olores;
Que al campo santo llevan a la Santa Susana.

78

FIVE

From Bel-Air to the Beach

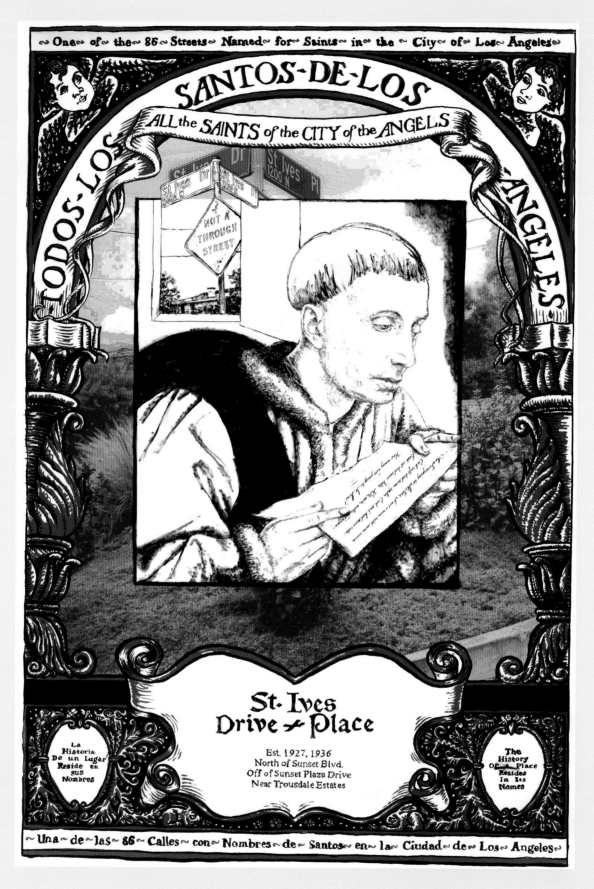

SANTOS·DE·LOS

TODOS·LOS

ANGELES

ALL the SAINTS of the CITY of the ANGELS

NOT A THROUGH STREET

St·Ives
Drive & Place

Est. 1927, 1936
North of Sunset Blvd.
Off of Sunset Plaza Drive
Near Trousdale Estates

La Historia De un Lugar Reside en sus Nombres

The History Of a Place Resides In Its Names

ST. IVES DRIVE and PLACE

Near Trousdale Estates

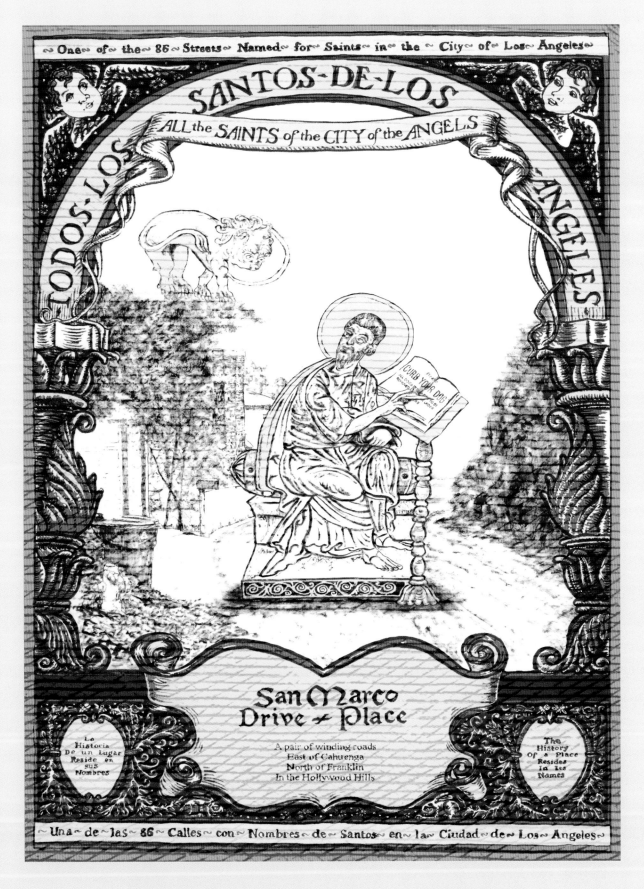

TODOS·LOS SANTOS·DE·LOS ANGELES

ALL the SAINTS of the CITY of the ANGELS

CURB YOUR DOG

San Marco
Drive ✦ Place

A pair of winding roads
East of Cahuenga
North of Franklin
In the Hollywood Hills

La
Historia
De un Lugar
Reside en
sus
Nombres

The
History
Of a Place
Resides
In Its
Names

~ Una ~ de ~ las ~ 86 ~ Calles ~ con ~ Nombres ~ de ~ Santos ~ en ~ la ~ Ciudad ~ de ~ Los ~ Angeles

SAN MARCO DRIVE and CIRCLE

Hollywood Hills

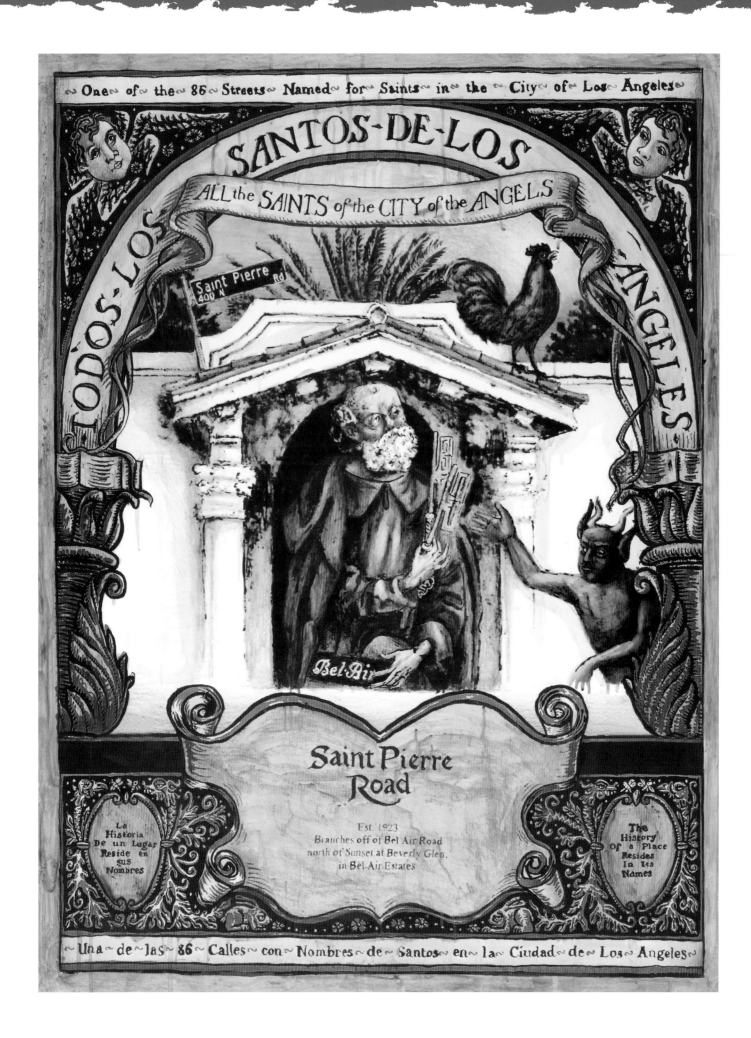

ST. PIERRE ROAD

Bel-Air

A 1921 oil gusher on his Santa Fe Springs lima bean farm propelled Alphonzo Bell into the forefront of that decade's fashioning of Los Angeles' popular image of wealth and ease.

As oil rained down onto the family tennis courts and homestead, Bell and brood hied themselves away to the more commodious (and now affordable) Beverly Hills Hotel, where they quickly developed a taste for the lifestyle and neighborhood. Setting ink to a pair of purchases, Don Alphonzo took possession of twenty-three thousand hillside acres along what was then Beverly (now Sunset) Boulevard, westward to the sea.

Translating the rustic "Rancho San José de Buenos Ayres" into a more refined and secular "Bel-Air" set the tone for Bell's elegant vision of "splendid homes and exquisite gardens...whose strength of appeal would be in direct proportion to the esthetic ideals" of the fortunate few.

A Grand Tour of Europe in the comfort of a chauffeur-driven Rolls provided Bell with melodic names for the streets his engineers would carve out of his new Mediterranean on the Pacific. Among these was St. Pierre, named for St. Peter, the guardian of the Pearly Gates at the entrance to paradise. And, indeed, St. Pierre Road lies just aside the eastern gateway to Bel-Air Estates.

St. Peter, we are told, bears two great keys made, as Milton writes, "of metals twain; the golden opes, the iron shuts amain." By what measure St. Pierre selects the key to this haven's gate, and with which key turns the lock to grant or deny admittance to Bell's Terrestrial Paradise, we may well know.

For, whether the path be truly straight and narrow, or roundabout as St. Pierre Road, it is not the streets here which are paved with gold, but rather the residents' bank accounts. What irony, then, that this road be named for one who heeded the call to abandon all and follow an ascetic master who taught that sacrifice in this life brings eternal happiness in the next.

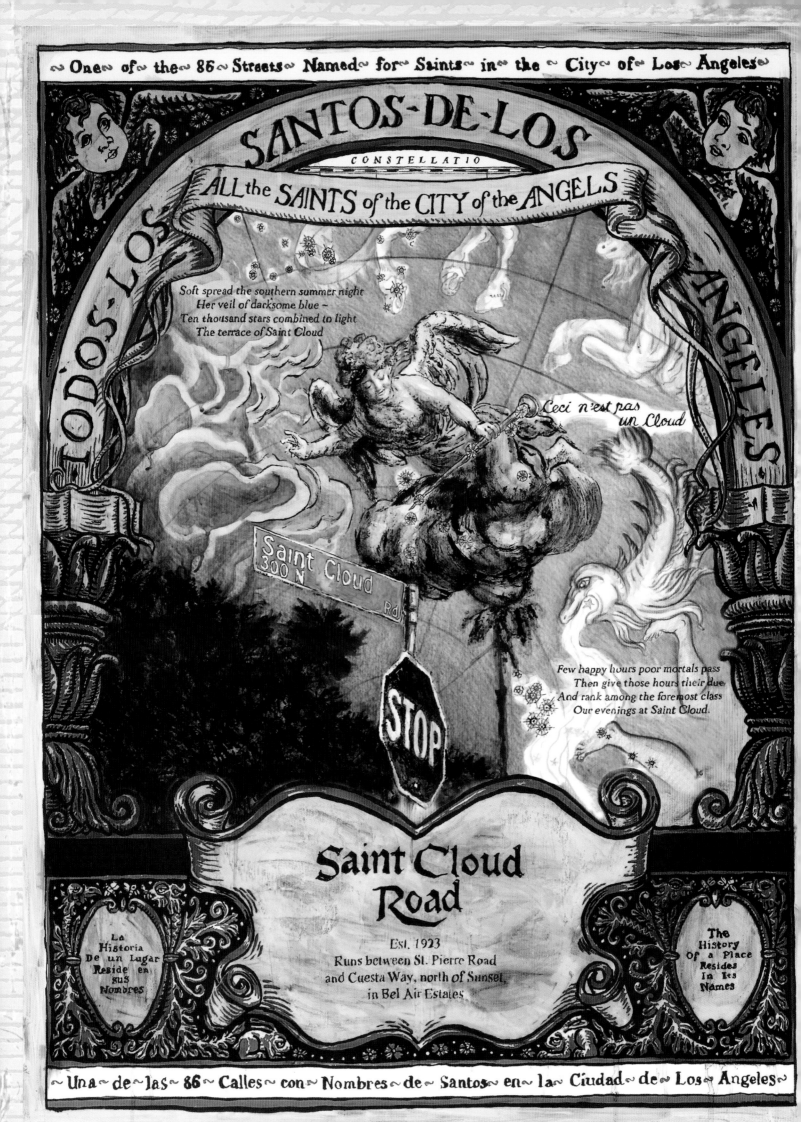

SANTOS-DE-LOS

CONSTELLATIO

ALL the SAINTS of the CITY of the ANGELS

TODOS-LOS

ANGELES

Soft spread the southern summer night
Her veil of darksome blue ~
Ten thousand stars combined to light
The terrace of Saint Cloud

Ceci n'est pas un Cloud

Saint Cloud
300 N
Rd

STOP

Few happy hours poor mortals pass
Then give those hours their due
And rank among the foremost class
Our evenings at Saint Cloud.

La
Historia
De un Lugar
Reside en
sus
Nombres

Saint Cloud
Road

Est. 1923
Runs between St. Pierre Road
and Cuesta Way, north of Sunset,
in Bel Air Estates

The
History
Of a Place
Resides
In Its
Names

ST. CLOUD ROAD

Bel-Air

When, in 1924, Alphonzo Bell toured Europe in a chauffeured Rolls, jotting down names for the streets of his ritzy Southern California neighborhood of Bel-Air, St. Cloud caught his eye—but not, perhaps, his ear. The French (who should know) pronounce this Parisian suburb like the English word "due"—or the French word "clou" (meaning "nail," the makers of which find themselves under the good saint's protection); while here in Bell's lair it rhymes with "endowed."

The boy prince who, in the sixth century, became St. Cloud fled a harrowing childhood: orphaned at birth, he narrowly escaped death when his uncles murdered his older brothers to gain their throne.

Alone at age eight, Cloud lived in hiding another ten years. Then, recognizing that "all which appears most dazzling in worldly greatness is no better than smoke," he renounced the world, cut off his hair, and became a monk.

Wandering lonely as a cloud, the youthful ascetic practiced austerities (becoming kingly master of his passions) and studied with Benedictine masters before returning to Paris, where, with wisdom so profound that light seemed to emanate from his forehead, he founded a community at the place which bears his name.

St. Cloud's name means "out of the mist"—an appropriate meaning for a follower of St. Benedict, who compared his monks to "clouds and water" that "wander freely across the world."

In the sky above St. Cloud Road, perhaps it is the popular mispronunciation of the good saint's name which finally proves more appropriate.

Although one comes to Bel-Air to see grand homes and estates, it is here above, in the interplay of light and clouds, where one may best sense the permanent truth of light in the transitory nature of clouds and mist, and finally arrive at Alphonzo Bell's Bel-Air dream: "a spot where the wings of care are folded and the soul has calm."

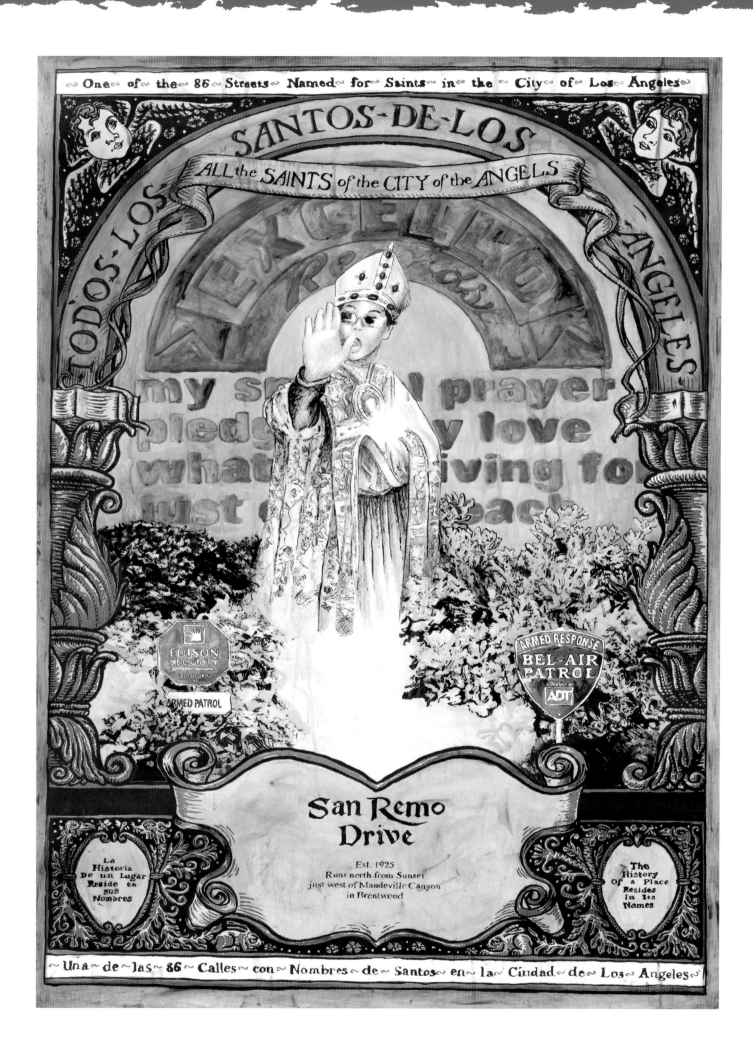

SAN REMO DRIVE

Riviera, Bel-Air

St. Romulus, that most anonymous and unknowable of saints, occupies three streets in the City of the Angels: San Remo Way, inside a gated community in Tarzana; Via San Remo, inside a gated community in Sylmar; and San Remo Drive, a privately patrolled street in Bel-Air.

As it snakes along the perimeter of the Riviera hilltop of Alphonzo Bell's Bel-Air, San Remo Drive embodies the dichotomy of its origins.

Initially inspired by an Italian gambling resort, the Drive ultimately owes its name to a seventh-century bishop whose very life is shrouded in mystery: a name, a city, and a date are all the archives divulge.

Passing the impressive, impassive homes arrayed along San Remo Drive, one senses that each yard's sentry-like signs for Bel-Air Patrol and Edison Security continue this work of protective silence and concealment.

And perhaps, if the homes also embody the twin opposites of the Drive's origins —both bishop and gambling resort— this is just as well.

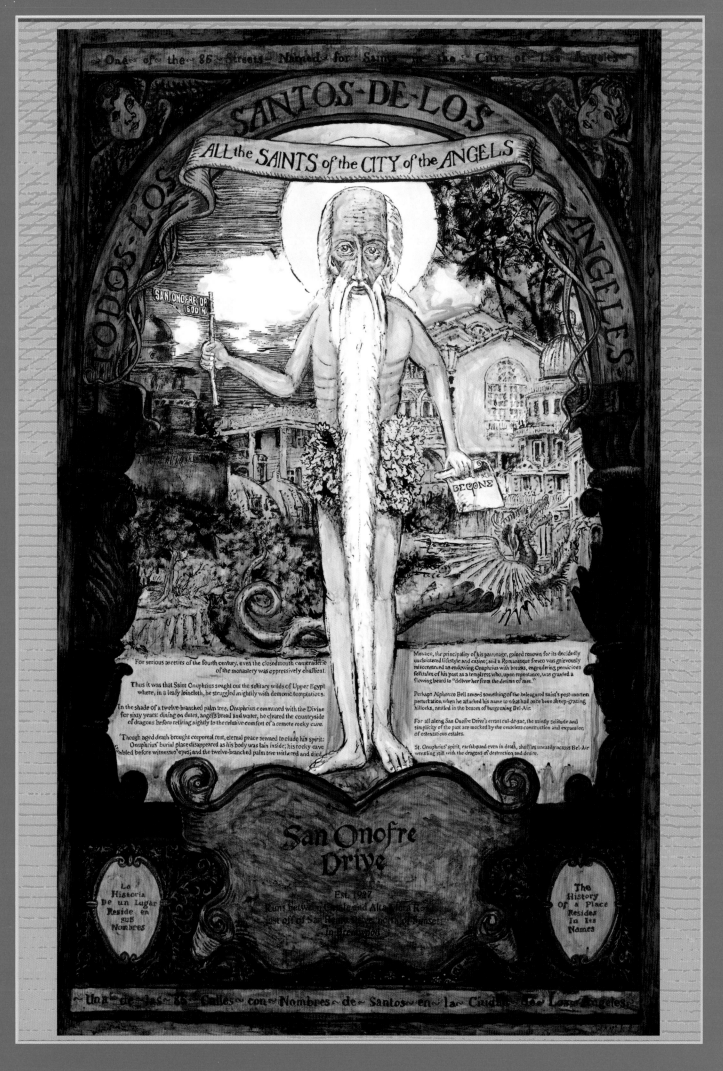

SAN ONOFRE DRIVE

Bel-Air

For serious ascetics of the fourth century, even the closed-mouth camaraderie of the monastery was oppressively ebullient.

Thus it was that St. Onuphrius sought out the solitary wilds of Upper Egypt, where, in a leafy loincloth, he struggled mightily with demonic temptations.

In the shade of a twelve-branched palm tree, Onuphrius communed with the Divine for sixty years: dining on dates and angel-catered meals of bread and water, he cleared the countryside of dragons before retiring nightly to the relative comfort of a remote rocky cave.

'Though aged death brought corporeal rest, eternal peace seemed to elude his spirit: Onuphrius' burial place disappeared as his body was lain inside; his rocky cave crumbled before witnesses' eyes; and the twelve-branched palm tree withered and died. Monaco, the principality of his patronage, gained renown for its decidedly non-monastic lifestyle and casino; and a Romanesque fresco was grievously misconstrued as endowing Onuphrius with breasts, engendering pernicious folktales of his past as a temptress who, upon repentance, was granted a flowing beard to "deliver her from the desires of men."

Perhaps Alphonzo Bell sensed something of this beleaguered saint's postmortem perturbation when he attached his name to what had once been sheep-grazing hillocks, nestled in the bosom of burgeoning Bel-Air.

For all along San Onofre Drive's errant cul-de-sac, the saintly solitude and simplicity of the past are mocked by the ceaseless construction and expansion of ostentatious estates.

St. Onuphrius' spirit, earthbound even in death, shuffles uneasily across Bel-Air, wrestling still with the dragons of destruction and desire.

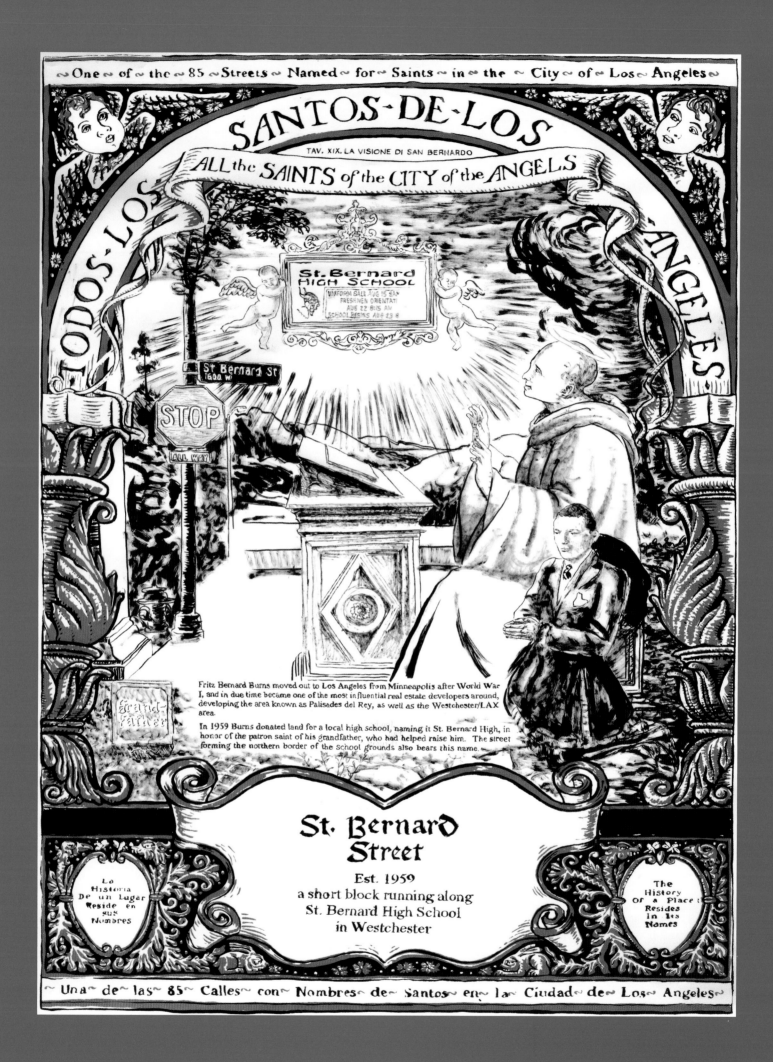

SANTOS·DE·LOS

TAV. XIX. LA VISIONE DI SAN BERNARDO

ALL the SAINTS of the CITY of the ANGELS

TODOS·LOS

ANGELES

St. Bernard
HIGH SCHOOL

UNIFORM SALE AUG 15 9AM
FRESHMEN ORIENTATI
AUG 22 8:15 AM
SCHOOL BEGINS AUG 23 8

St Bernard St
1600 w

STOP
ALL WAY

Grand-
Father

Fritz Bernard Burns moved out to Los Angeles from Minneapolis after World War I, and in due time became one of the most influential real estate developers around, developing the area known as Palisades del Rey, as well as the Westchester/LAX area.

In 1959 Burns donated land for a local high school, naming it St. Bernard High, in honor of the patron saint of his grandfather, who had helped raise him. The street forming the northern border of the school grounds also bears this name.

La
Historia
De un Lugar
Reside en
sus
Nombres

St. Bernard Street

Est. 1959
a short block running along
St. Bernard High School
in Westchester

The
History
Of a Place
Resides
In Its
Names

ST. BERNARD STREET

Westchester

A sly old adage about wealth advises, "Choose your parents well." How astute, then, Fritz Bernard Burns must have been, to have chosen so wisely both his grandfather and patron saint.

Fritz may not have inherited wealth, but he was ever grateful to his grandfather Bernard, who raised him, and mindful of his grandfather's patron saint, Bernard of Clairvaux.

At about the same age that St. Bernard abandoned the world and joined an abbey—twenty-one—Fritz abandoned Minneapolis and headed for the City of the Angels.

If, as *The Golden Legend* says, St. Bernard was a "mellifluous Doctor" of the Church, Fritz must have been a bit of a smooth talker as well, for he quickly became an impressive salesman, and one of the Southland's great real estate developers, developing Westchester, Playa del Rey, Windsor Hills, and parts of North Hollywood.

It is said that St. Bernard would ask himself each morning, "Why have I come here?" Fritz found this a good game plan, too, meeting daily with his sales reps to fire them up and remind them of their sales goals.

Mindful of the mantra that another of his mentors, real estate developer Clifford Gillespie, had often repeated—"Make them feel happy; give them presents"—Fritz decided in the 1950s to honor his grandfather with a lasting memorial.

He deeded the land for a high school, to be named for his grandfather's patron saint, in his beloved Playa del Rey and named one of the streets adjacent to the school property St. Bernard as well.

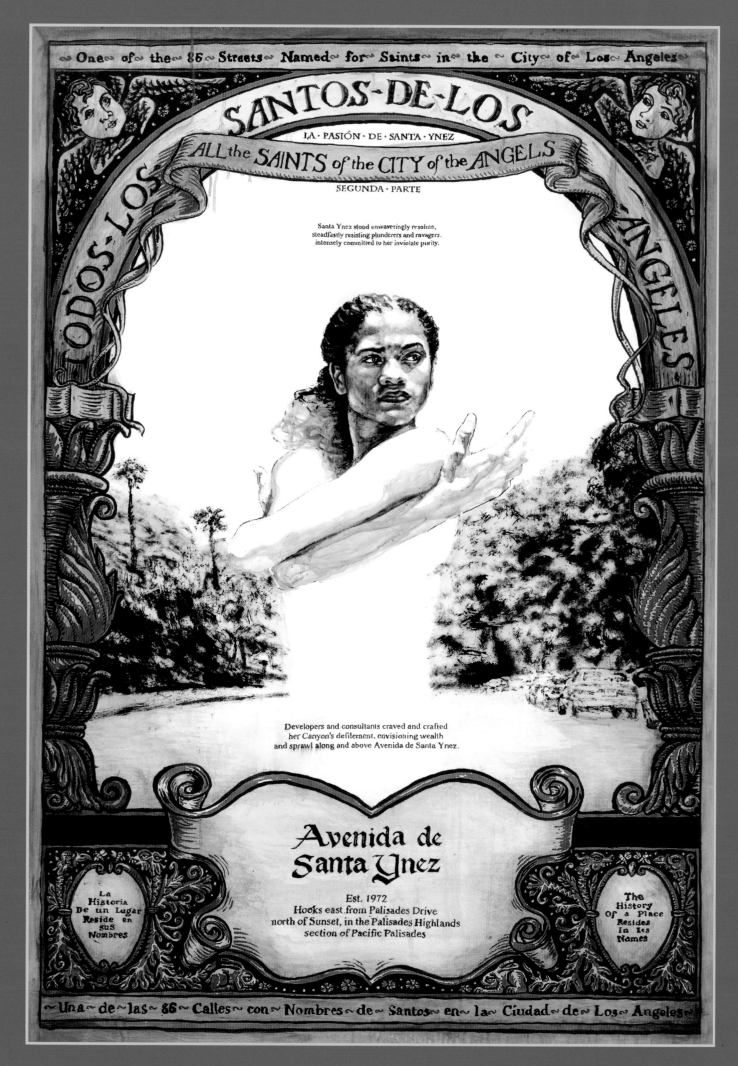

SANTOS·DE·LOS

LA · PASIÓN · DE · SANTA · YNEZ

ALL the SAINTS of the CITY of the ANGELS

SEGUNDA · PARTE

Santa Ynez stood unwaveringly resolute,
steadfastly resisting plunderers and ravagers,
intensely committed to her inviolate purity.

Developers and consultants craved and crafted
her Canyon's defilement, envisioning wealth
and sprawl along and above Avenida de Santa Ynez.

Avenida de Santa Ynez

Est. 1972
Hooks east from Palisades Drive
north of Sunset, in the Palisades Highlands
section of Pacific Palisades

La
Historia
De un Lugar
Reside en
sus
Nombres

The
History
Of a Place
Resides
In Its
Names

LA PASION de SANTA YNEZ

Avenida de Santa Ynez, Santa Ynez Road, and Via Santa Ynez

Pacific Palisades

It may seem a curiosity that so many places in Los Angeles should bear the name of this third-century martyr. Five streets in the City of the Angels are named for Santa Ynez: a street in Echo Park; a pedestrian pathway in Carthay Circle; and three roads in the Westside's Pacific Palisades. Yet the story of Santa Ynez, or St. Agnes, embellished over time with its myriad lurid details, can be reduced to a veritable parable of the California landscape.

Santa Ynez's beauty brought unwanted attention from avaricious men who so ardently desired her that, when rebuffed, they were willing to destroy her. Although she resisted, Ynez was ultimately martyred, leaving us to both mourn her passing and celebrate her courage.

Within a mile of each other, close to the ocean, just north of Sunset Boulevard, lies a trio of related Pacific Palisades streets: Avenida de Santa Ynez, Vía Santa Ynez, and Santa Ynez Road. Similar in name, they differ in history and geography; and, as such, we may consider them as moments in the story, or the Passion, of Santa Ynez.

Santa Ynez Road, the unmarked entryway to Santa Ynez Canyon Park, ambles lazily through a rich overgrowth of native trees and wildflowers, fed by a gurgling stream, conveying not only the saint's natural beauty, but a vivid sense of how much of this land looked before encroachment, conquest, and development.

Avenida de Santa Ynez, just up the hill and across Palisades Drive, lies inside the housing development of Palisades Heights. Although it appears settled and neighborly, this calm belies the threat posed three decades ago when developers designed to denude its hillsides and install dozens of skyscraping condominiums, supermarkets, and concrete parking lots. The community's success in staving off this threatened overdevelopment recalls the saint's resistance to ravagers and her defiance of those who would have their way with her.

Vía Santa Ynez, to the southeast, sheltered in the Palisades' Marquez Knolls area, dead-ends in a quiet community garden of wildflowers and native shrubs. This placid site of contemplation seems an appropriate place to consider the life—the Passion—of this martyred saint, as well as the ongoing struggle to protect our environment and heritage.

For here, on Vía Santa Ynez, we may pause to reflect that it was the community's activism that not only prevented overdevelopment of the lands around Avenida de Santa Ynez but also inspired the purchase and preservation, as Santa Ynez Canyon Park, of the lands enveloping Santa Ynez Road.

The example of this resilient and beautiful saint holds lessons for us all.

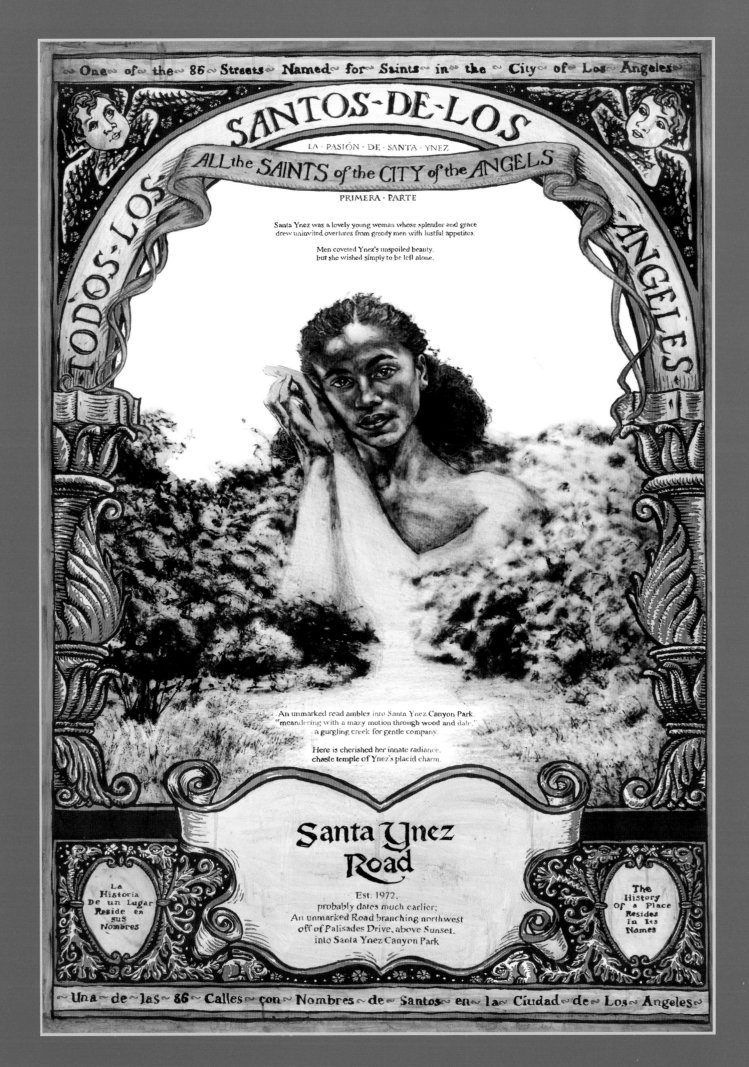

TODOS·LOS

SANTOS·DE·LOS

LA · PASIÓN · DE · SANTA · YNEZ

ALL the SAINTS of the CITY of the ANGELS

ANGELES

PRIMERA · PARTE

Santa Ynez was a lovely young woman whose splendor and grace
drew uninvited overtures from greedy men with lustful appetites.

Men coveted Ynez's unspoiled beauty,
but she wished simply to be left alone.

An unmarked road ambles into Santa Ynez Canyon Park,
"meandering with a mazy motion through wood and dale,"
a gurgling creek for gentle company.

Here is cherished her innate radiance,
chaste temple of Ynez's placid charm.

Santa Ynez Road

Est. 1972,
probably dates much earlier;
An unmarked Road branching northwest
off of Palisades Drive, above Sunset,
into Santa Ynez Canyon Park

La
Historia
De un Lugar
Reside en
sus
Nombres

The
History
Of a Place
Resides
In Its
Names

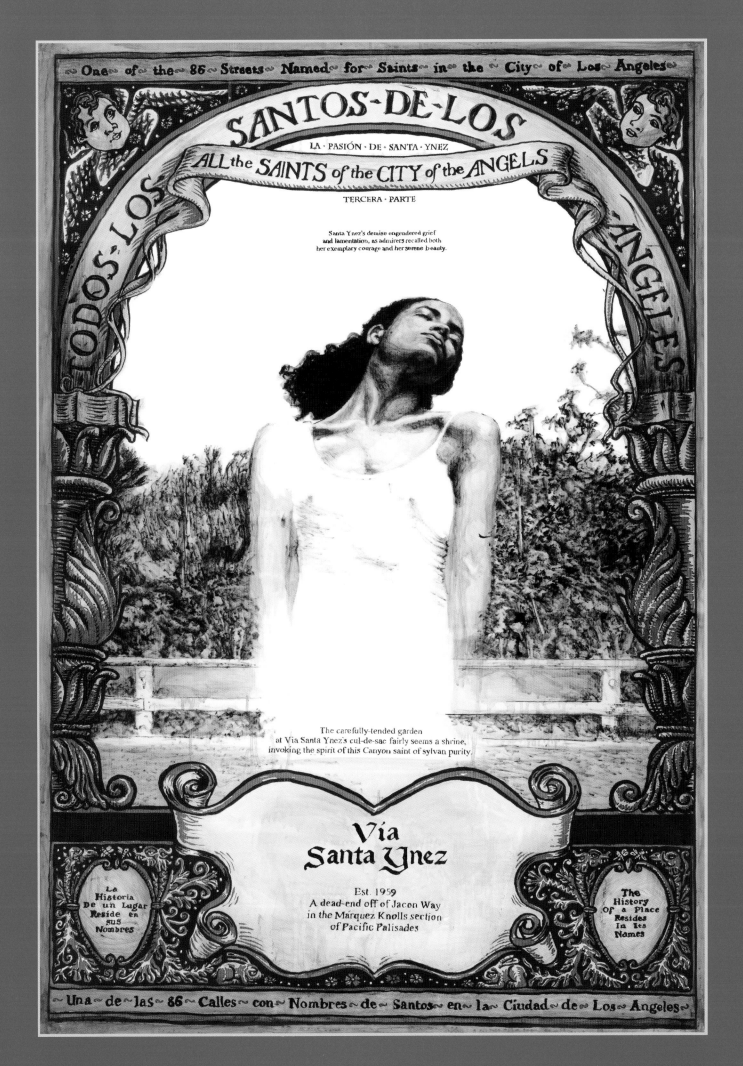

SANTOS·DE·LOS

TODOS·LOS

ÁNGELES

LA · PASIÓN · DE · SANTA · YNEZ

ALL the SAINTS of the CITY of the ANGELS

TERCERA · PARTE

Santa Ynez's demise engendered grief
and lamentation, as admirers recalled both
her exemplary courage and her serene beauty.

The carefully-tended garden
at Vía Santa Ynez's cul-de-sac fairly seems a shrine,
invoking the spirit of this Canyon saint of sylvan purity.

Vía Santa Ynez

Est. 1959
A dead-end off of Jacon Way
in the Márquez Knolls section
of Pacific Palisades

La
Historia
De un Lugar
Reside en
sus
Nombres

The
History
of a Place
Resides
In Its
Names

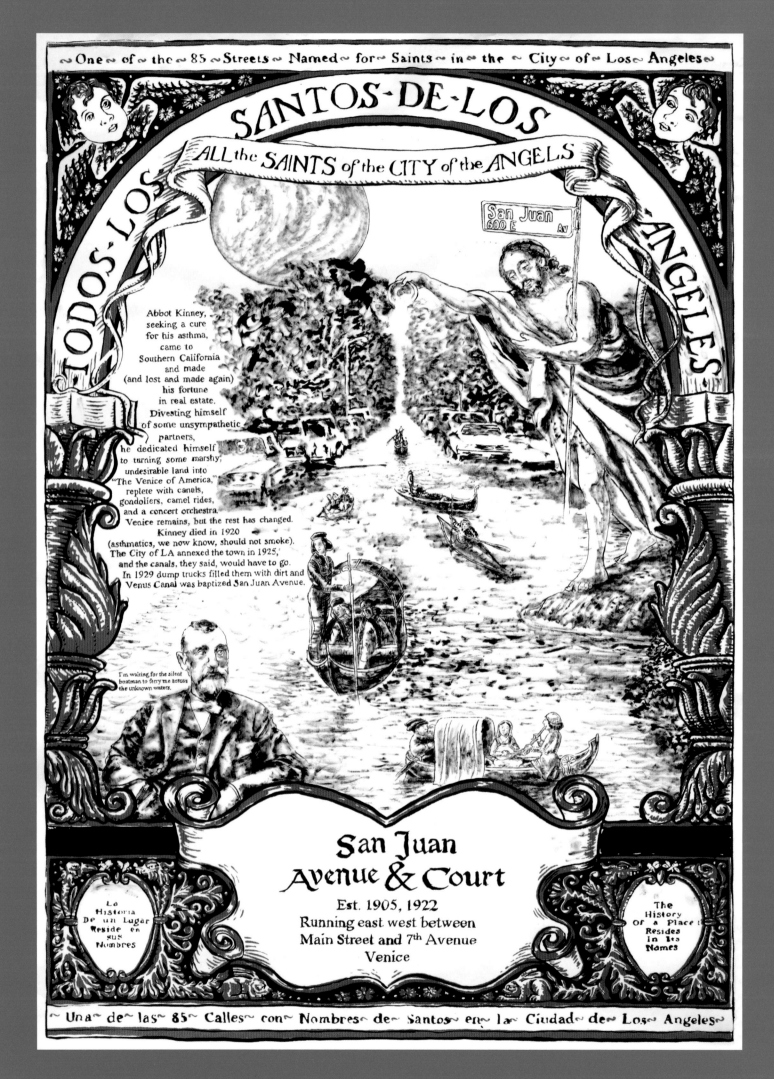

SANTOS·DE·LOS

TODOS·LOS

ANGELES

ALL the SAINTS of the CITY of the ANGELS

San Juan
600 E Av

Abbot Kinney,
seeking a cure
for his asthma,
came to
Southern California
and made
(and lost and made again)
his fortune
in real estate.
Divesting himself
of some unsympathetic
partners,
he dedicated himself
to turning some marshy,
undesirable land into
"The Venice of America,"
replete with canals,
gondoliers, camel rides,
and a concert orchestra.
Venice remains, but the rest has changed.
Kinney died in 1920
(asthmatics, we now know, should not smoke).
The City of LA annexed the town in 1925,
and the canals, they said, would have to go.
In 1929 dump trucks filled them with dirt and
Venus Canal was baptized San Juan Avenue.

I'm waiting for the silent
boatman to ferry me across
the unknown waters.

San Juan
Avenue & Court

Est. 1905, 1922
Running east west between
Main Street and 7th Avenue
Venice

La
Historia
De un Lugar
Reside en
sus
Nombres

The
History
Of a Place
Resides
in Its
Names

SAN JUAN AVENUE and COURT

Venice

Abbot Kinney, tobacco-rich gadabout and intellectual entrepreneur, came to Southern California in 1880 seeking a cure for his asthma, and made (and lost and made again) his fortune in real estate.

Ever curious and progressive, Kinney set up an agency to protect the forests of the San Gabriel Mountains, and he worked as translator for author-activist Helen Hunt Jackson as they visited, and documented the deplorable state of, California's native peoples.

In 1891, on his third or fourth attempt at real estate development, Kinney joined in the purchase of a mile-and-a-half strip of Santa Monica beachfront. Divesting himself, a few years later, of his disagreeable partners, he dedicated his substantial energies to transforming this fairly undesirable salt marsh into a refined, Old World community at the western edge of the New World. It took a number of years to realize, but when Kinney's grandiose "Venice of America" opened in 1905, replete with canals and imported gondoliers, orchestra, and humanist lecturers, it was an audacious example of turning deficits into benefits.

It might have struck lesser lights as brazen hubris to offer seaside lots at twice the price of those in elegant Beverly Hills; but eager, discerning homebuyers grabbed up Kinney's lots on Opening Day that Fourth of July. As regards the other, decidedly intellectual attractions that Venice boasted, the more entertainment-minded masses, arriving in Kinney-owned trolley cars, favored instead the freak shows, camel rides, and swimsuit contests that gradually replaced them.

Kinney would tweak the formula a bit before his death in 1920 (asthmatics, we now know, should not smoke). However, although he had been ahead of his time on so many issues, Kinney had failed to anticipate Southern California's love affair with the automobile: his streets were notoriously narrow; and he had neglected to provide a method to cleanse his canals of refuse.

Those canals running through his community seemed sacrosanct; intrinsic to the very concept of "Venice." Nonetheless, not long after Kinney departed the scene, commercial growth—intrinsic, it seems, to the very concept of Los Angeles—became a concern for Southern California's Venetians as well—and the canals were putting a definite damper on that.

And so, when Los Angeles annexed Venice in 1925 the canals, it was decided, would have to go. The dump trucks came and filled them in with dirt; and Venus Canal, watery reflection of the goddess of love, was baptized a chaste San Juan Avenue. *Arrivederci,* romance.

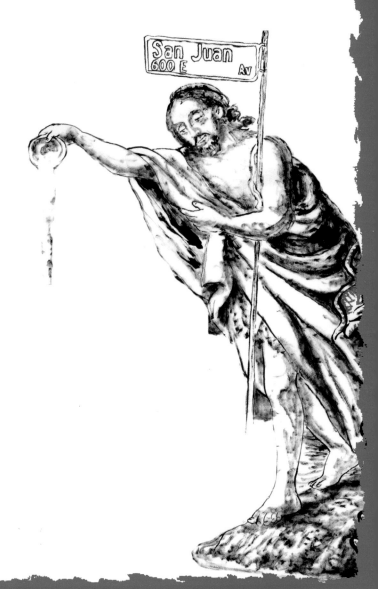

97

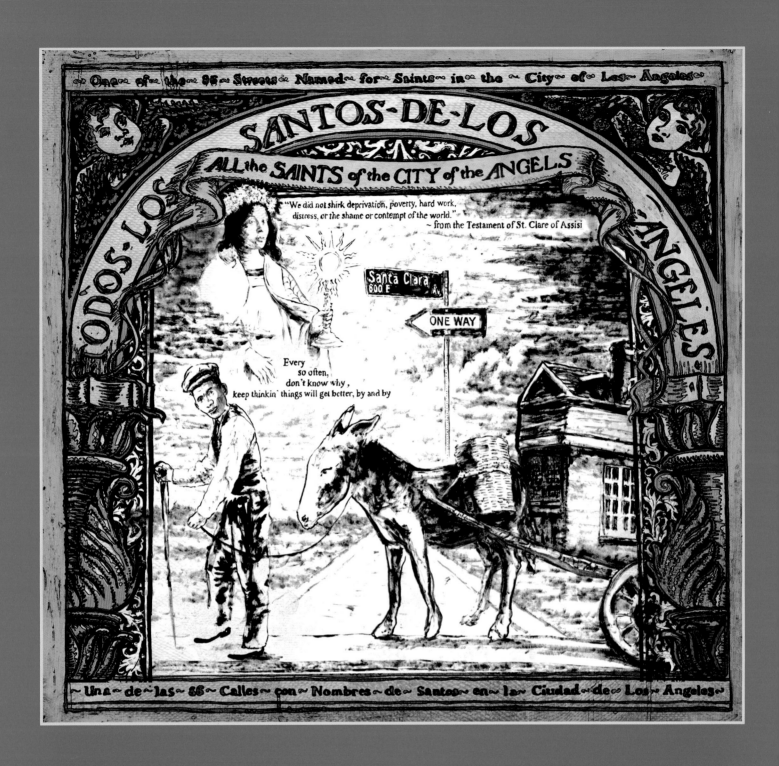

{ ...Irving Tabor exercised the Wisdom of Solomon. He sawed his house in twain, hitched it to his mules, and drove his house home... }

SANTA CLARA AVENUE and COURT

Venice

A progressive and singularly egalitarian man at the turn of the previous century, Abbot Kinney was known to give blacks a fair shake, welcoming them as builders of the evocative canals that would give his new, *fin de siècle* "Venice of America" its identity.

Perhaps no African American derived more direct or longer lasting benefit from Kinney's sense of fairness and equality than did the sixteen-year-old youth who happened to be sweeping his pier one day in 1913: Abbot Kinney approached Irving Tabor and invited him to become his personal chauffeur.

Over the next seven years, Abbot and Irving traveled everywhere together, even sleeping overnight in Abbot's fine automobile when southern hotel owners refused Irving admittance.

This professional friendship culminated, upon Abbot's death and his widow's departure, in the handing over to Irving of title to the Kinney home.

However, the same hostility that barred Irving (and thousands of other blacks) from entry to whites-only hotels also made his family unwelcome in the Kinneys' old neighborhood.

So Irving Tabor exercised the Wisdom of Solomon. He sawed his house in twain, hitched it to his mules, and drove his house home, across jury-rigged ramps over the same canals he had helped build, to its present site at the southeast corner of Sixth Street and Santa Clara Avenue.

Fortunately, Santa Clara, famed for having driven back the invading Saracen army by holding aloft a holy, golden monstrance, raised it this time, instead, as a welcoming beacon to Irving, his weary family, and his restored home.

SIX:

Over the Hills into

the Valley

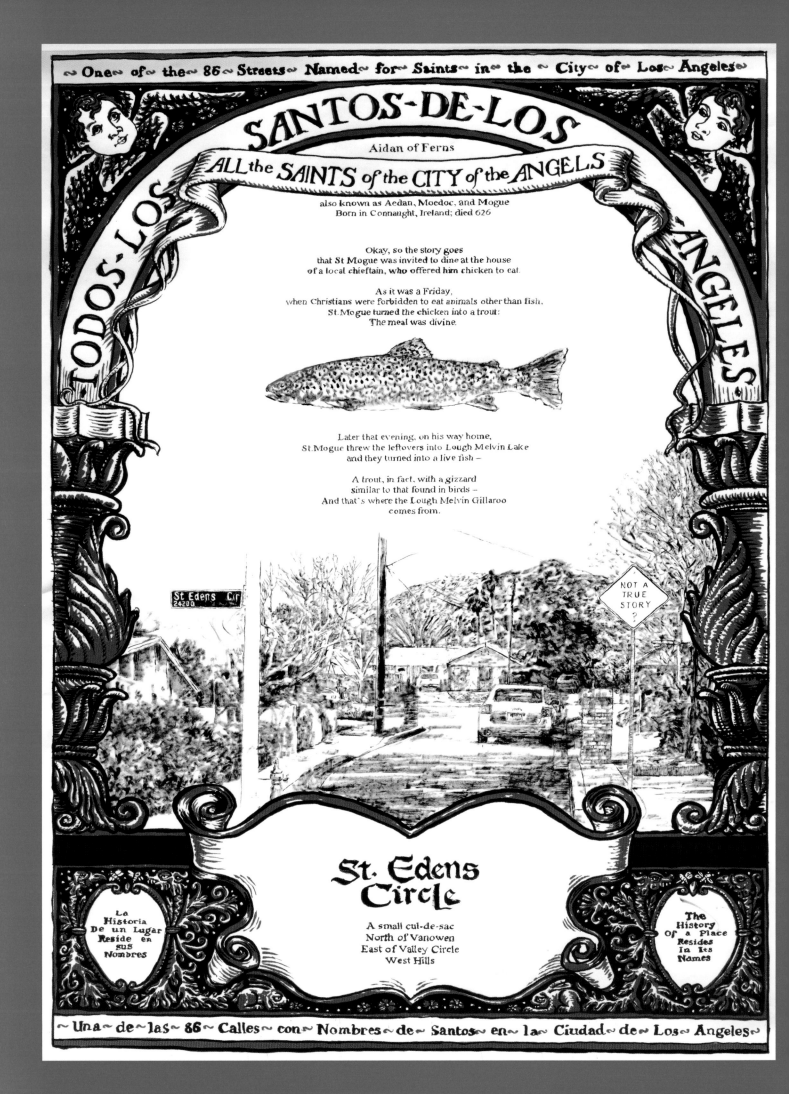

TODOS·LOS

SANTOS·DE·LOS

ANGELES

Aidan of Ferns

ALL the SAINTS of the CITY of the ANGELS

also known as Aedan, Moedoc, and Mogue
Born in Connaught, Ireland; died 626

Okay, so the story goes
that St Mogue was invited to dine at the house
of a local chieftain, who offered him chicken to eat.

As it was a Friday,
when Christians were forbidden to eat animals other than fish,
St. Mogue turned the chicken into a trout:
The meal was divine.

Later that evening, on his way home,
St. Mogue threw the leftovers into Lough Melvin Lake
and they turned into a live fish –

A trout, in fact, with a gizzard
similar to that found in birds –
And that's where the Lough Melvin Gillaroo
comes from.

St Edens Cir
24200

NOT A
TRUE
STORY
?

St. Edens Circle

A small cul-de-sac
North of Vanowen
East of Valley Circle
West Hills

La
Historia
De un Lugar
Reside en
sus
Nombres

The
History
Of a Place
Resides
In Its
Names

ALL the SAINTS of SYLMAR

Santiago Estates and Mountain Glen

Via San Anselmo, Via San Diego, Via San Felipe, Via San Marino, Via San Miguel, Via San Pablo, Via San Rafael, Via San Remo, Via San Ricardo, Via Santa Bárbara, Via Santa Catalina, Via Santa Clara, Via Santa Lucía, Via Santa María, Via Santa Marta, Via Santa Rosa, Via Santa Vista, Via Santiago

Where do the saints go when they want to get away from it all?

City life can be too distracting; too noisy and overcrowded. It helps to get out where coyotes hold sway over the nightlife; where the birds silhouetted against the sky are hawks, not helicopters.

The problem is—and every desert father and mystic since St. Onuphrius and Simon Stylites the Elder can attest to this—as soon as the word gets out, you attract souls seeking guidance, or at least comfort in contemplative company.

Pretty soon these newcomers attract a crowd as well, and like it or not you've got a bustling community on your devotional doorstep.

The Poor Clares, an order of meditative nuns following the ideals of Santa Clara (see chapter one), settled into a derelict isolated mansion on the hillside above Sylmar's Pacoima Canyon in 1975. The mansion had been abandoned by a Hollywood-hopeful Wise Guy in the forties and converted into a convent and retreat center by a group of Spanish nuns twenty years thereafter.

At the time the Poor Clares took over, the sweet scent of citrus trees drifted up from Pacoima Wash; the rocky hills of Angeles National Forest rose behind them; and little threatened the nuns' prayerful pace or monastic tranquility.

But eight years later a design was brought before the Los Angeles City Planning Commission that would slice into the forest-adjacent county land and carve a huge development right up to the Sisters' front door. Santiago Estates' proposal to extend the city limits and surround the contemplative nuns with nine hundred homes was approved.

The engineering and internal bickering among business partners delayed construction for so long, the nuns just might be forgiven for not seeing the invasion coming. Wilshire Builders, KB Homes, John Laing, Watt America, and MHC: the various owners and companies involved make identification of just who did what a little perilous. But by 1989 the first phase of construction was under way; and what had been, on paper at least, an integrated tract of homes was now divorced, subdivided, and controlled under separate ownership.

Santiago Estates, Mountain Glen, and Mountain View became the three components, none of which particularly evokes the personality of its name. The views from Mountain View's homes, for example, are not, as one might expect, from the mountain looking out over the valley, but from the valley looking at the mountain against which the homes are set: literally, *mountain views*. Mountain Glen is set not in a glen, but up above everyone else on the hill, looking out over the valley. And Santiago Estates, the only one of the three developments not behind locked gates, jam-packs its smallish modular homes tightly against one another in a decidedly non-estate-like fashion, along narrow streets the width of alleyways.

Between them, Santiago Estates and Mountain Glen have eighteen streets, each named for a saint (Via Santa Bárbara, Via San Ricardo, Via Santa Rosa, etc.). Or something purporting to be a saint: one presumes that since Mountain Glen's "Vía Santa Vista"—Holy View Road—cannot refer to any actual saint, it serves more to lord its privileged position over the less well-situated streets below.

Indeed, there seems to be something a little un-saintly, and unseemly, about the whole enterprise. Santiago Estates, technically a private mobile home park, was originally granted under a conditional use permit, which was changed a few years ago to a public benefits permit; one may well wonder what benefits the public enjoys on its private property. Far-fancier Mountain Glen objected to the change, possibly because Santiago Estates' modular homes not only obstruct Mountain Glen's otherwise commanding Valley views, but might actually be superior to them. Some members of the Santiago Estates community counter that Mountain Glen spews its runoff water onto their property.

Down below, the Poor Clares sit in contemplative unease, hemmed in by townhomes and SUV's. While KB Homes' bulldozers tore into the four hundred acres around the convent a decade ago, Sister Magdalena Garay reflected on the changes to come.

"We'll still try to maintain some tranquility," she hoped. "We'll still have a view, but it won't be the same."

The beleaguered sister might count her blessings, however: it could be worse. She could be situated among the feuding saints on the hill.

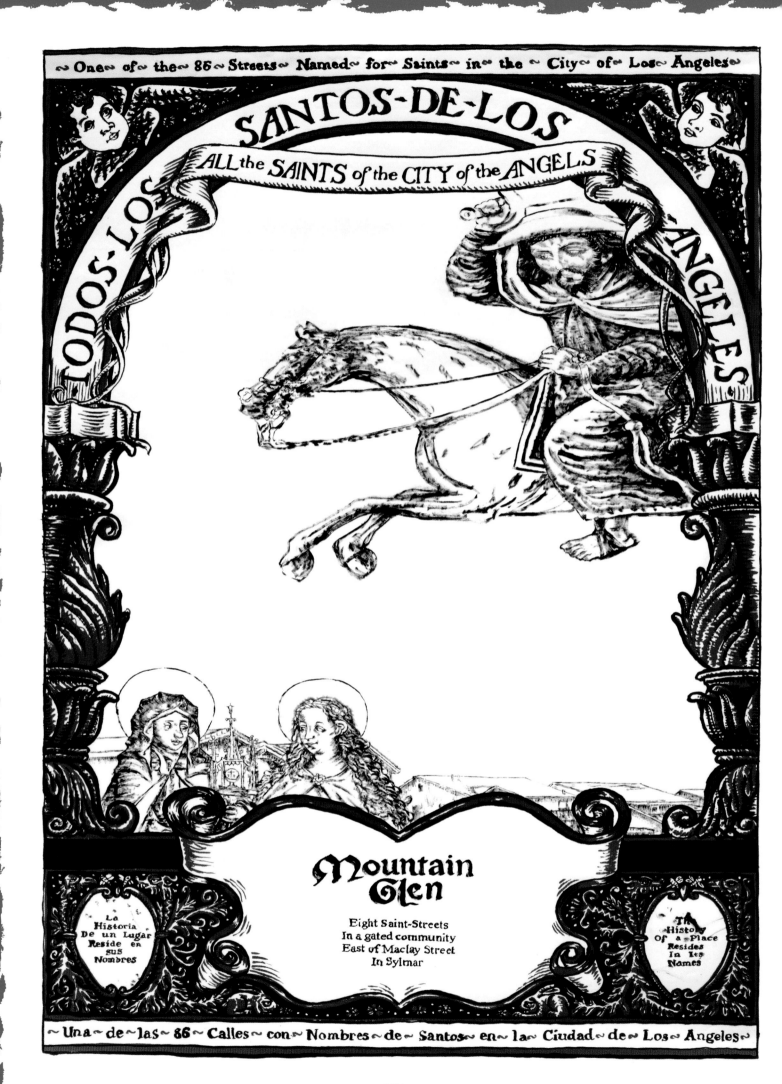

SANTOS·DE·LOS

ALL the SAINTS of the CITY of the ANGELS

TODOS·LOS

ANGELES

Mountain Glen

Eight Saint-Streets
In a gated community
East of Maclay Street
In Sylmar

La Historia De un Lugar Reside en sus Nombres

The History Of a Place Resides In Its Names

SANTOS-DE-LOS

ALL the SAINTS of the CITY of the ANGELS

TODOS-LOS

ANGELES

SLOW
SANTIAGO
BIKE WAY

SUGGESTED
SPEED
9½
FOR YOUR
SAFETY

Santiago Estates

Ten tiny Saint-Streets
Off of Maclay Street
In Sylmar

La
Historia
De un Lugar
Reside en
sus
Nombres

The
History
Of a Place
Resides
In Its
Names

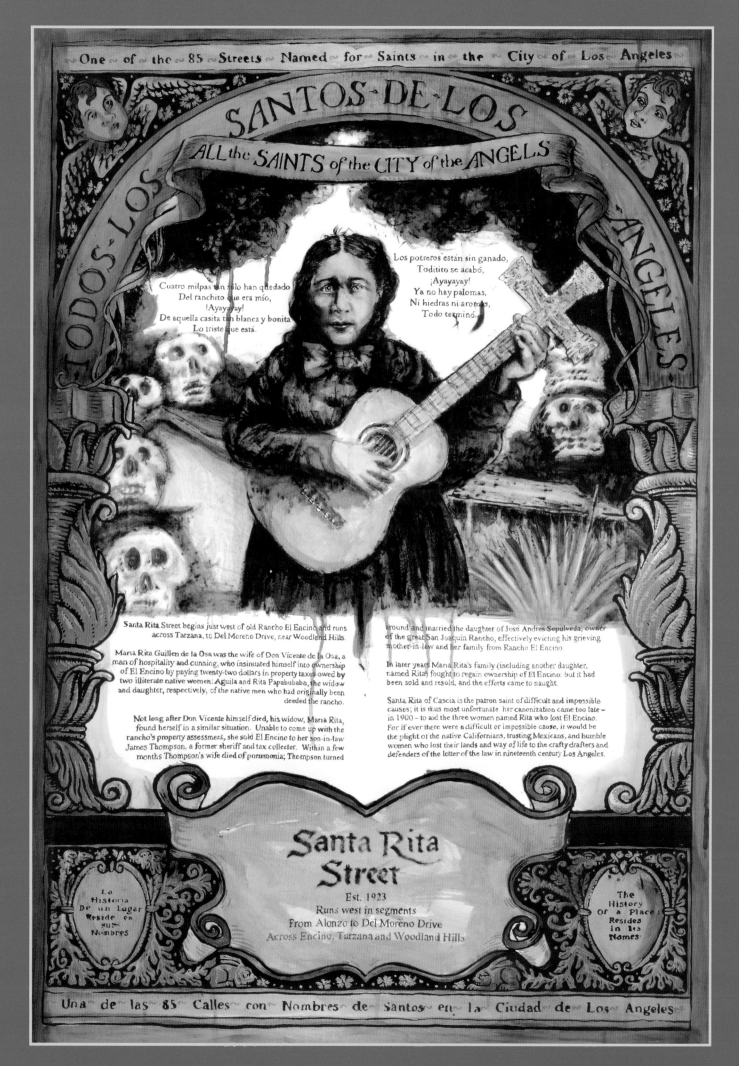

SANTOS · DE · LOS

TODOS · LOS

ANGELES

ALL the SAINTS of the CITY of the ANGELS

Cuatro milpas tan sólo han quedado
Del ranchito que era mío,
¡Ayayayay!
De aquella casita tan blanca y bonita
Lo triste que está.

Los potreros están sin ganado,
Toditito se acabó,
¡Ayayayay!
Ya no hay palomas,
Ni hiedras ni aromas,
Todo terminó.

Santa Rita Street begins just west of old Rancho El Encino and runs across Tarzana, to Del Moreno Drive, near Woodland Hills.

Maria Rita Guillen de la Osa was the wife of Don Vicente de la Osa, a man of hospitality and cunning, who insinuated himself into ownership of El Encino by paying twenty-two dollars in property taxes owed by two illiterate native women: Aguila and Rita Papabubaba, the widow and daughter, respectively, of the native men who had originally been deeded the rancho.

Not long after Don Vicente himself died, his widow, Maria Rita, found herself in a similar situation. Unable to come up with the rancho's property assessment, she sold El Encino to her son-in-law James Thompson, a former sheriff and tax collector. Within a few months Thompson's wife died of pneumonia; Thompson turned

around and married the daughter of José Andrés Sepulveda, owner of the great San Joaquin Rancho, effectively evicting his grieving mother-in-law and her family from Rancho El Encino.

In later years Maria Rita's family (including another daughter, named Rita) fought to regain ownership of El Encino; but it had been sold and resold, and the efforts came to naught.

Santa Rita of Cascia is the patron saint of difficult and impossible causes; it is thus most unfortunate her canonization came too late – in 1900 – to aid the three women named Rita who lost El Encino. For if ever there were a difficult or impossible cause, it would be the plight of the native Californians, trusting Mexicans, and humble women who lost their lands and way of life to the crafty drafters and defenders of the letter of the law in nineteenth century Los Angeles.

Santa Rita Street

Est. 1923
Runs west in segments
From Alonzo to Del Moreno Drive
Across Encino, Tarzana and Woodland Hills

Lo Historia De un Lugar Reside en sus Nombres

The History Of a Place Resides In Its Names

SANTA RITA STREET

Woodland Hills, Encino, and Tarzana

Rita of Cascia endured a most difficult life; and from the time of her death in mid-fifteenth-century Italy, she was venerated for her perseverance in the face of difficult trials. Throughout Colonial Latin America, and particularly in Mexico, *la Beata Rita* (Blessed Rita)—as she was then known—was quite popular, and many girls were baptized with her name.

La Beata Rita was recognized as a saint in 1900. Two decades afterwards, Santa Rita Street, in the San Fernando Valley, was named in her honor. The street begins just west of old Rancho los Encinos and runs across the community of Tarzana to Del Moreno Drive, near Woodland Hills. Both the street's name and the life of its namesake speak to the area's history in the half-century preceding Santa Rita's canonization.

María Rita Guillen de la Osa was the wife of Don Vicente de la Osa, that man of hospitality and cunning whose exploitation of two illiterate native women comprises the following tale.

Aguila and Rita Papabubaba were the widow and daughter, respectively, of one of the native men who had originally been deeded Rancho los Encinos. It is not clear if the women did not realize they had to pay property taxes, if they did not have the cash—or if Don Vicente simply offered to "take care" of the payments for them, without explaining the consequences. In any case, after paying the rancho's assessment three times in six years—a total of just over $120—Vicente de la Osa acquired forty-four hundred acres of prime Valley land.

Not long after Don Vicente himself died, in 1861, his widow, María Rita, found herself in a situation very similar to that of Aguila and Rita Papabubaba. Unable to come up with the rancho's property assessment, she turned to her son-in-law James Thompson, a former sheriff and tax collector, in hopes that he—astute, American, and literate—would know what to do. And on some cold, reptilian level he did: Thompson loaned María Rita the funds she needed in exchange for a lien on the family ranch.

Within a few months, however, both Thompson's wife Manuela and their infant daughters died of pneumonia. While María Rita was mourning the loss of her daughter and twin granddaughters, Thompson sought solace in the embrace of another woman with land on her hands: Francisca Sepulveda, whose father José Andres Sepulveda owned the great San Joaquín Rancho.

Thompson quickly married Francisca and, in an audacious series of strikes at María Rita's breaking heart, foreclosed on his loan to his ex-mother-in-law; sued her in court for $3500; took Rancho los Encinos in lieu of repayment; and evicted his shocked and grieving ex-in-laws from those 4,400 acres of prime Valley land. In later years María Rita's family (including another daughter, named Rita) fought to regain ownership of Rancho los Encinos; but Thompson had sold it within months of his mother-in-law's departure; and it had been subsequently resold; and their efforts came to naught.

Santa Rita of Cascia is the patron saint of difficult and impossible causes. It is thus most unfortunate that her canonization came a few decades too late—in 1900—to aid the three women named Rita who each lost Rancho los Encinos: Rita Papabubaba; María Rita Guillen de la Osa; and María Rita's daughter Rita de la Osa.

For if ever there were a difficult or impossible cause, it would be the plight of the native Californians, trusting Mexicans, and long-suffering women who lost their lands and ways of life to the crafty drafters and defenders of the letter of the law in nineteenth-century Los Angeles.

SAN MIGUEL STREET

Woodland Hills, 1923

We cannot weigh our brother with ourself:
Great men may jest with saints; 'tis wit in them,
But in the less foul profanation.
—The Merchant of Venice

In a tradition dating back to fifth-century Italy, when the bishop of Siponto, in response to a vision, built a church atop Monte Gargano to honor the Archangel Michael, high places have often been named for this celestial saint.

Woodland Hills honors this venerable practice atop one of its no-longer-so-woodland-like hills, where, nestled between Escobedo and Mármol Drives, lies the eastern terminus of San Miguel Street.

Just as the archangel's cult spread from East to West, so San Miguel Street runs haltingly westward, across Canoga Avenue and Topanga Canyon Boulevard to the San Fernando Valley's first elementary school, where it arcs into De la Osa Street for an overdue date with destiny.

Vicente de la Osa, for whom De la Osa Street was named, was born in 1808, and by his mid-twenties had become El Pueblo de los Angeles' equivalent of a city councilman. Within a decade—in 1842, to be precise—he had parlayed his political connections and public service into ownership of one of the Valley's smaller ranchos, La Providencia, the site of present-day Burbank.

All of this would be mere historical trivia and of little concern to us, were it not for the next stage of Don Vicente's upward mobility, at which he craftily insinuated himself into ownership of Rancho los Encinos—forty-four hundred acres of crop fields and grazing lands crowned by a pure spring, a fragment of which survives today as Los Encinos State Historic Park.

Forget the years in city government: it is his ownership of Rancho los Encinos that provides Vicente de la Osa a semi-romantic place in public memory. However, the methods Don Vicente used to attain that ownership beg closer examination.

San Miguel, it is said, decides our eternal fate by weighing our souls on his righteous scales. In the street sign that symmetrically balances the signage for the 22200 blocks of San Miguel and De la Osa Streets, one can indeed sense this exquisite tension, and imagine the saint's golden scales hanging down from this street sign, straining at the ends of their chains.

The eternal fate of José Vicente de los Reyes de la Osa—to give his full name—rests in the balance as we recall the transactions which define his historical place.

In the early 1840s, after the missions were secularized, Vicente de la Osa and two partners purchase Rancho La Providencia. Don Vicente subsequently buys out his partners at approximately the same time as Governor Pío Pico deeds Rancho los Encinos to three native men, named Tiburcio, Ramón, and Francisco. Within a few years Ramón moves up north to be with his family, and the other two men die, leaving behind an illiterate widow and daughter, named respectively Aguila and Rita Papabubaba.

Don Vicente sells his four thousand acres of La Providencia for $1500, pockets the profits, and bides his time, keeping an acquisitive eye on fair, spring-fed Rancho Los Encinos.

When Aguila and Rita Papabubaba find themselves short on cash, Don Vicente offers them financial assistance and grabs a third of their forty-four hundred acres—for $100 —in the process.

He builds a large, attractive adobe home on the property at which all travelers (presumably non-Indian) are welcome to drop in unannounced, in fine Californio tradition, for free lodging, free meals, and the refreshing of horses.

When Aguila and Rita next fall behind on their property taxes, Vicente doles out the $5.48 owed and takes another fifteen hundred of their acres—equivalent to purchasing their land for an extraordinary one-third of a penny an acre.

When the wandering Ramón, one of the original grantees, reappears from his stay up north, Don Vicente explains that the man's land is no longer his, having been purchased from the two native women; and he convinces the poor fellow to sign a release from all rights.

Finally, in 1851, after Aguila Papabubaba passes away, another $15 in property taxes come due. Because the sole surviving daughter, Rita, does not have—or know she needs to pay—the amount, Vicente coughs up the change and takes ownership of all her remaining land.

These three transactions total just over $120 for forty-four hundred acres of prime farmland—spirited away from the native grantees and their families for less than a tenth of the price Don Vicente received for his smaller and less valuable Rancho La Providencia. Don Vicente, however, is known in history books and celebrated at Los Encinos State Historic Park for his graciousness and hospitality.

José Vicente de los Reyes de la Osa was born on January 6th, Epiphany, the Feast of the Three Kings (this is where his middle name, *de los Reyes*, comes from). Perhaps, as patron saints are believed to do, the Three Kings will plead for leniency as St. Michael (San Miguel) weighs Don Vicente's soul on his mighty scales. From the other side may come a call for justice from the three landless native men, Tiburcio, Ramón, and Francisco, and their defrauded families.

If so, in that moment of divine judgment, which side will prevail? Can three Indians, against the tide of history, prevail against three kings?

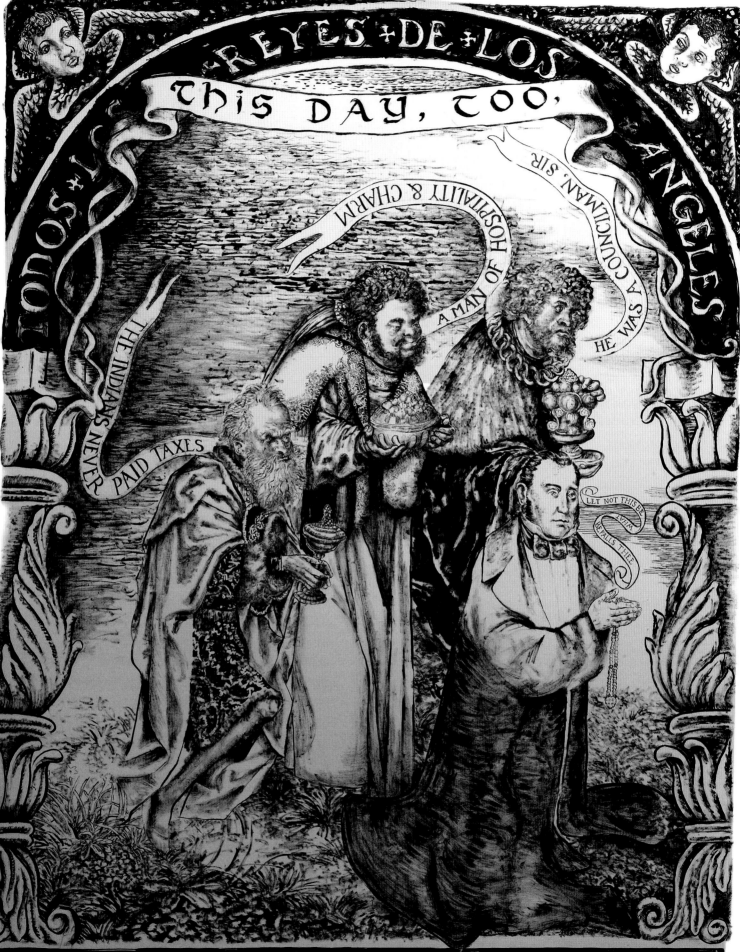

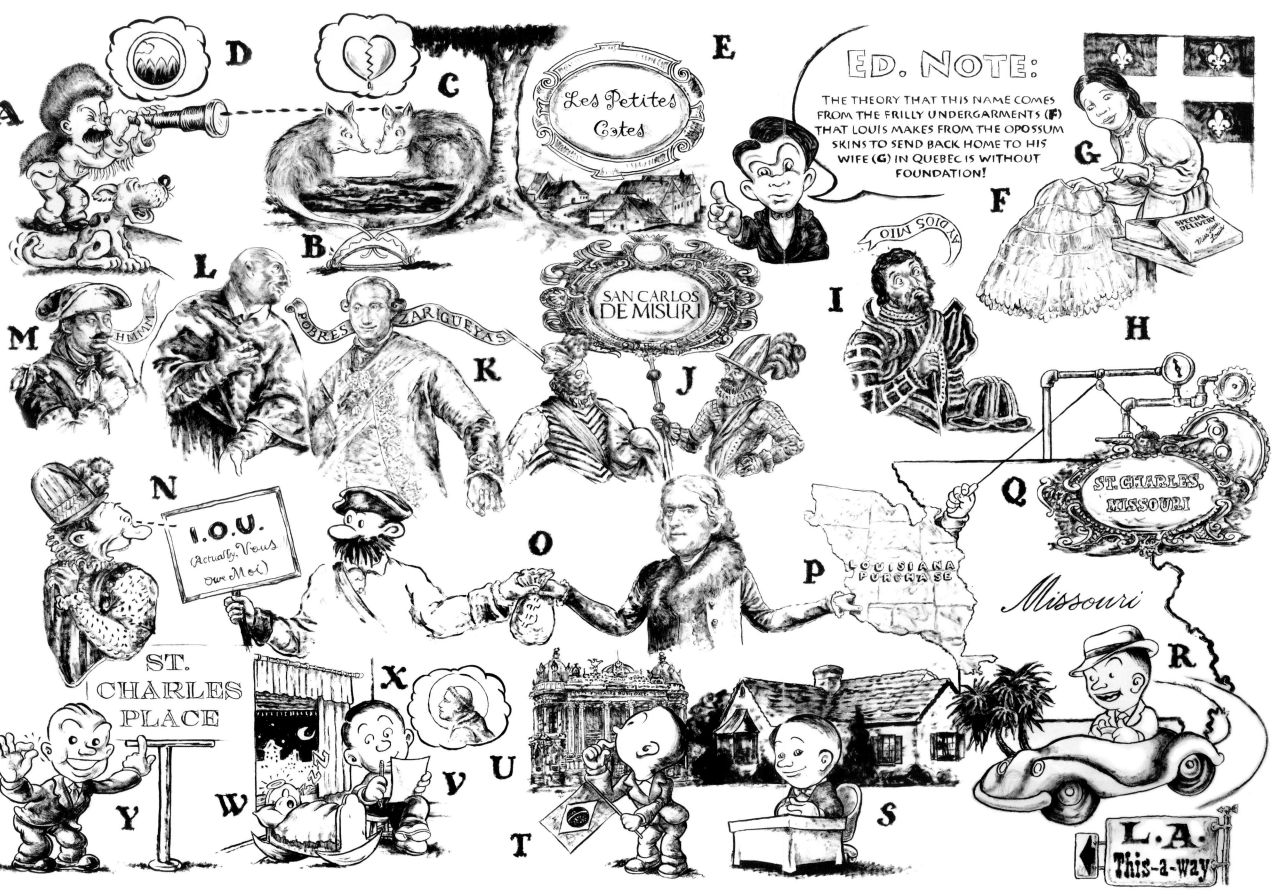

ST. CHARLES PLACE

Lafayette Square

How to Name a Street in Just 150 Years! In 1769 Louis Blanchette (A), out hunting raccoons in the corner of what will one day become the great state of Missouri, sets a trap (B) into which fall two opossums (C) whose little ears he confuses with little hills (D), a name that he gives to his new village, which being French, he calls "Les Petites Cotes" (E).

[Ed. Note: The theory that this name comes from the frilly undergarments (F) that Louis makes from the opossum skins to send back home to his wife (G) in Quebec is without foundation.]

The shocking sight of the petticoats (H) stirs awake the Spaniards (I), who remember that they own the land where Louis has settled, whereupon they change the town sign (J) so it will honor their king, Carlos IV (K), in a roundabout way, by naming the town for his patron saint, San Carlos Borromeo (L).

All this name-calling reminds the French (M) that they used to own the property, so they present the Spaniards with an IOU (N) and take back the land, which they sell to the Americans (O), who present them with a map (P) showing the great state of Louisiana extending quite a bit farther than anyone had anticipated.

The Americans turn the sign around (Q) so that San Carlos de Misuri becomes St. Charles, Missouri.

George Crenshaw (R) grows up in Missouri and comes out to Los Angeles, where he hangs out a shingle in the real estate trade (S), which launches him on a trip to Sao Paulo, Brazil (T), where he sees the Municipal Theatre Opera House (U), whose grand plaza inspires him to build a new housing development, whose grand central street needs a name.

While pondering a name for this street (V), Crenshaw hears the snores of his sleeping son Charles (W), whose angelic demeanor puts Crenshaw in mind of San Carlos (St. Charles) Borromeo (X), and for whom, together with the Missouri city of St. Charles, he names St. Charles Place (Y) in 1919.

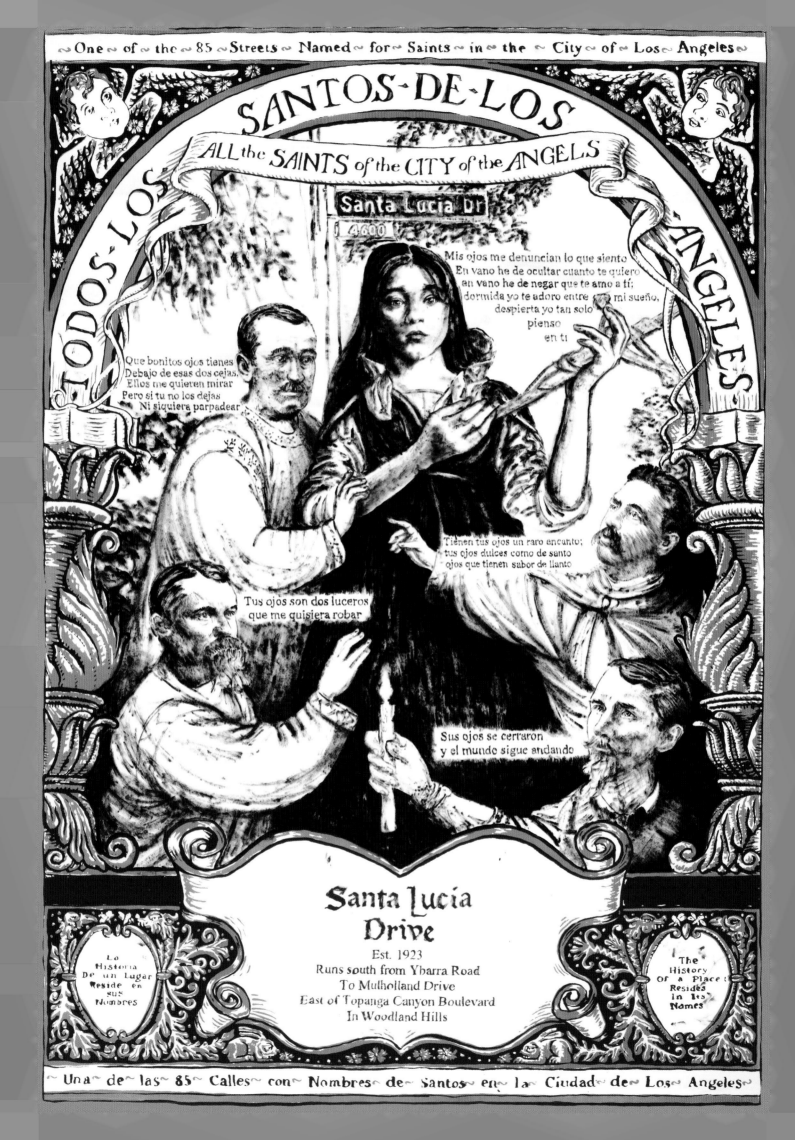

SANTA LUCIA DRIVE

Woodland Hills

...her eyes in heaven
Would through the airy region stream so bright
That birds would sing and think it were not night.
—Romeo and Juliet

"*Tus ojos son dos luceros,*" your eyes are two beacons, a traditional Mexican song flatters, only to add, disquietingly, "*que me quisiera robar,*" which I would like to steal.

From the earliest Holy Roman calendar, there has been a place saved—December 13th—for the lovely young woman who men found irresistible, St. Lucy, Woodland Hills' Santa Lucía. When she died, in the early fourth century, Lucía joined what would become a lamentably long line of similarly put-upon damsels with reflexively fetching features, including Saints Agatha and Agnes.

In Lucía's case, it was her eyes which drew unwanted attention and drove men to distraction and beyond. "*Qué bonitos ojos tienes,*" what lovely eyes you have, begins one of the most enduring Mexican songs, *Malagueña Salerosa*. It continues, "*Ellos me quieren mirar, pero tu no los dejas...ni siquiera parpadear,*" they want to look at me, but you won't let them...so much as blink.

Lucía's interests lay elsewhere, in her devout desire to pursue a spiritual life, a dream she could not conceal. "*Mis ojos me denuncian lo que siento,*" my eyes betray what I feel, begins another song, by the great Mexican composer José Alfredo Jiménez. Singing to God, Lucía might continue, "*Durmida yo te adoro entre mi sueño,*" asleep I adore you in my dreams; "*Despierta yo tan solo pienso en ti,*" awake I think only of you.

Santa Lucía's suitors were not easily rebuffed, and so, as regrettably occurs far too often even now, they killed her. One recounting of the legend permits Lucía at least one final, defiant act: she tears out her *bonitos ojos* and hurls them at her pursuers. Miraculously (for this is a legend), her eyes are restored to her in all their radiance. Indeed, it is her eyes' radiant quality that defines Santa Lucía, for it was her name's resemblance to the Latin word for light, *lux,* which doubtless inspired the tales.

In the end the young woman who became Santa Lucía attained immortality not so much for what she sought to do, as for how she was perceived by others and how she responded. The light in her eyes glowed from within, but it was a light tinged, no doubt, with sadness.

Because Santa Lucía Drive—like all of Woodland Hills—was once part of Mexico, we give Guty Cárdenas, another composer of Mexican traditional song, the final words: "*Tienen tus ojos un raro encanto,*" your eyes possess a rare enchantment; "*tus ojos dulces como de santo,*" your eyes as sweet as a saint's; "*ojos que tienen sabor de llanto,*" eyes the flavor of tears.

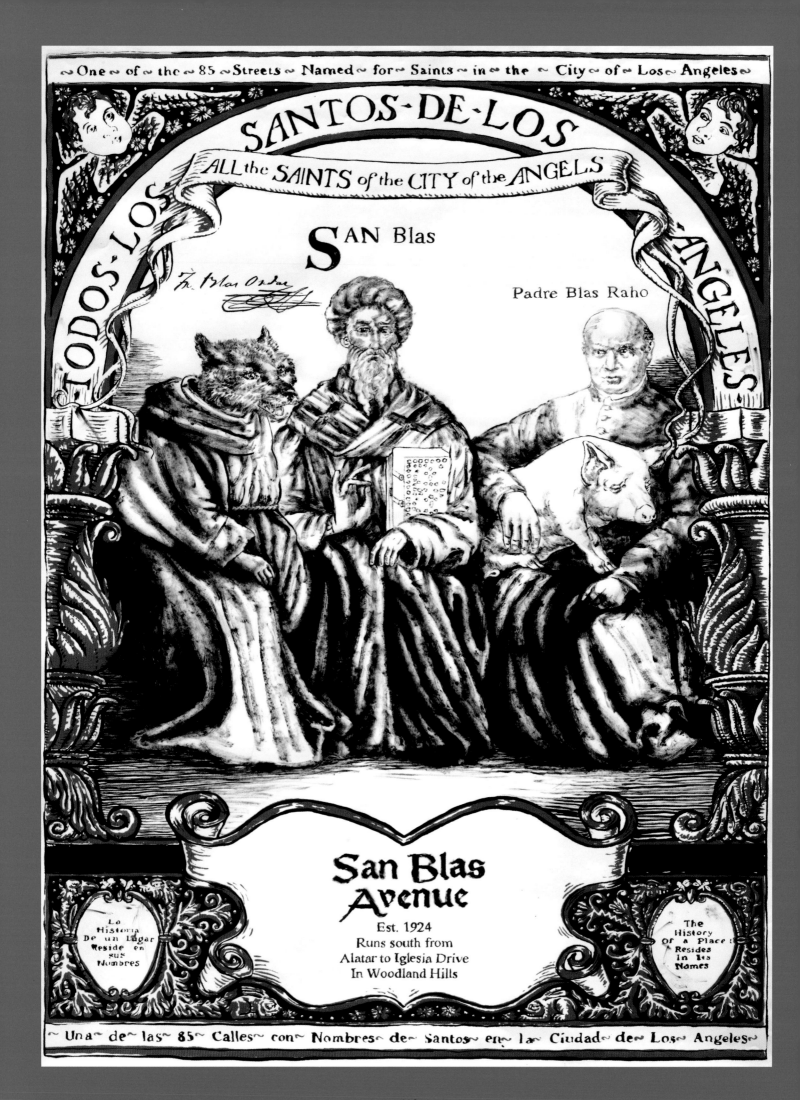

SANTOS·DE·LOS

TODOS·LOS

ANGELES

ALL the SAINTS of the CITY of the ANGELS

San Blas

Padre Blas Raho

San Blas
Avenue

Est. 1924
Runs south from
Alatar to Iglesia Drive
In Woodland Hills

La
Historia
De un Lugar
Reside en
sus
Nombres

The
History
Of a Place
Resides
In Its
Nomes

SAN BLAS AVENUE

Woodland Hills

Those lion-souled, eagle-eyed Padres of Spain,
Who lorded it grandly o'er mountain and plain;
As ready with fair Señorita to dance
As grant absolution, or balance a lance.
—*Albert Fenner Kercheval*, The Padres of Old

Along a ridge in southern Woodland Hills, San Blas Avenue intersects Iglesia Drive: here good St. Blaise, priest and physician, meets his Church.

Once, the hill itself was named for the saint, San Blas Hill. Given the saint's sensitivity toward nature (living in a cave, caring for wild animals), this is understandable. Photos of long ago portray vistas of sage, poplar, and alder. Even twenty-five years ago the land seemed open and relatively free. So much has encroached upon the saint's old stomping grounds, however, that his martyrdom seemed inevitable.

As it happens, the San Fernando Valley was served by two priests who, like this avenue, were named for San Blas.

Reverend Blas Raho, "a genial, broad-minded Italian," came to Our Lady of Angels Church, in El Pueblo, in 1856. As rector, he made numerous excursions into the Valley to visit parishioners and attend events. Although he served only six years, until his death in 1862, he strove to be inclusive, working and socializing with peoples of diverse faiths and backgrounds at a time when both El Pueblo and organized religion were becoming increasingly xenophobic. By contrast, Fr. Blas Ordaz may have possessed too liberal a concept of "socializing" with peoples. Even before his service in the Valley, at San Fernando Mission in 1837, there were veiled rumors of his proclivity for indiscretion with local women, which apparently continued after he moved to neighboring San Gabriel Mission in 1847, and up until his death there three years later.

Upon Fr. Ordaz's passing, these reports became more widespread. An easterner, enjoying a grand tour of Southern California, chanced to visit San Gabriel Mission the day of the friar's funeral and was shocked to learn that the young lady organizing the event was none other than the priest's own daughter. Letters and diary entries by fellow religious indicate tacit knowledge of these relations. Remarkably, they also point to the existence of several children by at least one mother, in addition to the young woman in charge of her father's funeral.

Indeed, in the baptismal records at Fray Ordaz's earlier post, Mission Santa Ynez, there are recorded two "legitimate children" born to a certain María Soledad and an "unknown father"—a probable invention by the philandering friar to offer some modest social protection to his otherwise unacknowledged offspring.

One of the more colorful legends of San Blas concerns an elderly widow who has lost her only pig to a wolf. San Blas comforts the distraught widow, reassuring her that the precious pig shall be restored. He calls out to the wolf, who shuffles forward, head bowed, tail between its legs. At the good saint's command, the wolf coughs up the badly shaken pig, which leaps, whole and squealing, into the open arms of the joyful widow.

It is tempting to imagine San Blas intervening in the affairs of Fray Blas Ordaz in similar fashion, to restore the good names of both the Church and the women with whom the licentious priest dallied. And should San Blas deign to restore the poor pig as well, clearly it should go to Father Raho, who, broad-minded as he was, would be by far the more trustworthy guardian.

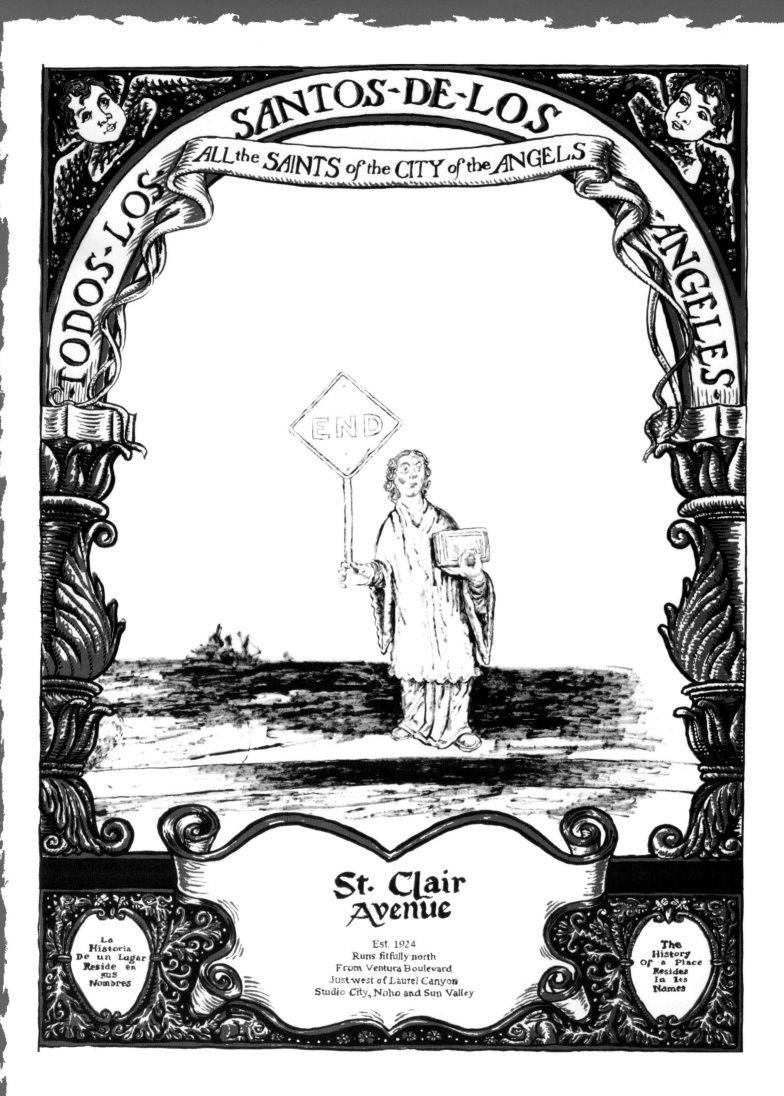

SANTOS-DE-LOS

TODOS-LOS

ANGELES

ALL the SAINTS of the CITY of the ANGELS

END

St. Clair
Avenue

La
Historia
De un Lugar
Reside en
sus
Nombres

Est. 1924
Runs fitfully north
From Ventura Boulevard
Just west of Laurel Canyon
Studio City, Noho and Sun Valley

The
History
Of a Place
Resides
In Its
Names

ST. CLAIR AVENUE

From Studio City north to Sun Valley

St. Clair is a slippery saint, darting in and out of view along one side or the other of the 101 and 170 freeways. He appears and reappears eight times in a mere six miles, searching for the simple life; trying to settle down and experience a hermit's quiet solitude.

Perhaps he appears so scattered because there are so many conflicting stories of just who he is. One English St. Clair moved to France, where he was murdered on New Year's Day. Another St. Clair, this one French by birth, served as the spiritual advisor for his widowed mother's convent. A third St. Clair came from Africa, founded the archdiocese of Albi, and was beheaded in the heartland of *foie gras* production.

What can we actually know about St. Clair?

He may be the patron saint of tailors, but then again, maybe not. Perhaps this is why there are clothing stores near, but not actually on, his street.

He might guard against myopia and nearsightedness, but then again, maybe not—which may explain why there are three optometrist clinics a block from, but never actually on, his street.

He may be the St. Clair who refused the overtures of a lovely woman who "used all her feminine charms to try to seduce the young man." But then again, maybe not—although the presence of the Gentlemen's V.I.P. Nude Club just around the corner from his street does give one pause.

In the end, it may well be that the reason St. Clair of the Valley is so hard to pin down, so hard to identify—so much the opposite of his name, which, of course, means "clear"—is that he ardently desires his hermit's solitude. Clearly, he doesn't wish to be seen. He lives happily with dead ends.

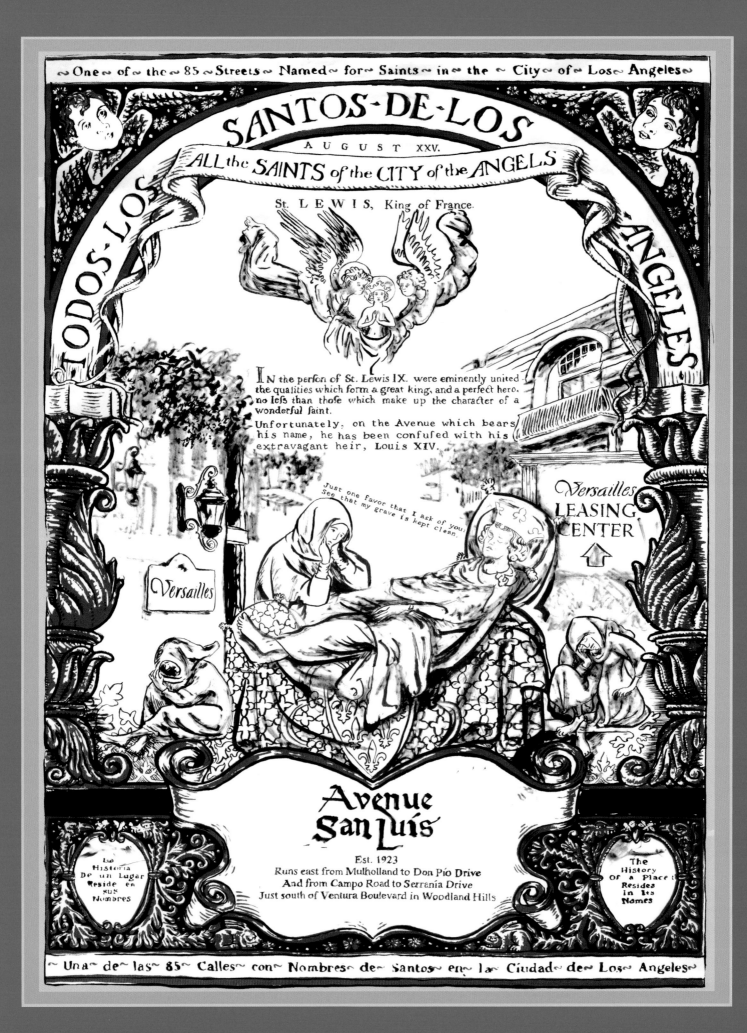

St. LEWIS, King of France.

AVENUE SAN LUIS

Woodland Hills

The connection is hard to make, given the present state of things. You need to erase walls and cut down the traffic considerably to permit thought. But the connection remains, and feels right: Avenue San Luis runs alongside El Camino Real.

San Luis is San Luis Rey de Francia, St. Lewis, or Louis IX, King of France, from the thirteenth century. His mother was Blanche of Castille, sister to the thirteenth-century Spanish King Ferdinand, the saint known to us as San Fernando Rey, whose name was bestowed upon Mission San Fernando and, consequently, the entire San Fernando Valley.

San Luis Rey was an able and fair ruler of his day, much concerned with matters of the spirit. He took his religion to heart and is depicted in art feeding the poor, tending the sick—even lepers—and burying the dead.

El Camino Real is the Royal Road, or King's Highway, established in 1769 when the first Spaniards strode north from Baja to establish a chain of missions along the coast. They traveled through this valley on the Portolá Expedition, pausing to meet the natives who lived here. Thirty years later, Misión San Fernando Rey was christened at the Valley's northern reach.

San Luis was a member of the Third Order of Francis, a Franciscan lay order, and led two crusades: one to Egypt, which resulted in his imprisonment; and a second, to Tunis, which cost him his life. The priests of the California missions along El Camino Real were all Franciscans, and thought of their labors here as a crusade as well. While none of them came to be imprisoned, and few were killed for their efforts, there is here, too, a sense of failure.

El Camino Real was paved over decades ago. Because engineers favor straighter causeways than those used by pilgrims and horsemen, Ventura Boulevard does not precisely mimic El Camino's path; rather, they dance around one another, as though El Camino's grace refuses to submit fully to the Boulevard's order. The later, roughly parallel Ventura Freeway races broad and powerful over a wider swath of El Camino's fragile trail.

Avenue San Luis abuts hard against this freeway's wall, too close in places for so much as a passable sidewalk. Across the street, at its western terminus, stands the improbable Versailles Condominium, a gray and beige overwrought block of stucco and wrought iron balconies.

El Camino Real lies all but trampled by impatient motorists and asphalt; while good king San Luis lies uneasily in his crusader's grave—saddened, no doubt, to see himself confused in Woodland Hills with his extravagant successor, Louis XIV.

SANTOS·DE·LOS

ALL the SAINTS of the CITY of the ANGELS

ROMULUS OF GENOA, BISHOP

Died at Matuziano (later called San Remo), Italy, after 641.
Saint Romulus was bishop of Genoa,
but nothing else is known with certainty about him.

SAN REMO WAY

Tarzana

There's a saint in Tarzana who cannot be seen. Just east of Reseda Boulevard, nestled between the Braemar and El Caballero Country Clubs, safely ensconced behind the massive iron gates of the private Silver Hawk Ridge community, hides San Remo Way.

What could be more appropriate?

In the early 1990s, when Silver Hawk's developer was seeking identities for his new streets, the thought occurred to select names of European resorts. One of these is San Remo, along the Italian Riviera, renowned for its casinos, flowers, music, and blue waters.

In an earlier age, the town of San Remo was known as Matuzia—apparently for Matuta, the goddess of dawn and those blue Riviera waters. In the seventh century, however, there lived a saintly bishop named Romulus, in the city of Genoa, some eighty miles northeast of Matuzia. And at some point in the Middle Ages, Matuzia's name was changed to that of St. Romulus, as San Remo. In turn, a decade ago, the name of San Remo was likewise bestowed upon our hidden street in Tarzana.

It is interesting to note that San Remo in Italy lies within the province of Porto Maurizio; while San Remo in Tarzana lies behind the gate of St. Moritz Drive. Both Maurizio and Moritz derive from the same root, and refer to St. Maurice, a third-century martyr. Porto Maurizio means the Port of St. Maurice; and the gate of St. Maurice, in Italian, would be Porta Maurizia. Either way, both are protected by the martyred saint.

There is another reason it is appropriate that San Remo Way lies protected behind St. Moritz's gates. For those of us on the outside, on Reseda Boulevard, nothing certain can be known about San Remo Way. And for those of us researching the street's namesake, nothing certain can be known about St. Romulus, or San Remo.

The hidden saint, on the hidden street.

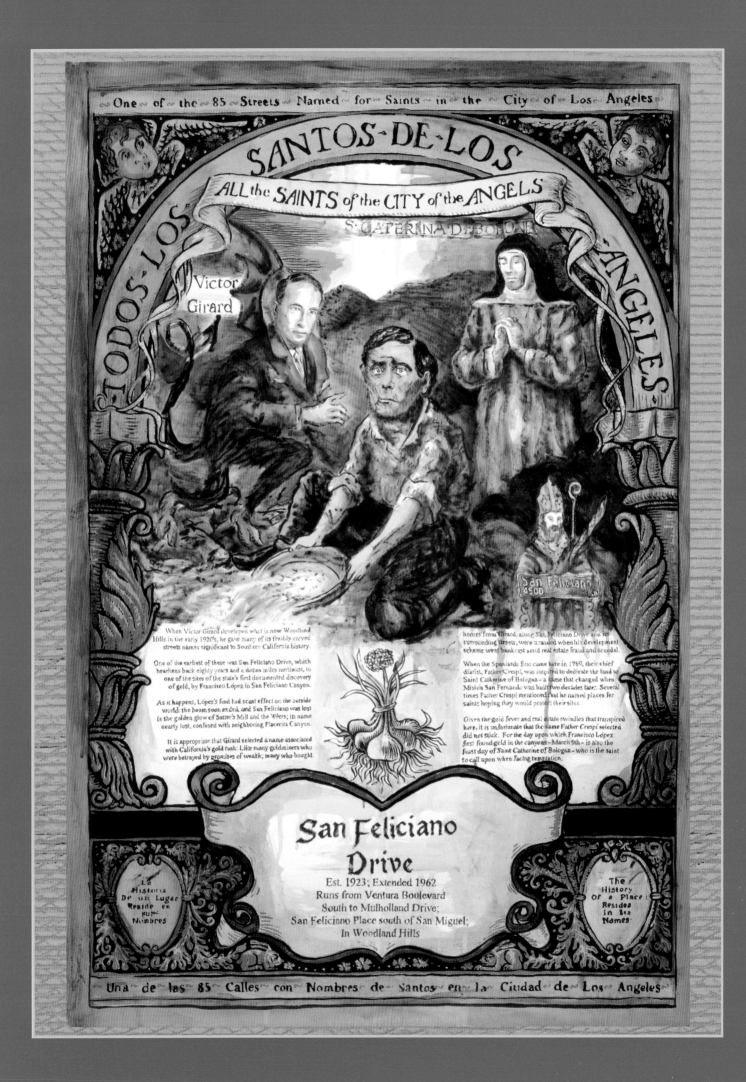

SAN FELICIANO DRIVE

Woodland Hills

When Victor Girard developed the southwestern corner of the San Fernando Valley in the early 1920s—the area that would become Woodland Hills—he christened many of its freshly carved streets with names significant to Southern California history: Crespí, Del Valle, De la Osa, and so forth.

San Feliciano Drive is one such street. Created in 1923, it recalls the site where the state's first documented discovery of gold occurred, eighty years earlier and a dozen miles northeast, in San Feliciano Canyon.

In March 1842 Francisco López, *mayordomo* of Ex-Mission San Fernando, found gold in San Feliciano Canyon while digging wild onions. Soon thereafter, dozens of miners—Sonoran, Native Californian, and transplanted American—were working sites nearby, improvising techniques to winnow the gold from the dry canyon dust.

As it happens, López' strike had scant effect on the outside world, and San Feliciano was soon lost in the golden glare of Sutter's Mill and the forty-niners. Even the canyon's name was nearly lost, becoming confused with neighboring Placerita Canyon, named for the placer gold which was found there around the same time.

It is appropriate, however, that Victor Girard should select a name associated with the quest for gold in California—that great flash in the pan, so to speak—for one of the streets in his new community. Just as many gold miners were betrayed by promises of great wealth, and after investing in equipment, supplies, and travel, found themselves unable to meet their debts, so, too, did many of those who bought into Girard's dream, purchasing land along San Feliciano Drive and surrounding streets, find themselves stranded when his development scheme went bankrupt amid real estate fraud and scandal.

It is reported that when gold fever reigned at San Feliciano Canyon, rumors of hoarded gold led avaricious souls to dig up the earthen floor of the San Fernando Mission in a misguided search for wealth. During Girard's reign, a similar greed led his real estate salesmen to sell and then resell the same plots of land to different homebuyers a dozen times or more.

When the Spaniards first came through the San Fernando Valley, in 1769, their chief diarist, Father Juan Crespí, was inspired to dedicate the landscape to St. Catherine of Bologna—a name which changed when Mission San Fernando was built two decades later. Several times in his diary, Father Crespí mentions that he would bestow upon locales the names of certain saints in the hope that they would protect their given sites.

Given all that transpired in the Valley—the gold fever, the real estate swindles—it is unfortunate, then, that the name selected by Father Crespí did not stick. For the day that Francisco López first found gold in the canyons—March 9th—is the feast day of St. Catherine of Bologna—the saint to be called upon when facing great temptation.

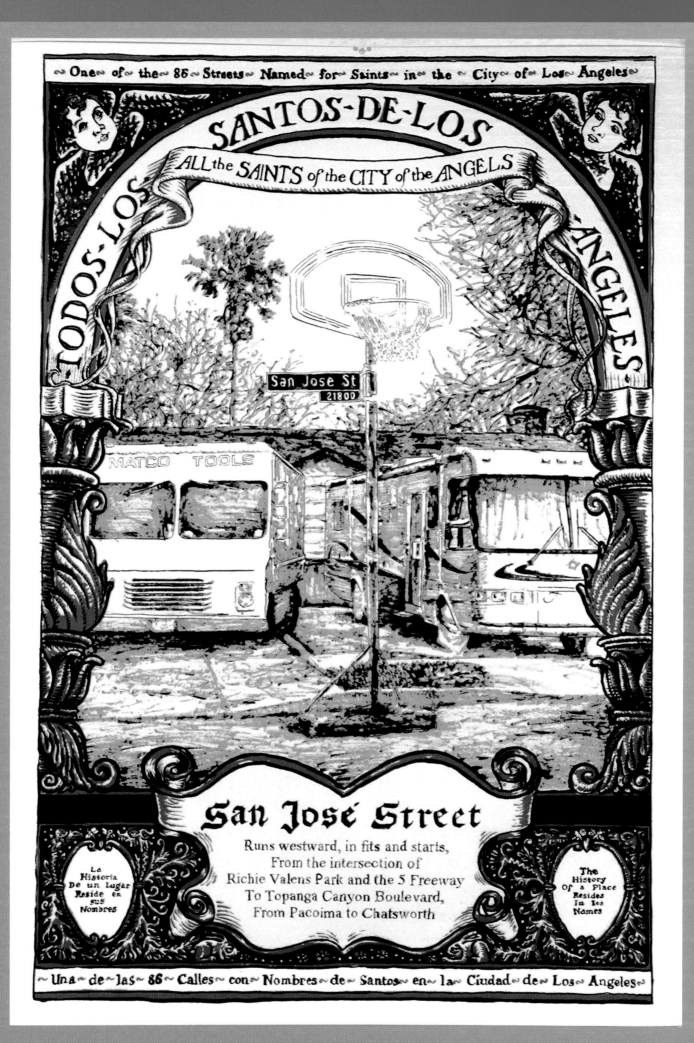

TODOS LOS

SANTOS DE LOS

ANGELES

ALL the SAINTS of the CITY of the ANGELS

San Jose St
21800

MATCO TOOLS

La Historia De un Lugar Reside en sus Nombres

San José Street

Runs westward, in fits and starts,
From the intersection of
Richie Valens Park and the 5 Freeway
To Topanga Canyon Boulevard,
From Pacoima to Chatsworth

The History Of a Place Resides In Its Names

SAN JOSE STREET

From Chatsworth to Pacoima

San José may have descended from the royal House of David, but he carries on a contented life among Chatsworth's middle classes.

He disappeared from the biblical narrative somewhere around chapter three, but on weekends you'll find him playing fútbol or grilling carne asada at his street's eastern border, in Ritchie Valens Park.

He is a true family man, whose driveways creak under the weight of giant RV's (the next flight into Egypt will be far more commodious).

He dotes on his athletic offspring: every other front yard boasts a basketball net and backboard.

San José's carports display his tools like well-worn libraries. His construction and tool trucks face the street, hallmarks of a careful craftsman.

Endowed with a humble dignity and acceptance of hardship, he presents the face of the hardworking dad, dutiful in his work, eager to be with the family on weekends.

Let the Child bask in all the attention; San José is content to take the side street and just watch.

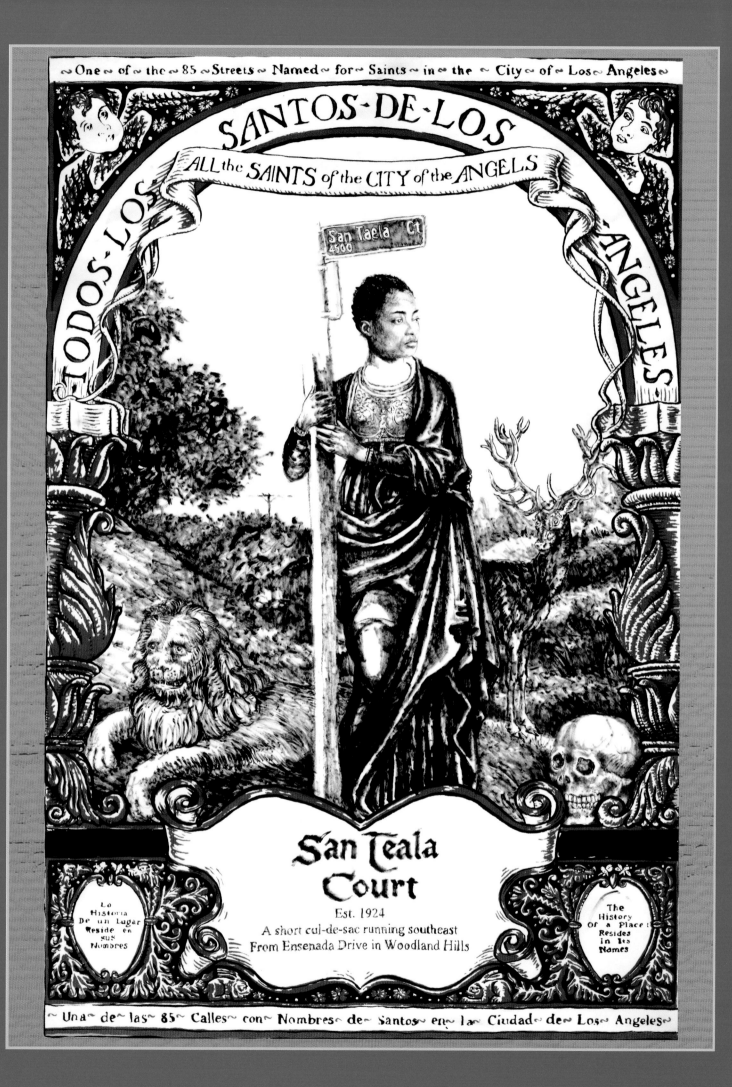

SANTOS · DE · LOS

TODOS · LOS

ANGELES

ALL the SAINTS of the CITY of the ANGELS

San Taela Ct
4500

San Teala Court

Est. 1924

A short cul-de-sac running southeast
From Ensenada Drive in Woodland Hills

La
Historia
De un Lugar
Reside en
sus
Nombres

The
History
Of a Place
Resides
In Its
Names

SAN TEALA COURT

Woodland Hills

On a hillside overlooking the Woodland Hills Country Club lies a small but perplexing mystery.

When Victor Girard laid out the plans for his eponymous city of dreams, Girard—that far-flung metropolis which slowly evolved into Woodland Hills—he gave seven of his streets the names of saints. San Miguel, Santa Lucía, San Blas: these and the other saints are readily identifiable and generally well known.

Save one. A short cul-de-sac just downhill from San Blas Avenue affords no such resolution: San Teala Court is obstinately anonymous. Or is it Taela? Street maps, street signs, and city records alternate the spellings, as if to compound the puzzle.

Yet, in either case, no such saint exists.

If neither St. Teala nor St. Taela exist, one wonders, could there have been an error in the transcription? Could a letter, or various letters, have been transposed or fallen out of place?

Could Teala, then, be Tecla, a woman from the turn of the second century? St. Tecla (or better, Thecla) was condemned to be burned; but a most timely rainstorm put an end to the flames. She briefly escaped, only to be thrown to the lions—who reverently bounded forth and sweetly licked her feet. She dressed as a boy for a time, and went to live out her life in a cave. When she finally passed away, decades later, her body was miraculously transported to Rome. Her refusal to submit to expectations, or to even be pinned down in one place after she died, evokes this little street's obstinance.

But St. Tecla, being a woman, would in Spanish be Santa Tecla; San Tecla just would not do.

Could St. Teala, then, be St. Tilo, the early Welsh saint who trained a stag to carry his firewood, and tied a dragon to a rock? The well where he died is reputed to proffer healing waters—but only when they are drunk from the venerable saint's skull. It may be just as well, actually, that the saint's skull has in recent years disappeared. That disappearance mirrors the absence of an explanation for this street's name.

But St. Tilo, being a man, would in Spanish be San Tilo; San Tila, or San Teala, just would not do.

Could San Taela perhaps be Santaela, or Santaella, the town

in Spain whose name comes from one of two different St. Eulalias, who both died in Spain in the same year of the early fourth century? The fact that they are often, understandably, confused makes them an appropriate possibility for our confusing dilemma. But some authors contend that the town Santaella's name comes not from a saint at all, but from a plant, senticella, the Moorish term for thornbush. Given the thorny tenacity of our problem, this, too, appeals.

Or could San Taela be Santa Ela; and might Ela be an abbreviation for Elena (as Ma. can abbreviate María)? Santa Elena (or better, Helena) was Constantine's mother, a pious woman with a penchant for organizing and an eye for buried treasure. In the fourth century she bustled about the Holy Land, uncovering relics which had lain unnoticed for three hundred years. The cross where Christ died; the nails which had secured him; the notice that hung above his head; the crown of thorns that rung his brow: all these freely presented themselves to her, as if awaiting her arrival.

Let us then, finally, leave this mystery in Santa Elena's hands. For, if an answer to the mystery of San Teala Court exists, it is most likely she will uncover it.

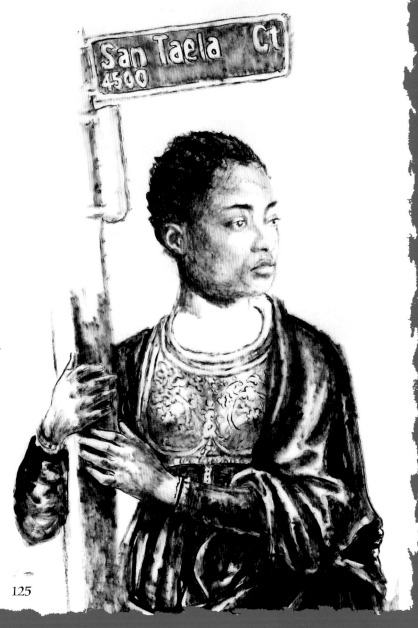

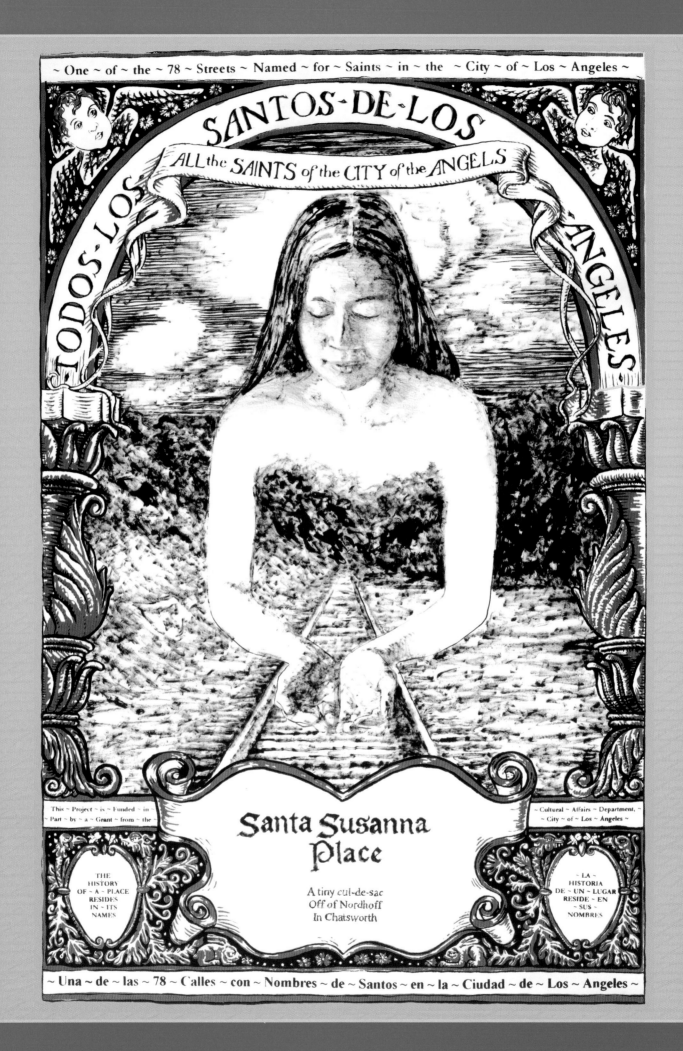

~ One ~ of ~ the ~ 78 ~ Streets ~ Named ~ for ~ Saints ~ in ~ the ~ City ~ of ~ Los ~ Angeles ~

SANTOS · DE · LOS

TODOS · LOS ·

ANGELES

ALL the SAINTS of the CITY of the ANGELS

This ~ Project ~ is ~ Funded ~ in ~ Part ~ by ~ a ~ Grant ~ from ~ the ~

~ Cultural ~ Affairs ~ Department, ~ City ~ of ~ Los ~ Angeles ~

Santa Susanna Place

A tiny cul-de-sac
Off of Nordhoff
In Chatsworth

THE HISTORY OF ~ A ~ PLACE RESIDES IN ~ ITS NAMES

~ LA ~ HISTORIA DE ~ UN ~ LUGAR RESIDE ~ EN ~ SUS ~ NOMBRES

~ Una ~ de ~ las ~ 78 ~ Calles ~ con ~ Nombres ~ de ~ Santos ~ en ~ la ~ Ciudad ~ de ~ Los ~ Angeles ~

SANTA SUSANNA PLACE

Between Canoga Park and Chatsworth

Just east of Topanga Canyon Boulevard, between Roscoe and Nordhoff, lies a tiny finger of a street: Santa Susanna Place, just three front yards long.

A few blocks to the east the incarcerated Santa Susana Wash—behind bars and ten feet deep in concrete—empties into the Browns Canyon Wash, in a journey to join the Los Angeles River's southeastern struggle to the sea.

A scant mile to the west lies the southern lip of Chatsworth Reservoir, a thirteen-hundred-acre open space that, despite its name, no longer holds water, thanks to the 1971 earthquake. It offers, instead, sanctuary to an abundance of wildlife and flora, and provides a home to great white and live oak trees that predate the Spaniards' first passage through here.

A mile to the north of Santa Susanna Place, the tracks of the Southern Pacific Railroad arc gracefully south-southeast towards Los Angeles after negotiating the intricacies of their pass through the Santa Susana Mountains and the longest tunnel on the West Coast.

History surrounds Santa Susanna, but she declines the chance to act, offers a polite "no" when invited to speak.

With grace and reserve she demurs and offers her Place to other martyrs; to others who fell in the Santa Susanas to the north—for whom she is named—and in the mountains to the east that join them.

Here we quietly, respectfully honor and recall the Chinese workers who built our railroads and carved our tunnels; who worked twice the hours for half the wage; who were called upon when needed, and outlawed when not; who were complimented for their work and caricatured for their traits; who gave their lives in the tunnels even as their names were lost to history.

Like Santa Susanna of old, you are anonymous and admired. And here, however small the gesture, you are mourned.

ST. ESTABAN STREET

Tujunga

St. Estaban lies hidden, snaking south of Foothill Boulevard, nestled in a cheery glen of great oaks and shade-gifting willow.

It's the kind of place where you want to settle down and raise a barefoot family: there's already a tree house; there's probably a rubber tire swing somewhere; and one can easily imagine the asphalt giving way to cool fluffy dirt and sumptuous squishy mud.

The houses are tucked in all askew and cozy along the curves, almost like someone asked, "Room for one more?" and the neighbors obligingly responded, "Sure, come on in," making do 'til the next homesick visitor pops by.

From the looks of it, nothing's up to code and everything's picture-perfect: all it lacks are a few dogs sleeping in the road and maybe a loose chicken or two.

How, though, do we square it all with the facts? I mean, does it matter that there is no St. Estaban? Could everyone—city engineers, mapmakers, sign printers, realtors, and residents—have gotten it all wrong? Did everyone misspell "Esteban" (Steven)? Or is the name just a Spanish play on words for the way things were (*estaban*, meaning "they were"), but no longer are?

Is it really possible—*how sad!*—that the friendliest street-saint in Los Angeles might not actually exist?

On St. Estaban Street they just shrug their shoulders, smile, and say, "I don't know, but would you like some lemonade?"—insisting with childlike assurance, faith, and determination on their very own communal happy ending.

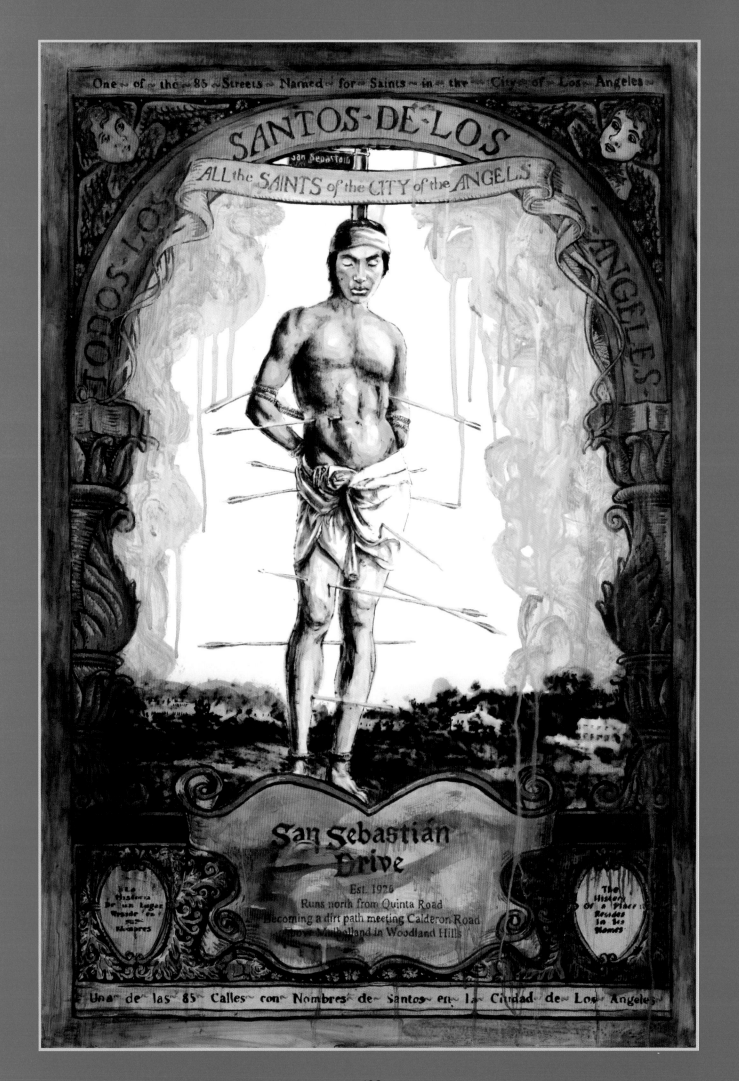

SAN SEBASTIAN DRIVE

Woodland Hills

One does not stumble upon San Sebastián Drive by accident, unless one is really lost. Rather, one drives first along the relatively quiet unmarked side street that parallels the eastern stretch of Mulholland Drive in the Valley, where cars race along between Topanga Canyon and the Ventura Freeway.

A north turn onto Margarita sweeps one gently eastward, to the beginnings of Quinta Road's snaking uphill climb, past overgrown houses. As the road straightens its ascent, San Sebastián Drive, its street sign exchanging the final "i" and "a" to form "San Sebastain," branches off due north.

A slight turn leads to San Sebastián's handful of homes, isolated and enclosed, their facades inviting no entry. The Drive itself exudes this same feeling: cold and closed in, a dead-end street. In the manner of many urban cul-de-sacs, the empty public space invites outsiders' castoffs. Fragments of computers, yards of cassette tape, even an abandoned Volkswagen litter the asphalt.

Walking uphill to the Drive's dead end, past the forlorn car and acacia trees, one discovers, unpredictably, that the asphalt turns into a concrete walkway between two of the houses. A walkway? To where?

As one passes between the silent homes, an unexpected vista opens up. Behind these last two houses—which begin to seem more like movie props—the concrete ends, followed by a dirt path.

The dirt path curves up and along a dirt hill: there are bushes, plants, some rocks, and less debris than one might expect. One has arrived at the exposed heart of Woodland Hills.

This narrow ridge of raw umber is exhilaratingly house-less, intoxicatingly natural after the lock-step march of development leading to this site.

Looking up and out from this earth toward the greater landscape, one is startled once more. All around, as far as the eye can see, winding in a giant arc from east to west, stands a great wall of mansions of apparently recent vintage, and resembling nothing so much as oversized condominiums. Along this circle of hills, first settled in an orderly fashion in the early 1920s, nothing looks older than twenty years—save the trees, which seem small and overshadowed by the overlarge houses, and this unclaimed ridge.

The effect is incongruous, a sliver of nature encircled by "Progress," until one remembers: this is Tongva land.

San Sebastián Drive is named for St. Sebastian, a legendary martyr who died seventeen hundred years ago. The story tells of Sebastian's rise through the ranks of the Imperial Roman guard, where he was well placed to offer quiet, and decidedly unofficial, aid to those persecuted for their faith. Discovered, he was sentenced to death and taken to a hillside, where he was tied to a stake and shot full of arrows, a martyr to his beliefs. Since the early Renaissance it is this climactic moment that has formed Sebastian's formal portrait.

Before the coming of presidios and missions, the Tongva roamed far and settled wide across the Los Angeles basin: perhaps ten thousand natives spread across some thirty sites. But the arrival of Europeans in the late eighteenth and early nineteenth centuries introduced a tragic litany of disruption: forced abandonment of traditional villages; coerced employment by soldiers, settlers, and priests; radical changes to diet and habits; and the stealthy intrusion of infectious disease.

Infant mortality soared as high as 50 percent; and among those tethered to the various missions, it was rare to survive longer than a dozen years after first entering the mission's gates. What land was not outright stolen from the natives was radically altered by invading herds of cattle and sheep gnawing away at the indigenous flora; and the Tongvas' freedom to continue any of their traditional ways of life—traditions particular to their place, nurtured across millennia—was systematically erased.

These intrusions struck at the heart of Tongva identity and contributed to a harrowing decline of their population within fifty years.

Although he is immortalized in art as tied to the archers' stake, St. Sebastian's life did not end with the marksmen's arrows. Left for dead and so heavily wounded and pierced that, *The Golden Legend* assures us, "he looked like a porcupine," he was taken in by a woman elder who nursed him back to health, so he could continue to defend his faith.

Nor have the Tongva died out, despite the enormous insensitivity, cupidity, cruelty, and arrogance of their invaders. Like St. Sebastian, the Tongva suffered great violence. Left, finally, to fend for themselves, they have relied upon their surviving elders to nurse them back to communal health, as they continue to struggle for the survival and prosperity of their way of life.

San Sebastián Drive, this earthen trail along this narrow ridge, encircled as it is by the picture-window gaze of countless overbuilt homes, quietly defies expectation. Austere and umber, it is not a place of obvious beauty: that lies within, like a silent seed, containing the promise—of San Sebastián, of the Tongva—of *renaissance.*

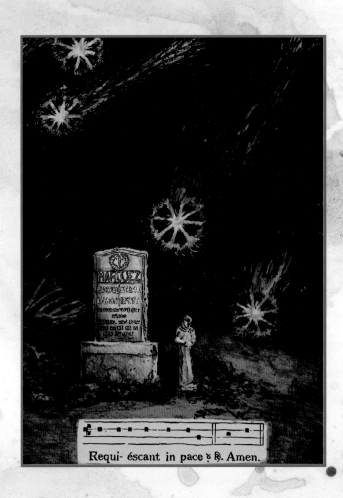

Requi- éscant in pace ℟. Amen.

SEVEN:

The Old Saints

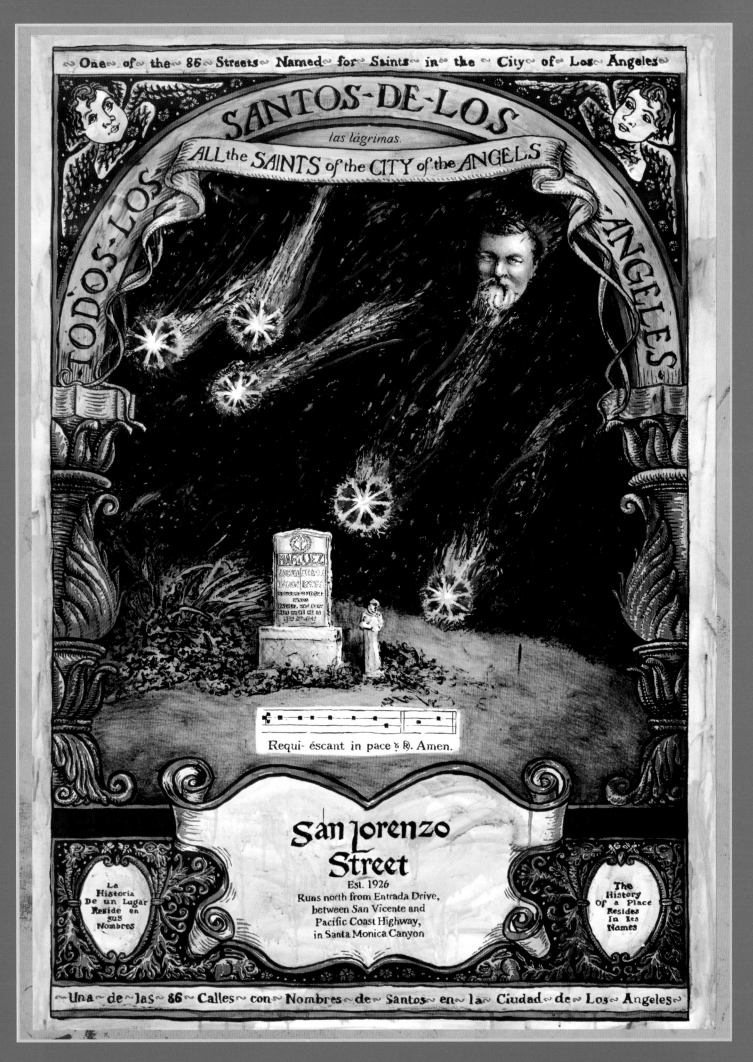

SAN LORENZO STREET

Santa Monica Canyon

Before the horsemen of New Spain rode into Santa Monica Canyon in the late eighteenth century, Tongva natives would set whalebones into the nearby sand to mark their cemeteries.

Within thirty years, both the whalebones and the Tongva were scattered, as Mexican settlers nestled into pockets of the surrounding landscape.

Among the early land grants, doled out by the government to favored soldiers and public servants, was Rancho la Boca de Santa Mónica, which comprised over six thousand acres of rolling hills and plateaus extending across present-day Pacific Palisades, Topanga, and Santa Monica Canyon.

In 1838 title to Rancho la Boca passed to native son Ysidro Reyes and blacksmith Francisco Márquez, who built his adobe home in Santa Monica Canyon and, in consequence of life's frailties, began setting wooden crosses in the nearby soil to mark the shortened lives of his children.

A dozen years later, Don Francisco was himself laid to rest under a large wooden cross in the shadow of the family adobe; and in the following decades, as drought and land speculation brought the rancho era to a close, some three dozen family and friends joined him in the earth.

The final grave was dug in 1916, within the foundation of the old adobe's ruins. Here Francisco's son Pascual, who had been an infant when the first cross was raised, was laid to rest, in venerable old age, in exactly the same spot where he was born.

Within a decade of Pascual's passing, the isolation and silence of the canyon passed as well, when, in 1926, Robert Loomis' Santa Monica Land and Water Company subdivided hill and dale into Tract 9247.

It so happened that the developer's daughter, Dorothy Gillis Loomis, loved California history and thus wished to protect the old burial grounds as a connection to our past. Convincing her father to set aside Lot No. 30 as the Márquez Family Cemetery, she commissioned well-known architect John Byers to enclose the graves within a gated adobe wall.

Dorothy then drove to a downtown Los Angeles *artesanía* shop on Broadway, where she purchased a statue to set in the adobe wall's *nicho*: the antique Mexican *bulto* she selected gave the street out front its name.

Every August the nighttime sky puts on one of its most remarkable displays, known as the Perseid meteor showers: for several nights, beginning about midnight on August 10th, hundreds of meteors stream down from the direction of the constellation Perseus.

Although astronomers only identified these meteor showers at about the same time that Ysidro Reyes and Francisco Márquez became owners of Rancho la Boca de Santa Mónica, it turns out that in Europe, rural peasants had known of them since before the first Spaniards came to California.

St. Lawrence was a deacon of the Church and a defender of the poor, on whose behalf he was martyred, around 258 C.E. A very gruesome and popular legend tells how the saint was roasted alive; and because his Feast Day falls on August 10th, believers interpreted the meteor showers as his fiery tears, raining from the heavens on the anniversary of his death.

Dorothy Gillis Loomis never disclosed why she selected a statue of *San Lorenzo*—St. Lawrence—to set in the *nicho* of the Márquez Family Cemetery; but it seems an appropriate choice.

For, every August the darting flares of San Lorenzo's tears remind us of the transience of our lives here and of our stewardship of this land. They also mourn the bygone evenings when *las lágrimas de San Lorenzo* streaked brightly against the ebony skies above Rancho la Boca de Santa Mónica, and throughout all of old Tongva and Chumash lands.

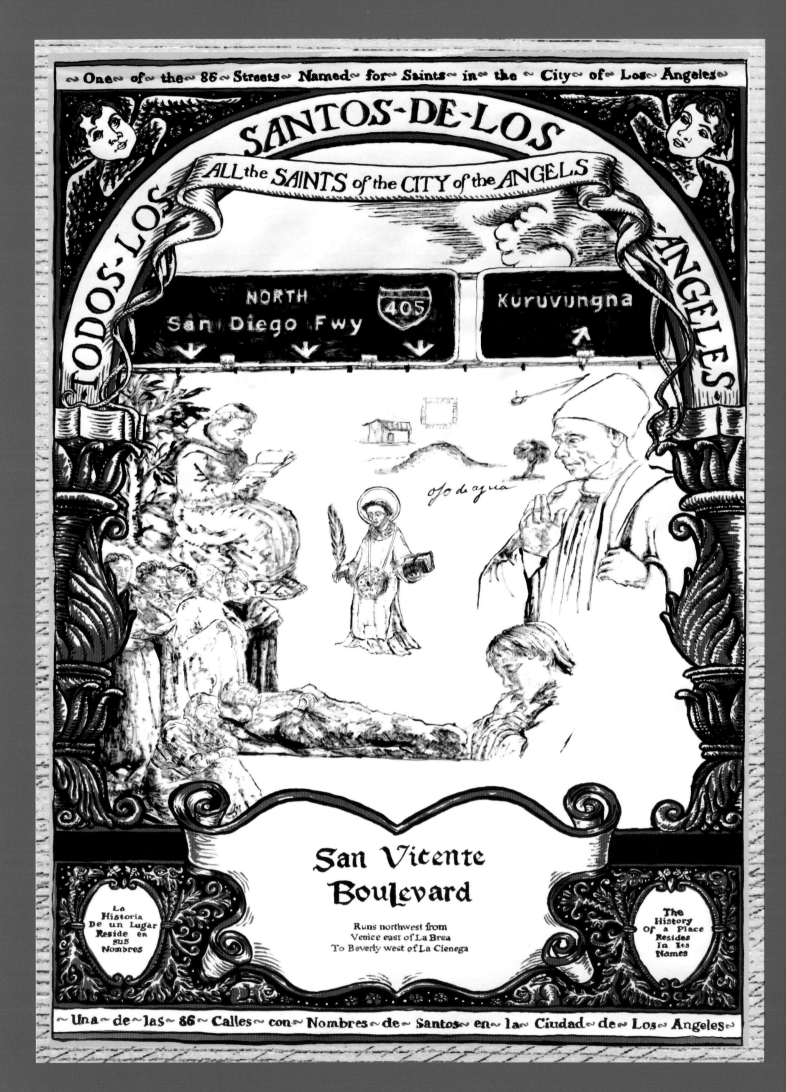

SANTOS-DE-LOS

ALL the SAINTS of the CITY of the ANGELS

TODOS-LOS

ANGELES

NORTH San Diego Fwy 405

Kuruvungna

ojo de agua

San Vicente Boulevard

Runs northwest from
Venice east of La Brea
To Beverly west of La Cienega

La Historia De un Lugar Reside en sus Nombres

The History Of a Place Resides In Its Names

SAN VICENTE BOULEVARD

Brentwood and Miracle Mile

San Vicente seems to be of two minds; at least he appears in two separate areas of the city.

Many people encounter him on the fast-paced stretch that courses south from West Hollywood's Sunset Strip, passing by the Beverly Center, tracing the eastern border of Beverly Hills, and finally folding into Venice Boulevard, tight between a shopping mall and an aquatic center, near the intersection of La Brea and Venice.

But there is another San Vicente, more grounded in time and connected to our land's history and struggles.

This San Vicente runs counter to his twin, northeast from the ocean at Santa Monica's upper border, and then nearly rights himself to flow east, stopping at the park-sized environs of the Veterans Administration, on the old Soldiers' Home lands by the 405 Freeway.

This San Vicente of the Westside lies wholly within the history before it appeared on Sepúlveda's map. Seventy years before, Father Juan Crespí of the Portolá Expedition recorded its appearance and noted its bounty in his journal: "an exceedingly copious spring" set amid "very tall thick sycamores."

In fact, this spring and its surroundings were so inviting that Father Crespí elected to pen his observations while "seated in the shade of the sycamores" and "enjoying the beauty of this spring (which is very fresh, pure water)."

The area's charm was probably enhanced by the abundance of antelope and "quite large hares" here. Indeed the soldiers tried to kill one of the antelope, but succeeded only in wounding it: they would finish it off the next day (perhaps nature's annoyance with this act inspired the minor earthquake which soon followed).

True to form, Father Crespí dedicated the spring to one of his beloved saints (albeit not, interestingly enough, to St. Vincent: we do not know how he arrived here, or even, with certainty, which St. Vincent he may be). Rather, because the date (August 3) was the commemoration of the "Finding of the Relics of St. Stephen," Crespí christened the site *"El Ojo de Agua de los Alisos de San Esteban"* ("The Spring of the Sycamores of St. Stephen").

There was, as is often the case, a certain poetry to Crespí's

...this site was also—it *is* also—one of the most sacred spots in the Los Angeles valley: it is Kuruvungna Springs, a name which is interpreted to mean the "place where we are in the sun."

limits of his namesake, the Rancho San Vicente y Santa Mónica, Francisco Sepúlveda's thirty-thousand-acre land grant from the late 1820s.

The Bancroft Library possesses a charming document, a hand-drawn map, or *diseño,* from the 1840s, depicting this rancho. The mountains and shoreline along its northern and western borders are hastily sketched, a large tree and solitary adobe two of the few elements rising near the *diseño*'s eastern edge.

And lying here, between the adobe home and venerable tree, the map's author has penned in the notation *"ojo de agua"* — a spring of water.

This spring had already figured in Southern California romantic, baroque christening, and it is tantalizing to wonder just how aware of this he was.

For, this site was also—it *is* also—one of the most sacred spots in the Los Angeles valley: it is Kuruvungna Springs, a name which is interpreted to mean the "place where we are in the sun."

Recovering and honoring Kuruvungna has been a long struggle for the Tongva peoples whose ancestors gathered here over many centuries past. Located on what is now the grounds of University High School, a half-dozen blocks south of San Vicente Boulevard's eastern edge, the spring has not been treated reverently by those who, after conquest, gained

ownership of its surroundings. It has taken state legislation, petitions, and hundreds of hours of volunteer work to save and restore the site to a semblance of its former beauty.

Nonetheless, Kuruvungna now receives a modicum of protection; it glows with a special beauty; and it is visited and used frequently for sacred Tongva rites.

Returning for a moment to Father Crespí, seated on the future campus of University High School, a half-mile from the 405 Freeway, we join him in recalling the feast day that marks the recovery of St. Stephen's relics.

The Golden Legend tells us that the relics of St. Stephen had lain hidden for many years and wanted to be found. A priest named Lucian, half-asleep, saw a vision directing him to go uncover the venerable tomb where the sacred relics lay.

Here by this spring—the Tongvas' Kuruvungna, the Franciscans' San Esteban—we listen for Father Crespí to tell us what happens next.

"Upon the opening of St. Stephen's coffin," he begins—when all is jolted by, in Crespí's vivid journal phrase, "a strong earthquake lasting less than a Hail Mary."

Father Crespí begins again, "Upon the opening of St. Stephen's coffin the earth shook." Just as here, at Kuruvungna, on the feast day of St. Stephen, the earth shook.

Juan Crespí understandably interpreted time and place within the context of his era and his beliefs. But here in the City of the Angels, where San Vicente, San Esteban, and Kuruvungna intersect, he was right: as the Tongva can attest, this is truly a sacred place.

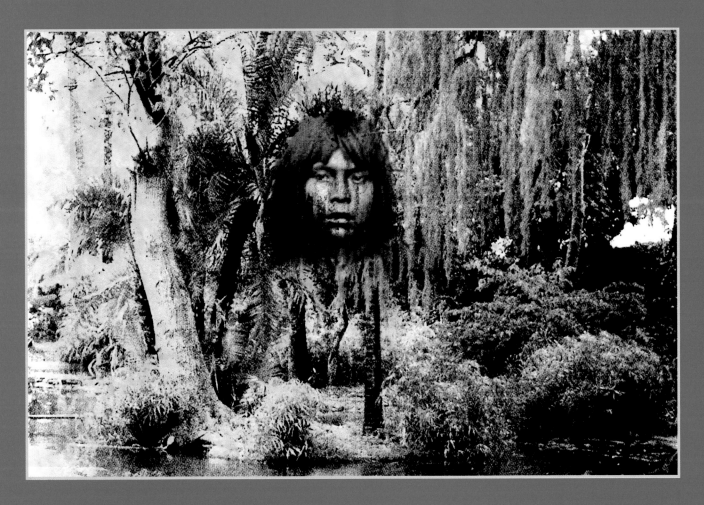

KURUVUNGNA
SPRINGS

We had always been here.
Before you left Villacatá we were here.
Before your forefathers landed their fateful ship at Veracruz,
we were here.
Before each and every one of your saints was born,
led his exemplary life, and died,
we were here,
on this, our land.

Of course we knew you were coming.
Even a small child should know every sound in this world,
would recognize every birdcall,
locate every rustling brush,
and identify every voice or distant tongue.
Our brothers across the hills had alerted us of your approach,
accompanied by earthquakes, strange beasts,
and confusing habits.
We heard the soldier's rifle blast when he took aim at the young deer,
heard the strange cries that followed,
and saw your pitiful attempts at pursuit.

When the deer approached our stream, lame of leg,
we did not touch it, of course:
it had been wounded by something not of this world,
and was unclean.
All night we watched the smoke from your campfire below,
convinced of your imminent visit,
and considered our response.
Our women stayed up the night,
preparing baskets of dried seeds and fragrant sage;
stringing necklaces of trade shells, crimson and white.

We tried to occupy ourselves the next morning,
in the long hours of anticipation before you arrived.
We saw you stop at our twin springs and sniff at our rosebushes,
and tentatively we considered you friend.
We gave you time to settle and begin a fire,
forgiving the herbs you trampled out of ignorance.
As one people we gathered up our bounty
to welcome you into our world.

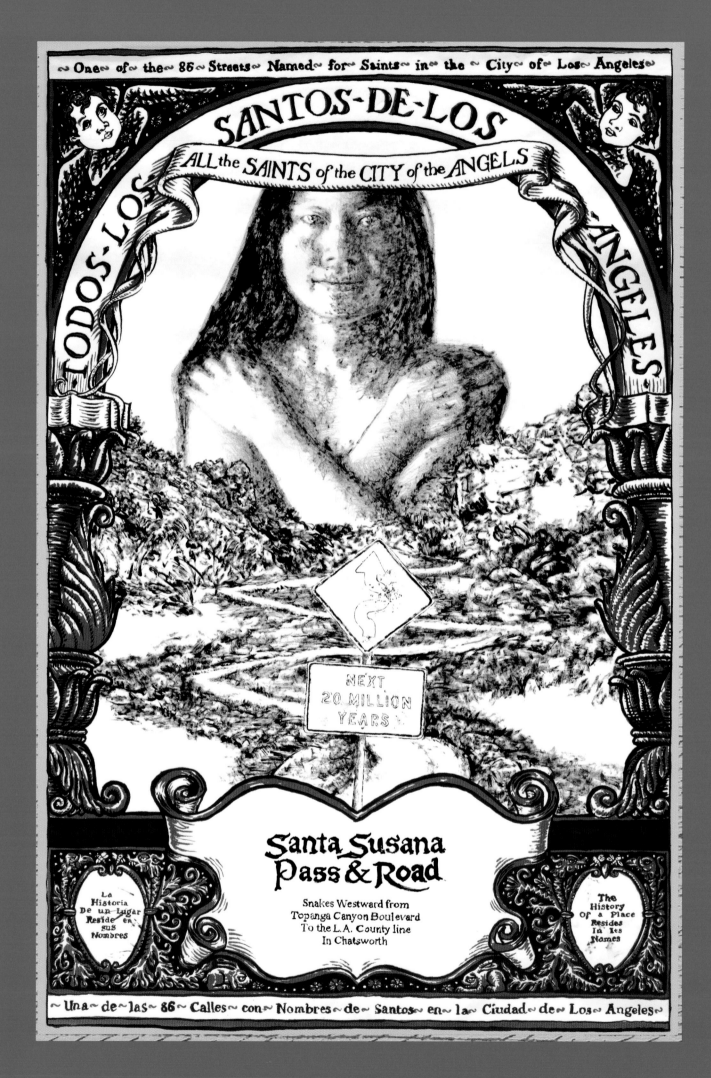

One of the 86 Streets Named for Saints in the City of Los Angeles

SANTOS-DE-LOS

TODOS-LOS

ANGELES

ALL the SAINTS of the CITY of the ANGELS

NEXT
20 MILLION
YEARS

Santa Susana Pass & Road

Snakes Westward from
Topanga Canyon Boulevard
To the L.A. County line
In Chatsworth

La Historia De un Lugar Reside en sus Nombres

The History Of a Place Resides In Its Names

~Una~de~las~86~Calles~con~Nombres~de~Santos~en~la~Ciudad~de~Los~Angeles~

SANTA SUSANA PASS and OLD SANTA SUSANA PASS ROADS

Chatsworth

Pine forests were giving way to live oak, purple sage, and sumac as the first people found their way over these mountains. The basalt, quartzite, and shale provided raw materials for their tools; and black bear, bluebirds, and coyotes were here to greet them.

Each creature on two legs or four traced a shallow path across the stone and silt; as did the winged creatures and stars across the sky; as did the rain, sun, and cold across the days.

Men and women learned the rhythms of this place and eased into them; learned when the walnut and acorn would ripen, and when the mule deer had nursed and could be spared for meat.

They learned to amend the rhythms here in acceptable, measured paces, and how to hasten a harvest, or increase its yield. They learned to pass over these mountains, to pass through this place and its time in ways which did not disturb its tranquility.

Two hundred years back, Spanish priests already called Santa Susana's name while climbing from Mission San Fernando and across these rocks to the Chumash villages in the western valley, or on to Mission San Buenaventura in the north.

If the taxing climb was less tiring on horseback, it could also be more perilous; Indian laborers cut steps in the rock to afford horses hope of better footing.

The stagecoach struggled here, too, its rear wheels chained to prevent back-sliding or horse-crushing. With passengers debarked and on foot, vaqueros were roped in to drag the coaches uphill, as horses negotiated the uneasy terms of survival.

The comings and goings of man have grown in number and intensity over the past hundred fifty years. Here and to the east, the Southern Pacific brought in graders and stonemasons to attack the hills, arduously boring through the massive rock to create tunnels for its trains.

As the century dawned and automobiles were born, new and wider paths were designed, then amplified, then discarded and replaced. Impatient with the mountains' pace, men now have cut a broad swath through the rock and earth.

There may well be no moment when man does not pass through here; no moment now when the only two-legged creatures here are still: rather, all is fury of movement and flight.

The gravel, silt, and sand that pass for soil have tossed about in the wind for some twenty thousand years; the shale and volcanic rock have lain exposed five hundred times as long; and the great sandstone ramparts and bedrock date back further still: more than fifty million years.

Whether it was the priests, or the settlers, or these mountains themselves who chose the name, they were right.

The sandstone boulders push themselves up from the earth's crust and onto the siltstone surface to watch over the plains like millennial sentries, gazing unfazed at our comings and goings.

Santa Susana, self-possessed, unmoved, disdains the advances of men.

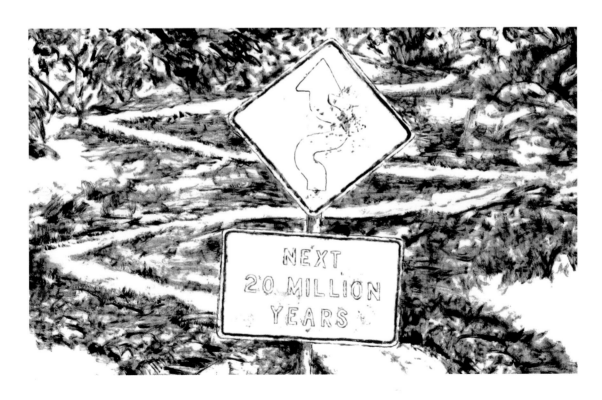

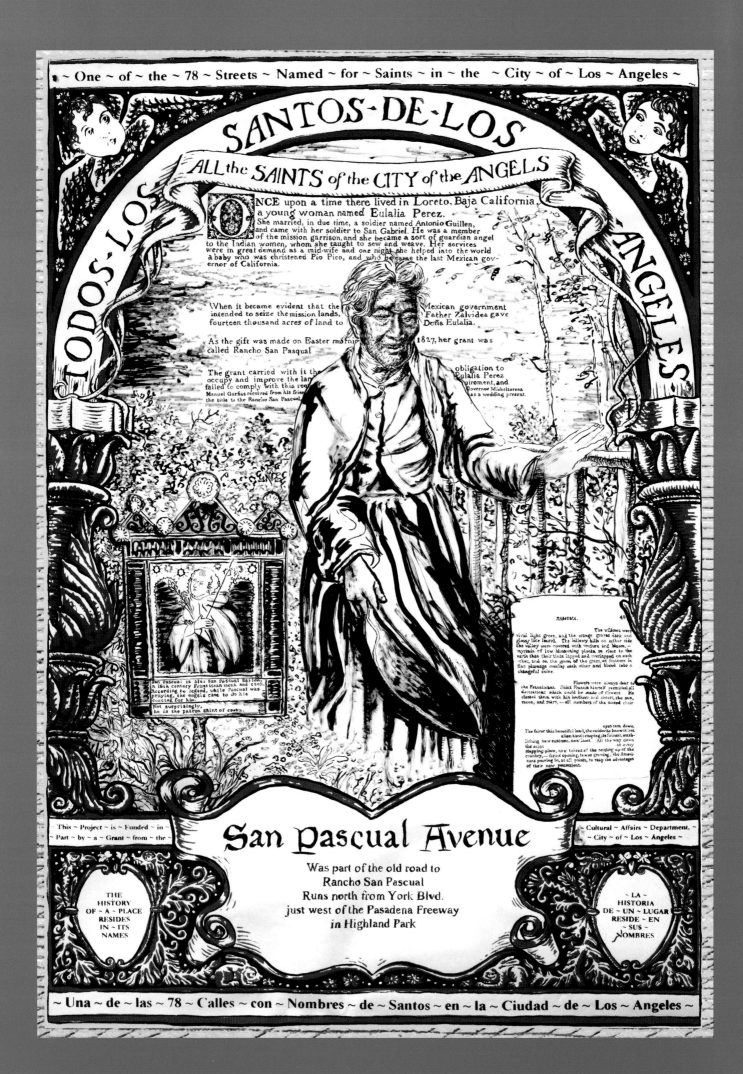

SANTOS · DE · LOS

TODOS · LOS

ANGELES

ALL the SAINTS of the CITY of the ANGELS

ONCE upon a time there lived in Loreto, Baja California, a young woman named Eulalia Perez.
She married, in due time, a soldier named Antonio Guillen, and came with her soldier to San Gabriel. He was a member of the mission garrison, and she became a sort of guardian angel to the Indian women, whom she taught to sew and weave. Her services were in great demand as a mid-wife and one night she helped into the world a baby who was christened Pio Pico, and who became the last Mexican governor of California.

When it became evident that the intended to seize the mission lands, fourteen thousand acres of land to — Mexican government Father Zalvidea gave Doña Eulalia.

As the gift was made on Easter morning 1827, her grant was called Rancho San Pasqual

The grant carried with it the obligation to occupy and improve the land. Eulalia Perez failed to comply with this requirement, and Manuel Garfias received from his friend Governor Micheltorena the title to the Rancho San Pasqual as a wedding present.

San Pascual is also San Pascual Bailon, a 16th century Franciscan monk and cook. According to legend, while Pascual was praying, the angels came to do his cooking for him.

Not surprisingly, he is the patron saint of cooks.

RAMONA. 49

The willows were vivid light green, and the orange groves dark and glossy like laurel. The billowy hills on either side the valley were covered with verdure and bloom,—myriads of low blossoming plants, so close to the earth that their thin lipped and overlapped on each other, and on the grass of the grass, at instances in fine plumage overlap each other and blend into a changeful color.

Flowers were always dear to the Franciscans. Saint Francis himself permitted all decorations which could be made of flowers. He classed them with his brothers and sisters, the sun, moon, and stars,—all members of the sacred choir

eyes cast down. The fairest this beautiful land, the raiders to know it lost alien hands reaping its fullness, establishing new customs, new laws. All the way down the east at every stepping-place, new tokens of the settling up of the country,—farms opening, towns growing, the Americans pouring in, at all points, to reap the advantages of their new possessions.

~ This ~ Project ~ is ~ Funded ~ in ~ ~ Part ~ by ~ a ~ Grant ~ from ~ the ~

~ Cultural ~ Affairs ~ Department, ~ ~ City ~ of ~ Los ~ Angeles ~

San Pascual Avenue

Was part of the old road to
Rancho San Pascual
Runs north from York Blvd.
just west of the Pasadena Freeway
in Highland Park

THE HISTORY OF ~ A ~ PLACE RESIDES IN ~ ITS NAMES

~ LA ~ HISTORIA DE ~ UN ~ LUGAR RESIDE ~ EN ~ SUS ~ NOMBRES

SAN PASCUAL AVENUE

Garvanza, Northeast Los Angeles

i. Mission San Gabriel, 1828

San Pascual, the patron saint of cooks,
Enters the kitchen before dawn, head bowed, and
Permits himself a graceful flourish, the blanket unfurled from
His shoulders; warm cocoon left folded on the rough-hewn chair.
Ceremony begun, he side-kicks his sandals to the foot of
The chair, arms out, hands splayed, knees cocked, like a
Diver before leaping.
Eye and heart on the cross on the wall he
Lowers himself, humbles himself, before it, his
Bruise-boned knees melting into earth as his
Arms come forward in silent symmetry, his
Hands up, fingers touch, then hand grasps hand, he
Sees into the cross past
The wood into the pain, he's
Lost in prayer—or found—and
All around him the work goes on.

Brown feet shuffle on the
Packed dirt floor and
Rumble of fire in the stove the
Crackling wood breaking into flame with
Sweet smelling manzanita like a
Grace note over slow-burning oak.
Everywhere is bustle every
Hand to the task at hand as the
Women check the corn boiled, simmering through
Last night's long hours, now the
Steaming kernels cupped into grinder as the
Servant girls use both arms and set jaw to
Turn the cast-iron crank that turns the heat-soaked kernels into
Snowflakes of meal.
Meal laced with lime doled out in disks cover the
Great wide stove becoming a thousand tortillas—
Sufficient unto the day.
Limeless meal mixed with cinnamon brittle ribbons,
Dense piloncillo cones, great pots of well water, and
Chocolate bars made from last month's cacao shipment,
Forming the champurrado, stirring
For the morning's communal meal.

Doña Eulalia's voice floats in from the courtyard on birdsong.
Thin and erect, sixty and still graceful,
Spare in movement, careful with words, she
Addresses the assembly with *Buenos días* and *Salve María;*
Reminding the *leñero* of extra wood for the padres' evening dinner;
Directing *El Gentil* to fetch four good hens once the butchering's done;
Inquiring of Luis how the soap is coming along;
Telling Domingo to round up neophytes to crush the olives in an hour,
Lucio to check the stores of garbanzos and manteca (they might be
 getting low),
María del Rosario to ensure the shoe and saddle workshops are open and
 well stocked (*Toma*, here's the key),
María Antonia to get to work on the sewing she's laid out (*por favor*), and
María de los Angeles to give the fieldhands head count to Padre Sanchez
 (*Lo está esperando*).
Entering the *cocina* now, black-haired-head bowed 'neath the low
 doorway, she
Passes her shawl to a waiting servant girl,
Stores her keys in her apron pocket,
Takes in the converging aromas, the
Placement of every pot, spoon, and ladle,
Rests her quick gaze on the saint still at prayer
(*Dios lo bendiga*),
Arches her eye at Tomás, her best-trained cook, and
Smiling, says,
"*Pues, vamos.* Let's get to work."

San Pascual arises from prayer just as lunch is being served:
Manchamanteles from this morning's butchered hog and
Tomato ground with chile, stewed with pepper, olives, and yams.
Indians stand or sit about the courtyard, slurping from their bowls, their
Tortilla bits eking out the final last morsel, their
Eyes focused on the middle distance as the
Mind tries to convince itself that the stomach is full.
San Pascual rarely eats with the padres; he
Prefers the company of cooks, being a
Former fellow cook himself.
Doña Eulalia, María del Rosario, María de los Angeles, and Tomás
Set their bowls gorged with stew on the

Long oak table made with some of the first-cut timber from this valley.

Warm thick tortillas in a Chumash basket graced with embroidered cloth, a

Punto de Cruz design Eulalia completed not long after arriving here.

San Pascual seated, takes a tortilla, tears it in half like a sacrament,

Places half of it back then feeds the rest to himself in

Slow, tiny bits like he's feeding a pigeon.

Eulalia has given up trying to convince the *santo* to eat more—

It will never happen, she knows; still, custom dictates she ask,

¿Usted no va a comer más, Sr. Santo?

In a few years, people will know the value of land and

Will want it for themselves, will want the mission's great fields and stores.

Everything will fall apart: relationships, orchards, flocks and fields,

Even these buildings and the dysfunctional balance of nature and man.

More so the natives, especially the natives, orphaned twice over and

Left for dead: denuded of tradition, language, knowledge, and sustenance.

ii. San Isidro Ranch, near Mission San Gabriel, 1878

San Pascual enters María del Rosario's kitchen just after dawn, a

Bit unsteady, shuffling slowly, frail hand on thick cane, his

Eye and heart on the cross on the wall.

Pausing, he humbles himself ever so slightly, his

Genuflection a sincere if threadbare gesture.

Bruise-boned knees melting into pain, he

Inches on toward the rough-hewn chair, his

Jacketed shoulders forming a warm cocoon as he

Folds himself between stove and window.

Hands on cane, his fingers wrap and rewrap themselves, his

Ears cocked eyes wide, listening for birdsong.

Doña Eulalia's slippered feet patter in from her daughter's courtyard, her

Rebozo'd carriage still thin, nearly erect,

One hundred ten years old and still *garza*-like graceful, her

Gaze meets the saint's and

Both begin singing the Virgin's morning hymn—

¡Buenos días, paloma blanca! Hoy te vengo a saludar...

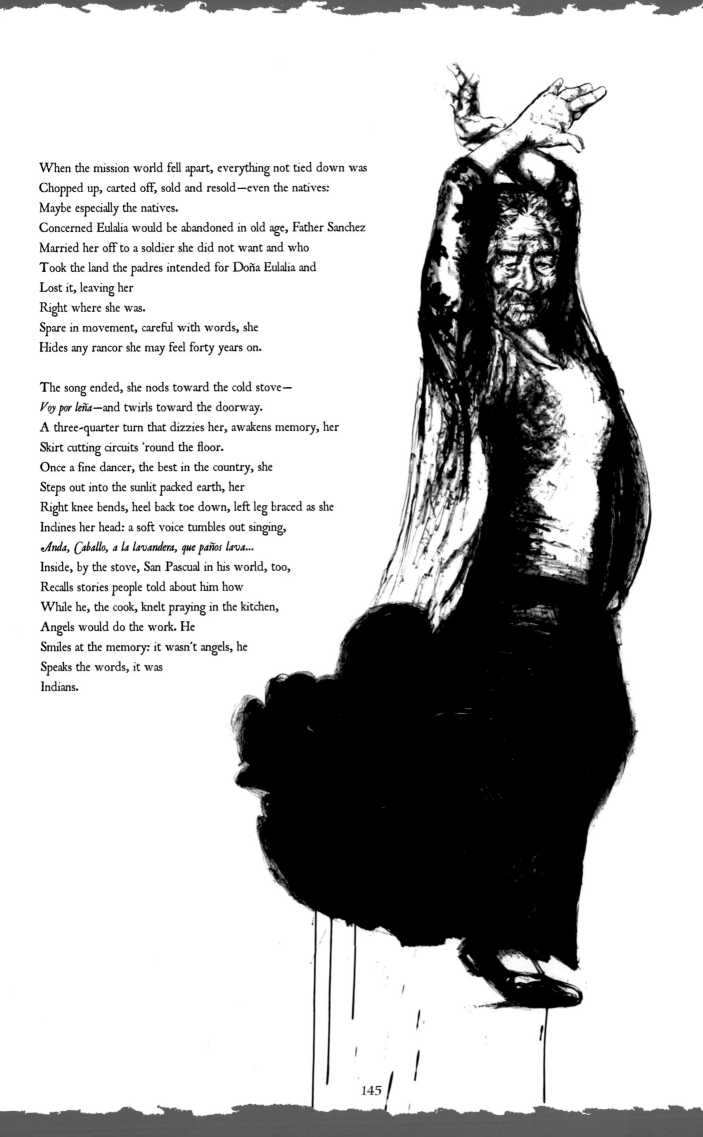

When the mission world fell apart, everything not tied down was
Chopped up, carted off, sold and resold—even the natives:
Maybe especially the natives.
Concerned Eulalia would be abandoned in old age, Father Sanchez
Married her off to a soldier she did not want and who
Took the land the padres intended for Doña Eulalia and
Lost it, leaving her
Right where she was.
Spare in movement, careful with words, she
Hides any rancor she may feel forty years on.

The song ended, she nods toward the cold stove—
Voy por leña—and twirls toward the doorway.
A three-quarter turn that dizzies her, awakens memory, her
Skirt cutting circuits 'round the floor.
Once a fine dancer, the best in the country, she
Steps out into the sunlit packed earth, her
Right knee bends, heel back toe down, left leg braced as she
Inclines her head: a soft voice tumbles out singing,
Anda, Caballo, a la lavandera, que paños lava...
Inside, by the stove, San Pascual in his world, too,
Recalls stories people told about him how
While he, the cook, knelt praying in the kitchen,
Angels would do the work. He
Smiles at the memory: it wasn't angels, he
Speaks the words, it was
Indians.

EIGHT:

The Island Saints

Five Los Angeles streets share names with the Channel Islands that dot the Southern California coastline: Santa Catalina View, in Brentwood; San Clemente Avenue and Santa Cruz Street, in San Pedro; San Miguel Avenue, in Venice; and St. Nicholas Avenue, near Culver City.

Although only Catalina Island (once Santa Catalina) is populated today, each of the islands for which these streets were named was once home to thriving communities of Chumash or Tongva natives. Indeed, the Chumash living on the mainland believe the islanders were the first peoples here. These natives' residency on the various islands reaches back as long as ten thousand years and continued up until as recently as one hundred fifty years ago.

During this great span of time, native Californians developed cultures remarkable for their innovations and adaptations, all of which makes their fateful encounters with the peoples who arrived to despoil the islands' fragile balance the more lamentable.

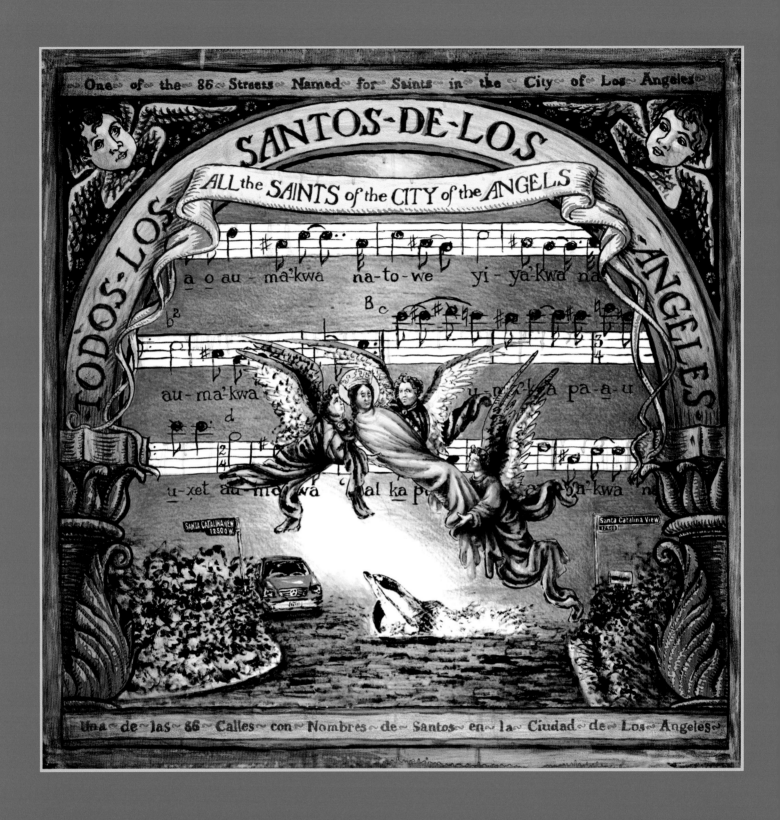

Celestino sang a Spirit Song with the lyrics "Dwell there my spirit, stay there my spirit."

SANTA CATALINA VIEW

Brentwood

From this hilltop street of fine homes and ample trees, one can no longer see the island that gives this site its name: the view has abandoned Santa Catalina View.

But out there across the haze and sea, four hundred years ago Sebastian Vizcaíno cast anchor and named its peaks and ridges for a third-century saint, St. Catherine: Santa Catalina.

Since long before Vizcaíno's time—indeed, since long before St. Catherine's time—the island was known as Pimu, the home of the Pimuvit people, a venerable branch of the Tongva Indians, who have called much of Southern California their home for millennia. These Pimuvit carved stone, built canoes, played flutes, and feasted on barracuda and whale—watched over by the sacred porpoises that leaped about off Pimu's shores.

By 1833 any Pimuvit who had survived the white man's diseases and incursions were herded off their island and shipped to Mission San Gabriel, from which they were further dispersed, after secularization, to Los Angeles and parts unknown.

A century later, an ethnomusicologist named Helen Heffron Roberts tracked down a lone descendant of the exiled Pimuvit people, a man by the name of Celestino Awatu, and transcribed some of the songs he sang for her.

When St. Catherine—Santa Catalina—was martyred, her legend tells us, angels came to carry her body away to Mount Sinai.

Celestino sang a Spirit Song with the lyrics "Dwell there my spirit, stay there my spirit." This was a song, Celestino explained, that expresses the Pimuvit belief that, when we die, "[our] spirit goes back to Catalina to stay there."

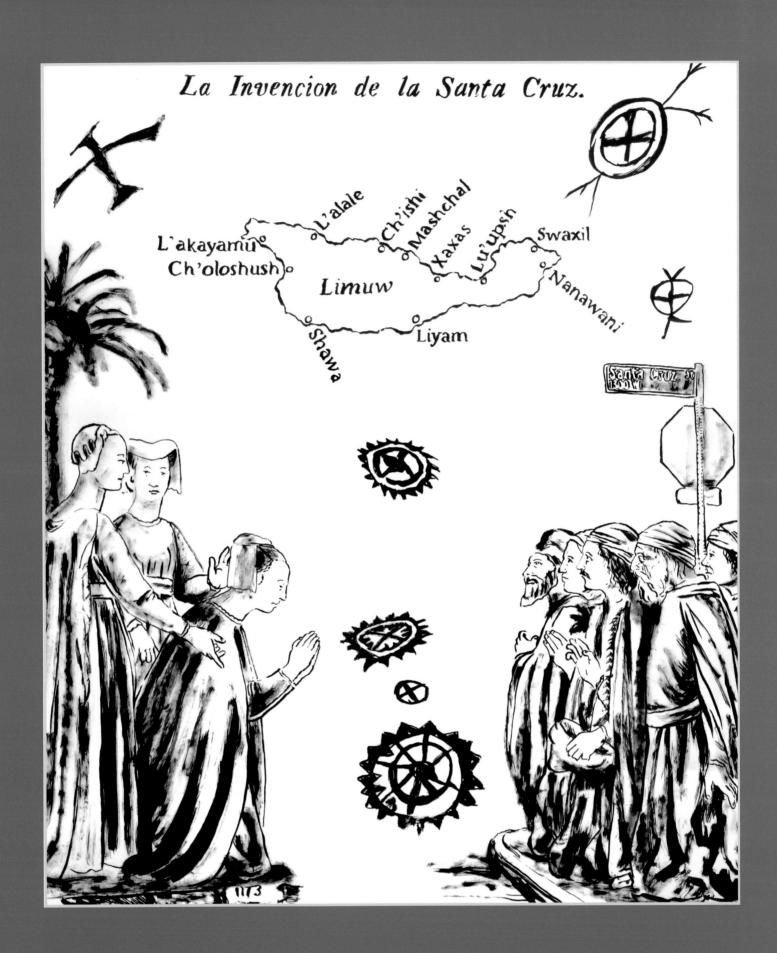

La Invencion de la Santa Cruz.

SANTA CRUZ STREET

San Pedro

Many millennia ago in the oceans west of Santa Barbara, the first Chumash peoples found themselves in danger of overpopulating their island home of Limuw.

To ease this growing burden, the Earth Goddess Hutash created a rainbow bridge across which her people could cross to the mainland. Unfortunately, the way was so steep and narrow that some Limuw, dizzied by the great height, tumbled into the sea.

"I must save my people," Hutash cried, and transformed them into dolphins. She told these dolphins to remain in the waters and keep company with their brothers on the island and on the shore. And they did.

Thousands of years went by like this; then one day, on the other side of the globe, the mother of a king set out to visit the Holy Land of her people.

Walking, she came to a place and said, "Here is the Holy Cross of my people. Dig here."

And so the people began to dig. They uncovered three crosses and did not know which one was the Holy Cross; but Helen told them to touch a sick woman with the three crosses, and the one which would make the woman well again would be the holy one.

They touched the sick woman with the first cross and nothing happened; they touched her with the second cross, and again nothing; but when they touched her with the third cross, she stood up and was well.

Helen took the Holy Cross home to her people, giving a piece of it to her son to make him strong in battle, and also sending pieces to the good people in other lands.

Many years went by like this, until one day, the people of the Holy Cross traveled around the globe to the side of the world where the people of Limuw live.

The priest of the Holy Cross came with his soldiers to visit the island of Limuw, and all the people came down to greet him. They took him through the forest to the great village of Xaxas, where the chief and his people welcomed him with great gifts of fish and other good things to eat. This made the priest very happy, and he gave the chief necklaces of glass beads from the other side of the world, beads which were not like the shell beads of the people of Xaxas.

When the time came to go home, the priest and his soldiers boarded their small boat and rowed to the big ship on the water, where the other Holy Cross people were waiting to hear about their visit.

When they got on board the ship the priest did not have his Holy Cross with him. "Oh no," he said. "We have left the Holy Cross behind; we left it on the island of Limuw."

The people on board the ship said, "The people of the island will want to keep the Holy Cross for themselves. It is dark now and we will never see our Holy Cross again." And the dolphins heard them crying all night long.

Then the dolphins went to the island and said to the people of Limuw, "The strangers on the big ship are crying because they have lost their Holy Cross. Go look for it in the forest, see where they dropped it, and take it to them."

In the morning, when the sun came creeping up over the hills, the people awoke on the big ship and saw a canoe coming towards them: it was coming from the island of Limuw. Strong oarsmen were guiding the canoe, and in the center of the canoe sat the bravest villager, holding the Holy Cross in his hands.

This brave one climbed onto the big ship where there were many men, and presented the Holy Cross to the priest, who thanked him with many words and signs. The priest gave him more necklaces of glass beads like before, and the warrior returned to the canoe.

When the men returned to Xaxas, the brave one told us everything that had happened and everything he had seen there.

What was the ironic jest that placed Sebastian Vizcaino in the bay of this distant island on December 6th, 400 years ago — on the feast day of Saint Nicholas?

ST. NICHOLAS AVENUE

Southwest Los Angeles

What was the ironic jest that placed Sebastian Vizcaíno in the bay of this Channel Island on December 6th, four hundred years ago—thus naming its Tongva community for the feast day of St. Nicholas, patron saint of Russia?

From the days of Constantine, monks in Asia Minor had honored the remains of St. Nicholas in a holy shrine; but sword-wielding merchants descended upon the monastery in 1087 and spirited his remains away to Bari, in southern Italy, where Orthodox Russian pilgrims in particular flocked to see their patron saint.

A world away—and since long before Constantine's time—Tongva natives had made their home on this semi-desert island off the California coast, negotiating its choppy waters, trading with mainlanders, and striking a balance with its ample marine life.

But in the late eighteenth century—some seven hundred years after Russian pilgrims began flocking to St. Nicholas' Italian shrine—Russian fur traders descended on San Nicolas Island in search of more earthly treasure. Abetted by their well-armed Kodiak hunters, who massacred the native men and enslaved the women, the invaders slaughtered the island's sea otters for their luxuriously soft pelts.

After enduring fifty years of continuous rapacious assaults, the last few dozen Tongva were spirited off their island home in 1835 and sent to Mission San Gabriel. The fur merchants were thus enabled to complete their work unmolested, as they drove the sea otters to near-extinction. The San Nicolas Tongva, however, were not even this "fortunate": within twenty years they were *all* gone.

As the Tongva were being expelled from their homeland, a storm arose at sea. One of the women noticed her child missing, and swam back to shore. Because of the storm the ship could not follow her; when she made it ashore, her child was gone; and because of subsequent storms, and a general disinclination on the part of the Anglo populace to fund her search, she survived alone on San Nicolas Island for eighteen years.

When at last the woman was found and brought to the mainland, none remained who could speak her tongue; the diet and society to which she was introduced proved far too alien, and within two short months of exposure to "civilization" she was dead.

St. Nicholas, it is said, was generous to the poor, a special protector of mariners and children, of the wronged and the innocent. He is invoked against robbery, against theft, against murder. But on his island, it did not happen this way.

What was the ironic jest that placed Sebastian Vizcaíno in the bay of this Tongva island on December 6th, four hundred years ago—on the feast day of St. Nicholas?

For surely it seems a slip of the cartographer's pen: Vizcaíno should have passed by—if at all—on December 28th: the Massacre of the Innocents.

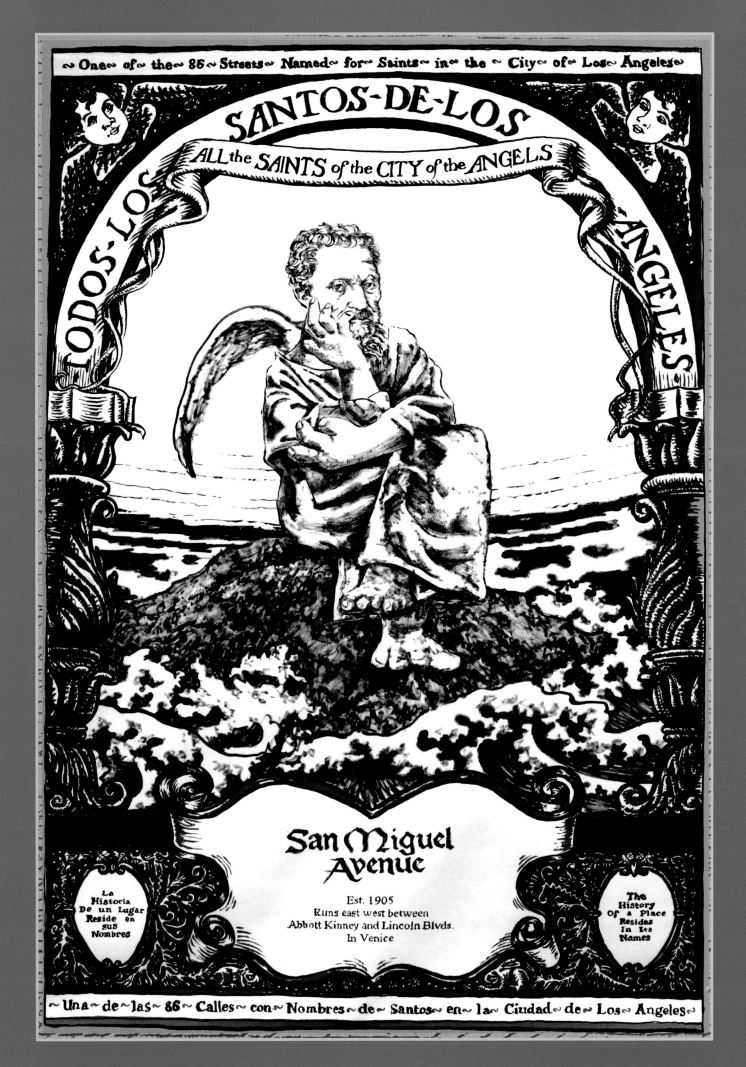

TODOS-LOS

SANTOS-DE-LOS

ALL the SAINTS of the CITY of the ANGELS

ANGELES

San Miguel Avenue

Est. 1905
Runs east west between
Abbott Kinney and Lincoln Blvds.
In Venice

La
Historia
De un Lugar
Reside en
sus
Nombres

The
History
Of a Place
Resides
In Its
Names

SAN MIGUEL AVENUE

Venice

San Miguel the Archangel has waded into the battles of good and evil for so long; thrown himself into the struggles of life and death so deeply; and weighed the souls of men and women so often, he needs a place where he can just get away.

The Chumash island of Tuqan, most remote of California's Channel Islands, battered by twenty-five-knot winds and eight-foot waves, beckons, its secrets shrouded in fog.

Patron saint of both soldiers and sailors, San Miguel is patron of artists as well. But not like St. Luke, with his saccharine hearth scenes of mother and child, or St. Catherine of Bologna, with her mysticism and sweet perfume. No, the archangel deals in issues of life and death; in meditations on the caprice of human action.

Here, for example, the first European to set foot on Tuqan, Juan Rodriguez Cabrillo, fell and suffered a deadly injury in 1542. Shortly after naming the island *"Posesión,"* Cabrillo died and was buried here—possessed by, rather than possessing, the island, a victim, perhaps, of his own hubris.

After Cabrillo's fall, Tuqan's islanders endured nearly three centuries of greed-bred invasions by foreign hunters and gatherers, intent on acquiring *"posesión"* of the island's fur seals, sea otters, and native women.

In 1816 the last thirty survivors of the white man's avarice fell victim to the white man's benevolence, when the remaining Tuqans were shipped off to Mission La Purísima, in present-day landlocked Lompoc. The natives' baptisms there may as well have been last rites, for most soon succumbed to European infection and disease.

In 1850, shiploads of sheep, helmed by oblivious herders, came by the thousands to graze on Tuqan's rich flora, ravaging its fragile ecosystem, exposing the soil and turning it to sand.

As if to rub salt into these freshly exposed wounds, a steamer heading for Panama three years later crashed into the island of Anacapa. Before it sank, the ship spilled its hold of black rats, who hopped, skipped, and swam over to San Miguel's island, where they began to feast on the native deer mice.

Over the next century Tuqan threatened to become a monochromatic wilderness: white sheep, white sands, black rats. In 1948 the United States Navy took ownership of the island, evicting the last sheepherder—but not, disappointingly, his sheep—and, in the blossoming Cold War, converted the island into a target range for its missiles and bombs.

In the mid-sixties the last sheep were finally removed, and not long thereafter the Navy stopped firing missiles at the island.

Freed at last from invading hunters, herders, and gunners, San Miguel settled into his sad, despoiled island and surveyed the situation: Tuqan's native culture destroyed and awaiting recovery; deer mice preyed on by invasive black rats; the island fox threatened by golden eagles; nearly two hundred native plant species gnawed to near extinction by six thousand relentless sheep; the once-fertile island turned to sand and inching back to life.

These are long odds, the archangel concedes, but he has seen long odds before and can relate. He sets up his studio to face the harsh, bracing wind and relax.

San Miguel paints his island with a vivid palette, tossing color back against the odds:

San Miguel needs this place; needs its drama and outsized extremes.

The crystalline ice-plant, its fuchsia-tipped leathery tulips proffering white noodly tendrils to the sun;

His very own milkvetch, with green-grape fruit and milky flower clusters scattered like Christmas tree ornaments across tightly packed leaves;

And the daisy-yellow coreopsis, bright and perky and cornstalk-tall, towering above her sister flora—hardy, brave, and big fans of teamwork, one and all.

He sculpts another island fox, apartment-size cute, the weight of a mere bag of sugar, and sends it scouting for deer mice, hoping for sand crabs, settling for insects.

Working with found materials—the calcified remains of a once-verdant plain—he reworks two-foot-high tree trunks in sand and silt to fashion a site-specific installation: a bone-white caliche forest of ghosts in the sun.

For performance art he gathers ten, maybe twelve thousand fur seals; fifty thousand elephant seals; and seventy or eighty thousand sea lions, to alternately lounge, lunge, lurch, and lunch in foggy cacophony, filling the ocean air with screeches, rumbles, bellows, groans, and a primordial smell.

In a meditative mood, he posits a thousand harbor seals, reticent wallflowers of the pinniped clan, in cozy coves of their own.

For flights of fancy: cormorants, storm petrels, snowy plovers, and black oystercatchers watched over by, and watching out for, peregrine falcons and red-tailed hawks.

San Miguel needs this place; needs its drama and outsized extremes. With a day job like his—fighting demons, weighing the souls of men and women—this island's volatile mix of tenuousness and tenacity appeals. Out here on the harsh open sea, he can really stretch out and create.

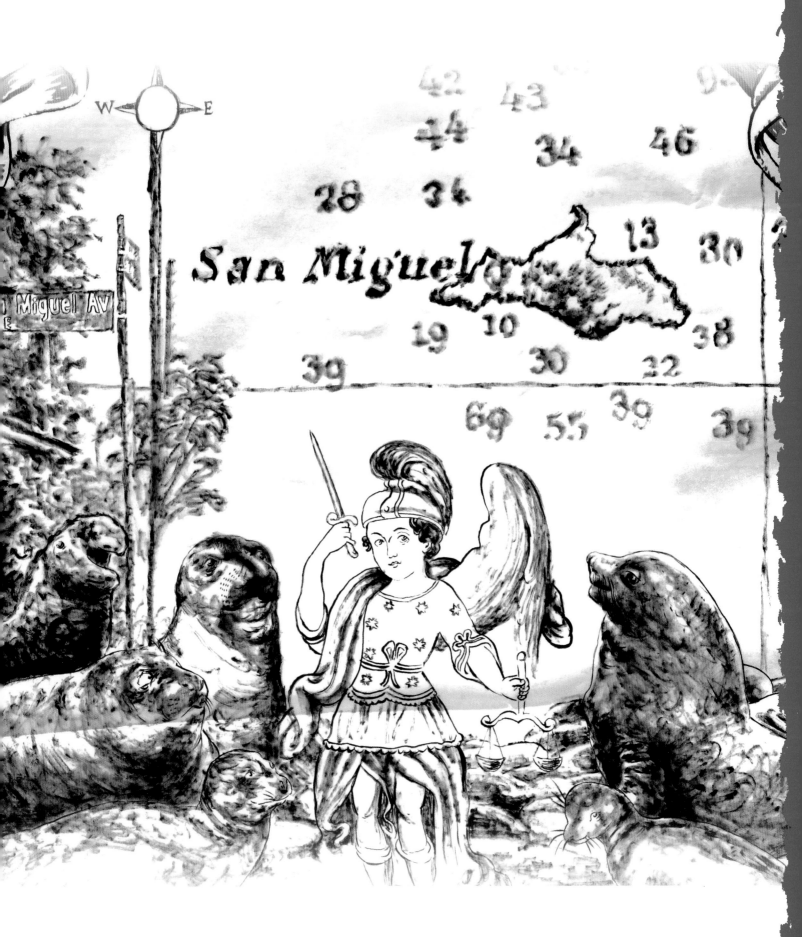

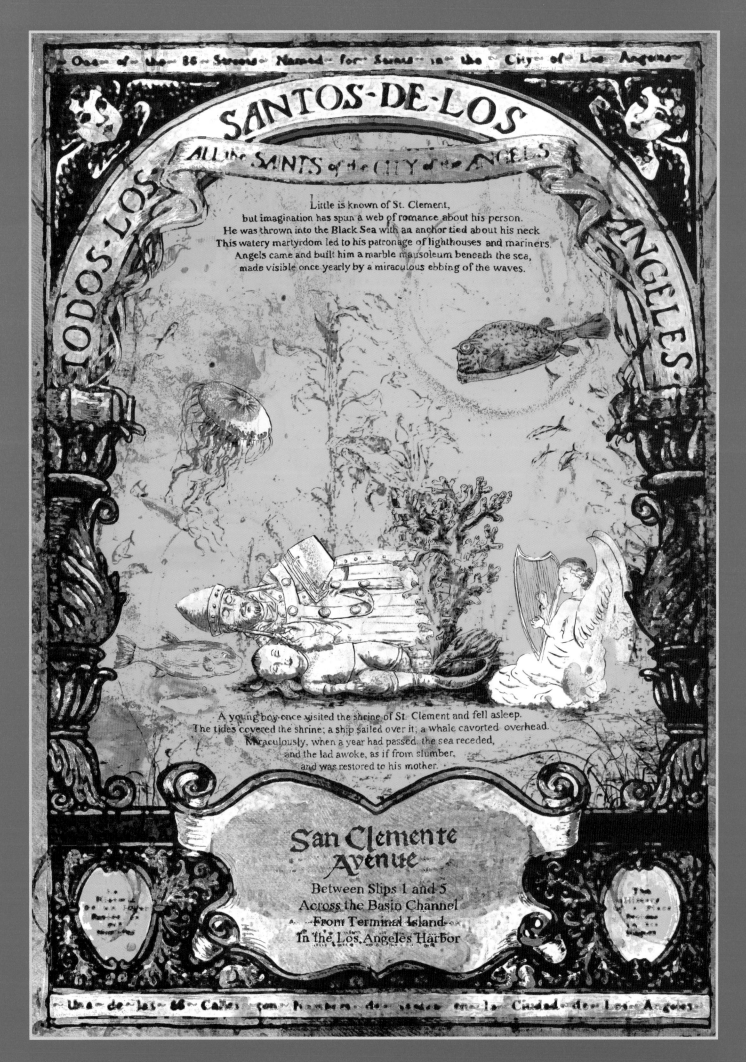

SANTOS·DE·LOS

TODOS·LOS

ANGELES·

ALL the SAINTS of the CITY of the ANGELS

Little is known of St. Clement,
but imagination has spun a web of romance about his person.
He was thrown into the Black Sea with an anchor tied about his neck.
This watery martyrdom led to his patronage of lighthouses and mariners.
Angels came and built him a marble mausoleum beneath the sea,
made visible once yearly by a miraculous ebbing of the waves.

A young boy once visited the shrine of St. Clement and fell asleep.
The tides covered the shrine; a ship sailed over it; a whale cavorted overhead.
Miraculously, when a year had passed, the sea receded,
and the lad awoke, as if from slumber,
and was restored to his mother.

San Clemente Avenue

Between Slips 1 and 5
Across the Basin Channel
From Terminal Island
In the Los Angeles Harbor

158

SAN CLEMENTE AVENUE

San Pedro

i. on land

Little is known of St. Clement, but not to worry. "Imagination," hagiographer Sabine Baring-Gould reassures us, "has spun a web of romance about his person."

An early bishop of Rome, he was thrown into the Black Sea with an anchor around his neck: this watery martyrdom led to his patronage of lighthouses and mariners.

Angels dove to the bottom of the sea (some two thousand meters) and built him a marble mausoleum, made visible once yearly by a miraculous ebbing of the waves.

During one of these annual ebbings, a young boy came to visit St. Clement's shrine and fell asleep. The tides returned, covering both boy and shrine. Ships sailed past; whales cavorted in the waters overhead.

Miraculously, when a year had passed and the sea again receded, the lad awoke, as from a deep slumber, and was restored to his mother.

Perhaps it is so with San Clemente Avenue as well: there it is on the map, plotted between Slips 1 and 5, across the channel from Terminal Island; and yet the road leading up to it disappears in a sea of concrete, strewn about with weeds and abandoned tires.

Does the Avenue lie there still, beneath the surface? Might it appear, briefly, on November 23rd, San Clemente's feast day (and if it does, should one chance napping there)?

Or is this all just another romance spun from imagination's web, a not-very-concrete cement San Clemente?

ii. on sea

Where, though, the romance for Kinkingna, the Avenue's sandy twin: the island which gave the reclusive street its name? What romance spun could save its ill-fated islanders?

Out there at eye's outer edge, fifty miles from shore, across "a treacherous sea, the tide rushing up and down, the sea running in and around, and the wind whistling a mournful dirge," Tongva natives thousands of years ago established this as their home: isolated and large enough to be self-sustaining, yet near enough to the coast and to other Channel islands to permit commerce and intermittent contact.

Communities arose and fell, then arose and fell again, across the island, across millennia. No surprise, really, that natives had no ready reply when queried by Spaniards as to their origins: they had, literally, been here forever—ten thousand years, before the Great Pyramids and the Age of Bronze.

Spaniards marvelled at the natives' mastery of the seas: rowing "with indescribable lightness and speed"; harpooning sea lions; planing pine planks with stone scrapers for their twin-prowed canoes.

Ah, but those charcoal blankets of warmth and great heft,

those velvet brown pelts wrapped 'round the Kinkingnans' shoulders: Vizcaíno's diarist thought they were bear, but they were sea otter, and bore the seed of extinction more surely than they might bear fleas.

Before Spaniards established the first mission in Alta California, in 1769, Siberian fur traders had already descended on the coasts and islands of the Alaskan Gulf, taking sea otters for their pelts and native Aleuts for their slaves. As they depleted the sea otter colonies up north, they swarmed down the Pacific coast, with their Aleut and Kodiak mercenaries in tow, literally moving in for the kill.

California island natives were no match for the invaders' ferocity—nor for their numbers, as ships manned by Americans and Pacific Islanders also joined the destructive fray.

The Kinkingnans' peoples and culture were ravished and crushed. A way of being in the world, nurtured across ten millennia, disappeared in thirty greed-fueled years—a virtual broken heartbeat.

With the extermination nearly complete, "it became the better part of mercy" to ship the final few survivors to Mission San Luis Rey. Kinkingna then truly became the Island of San Clemente, saint of the watery death.

Unlike San Clemente, however, no marble mausoleum marks where the Kinkingnans fell; but middens may make more meaningful memorials—and archaeologists, rather than angels, may be the attendants.

Eel Point, on San Clemente's central-western shore, offers rich information about the Kinkingnans' lives and their development of tools and skills. Burins, drills, chisels, planes, abraders, and reamers: the evidence of their technology lies waiting, buried in the mounds.

When the great linguist and ethnographer J. P. Harrington was conducting research among Island descendants, one native consultant helped unlock the key to Kinkingna's name: "We are living," the native explained, "on the island of the uncovered earth."

When San Clemente's fabled mausoleum was annually uncovered by receding tides, it was to be revered; as San Clemente's fruitful middens are analytically uncovered by archaeologists, they are to be understood.

Perhaps the best gift we can offer at this remove from the natives' destruction is not to spin a web of romance, as with the saint; but rather to free the natives of romance. The gift is to learn enough to see—and appreciate—the Kinkingnans, finally, as they really were.

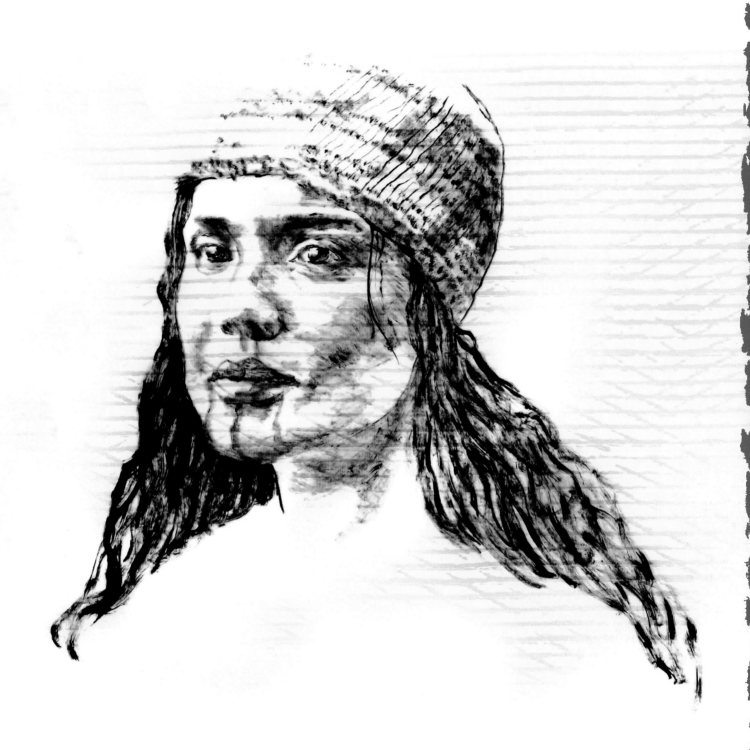

NINE:

The Saints of Battle

Rising northwest from the axis of Sepulveda and Wilshire Boulevards, on what was once part of Rancho San Vicente y Santa Mónica, Los Angeles National Cemetery honors the remains of over eighty thousand soldiers who served in wars dating across the past century and a half.

Founded in 1889 as part of a disabled veterans' home, the cemetery has grown from 20 to more than 114 acres.

Its silent streets—Gettysburg, Batteau Wood, Argonne, and so forth—recall the names of some of the battles in which the interred fought.

Two such streets, and their battles, bear the names of saints: San Juan Hill Avenue, for the well-known battle of the Spanish-American War; and Saint-Michel, or Mihiel, Avenue (it appears both ways), for a battle fought late in the First World War.

As it happens, these two saints, Juan and Mihiel (John and Michael), are the only saints mentioned in the battle-heavy Book of Revelation, also known as The Apocalypse.

And, as it also happens, among those interred at Los Angeles National Cemetery are some one hundred Buffalo Soldiers, from the same regiments that served at San Juan Hill, in 1898.

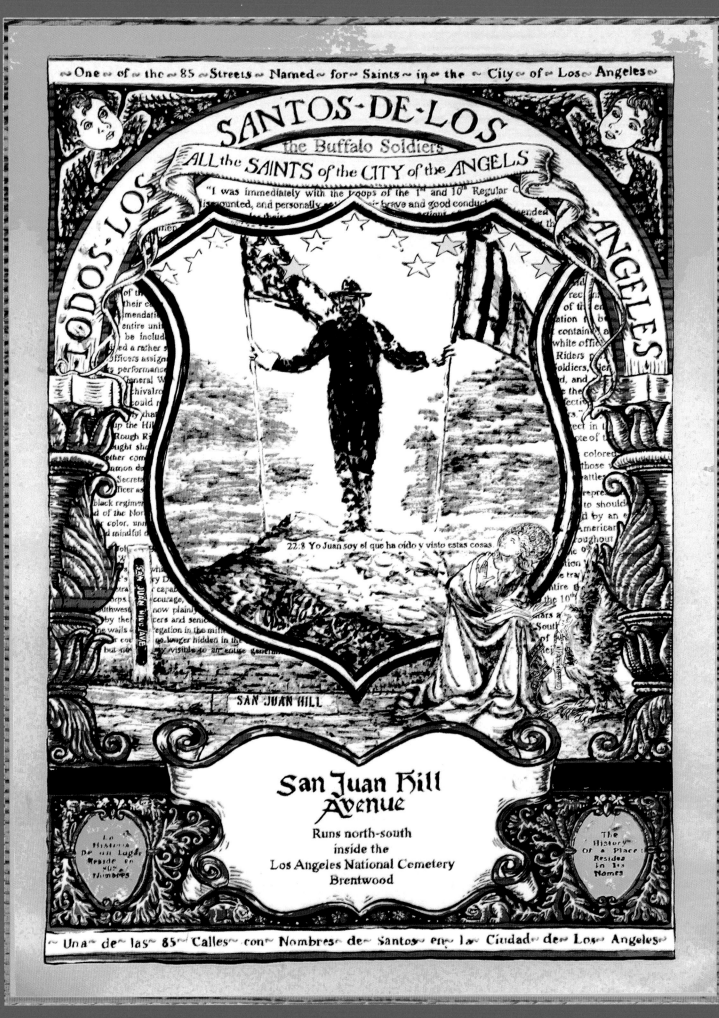

SANTOS·DE·LOS

the Buffalo Soldiers

ALL the SAINTS of the CITY of the ANGELS

TODOS·LOS

ANGELES

22:8 Yo Juan soy el que ha oído y visto estas cosas

SAN JUAN HILL

San Juan Hill
Avenue

Runs north-south
inside the
Los Angeles National Cemetery
Brentwood

SAN JUAN HILL AVENUE

Los Angeles National Cemetery, Brentwood

The stalwart form, the dusky face
Of those black heroes, climbing up
To win fair glory for their race.
—*Olivia Ward Bush-Banks*, A Hero of San Juan

Perhaps no human enterprise resists reduction to generalization as adamantly as does war. Each person's experience of it is necessarily unique: the war becomes *their* war.

Nevertheless, our cultural need for definition requires that we wrap personal experience into an unavoidably inadequate "official" narrative that comes to substitute for individual memory and truth.

Although it took place a little over a century ago, the Spanish-American War remains a contentious example of unresolved narrative: there are questions regarding its necessity; arguments as to whether blame was properly attributed for the explosion of the USS *Maine*; and disagreements over who most deserves credit for the 1898 victory at San Juan Hill.

Discussions of a war's necessity are perhaps best left to moral philosophers and historians; and historians and technical experts may best examine the evidence regarding the sinking of the *Maine*.

But assigning relative merit to the soldiers who fought—and in many cases gave their lives—in battle seems irrelevant and discourteous at best, and, more profoundly, a devaluation of the soldiers' efforts and, ultimately, of their lives.

The Spanish-American War was a swiftly fought conflict between Spain and the United States that lasted from April through August of 1898. Ostensibly fought to liberate Cuba from Spanish rule, its effective result was to place under American control several places Spain had until then laid claim to: Guam, Puerto Rico, and the Philippines; and to end Spain's reign as a world power, while introducing the United States as a new one.

Most of the fighting took place in the Philippines and Cuba; and it was the Cuban conflict that garnered the greatest public attention, in newspaper articles and film.

Nearly a quarter of the U.S. troops serving in Cuba were African American, many of them veterans of the so-called Indian Wars. In fact, it was the Kiowa Indians, with whom they had skirmished, who had bestowed the popular name Buffalo Soldiers on them. This name was soon enshrined in fondness and admiration by fellow blacks who hoped majority recognition of the Buffalo Soldiers' sacrifice and valor would "rectify, or at least ameliorate...the deteriorating status of the black man in the United States." Three black divisions—the 24th Infantry and the 9th and 10th Cavalry—were assigned to take San Juan Hill, in eastern Cuba, on July 1st, serving beside the regular white army and Teddy Roosevelt's Rough Riders.

Perhaps it is the normal way of war, but the exact succession of events that July day remains unclear. The popular story has Roosevelt leading his Rough Riders up San Juan Hill past timid black and white regulars, urging them on in his wake. This version, dispatched from the front by Roosevelt's virtual publicist, reporter Richard Harding Davis, was quickly distributed across the wires, converted into a sea of chromo-lithographic prints, and seared into public memory.

Other interpretations, some early and some the result of recent scholarship, find Roosevelt and his men instead taking nearby Kettle Hill and then joining the Buffalo Soldiers and their white colleagues as the struggle for San Juan Hill was already advancing toward victory.

What we know for sure is the battle was bloody—"It seems now almost impossible," one black infantryman recounted, "that civilized men could so recklessly destroy each other"—and costly: two hundred American dead, twenty-six of them black.

After it was over, Roosevelt spoke highly of the African American men with whom he had fought: "...no one can tell whether it was the Rough Riders or the men of the 9th who came forward with the greater courage to offer their lives in the service of their country."

Regrettably, this accolade would soon be eclipsed by derogatory statements Roosevelt made to describe these same soldiers ("shirkers in their duties") as he began his successful candidacy for the presidency the following year.

The Buffalo Soldiers who served with distinction at San Juan Hill, and throughout the Spanish-American War, formed part of a decades-long sacrificial bond that blacks made with a purported "purer" essence of America, the one ensconced in the words of the Bill of Rights and the Declaration of Independence. In so doing, the Buffalo Soldiers manifested a profound willingness to fight for the ideals of a country that did not yet fully acknowledge them as citizens.

Towards the end of the Book of Revelation, its author—traditionally understood to be St. John (the *San Juan* of San Juan Hill)—seeks to underscore the veracity of his tale this way: "I John heard and saw these things."

Only the soldier knows what he—or she—experiences, knows what truly occurs in the fire of war.

The popular image of Teddy Roosevelt and his Rough Riders leading the charge up San Juan Hill is hard to shake—even if it is more romantic than accurate. An equally compelling image might show the Buffalo Soldiers leading the charge on foot, taking the Spaniards' bullets as they fell, engaging the enemy in hand to hand combat as the Spaniards turned to run.

Only those on the Hill that day—some of them now interred aside San Juan Hill Avenue—know which version best reflects what they heard and saw through the summer heat and smoke.

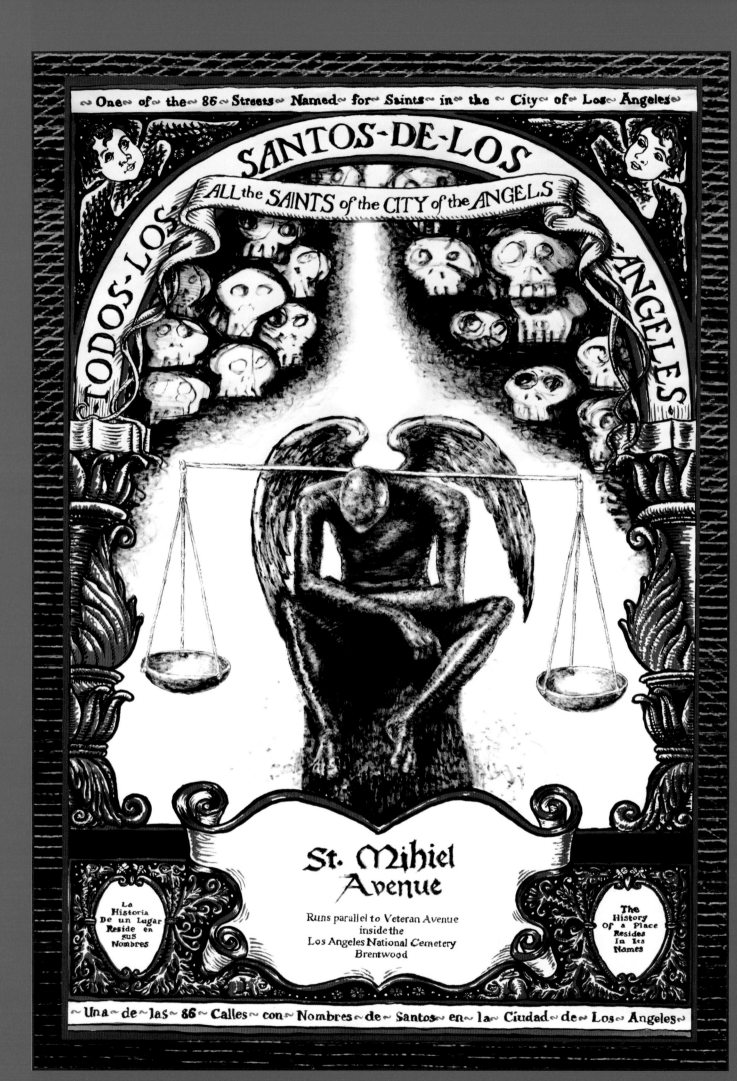

ST. MIHIEL AVENUE

Los Angeles National Cemetery, Brentwood

Through the din of cannon thunder,
I could hear the cries of young and old,
Someone will answer for this violence.
—Joe Young and Sam M. Lewis, "The Tale the Church Bell Told"

At one time, perhaps, each generation thought its war would put an end to war; thought that, surely, no one would choose to revisit such suffering and destruction in the future.

Certainly, at the very least, this was the Allied hope at the close of World War I—but, alas, we have seen this bright hope dashed, and more.

Saint-Mihiel, a small town in northeastern France, dates its beginnings to the founding, in the eighth century, of a Benedictine abbey named for the archangel St. Michael.

Trade developed around the abbey and flourished across the centuries, but Saint-Mihiel has remained modest, its population some five thousand, its chief industries the manufacture of plywood and eyeglasses.

Nonetheless, its position on the River Meuse and the singular geography of its terrain made Saint-Mihiel highly prized by the German army during the First World War. Indeed, the town's capture enabled the Germans both to cover their most sensitive position on the western front and to interrupt the Allies' rail line between Paris and the eastern front.

From September 1914 to September 1918, the situation was grim, the region often awash in bloody battles. But just before dawn on September 12th, some three hundred thousand Allied soldiers, led by American forces under the command of General Pershing, began a four-day, two-pronged assault on the German position, ending in the Germans' retreat and the freeing of both the town and the rail lines.

The Allies suffered some seven thousand casualties in the woods and plains of Saint-Mihiel during those four mid-September days, but their victory produced a great surge of enthusiasm and confidence for the American army, and a lifetime of gratitude on the part of local citizens. Two months later, on November 11th, Armistice was declared, effectively ending the war.

The patron saint of Saint-Mihiel, the archangel St. Michael, has two important tasks assigned him.

The first is to do battle, as the Allies did, with the demons threatening the world: "Then war broke out in heaven," the Book of Revelation says. "Michael and his angels battled against the dragon. The dragon and its angels fought back, but they did not prevail."

St. Michael also weighs the souls of women and men to determine whether, in death, they dwell in paradise or its opposite. Judgment can evoke joy, if the path leads to paradise, or agony, if the verdict is damnation.

But there may be another response, one that better squares with our history.

When World War I ended, more than nine million soldiers and over ten million civilians had died. It seemed inconceivable that anyone would think to use war again as means to an end. Yet, twenty years after these twenty million deaths, World War II began, slaughtering sixty million more.

St. Michael may well weary, as we do, of these ceaseless battles of good and evil. Holding aloft his great scales to weigh the fate of the dying, he may shudder beneath the weight of so many corpses, and mourn their loss, bemoan this endless waste.

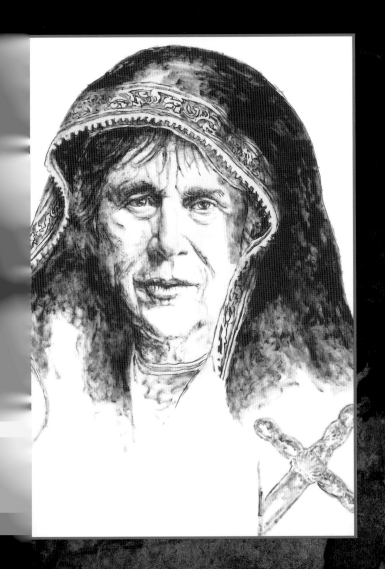

TEN:

El Sagrado Corazón de los Angeles— Getting to the Heart of L.A.

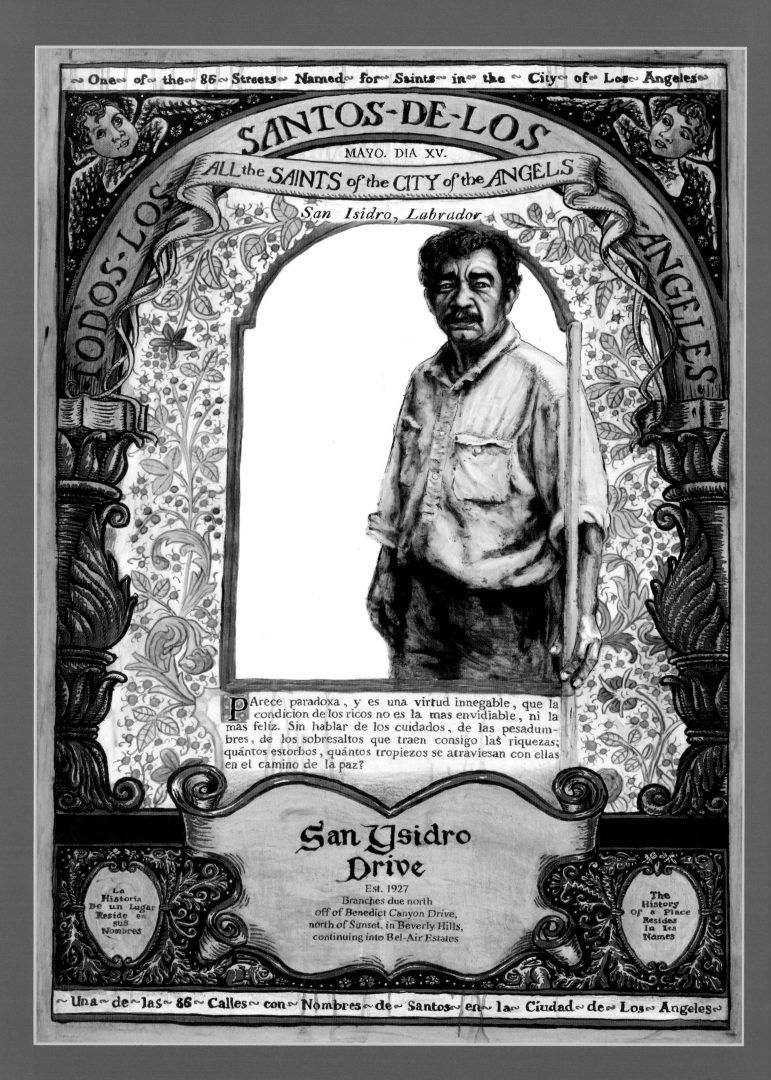

SANTOS·DE·LOS

MAYO. DIA XV.

ALL the SAINTS of the CITY of the ANGELS

San Isidro, Labrador

TODOS·LOS

ANGELES

PArece paradoxa, y es una virtud innegable, que la condicion de los ricos no es la mas envidiable, ni la mas feliz. Sin hablar de los cuidados, de las pesadumbres, de los sobresaltos que traen consigo las riquezas; quántos estorbos, quántos tropiezos se atraviesan con ellas en el camino de la paz?

San Ysidro Drive

Est. 1927
Branches due north
off of Benedict Canyon Drive,
north of Sunset, in Beverly Hills,
continuing into Bel-Air Estates

La Historia De un Lugar Reside en sus Nombres

The History Of a Place Resides In Its Names

SAN YSIDRO DRIVE

Bel-Air

San Ysidro Drive branches due north from Benedict Canyon above Sunset Boulevard, flowing gently past the mansions and multi-acre estates of Beverly Hills on its way to the more modest, merely multi-million-dollar homes of Bel-Air.

Through much of the nineteenth and early twentieth centuries, this land bore real fruit: vineyards flourished here, and beans and alfalfa were grown. Herds of sheep grazed, too, in these hills and vales of what was then called Rancho San José de Buenos Ayres.

But in the furious decade of building and reinvention that was Los Angeles of the 1920s, the land was bought and sold, fenced, tamed, and parceled; and its fields were converted to estates and tracts.

One of the first streets to be plotted, San Ysidro Drive, was named for a poor Spanish farmer, *San Ysidro Labrador,* a twelfth-century laborer who had to work on other men's lands to support his family.

In 1622 San Ysidro was formally canonized, and the conquering Spaniards brought his legend and devotion to Mexico, where the largely rural culture found him an appealingly empathic and readily identifiable figure; and his cult spread far and wide among men and women of the soil, who, over time, also spread far and wide.

Indeed, here in California they can be glimpsed, fleetingly, along our highways, stooping in the sun to pick lettuce and strawberries; or perhaps at dawn, rigging netting over lemon trees; or at dusk, lighting heaters in orange groves during a cool spring. For hours they lift berries from bushes as if they were tiny precious infants, and bear bushels of peaches like an endless series of burdens imposed by some inexplicable curse.

These sons and daughters of San Ysidro, however, are visible not only from the cars of travelers speeding along the Golden State Freeway or curious motorists wandering off Highway 86. They live not only in unheated trailer parks in Coachella Valley or jerry-rigged, bush-hidden tarp tents from San Diego north to San Joaquin. They also fill crowded apartments in L.A.'s Pico-Union District, in East Hollywood, and the San Fernando Valley.

While the daughters of San Ysidro wait for a series of early morning buses to take them to work in other people's kitchens, pantries, and laundry rooms, the sons of San Ysidro inch their dented pickup trucks along the western curves of Sunset Boulevard, holding back a frustrated tide of Porsches, Audis, and BMW's; their truck beds filled to overflowing with cuttings from the gardens that abut the garages of these same Porsches, Audis, and BMW's.

Once or twice a month the sons of San Ysidro coax their tired, incongruous trucks onto the mansion-lined street that bears the saint's name. Because of their labors, one notices the yards as much as the homes: the well-thought-out gardens, the carefully tended plants, and the luxuriant foliage.

Although San Ysidro was poor, his skills brought abundant life to the lands on which he worked; and although the title to these lands was in another man's name, it was the saint's guiding touch that enriched the soil. So it was then, so it is now.

The centuries come and go, people migrate, and the lands change names as the titles change hands; but the essence remains the same. Driving along San Ysidro's namesake Drive, only certain men are seen. They do not live here, but these sons of San Ysidro have kept the land alive and vibrant for two hundred years.

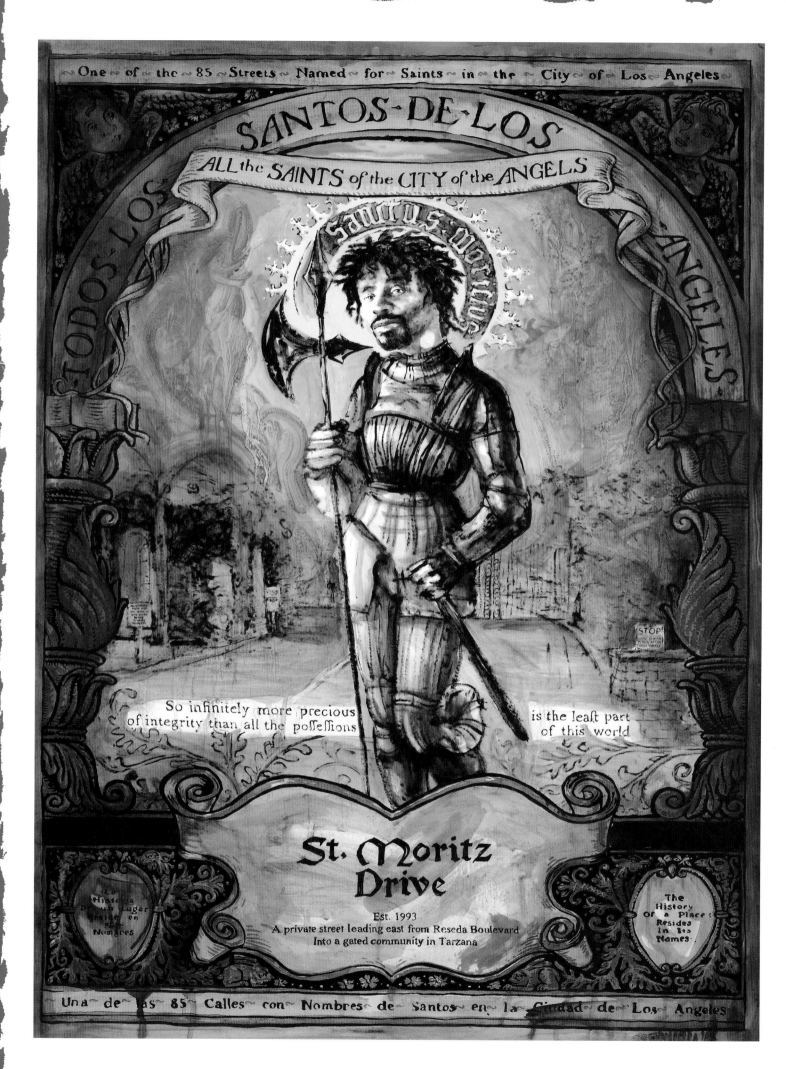

SANTOS·DE·LOS

TODOS·LOS

ANGELES

ALL the SAINTS of the CITY of the ANGELS

Santos·Moritus

So infinitely more precious of integrity than all the possessions is the least part of this world

St. Moritz Drive

Est. 1993

A private street leading east from Reseda Boulevard
Into a gated community in Tarzana

La Historia de un Lugar Reside en sus Nombres

The History Of a Place Resides In Its Names

ST. MORITZ DRIVE

Tarzana

When the gated community of Silver Hawk Ridge was laid out in 1993, the developer named a number of his streets for European resorts, among them the gated and guarded entryway of St. Moritz Drive.

The name of St. Moritz graces a world-famous ski resort and spa in southeastern Switzerland that has drawn vacationers for a century and a half. However, the saint's earlier renown derives from events that occurred in a city, now also named for him, at the opposite end of that country over seventeen hundred years ago.

In the late third century, in a village called Agauno, some two hundred miles west of present-day St. Moritz, the Roman Emperor Maximian led his army in putting down a revolt. Among his soldiers was a contingent known as the Theban Legion, recruited out of Egypt.

Maximian's army routed the rebels; and the Thebans played a major role in the victory. In celebration, Maximian directed that offerings be made to the gods whom he believed responsible for the army's success. The Thebans, however, happened to be Christians and elected not to sacrifice. Emperors never like to take no for an answer, and Maximian was certainly no exception. He threatened to decimate the Theban Legion—which is to say, kill a tenth of them; when this had no effect, Maximian ordered the deaths of successive tenths until finally, in a fit of rage, he had all the Thebans executed.

In a short matter of years, the site of these executions became a pilgrimage site for the European faithful. Relics of the martyred soldiers were prized souvenirs to be marveled at in distant churches. Of all the anonymous soldiers who died at Agauno, none was more beloved or prized than the commander of the Theban Legion, who acquired the name Maurice.

Maurice's name originated at the intersection of linguistics and geography, where it shares root with similar words, such as Moor, Morisco, Morocco, and Mauretania. Thus, Maurice suggested itself as the name for a soldier of northern Africa.

The cult of St. Maurice grew enormously. A sanctuary to hold his sacred bones was built in the early sixth century on the site of his execution, now known as St.-Maurice-en-Valais; and a perpetual chant in his honor was begun in the abbey, where it has continued uninterrupted for almost fifteen hundred years. Nearly six hundred churches in Europe are dedicated to him, as are dozens of cities in France, Germany, and Switzerland—including St. Moritz.

Most of these dedications, as well as most depictions of St. Maurice, occurred in the Middle Ages. At that time, European boundaries looked much different than they do today, with much jostling for territory; and rulers were quick to associate themselves with Maurice's holy yet militant power, while towns lying in the middle of such conflicts called upon Maurice for his guardian protection.

Hundreds of paintings and sculptures depicted St. Maurice as a strong, powerfully graceful soldier, generally a knight, in full regalia. What gave artists pause, however, was portraying the saint's face.

When St. Maurice's cult began, in the fourth century, Europeans had next to no knowledge of the outside world; and while they may have understood that Maurice came from the north of Africa, they could not conceive of his looking different from themselves.

After the Crusades gave Europeans experience of peoples to the south, St. Maurice began, haltingly, to look more "Moorish," more like he "really" was. But his depiction as a black man with African features presented a fundamental obstacle for those who equated spiritual perfection with a narrow, Eurocentric concept of physical beauty.

By the time artists developed the skills to render St. Maurice in a manner faithful to his origins—recognizably black yet sympathetically individual—the world was shifting. Soon, the ideal of the valiant knight would lose its appeal for rulers; and, tragically, the sensitive depiction of a strong black man would clash all too clearly with his subordinate place in society.

St. Maurice, black saint for a white world, was abandoned to await a more inclusive time; perhaps we will yet produce one. In the meantime he can be found just off Reseda Boulevard, guarding the entrance to Silver Hawk Ridge. As we peer through the development's wrought iron gates, we may do well to recall these words from his legend:

> So infinitely more precious is the least part of integrity than all the possessions of this world.

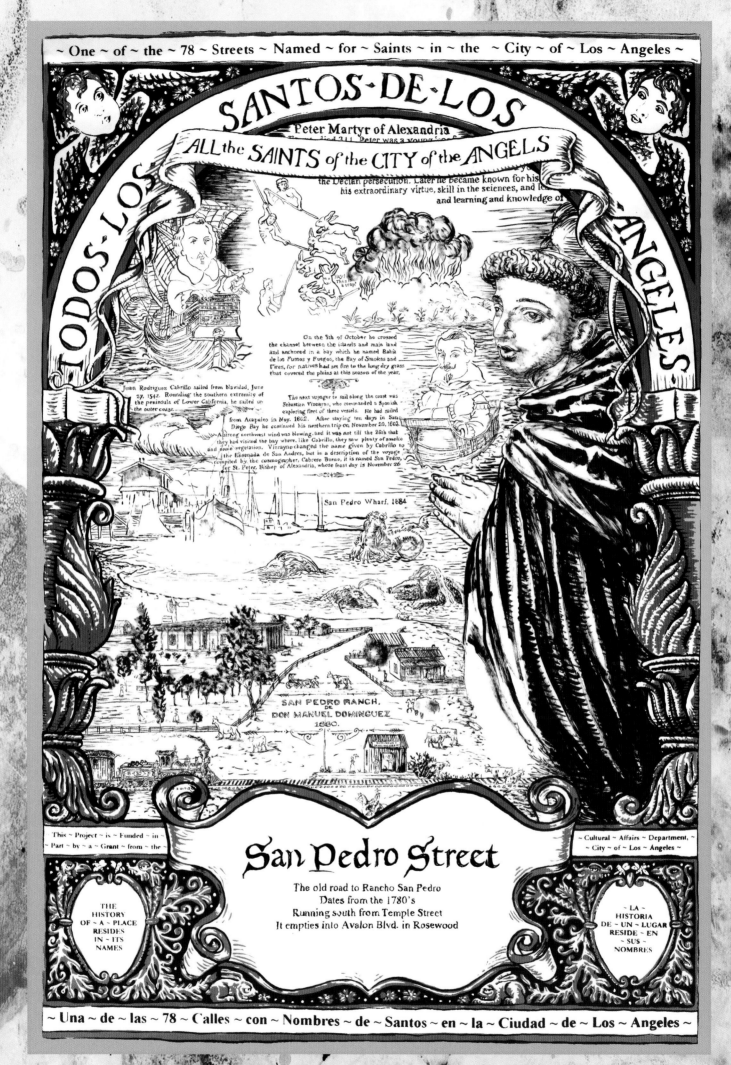

SANTOS · DE · LOS

Peter Martyr of Alexandria

ALL the SAINTS of the CITY of the ANGELS

TODOS · LOS

ANGELES

Peter was a young... of the Declan persecution. Later he became known for his ... his extraordinary virtue, skill in the sciences, and le... and learning and knowledge of ...

Juan Rodriguez Cabrillo sailed from Navidad, June 27, 1542. Rounding the southern extremity of the peninsula of Lower California, he sailed up the outer coast.

On the 5th of October he crossed the channel between the islands and main land and anchored in a bay which he named Bahía de los Fumos y Fuegos, the Bay of Smokes and Fires, for natives had set fire to the long dry grass that covered the plains at this season of the year.

The next voyager to sail along the coast was Sebastian Vizcayno, who commanded a Spanish exploring fleet of three vessels. He had sailed from Acapulco in May, 1602. After staying ten days in San Diego Bay he continued his northern trip on November 20, 1602. A strong northwest wind was blowing, and it was not till the 26th that they had visited the bay where, like Cabrillo, they saw plenty of smoke and some vegetation. Vizcayno changed the name given by Cabrillo to the Ensenada de San Andres, but in a description of the voyage compiled by the cosmographer, Cabrero Bueno, it is named San Pedro, for St. Peter, Bishop of Alexandria, whose feast day is November 26

San Pedro Wharf, 1884

SAN PEDRO RANCH, DE DON MANUEL DOMINGUEZ 1880.

~ This ~ Project ~ is ~ Funded ~ in ~ ~ Part ~ by ~ a ~ Grant ~ from ~ the ~

~ Cultural ~ Affairs ~ Department, ~ ~ City ~ of ~ Los ~ Angeles ~

San Pedro Street

The old road to Rancho San Pedro
Dates from the 1780's
Running south from Temple Street
It empties into Avalon Blvd. in Rosewood

THE HISTORY OF ~ A ~ PLACE RESIDES IN ~ ITS NAMES

~ LA ~ HISTORIA DE ~ UN ~ LUGAR RESIDE ~ EN ~ SUS ~ NOMBRES

SAN PEDRO STREET

From Little Tokyo to the Bay

W as it perhaps, early on, a fall day like any other, the waters clear and clean, the sky "a sharp Sunday blue"?

The men lighting fires along the steep hill's hem; others straining bows, anticipating thick autumn pelts; arrows trained on rabbits leaping, frozen-eared and taut-limbed, skitting past flame and precipice; the chaparral burning down to char, inciting next spring's feverish eruption of growth.

An island away, Juan Cabrillo, beckoned by the billowing black smoke, captained his Spanish crew's trio of ships toward the commotion—distracting enough astonished Tongva with his brief appearance to proffer the hares a hope of escape—and called it as he saw it: La Bahía de los Fumos, the Bay of Smokes.

Cabrillo soon passed from the scene, but likely as not some native boys on the hill above Xuxungna that day were elders when the next known ship—that of Sebastian Vizcaíno—entered the bay on its way up the coast in 1602.

Several generations would pass before another European—or newfangled American—ship was spied in these waters, by which time the Tongva had been rounded up from their millennial home and dispersed to work on Spanish ranchos or in Franciscan missions.

By the 1820s trade ships of contraband were making furtive rendezvous at Bahía de San Pedro (as it was now called): first trading with the hard-bargaining priests of Mission San Gabriel; later with the eager if innocent gentlemen and ladies of El Pueblo's assorted adobes and ranchos, who sent their oxcarts "laden with countless hides and tons of tallow"—and driven by the great-grandchildren of the Tongva who once called this land

theirs—to be exchanged "for the silks and velvets and fol-de-rols of the outside world."

Thus did the dirt road connecting San Pedro and El Pueblo de Nuestra Señora de los Angeles become a thirty-mile lifeline between the present and the future, facilitating commercial flirtations, bringing commerce, visitors, settlers, and news.

Thirty years on, California was U.S. soil, and business at San Pedro was brisk: schooners, side-wheelers, and steamers anchored in the bay; whalers, shark hunters, and otter skinners embarked here; Chinese divers brought in abalone from Catalina Island; and stagecoach drivers raced the wide, level, squirrel-holed pampa from the cove to the city, competing for customers.

By the end of the nineteenth century, the waters the Tongva had fished for thousands of years were being fished by men thousands of miles from their homelands: Japanese, Chinese, Sicilians, and Croatians, harvesting albacore, abalone, sardines, and mackerel.

As thousands of Japanese drifted into Los Angeles from railway jobs and San Francisco's earthquake upheaval, most cast anchor at either end of the San Pedro road: in cannery-built fishermen's houses on Terminal Island, in the Bay; or working as merchants, laborers, and restaurateurs at the north end of San Pedro Street, in Little Tokyo.

Both sites became profound loci of Japanese culture, where Issei, first-generation Japanese Americans, sought the sense of community from which they were otherwise excluded by laws barring them from citizenship and ownership of land.

As the numbers of Japanese women increased in San Pedro's canneries, families of Nisei—citizens by birth—called the harbor island their home, creating a culture that mixed—and hoped to bridge—their worlds.

Unfortunately, the Nisei dream of acceptance was crushed by a tidal wave of racial hostility that crashed on San Pedro's shores in early 1942, when fixed-bayonet soldiers, under Executive

San Pedro Wharf, 1884

Order 9066, swept the families off to the Manzanar internment camp, in Owens Valley.

Three bitter years passed before San Pedro's Issei and Nisei were released, and new shocks followed old: Issei were forbidden to hold commercial fishing licenses; their hard-earned boats and nets were confiscated or stolen; and the buildings of Terminal Island—their homes, school, and shops—had been razed to the ground.

Little Tokyo, at the north end of San Pedro Street, remained, and would prosper; but the Japanese experience at San Pedro Bay had ended in sorrow and shame.

When Don José Gonzales Cabrera Bueno was compiling his *Treatise on Navigation* in 1734, something about Sebastian Vizcaíno's account of his 1602 travels along the California coast troubled him.

In late November, when Vizcaíno entered the waters Cabrillo had named Bahía de los Fumos, he rechristened them Ensenada de San Andrés (St. Andrew's Cove).

But Vizcaíno's visit, Cabrera Bueno noticed, was on November 26th—two days before the feast day of San Andrés. So the cartographer changed the bay's name to honor the saint whose feast day actually falls on the 26th—St. Peter of Alexandria—thus bequeathing us San Pedro (St. Peter) Bay.

One wonders, though, if Vizcaíno didn't have the better idea. Certainly Cabrera Bueno was the superior cartographer, but Vizcaíno's Ensenada de San Andrés offers something more than poetry.

Nothing is certain here—after all, the Constitution itself had failed these people. Still, it provides a wistful hope.

San Andrés is the patron saint and protector of fishermen, and, like the Issei, he is usually portrayed as an elderly man.

How sweet it would have been, how much better for us all, if our Japanese neighbors, returning to a bereft bay after three illegal years in the camps, had been met instead by San Andrés, sitting in his boat, tending his nets, welcoming them back home and beckoning them to come join him at sea.

176

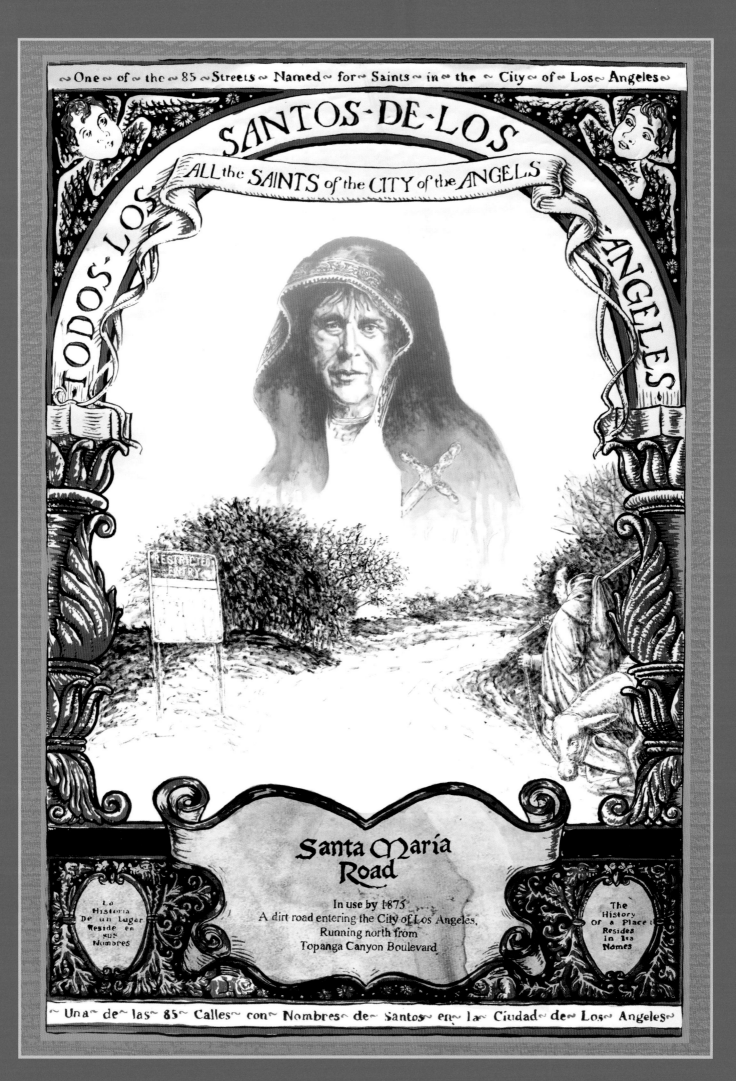

TODOS · LOS

SANTOS · DE · LOS

ANGELES

ALL the SAINTS of the CITY of the ANGELS

RESTRICTED ENTRY

Santa María Road

In use by 1875
A dirt road entering the City of Los Angeles,
Running north from
Topanga Canyon Boulevard

La
Historia
De un Lugar
Reside en
sus
Nombres

The
History
Of a Place
Resides
In Its
Names

SANTA MARIA ROAD

Woodland Hills

When love, converted from the thing it was,
Shall reasons find of settled gravity,—
Against that time do I ensconce me here.
—William Shakespeare, Sonnet 49

A narrow winding road arches north and eastward off Topanga Canyon Boulevard, tracing the folds of the Santa Monica Mountains in search of the San Fernando Valley sun.

One must brave an army of "Restricted Entry" and "Not a Through Street: No Turnaround" signs, arrayed in defense of the rambling estates and horse ranches tucked into this shady glen, to get to the heart of Santa María Road. Upon passing the last of the ranches, one encounters, curiously, north-facing "Restricted Entry" signs with the same warnings—"Not a Through Street: No Turnaround"—posted like dissembling sentries, defending the northern perimeter.

Here the dark veil lifts, the aptly named Glenview border is traversed, the asphalt ends, and Santa María truly becomes a "Road," a dirt and dust pathway into the southwestern reaches of the San Fernando Valley.

One halts in wonder, thankful for small miracles, to find a road in Los Angeles neither paved nor tamed, whose dust rises with the wind and meshes, effortlessly and naturally, with the scruffy surrounding landscape.

Into this canyon of willow and sage came a stranger from Sonora, Mexico, named Jesús Santa María, in 1875. Marrying a *paisana* named María Elena, Jesús settled into the canyons to eke out a living from the fertile but by no means level land.

Already, by the 1870s, firewood for the residents of El Pueblo de Los Angeles—some thirty miles distant—was at a premium; so Jesús Santa María drummed up a small business, hauling cords of manzanita into town via the circuitous route of the period: north from his ranch to El Camino Real (now Ventura Boulevard), and from there southeast into El Pueblo.

Jesús and María Elena found a good life in these hills, and prospered well enough to raise a strikingly large family of eighteen children—enough, it is said, to keep the local country school in business. Many of their children went on to raise families themselves, and the great-grandchildren now have families of their own: Jesús Santa María, like Abraham, has been blessed with "descendants as numerous as the stars in the sky."

But there is a curiosity about that last name. Santa María (sometimes spelled Santamaría) means Saint (or Holy) Mary and refers to the woman many believe to be the mother of God. Tragically, however, her appearance as a last name is associated with one of the more deplorable episodes of the Middle Ages.

The inhabitants of medieval Europe were encouraged to view the spiritual and physical realms as seamlessly related, and to identify with important biblical events. Although this lent great meaning to their lives, it also occasioned terrible abuse. The fourteenth and fifteenth centuries are stained with accounts of churchgoers attacking their Jewish neighbors, who they viewed as descendants of the antagonists in the biblical passion tale.

Spanish Jews suffered waves of mob violence. Shuttered into ghettos, they were denied passage from one area of town to another and subjected to ever more restrictive codes of conduct. Perhaps the most oppressive of these was the forced conversion to Catholicism, and the imposition of "Christian" names, such as Santa Fé (Holy Faith), Santa Cruz (Holy Cross), and Santa María.

Even the most magnificent synagogue in Toledo underwent forced conversion, to become a Catholic church, Santa María la Blanca (St. Mary the White).

Finally, in the spring of 1492, King Ferdinand and Queen Isabella issued an edict expelling a quarter-million Jews from their homeland. Many of those who fled made their way to New Spain, where, over time, the ultra-Catholic names of these so-called *"conversos"* (converted ones) won them easier acceptance into societies prejudiced against Jews. As succeeding generations of *conversos* have confronted an ever-changing social landscape, they have responded in a spirit of improvisation and adaptation, of integration and reinvention, of forgiveness and forbearance.

Artists, mystics, and writers have described the Virgin Mary, Santa María, in dozens, perhaps hundreds of forms over the centuries: Our Lady of Mercy, the Immaculate Conception, Madonna del Parto, and so forth. In each depiction, in each imagining of Santa María, she offers hope, compassion, and aid; rarely is she judgmental or vengeful.

One of the most compelling depictions is Our Lady of Sorrows, *La Virgen de Dolores*, where her empathic sorrow for the suffering of others is palpably profound.

The bitter winds that ripped Jesús Santa María's forebears and fellow *conversos* from their homeland and sent them along the path of sacrifice and survival have alternately raged and subsided across the centuries and continents.

Here in Southern California the winds have largely calmed; but occasionally they still kick up dust and conflict.

The winds deposit us here on Santa María Road, on this pilgrim's dirt path, a Road affronted (as Jews have been for centuries) with "Restricted Entry" signs. And here, under the mournful gaze of Our Lady of Sorrows, we consider our next step.

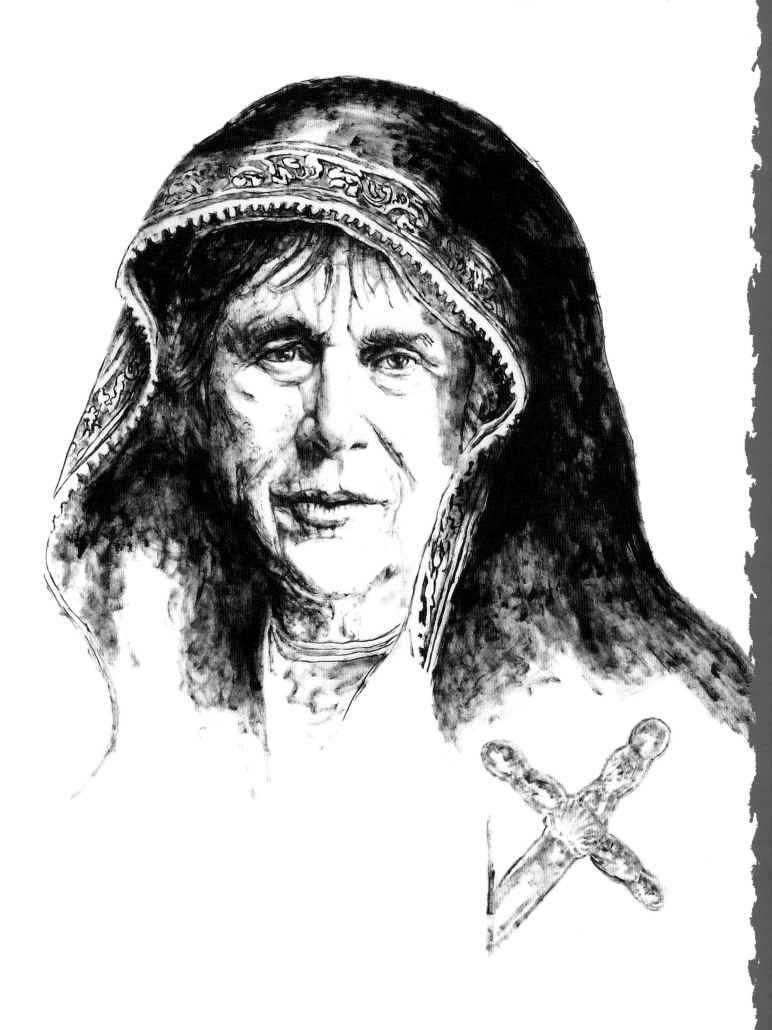

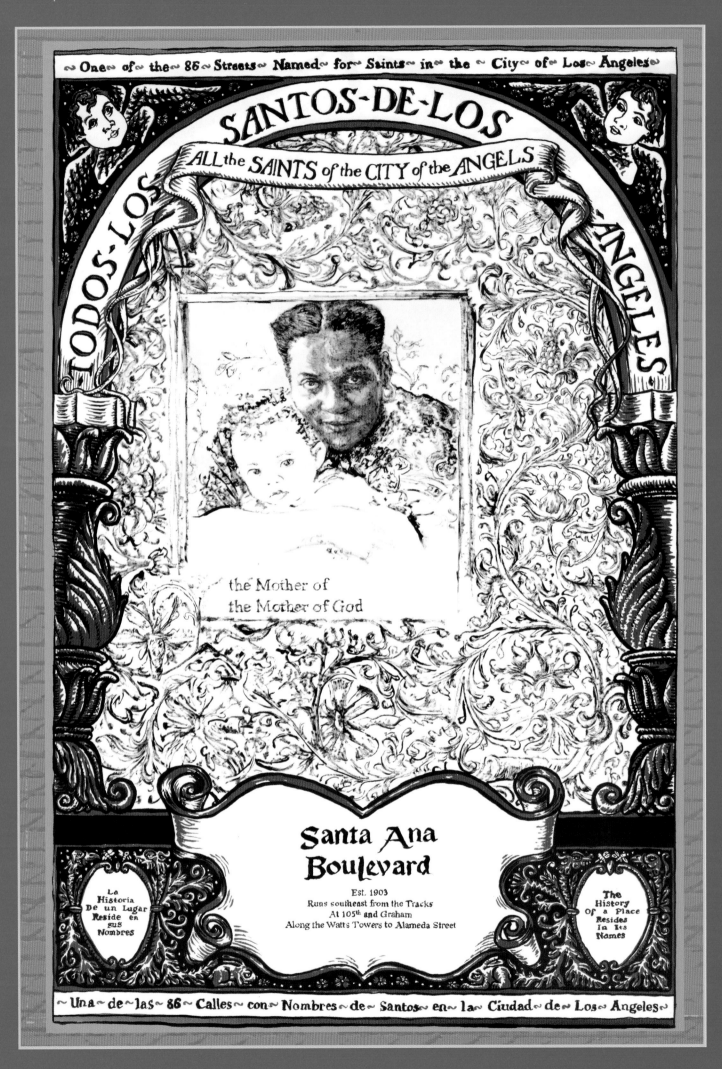

TODOS·LOS

SANTOS·DE·LOS

ANGELES

ALL the SAINTS of the CITY of the ANGELS

the Mother of
the Mother of God

Santa Ana Boulevard

Est. 1903
Runs southeast from the Tracks
At 105th and Graham
Along the Watts Towers to Alameda Street

La
Historia
De un Lugar
Reside en
sus
Nombres

The
History
Of a Place
Resides
In Its
Names

~ Una ~ de ~ las ~ 86 ~ Calles ~ con ~ Nombres ~ de ~ Santos ~ en ~ la ~ Ciudad ~ de ~ Los ~ Angeles ~

SANTA ANA
BOULEVARD

Watts

Like it was a scene in some Romare Bearden painting
The mother of the mother of God lives
Over by the railroad tracks
Making do on
Just under seven thousand dollars a year,
Holding her family together with heart-sewn threads
Prayer-lit candles
Serious black-eyed peas and menudo.

The mother of the mother of God
Probably didn't finish high school,
Certainly didn't get a degree,
Likely speaks Spanish
And definitely expects you to finish your homework
And let her know
Where you're going,
Who with,
And how long you're going to be there.

The mother of the mother of God
Recognizes injustice and long odds
And keeps these things hidden in her heart
—until she's ready to speak her mind.

She enfolded Simon Rodia in the crook of her arm
"Clad in tattered overalls and a dusty fedora"
As he, like her, made life out of nothing—
Just workin' with the scraps you was given—
Twisted railroad ties, pottery shards, glass marbles and poetry:
A veritable vertical midden of the century's first half, a
"Jazz cathedral" to all things unseen, possible and imagined.

His towers rising majestic into the big empty sky
Pointing the only way out of dire circumstance:
Hard work and dedication, open heart and imagination.

Santa Ana Boulevard, the mother of the mother of God,
Tires of her neighborhood's "concentrated poverty" and
Maybe even more,
Tires of the endless studies and news reports about it
That don't *do* anything about it while she
Works odd jobs in the "informal economy"
Comin' home after work late—
Just another boulevard, nothing much you'd think twice about,
Just one more black or brown mother with
Eyes withdrawn while she
Worries about the rent and the
Children getting home safe

And the
Children nothing much Los Angeles thinks about either
But, you know?
Simon Rodia was nothing much you'd think about:
Think about *that.*
And that Boulevard? Santa Ana?
She turns around and lets wail a full-throttle throaty saxophone trail
You never know *who* will turn out to be
the mother
of the mother
of God

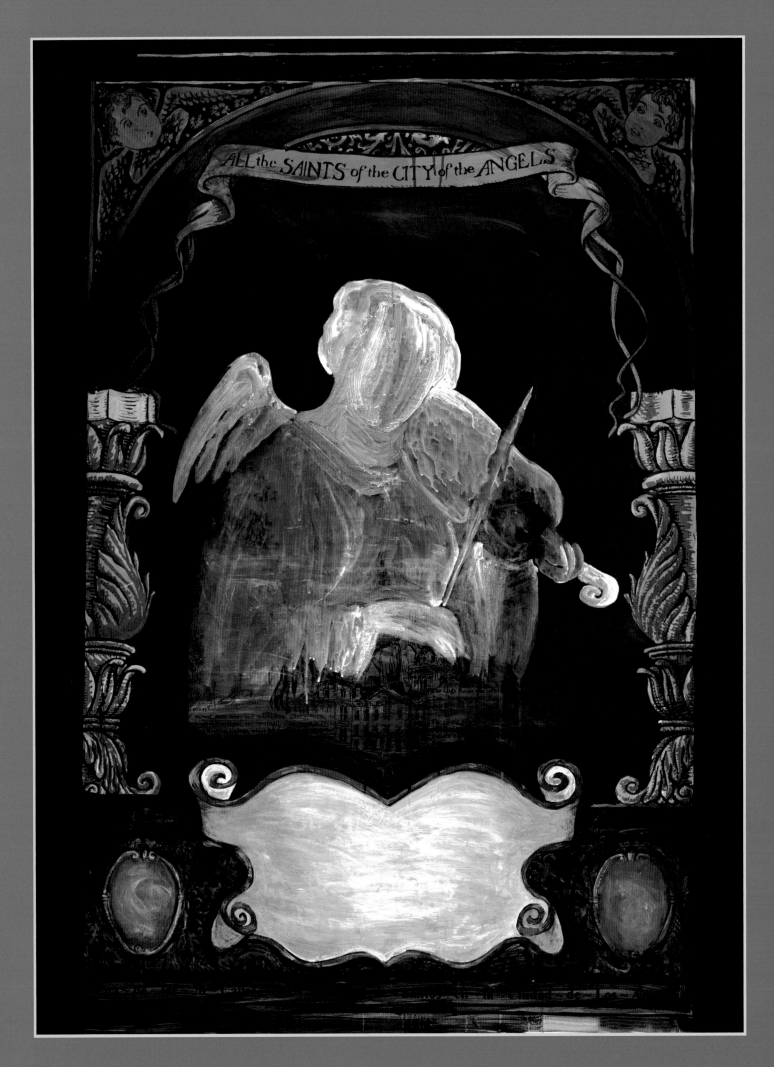

ALL the SAINTS of the CITY of the ANGELS

AFTERWARDS

The Once and Future Lobos Angeles

The prayers of holy saints and wronged souls
Like high-rear'd bulwarks, stand before our faces...
—Richard III

The saints have been part of the Southern California landscape since Juan Cabrillo sailed north from Baja in 1542 and sought refuge in a port he named San Miguel—later changed, by Vizcaíno, to San Diego.

As omnipresent as palm trees, the saints fill our maps with the poetry of another age, one as comfortable with fact as with fantasy. Yet the tales they tell bespeak humankind's ageless quest to live in harmony with a world of multiple interpretations.

Back on that first Wednesday in August 1769, when Fray Crespí gave El Pueblo de Nuestra Señora de los Angeles its name, his inspiration was St. Francis of Assisi's thirteenth-century chapel. That chapel, in turn, was named for the valley where it stood; and that valley, an ancient legend tells us, was so named because of "the singing of angels which had been frequently heard there."

The next morning Crespí's party, wandering along future Wilshire Boulevard, somewhere around MacArthur Park, came upon Tongva villagers who "on seeing us, came out into the road [and] began to howl like wolves."

Wolf howls and angel songs may seem worlds apart—surely they must have seemed so to Crespí and company. Yet each expresses the story and spirit of its land and peoples, and implies a spiritual connection to the earth.

As the Tongva and Chumash were driven from their homelands by the successors to Crespí and his band of soldiers, the wolf howls fairly ceased here; and any angel songs which might have supplanted them were themselves silenced by the imminent march of "Progress" several decades thereafter.

Had the Spaniards and natives somehow met as equals (as the natives, apparently, were prepared to do), had Fray Crespí and his men only understood that they had as much (or more) to learn as to teach, the wolf howls would not have been silenced, the saints' roots here might be more secure, and angels' songs might more readily be heard.

In the City of Los Angeles, whose multicultural richness and complexity make it emblematic of much of the world of the future, the opportunity for such encounters will surely continue. Santa María, St. Moritz, San Pedro, and San Ysidro each remind us of our troubled history of failing to treat with equality and respect those whose lives intersect with our own—those we err in considering "other."

And yet, as Santa Ana demonstrates, we can never imagine the potential for positive, creative gifts that those around us possess.

If the narrative arc of this book sometimes tends toward lament, it is for losses suffered—of the land and its native peoples and cultures; of opportunities for cooperation and fair exchange; of civic will and magnificent architecture.

Yet hope abides here, too. For, as the stories of these streets make plain, it is only by reaching out—to aid, to understand, to build, and to preserve—that our community is made whole.

Those who struggle to accomplish these goals, to the benefit of us all, are truly All the Saints of the City of the Angels.

DAMOS GRACIAS

Giving Thanks

Of course in the end the really curious part of it is, it's your name all alone on the spotlit stage of the title page, your name on the cover taking the bows. Surely one day long ago the Acknowledgments page was invented to assuage some of that guilt; to *acknowledge* how much more complex and felicitous life is; how interconnected we all are by the selfless gestures, large and small, of others who have made possible whatever it is we hope to accomplish.

First, I want to thank the saints themselves—vivid, individually unique, and occasionally gratingly insistent that I get their stories *right*—for inviting me to rescue their relevance from historical obscurity.

I was warmly received by a community of scholars and historians—a great gift in and of itself; and a number of them provided information, advice, and counsel when sorely needed. Chief among these has been Michael Engh, Associate Dean, Loyola Marymount University. But, thanks also to Stafford Poole, independent scholar of Colonial New Spain; John R. Johnson, Curator of Anthropology, Santa Barbara Museum of Natural History; Angie Dorame Behrns, President, Gabrielino Tongva Springs Foundation; Jaime Lara, Associate Professor of Christian Art and Architecture, Yale School of Divinity; Msgr. Francis Weber, Archivist, San Fernando Mission; Ernest Marquez, independent historian of Santa Monica Canyon; Betty Lou Young, historical laureate of the Pacific Palisades; Richard K. Cacciopo, independent historian of Woodland Hills; Father Michael Kennedy, Dolores Mission Church, Boyle Heights; and Cindi Alvitre, Culturalist, Department of World Arts and Cultures, UCLA.

For collegiate support and encouragement over the years, Jonathan Spaulding, Vice President for Exhibitions, Autry National Center, and Executive Director, Museum of the American West, has been a joy to bounce ideas off of. Thanks in a similar vein to Janet Fireman, editor of *California History* and Curator of History at the Museum of Natural History of Los Angeles; Amy Scott, Curator of Visual Arts, Museum of the American West, Autry National Center; William Deverell, Professor of History, University of Southern California; Dr. Thomas Andrews, Director (retired), Historical Society of Southern California; James Rojas, Founding Director of the Latino Urban Forum, Los Angeles; Gloria Lothrop, Cal State Northridge emeritus professor of California history; and Cynthia MacMullin, Director of Exhibitions, Museum of Latin American Art, Long Beach, California.

Special thanks to Michael Engh, Janet Fireman, John Johnson, and Cindi Alvitre for reading parts of this manuscript and making important suggestions for improvement.

Thanks to all my models and muses: Tonantzin Carmelo (Kinkingna); Ai-Hsien Carreon (Santas Susana and Susanna); Natasha Diamond-Walker (Santa Ynez of the Palisades); Xochitl Duran (Santa Lucía); Natalie Jatib (Santa Clara Street); Stephanie Raygoza (St. Stephanie); Doris Sosin (Santa María); Jevona T—— (Santa Ynez Street); Indira Tyler (San Teala); Veronika Waller, David, Imani, and William (muses for Santa Ana); Darrel Wright (St. Moritz); Willa and Cristina (models for Santa Ana); David, Inge, and fellow guests of LAMP (San Julian); las Madres de Dolores Mission (Santa Mónica); the anonymous gardener of San Ysidro Drive; and the anonymous native of San Sebastián.

For help with logistics, access, connecting the dots between people, and endless other details, thanks to Felicia Kelley, Senior Programs Manager, Los Angeles office, California Council for the Humanities; Judith Luther Wilder, Founding Director of the Center for Cultural Innovation; Rosie Lee Hooks, Director, Watts Towers Arts Center; Cindy Sewell, Vice President, Bartlein and Company; Vanda Vitali, then-Vice President of Public Programs, Museum of Natural History, Los Angeles; Brandy Maya Healy, Joe Smoke, Michelle Berne, and Dee McMillin of that buried treasure, the Department of Cultural Affairs, City of Los Angeles; Carolyn Kozo Cole, Curator, Photo Collection, Los Angeles Public Library; Edward Nygren, then-Director of the Huntington Art Collections, Huntington Library, San Marino, California; Suzanne Lummis, poet-anthologist of the Arroyo; Anne

McGann of Holy Family Bookstore, South Pasadena, California; Pete Neeley, S.J.; Ernestina Sanchez and Kristen Contreras, intrepid bibliographers; Vicky Curry and Val Zavala of KCET's *Life and Times Tonight*; Gia Gittleson and Sarah Blackwill, *Los Angeles Magazine*; Mary Rourke, Teresa Watanabe, and George Ramos, *Los Angeles Times*; Mary Lou Teel, Producer, *CBS Sunday Morning*; Nancy Smith, *Palisadian Post*; Mike Lee and George Hernández, for seven years of digital scans, prints, and photographs; Cidne Hart, patient designer of my past attempts at a book; and Edward Carreon and Annie Wells, portrait photographers.

Thanks to the Avenue 50 Studio Gallery's founder and Director, Kathy Gallegos, for exhibiting and supporting *All the Saints* through its early years. Thanks also to Gallery 727, Downtown Los Angeles; Oranges/Sardines Window Gallery, Highland Park; Hollywood Public Library; Occidental College Library gallery; Tía Chucha's Coffeehouse and Gallery, Sylmar, California; and Mark Greenfield, Director, Municipal Art Gallery, Barnsdall Park, Los Angeles.

For financial support, the Department of Cultural Affairs of the City of Los Angeles, the California Council for the Humanities, and the Arroyo Arts Collective of Northeast Los Angeles have been indispensable. Thanks also to The Seaver Institute as well as the individual contributors to *All the Saints:* Romaine Ahlstrom and Daniel Strehl; Martha Harris and Morgan Lyons; Susana Jacobson; Judson Studios, Highland Park; Felicia Kelley and family; Mary Kelly and Allan Heskin; Edward and Julie Nygren; Vincent Paterson; Jeannine Patria; Pamela and Edward Rappaport; Ruby Rojo; George and Mary Saulnier; Hank and Patricia Schwarz; Doris Sosin and Rolfe Wyer; Elena Sotelo-McCrary; Patricia Washington; Elta Wilson; the Latino Urban Forum; and an Anonymous or two.

Special thanks to Felicia Kelley for leading me to my personal Moses, Malcolm Margolin of Heyday Books, who has made good on his promise to be "not only a good publisher but a good friend"—although he seriously undersold himself in both categories. Thanks to Malcolm, as well, for saddling a star team with keeping this lumbering project on track: my tenacious yet *cariñosas* editors Kate Brumage and Jeannine Gendar, inspired designer Lorraine Rath, and the assorted denizens of Heyday Hall, who lit votive candles and pinned *All the Saints* icons above their desks to keep me going until the end.

Thanks to heart-of-gold Judith Luther Wilder for introducing me to Vanda Vitali, who led me to Jonathan Spaulding, who provided *posada* for *All the Saints* at the Museum of the American West, Autry National Center, where they (and I) have been further nurtured by Melinda Utal-Martinez, Evelyn Davis, Jasmine Knowles, Paula Kessler, Owen Brady, Marlene Head, and John Gray, among many smiling others.

This book, like everything I've created over the past three decades, would never exist without the support of—and at its deepest, truest level is offered in gratitude to—my wife, Mimí. Close behind (and about a foot taller) stands the critic whose opinion matters to me most, our magical son, Jacobo.

It is unlikely I would have begun this project without the financial support and encouragement, in 2000, of the Department of Cultural Affairs of the City of Los Angeles: certainly I would have been unable to continue without ongoing grants through its Artist in the Community program. At a time when Los Angeles remains one of the few cities in the country providing direct funding to artists (and that funding is ever in danger of disappearing), I offer this book as grateful, humble testament to what such support can engender—and in this case has most definitely profited from: a community of saints.

J. Michael Walker

El Pueblo de Nuestra Señora de Los Angeles, Alta California

31 julio 2007, Día de San Ignacio de Loyola

NOTES

NOTES

Websites referred to in these notes were current as of the week of July 23-29, 2007.

Introduction

Bolton, in *Fray Juan Crespi* (1927, p. 147) places the Spaniards' camp "probably near Downey Avenue" (the name, when Bolton was writing, of present-day Broadway Blvd. north of the L.A. River, in Lincoln Heights), around *La Playita* Seafood Restaurant; quotes describing the natives and locale, ibid., p. 146 ff. For Crespi's use of saints' names for dates and places, and the variety of flora and fauna found, see Crespi's *A Description of Distant Roads* (2001, pp. 261-342). Nadeau's *City-Makers* (1965) and Newmark's *Sixty Years in Southern California* (1930, 3d ed., p. 569 ff.) convey a sense of the easterners' effect on Los Angeles; while Deverell's *Whitewashed Adobe* (2004, p. 59 ff.) neatly addresses their attempt to recreate the city's "Spanish" past. For morning hymns to the Virgin, see H. H.'s "Echoes in the City of the Angels," *The Century Magazine* (vol. 27, no. 2, p. 194 ff.). For *"las peras de San Juan,"* see López de Balderrain's "The Awakening of Paredón Blanco under a California Sun," *Historical Society of Southern California Annual Publication* (1928, p. 72).

One: The Journey Begins

San Julian Street and Place

This piece is informed by (and two quotations are taken from) the epic narrative "The Life of Saint Julian the Hospitaller" (1286, trans. Morinelli), which can be found on the Internet Medieval Sourcebook website, www.fordham.edu/halsall/sbook.html (hereafter Medieval Sourcebook); also by one of the several saints' lives narrated in "Saint Julian" of *The Golden Legend* of Jacobus de Voragine (1993, vol. 1, p. 126 ff.); as well as by my interactions with LAMP's founder and then-director, Mollie Lowry; its current program director, Patricia Lopez; and by the dozen "guests" who posed for my painting as contemporary San Julians, including David, Inge, Leon, Kenny, and others. LAMP's walk-in shelter is located at 627 So. San Julian Street, L.A. 90012.

Santa Ynez Street

Quotations heading sections ii-v are taken from "Saint Agnes, Virgin," in *The Golden Legend* (vol. 1, pp. 101-104). Painting: image based on depiction of St. Agnes by the Master of the St. Bartholomew Altarpiece.

Santa Clara Street

Names and locations of long-gone streets near Santa Clara are taken from nineteenth- and early twentieth-century Sanborn Maps of Los Angeles, Los Angeles Central Library History Department; Santa Clara's life, from the "Saints O'the Day" section of the website for St. Patrick Catholic Church, Washington, D.C., www.saintpatrickdc.org (hereafter Saints O'the Day). The poem's final line is taken from the "Common Questions about Religious Life" page of the Monastery of St. Clare website, www.poorclaresc.com/faq.html. Painting: central image based on unknown artist's portrayal of St. Clare from Rev. Daniel A. Lord's *Miniature Stories of the Saints*, book 2 (1943). Santa Clara's lantern is an Adams & Westlake "Santa Fe" railroad tall-globe, from the Key, Lock & Lantern Railroadiana Collectors website, www.klnl.org.

St. Vincent Court and Place

From Newmark's *Sixty Years:* descriptions of Vicente Lugo and adobe (p. 99); O. W. Childs (pp. 69, 232); Rosa Newmark (note for p. 341); St. Vincent College (pp. 232, 660-661). Vincent de Paul quote from the Patron Saints website, www.catholic-forum.com/saints/indexsnt.htm (hereafter Patron Saints).

St. Joseph's Place

Image of and information about St. Joseph's Church come from the article "Busy Franciscan Monks in This City," *Los Angeles Sunday Times* (March 3, 1901). For the history of St. Joseph's, see also Hermine Lees' "What Ever Happened To...?" in *The Tidings* (Feb. 4, 2005). Depiction of Rev. P. Victor Aertker from the *Catholic Directory an Parish Gazetteer* (1899, p. 56). Image of St. Joseph based on the *bulto* by Rafael Aragon.

Santa Mónica Boulevard

Tale of the Spanish explorers and the tears of Santa Mónica recounted in *Los Angeles: City of Dreams,* by Harry Carr (1935, p. 24), who felt

the story did not hold water. St. Augustine's quote, from his *Confessions*, taken from Jean Croiset's *Año Cristiano* (1803, tomo 5, p. 59) as part of the story of Santa Mónica: "En qué abismo estaba yo metido...y vos...extendisteis...ácia mí vuestra mano misericordiosa para sacarme de aquellas profundas tinieblas..." (English translation by this author).

St. Stephanie de los Niños

In addition to personal experience, this piece is informed by the Los Angeles Police Department Press Release of Monday, Oct. 9, 2000, "Shooting Leaves Two Dead"; by the "Statement by Rita Chairez" before the Catholic Campaign for Human Development in Washington, D.C., on Feb. 11, 2007; and by the editorial "Death Penalty Diminishes Our Society," co-authored by Bishop Gabino Zavala and Father Michael Kennedy ("Special to the *Los Angeles Times*," Oct. 31, 2000). It is from the latter piece that the prayer authored by Stephanie's cousins is taken.

Two: False Moves

All the Saints of Carthay Circle

McGroarty's egregious quote is taken from his *California: Its History and Romance* (1926, 11th ed, p. 42 ff.); "there is a feeling of regret," ibid., p. 153. For the quotations about, and history of, Carthay Circle and J. Harvey McCarthy, see "A Monument to California Pioneers," *The Grizzly Bear* (Sept. 1922, p. 16 ff.) and "Pioneer Mother Honored," ibid. (May 1923, p. 36 ff.). For attitude of Native Sons of the Golden West toward Asians in the 1920s, see Daniels' *The Politics of Prejudice* (1977, p. 85 ff.). For heartbreaking abuses at Mission San Diego, see the short book *Letter of Luis Jayme, O.F.M., 1772* (1970)—and for their consequences, see Fuster's letter in "1775: Rebellion at San Diego," *Lands of Promise and Despair*, ed. Beebe and Senkewicz (2001, pp. 186-192). For abuses and revolt at Mission Santa Ynez, see González' "1824: The Chumash Revolt," ibid., pp. 323-328, as well as Monroy's *Thrown among Strangers* (1993, p. 94 ff.).

San Fernando and San Fernando Mission Roads

Fr. Juan Crespí's description of the San Fernando Valley as a "very pleasant and spacious valley" taken from Bolton's *Crespi*, p. 150. Infant mortality figures from Johnson's "The Indians of Mission San Fernando," in *Mission San Fernando, Rey de España, 1797-1997: A Bicentennial Tribute*, ed. Nunis (1997, p. 255 ff.). For Eulogio de Celis' purchase of San Fernando, see The Valley Observed, (www.americassuburb.com/ brief_history.php). The price: $14,000 for at least 116,858 acres; alternatively, Guinn's *A History of California and an Extended History of Los Angeles and Environs* (1915) claims 125,000 acres; W. W. Robinson, in *The Story of San Fernando Valley* (1961, p. 12), calls it "13 square leagues." For Charles Maclay's first view of, and quote about, the Valley, ibid., p. 24 (the second half of the "quotation" is, of course, this author's invention.) For participation in the purchase by Southern Pacific Railroad's president, Leland Stanford, ibid. and see also Jorgensen's *The San Fernando Valley: Past and Present* (1982, ch. 6, sec. 4). For the sad tale of Rogerio Rocha and Charles Maclay, see mainly Painter's *Studying the Condition of Affairs in Indian Territory and California* (1888, pp. 74-92). For Eulogio de Celis' "possession of the lands,..." ibid., p. 82. For deputies' testimony, ibid., pp. 85-86 ("Statement" by Ex-Deputies Hammel and Agiurre [sic], July 30, 1887). For Maclay's sale of Rogerio's land (and, in particular, the value of the spring located there) and its connection to the founding of his theology school, ibid., p. 89, C. C. Painter: "That the valuable spring of water on this land, the thing for which the fight was really made, did give value to the land out of which the money given for this school was realized, and really constitutes the foundation of this school...this is not denied, and perhaps will not be." For King Ferdinand's fear of an old woman's curse, see Saints O'the Day, "Ferdinand III, King of Castile." See also Harrison's *The New Calendar of Great Men* (1892, p. 303): "I fear more the curse of one *poor* old woman than a whole army of Moors" (emphasis added). Painting: portrait of Rogerio Rocha based on photograph by Charles Lummis, Autry National Center, Braun Research Library, Los Angeles.

Three: *Puro* Eastside

San Marcos Place

Painting: quotation on back wall taken from "Mark the Evangelist," Coulson's *The Saints: A Concise Biographical Dictionary* (1957, pp. 512-513). Image of San Marcos based on illumination by Simon Marmion, ca. 1470, coll. Huntington Library, San Marino, Calif. Lion in rondel based on a church ceiling painting on amate paper by *tlacuillo* Juan Gerson, perhaps the earliest post-Conquest named native artist, Iglesia de la Asunción de Ntra. Sra., Tecamachalco, Puebla, Mexico, ca. 1580.

Santa Fe Avenue

Material on the coming of the Southern Pacific and Santa Fe Railroads to Los Angeles is readily available; see, for example, practically all of Nadeau's *City-Makers*. For efforts to bring the Southern Pacific to L.A., see Newmark's *Sixty Years*, p. 440 ff., 502 ff.; for the arrival of the Santa Fe, ibid., p. 549; for cost-cutting fares, ibid., p. 556 ff.; for a good sense of the manic air of the resulting "boom," ibid., p. 569 ff. For Anglo L.A.'s complicated rapprochement with its "poor" *madre*, see Deverell's *Whitewashed Adobe*, p. 59 ff.

San Pablo Street

As it happens, since this piece was written and painted (in 2000), San Pablo Street's "child's rendering of a factory" was torn down and its southern "dead-end at hilltop" has been closed to the public. Locations of Biggie Tract, Lambie Subdivision, et al. based on Sanborn maps and the 1891 and 1894 panorama maps of Los Angeles in the online collection of the Library of Congress. Painting: Pablo's quote, "Though I speak with the tongues of men and of angels," taken from 1 Corinthians 13:1, KJV.

San Benito Street

Painting: St. Benedict's face from Fra Angelico's *Crucifixion* fresco, Museo di San Marco, Florence; background text from an illuminated manuscript of the Rules of St. Benedict; peripheral depictions are Mexican president Benito Juarez, nineteenth-century Angelino B. D. "Don Benito" Wilson, and another St. Benedict, Benito de Palermo.

St. Louis Street

Life of William Workman taken from Warner's *An Illustrated History of Los Angeles County, California* (1899, p. 826 ff.) and Guinn's *Historical and Biographical Record of Los Angeles and Vicinity* (1901, p. 863). Painting: image of St. Louis from *bulto* at Mission San Luis Rey; "City View Tract" advertisement taken from the Los Angeles *Tribune* (March 14, 1887); WHW portrait from Hill's *La Reina: Los Angeles in Three Centuries* (1929).

San Andreas Avenue

Painting: image of San Andreas based on stained glass from Workshop of Veit Hirsvogel the Elder, ca. 1504, coll. Forest Lawn Memorial Park, Glendale, Calif. Quotation from Saints O'the Day, "Andrew the Apostle."

San Ramón Drive

For San Ramon Nonato, see Giffords' *Mexican Folk Retablos*, pp. 106-107, and Saints O'the Day, "Raymond Nonnatus, O. Merc. Cardinal." Painting: central image based on a nineteenth-century *bulto*, Taylor Museum coll., Colorado Springs, Colo.

San Rafael Avenue

For the history of Rancho San Rafael, see Kielbasa's *Historic Adobes of Los Angeles County* (1997, pp. 58-68); "his two favorite children," ibid., p. 62. Julio Verdugo's 1861 loan from Jacob Elias is given as $3445.47 at a "three-percent interest payment due every four months," ibid., p. 64; "out of pity for the once proud ranchero," ibid., p. 65. Quote from the Book of Tobit taken from chapter 5, verse 27. Painting: based on tempera panel *The Archangel Raphael and Tobias* by Neri di Bicci (1419-1491), Lehman coll., Metropolitan Museum of Art, New York.

St. Paul Avenue and Place

For history of St. Paul's, see Newmark's *Sixty Years* (p. 301 and note) and *Los Angeles City Directory* (1886, pp. 49, 54). For location of land for church and school, see Sanborn Map, 1920: "Subdivision of St. Paul's School Land" bounded by Lucas and Beaudry, 6th and 7th Street; "St. Paul's Church" land bounded by Lucas and Boylston, 7th and 8th Streets. For destruction of the cathedral and related quotes, see "Wreckers at Work on St. Paul's Cathedral," *Los Angeles Times* (March 11, 1980, pt. 2, p. 1). The author thanks Janet Kawamoto, Director of Communications, Episcopal Diocese of Los Angeles, for help and discussion on the diocese's actions. (For the record, the diocese disputes the assertion made by the *Times* that they were looking to sell the property; their present position is that the sale was made with regret because it would be prohibitively expensive to bring the cathedral up to safety standards.) St. Paul quote, "Wherefore let him that thinketh he standeth take heed lest he fall," taken from 1 Corinthians 10:12, ASV. Painting: several elements taken from the *Times* article noted above and its accompanying photographs. Paul's lament about "the fashion of this world" from 1 Corinthians 7:31, KJV.

St. Albans Street

For information on St. Alban, see Saints O'the Day, "Alban of Great Britain," and also the Diocese of St. Albans website. Painting: central image of sneakers hanging from telephone lines based on author's photograph taken on St. Albans Street, Highland Park, fall 2000.

Four: The City Spreads West

St. Andrews Place

St. Andrews Place's geography is informed by Sanborn Map, 1900; California Index of the Los Angeles Public Library; and *Thomas Guide to Los Angeles County Streets* (2000) (hereafter *Thomas Guide*). Count of stop signs, speed bumps, and all the rest from personal observation, 2002 (thanks to Xitlaly Carrasco for keeping score).

San Jacinto Street

For the *Acta Sanctorum* quote about St. Hyacinth, see "Saint Hyacinth Odrowaz" in O'Daniel's *The First Disciples of Saint Dominic* (1928, ch. 23). Haiku is author's own.

St. George Street

Painting: St. George is patron saint not only of England but also of Ethiopia, and this piece is offered in honor of Los Angeles' Ethiopian community. For St. George in Ethiopia and his connection to one of the most remarkable churches in that country, if not the world, Bet Giorgis, see the Places of Peace and Power website, www.sacredsites.com/africa/ethiopia/sacred_sites_ethiopia.html. The painting's central image is based on an icon by the Venetian (!) artist Nicolò Brancaleone (active 1480-1526), "who spent more than thirty years working in Ethiopia for Ethiopian aristocratic patrons" (Heldman, African Zion, 1993, p. 88, cat. 88). Background text is a medieval prayer to St. George in Latin. Lower image, based on the logo of Los Angeles' beloved Western Exterminators, commemorates St. George as the forefather of modern pest exterminators.

San Marino Street

Painting: central image of San Marino (Marinus the Dalmatian) as a stonemason taken from the website of the Italian city-state of San Marino (2003); portrait of Andrew Shorb is set inside the City of San Marino's City Seal; female image is that of a Korean *Bune* (coquette) traditional dancer.

St. James Park and Place

For the history of Charles Silent and St. James Park, see Ruth Powell's booklet "Chester Place," 1964. For the storied history of London's St. James Park, see the park's very own (and very British) website, www.royalparks.org.uk/parks/st_james_park. Information on Frank D. Lanterman High School courtesy of an interview with Principal Gwendolyn Brumfield, spring 2007.

St. Charles Place

Painting: organization inspired by, and in homage to, the work of Rube Goldberg (see Wolfe's *Rube Goldberg: Inventions*, 2000). For Charles Crenshaw, see *Los Angeles Times* (Aug. 19, 1937, pt. 2, p. 1; Aug. 20, 1937, pt. 2, p. 4). History of St. Charles, Missouri, and Louis Blanchette courtesy of the State Historical Society of Missouri. For Charles Borromeo, see that saint's entry on Patron Saints. On the importance of Crenshaw's trip to Brazil, see the Los Angeles Lafayette Square Neighborhood Association website, www.lafayettesq.org/History.asp.

St. Elmo Drive

For the entwined legends of Saints Erasmus and Peter Gonzalez, see Saints O'the Day, "Erasmus of Formiae" and "Peter Gonzalez," respectively. For St. Elmo's Fire, see "The Earth's Anomalous Lightforms" on Sean Palmer's InaMidst website, inamidst.com/lights; for the Columbus diary entry, see Tomlinson, *Thunder-Storm* (1848), p. 107. Roderick Sykes' quotes taken from Community Television of Southern California's *Life and Times* (July 22, 2003). For the Village motto, go see the Village sometime. Shakespeare quote from *The Tempest* (Act I, Sec. 2). Painting: central image is of Roderick Sykes, based on a photograph by Sarah M. Brown, *Los Angeles Times*.

Santo Tomás Drive

For Rancho la Ciénega o Paso de la Tijera, see Kielbasa's *Historic Adobes*, p. 115 ff. For the history of La Misión de Santo Tomás de Aquino, see "Las Misiones en Baja California" on the Cetys Universidad website, www.mxl.cetys.mx/Expos/MisionesBC; see also

Vernon's *Las Misiones Antiguas: The Spanish Missions of Baja California, 1683-1855* (2002). For St. Thomas' "Student Prayer," see the "Prayer of St. Thomas Aquinas before Study," published in *Raccolta* no. 764, Pius XI Studiorum Ducem, 1923. ("Tu, qui linguas infantium facis disertas, linguam meam erudias atque in labiis meis gratiam tuae benedictionis infundas. Da mihi intelligendi acumen, retinendi capacitatem, addiscendi modum et facilitatem, interpretandi subtilitatem, loquendi gratiam copiosam.") For the Kumeyaay peoples, see kumeyaay.com and www.kumeyaay.info. Thanks also to the principal of Marlton School for her time and assistance. Painting: Santo Tomás is based on an anonymous seventeenth-century Cuzco School painting, *Santo Tomás Fulminando al Demonio con su Pluma*, coll. Museo de Arte de Lima; an image of Marlton School is substituted for the church Tomás normally holds.

Santa Rosalía Drive

For Anthony Van Dyck's travel to Sicily, see, among others, *Arte Historia*, www.artehistoria.jcyl.es/genios/cuadros/1211.htm. For the legend of Santa Rosalía, see the remarkable "Santa Rosalía, Virgen" in Croiset's *Año cristiano* (1804, tomo 9, p. 75 ff.); also "Saint Rosalía" on Patron Saints and "Rosalía of Palermo" on Saint's O'the Day. For the mission of Santa Rosalía de Mulegé, see Cetys Universidad website. For Cochimí cave painting, see, among others, the "Local History" section of the Parque del Palmerito website, www.catavina.com/park.html, as well as kumeyaay.com. Painting: Anthony Van Dyck self-portrait; one of several paintings Van Dyck made of Santa Rosalía; Cochimí cave paintings.

St. Susan Place

There are at least four saints named Susanna, with feast days of Jan. 18, May 24, July 23, and Aug. 11. The last one is the presumed saint for our street. As Coulson's *Saints* sums it up, "[S]he possessed not only beauty but learning and was so highly regarded that the Emperor Diocletian wished her to marry his son-in-law, Maximian. She...refused to accept this offer, preferring to remain celibate, but...was eventually beheaded" (pp. 703-704).

"El Corrido de Santa Susana"

"El Corrido de Santa Susana" was composed by the author of this book in offering to all female victims of domestic violence. Painting: the design is inspired by, and in homage to, the graphic work of José Guadalupe Posada, the great late-nineteenth- and early-twentieth-century Mexican graphic artist.

Five: From Bel-Air to the Beach

San Marco Drive and Place

Painting: central image is based on the miniature of St. Mark in the Godescalc Gospels, created in Aachen in 781 to 783 for Charlemagne. The text on the evangelist's tablet comes from a sign posted on San Marco Drive, spring 2007.

St. Ives Drive and Place

There are two saints named Ives: a woman, also known as Ia, who crossed the Irish sea on a leaf; and a Persian fellow, also known as Ivo, whose gravesite was discovered in England some four hundred years after he died. Hard to choose (although neither particularly relates to our streets). The central image is based on a painting attributed to Rogier van der Weyden, ca. 1450, supposed to be a depiction of St. Ivo (National Gallery, London). The border is based on this author's photograph of the corner of St. Ives Drive and Place. Our saint contemplates a very well-known riddle.

St. Pierre Road

For the history of Alphonzo Bell, see his son Alphonzo's autobiography, *The Bel-Air Kid* (2001); see also the Bell High School website, www.bell.k12.ca.us (the city of Bell is named for Bell Sr.). The quote about Bell's vision taken from his promotional brochure, "Bel-Air: The Exclusive Residential Park of the West," 1923. Painting: St. Pierre, from the painting by the Master of the St. Bartholomew Altarpiece, National Gallery, London.

St. Cloud Road

For the legend of St. Cloud, see Saints O'the Day, "Cloud (Clodoald, Clodulphus) of Nogent, Abbot." Quotes from the Rules of St. Benedict can be found in "The Rule of St. Benedict, c. 530," on Medieval Sourcebook. Description of Bel-Air taken from "Bel-Air: The Exclusive Residential Park of the West." Painting: image from Schiller's *Coelum stellatum Christianum* (1623). Lines beginning "Soft spread the southern summer night" from the poem "Saint-Cloud" by Sir Walter Scott.

San Remo Drive

For the basic *nada* known about this saint, see Saints O'the Day, "Romulus of Genoa."

San Onofre Drive

For legend of St. Onuphrius, see Saints O'the Day, "Onuphrius of Egypt, Hermit," and the Orthodox Church in America website, "Lives of the Saints" (www.oca.org/FSlives.asp?SID=4). The Romanesque fresco in question is located in the eleventh-century Yilanli Kilise (Church of the Serpent), Goreme, Turkey: Onuphrius' stylized form has led to a cottage industry of tour guide and tourist misinterpretations which, through repetition on tourism websites, have taken on the air of urban legends (ironic for a desert hermit). Painting: based on a fourth-century Byzantine icon, accessible on the Orthodox Church in America website. Besides images of homes on San Onofre Drive, note also the San Onofre nuclear power plant (shaped, oddly, like breasts)—a dragon which, unfortunately, the saint cannot drive away.

St. Bernard Street

For information about Fritz Burns, see *Southern California Quarterly* (vol. 65, p. 269 ff.) and the Fritz Burns Papers on the Department of Archives and Special Collections of Loyola Marymount University website, www.lmu.edu/Page4557.aspx. For information about St. Bernard High School, see that school's website, stbernardhs.com/srpage.html. For "Bernard of Clairvaux," see his entry on Saints O'the Day.

La Pasión de Santa Ynez

For a history of community resistance to overdevelopment in the Pacific Palisades, see Betty Lou Young's *Santa Monica Canyon* (1997, p. 96) and Pitt's *Los Angeles: A to Z* (1997, p. 375). For a concise explanation of the connection between Avenida de Santa Ynez and Santa Ynez Road, see the [California] Board of Recreation and Park Commissioners' "Report of General Manager," June 21, 2006: "On April 25, 1969, Headland Properties, Inc., offered to donate in conjunction with its proposed development of the Palisades Highlands...150 acres of land to be used for park and open space...The proposed donation was a condition for the subdivision of the development area...In 1972, Headland Properties donated to the City of Los Angeles approximately 48.6 acres of land, which would be developed as Santa Ynez Canyon Park," p. 1.

San Juan Avenue and Court

Not surprisingly, information on such a colorful figure as Abbot Kinney is readily obtained. Besides numerous Venice, California, web sources, see also Carolyn Elayne Alexander's *Venice, California* (1999) and Tom Moran's *Fantasy by the Sea* (1979). For Kinney's work with Jackson, see Appendix 15, "Report on the Condition and Needs of the Mission Indians of California, Made by Special Agents Helen Jackson and Abbot Kinney, to the Commissioner of Indian Affairs," July 13, 1883, in Jackson's *Century of Dishonor* (1885, p. 458 ff.). For Kinney's failure to anticipate the importance of cars, see George Garrigues' *He Usually Lived with a Female* (2006). For names of, and problems with, the canals, see Glen Howell's "Venice Canals" article on the Mar Vista Historical Society website, www.marvistahistoricalsociety.net. You gotta love a canal in Venice named Venus.

Santa Clara Avenue and Court

For Abbott Kinney's relationship with Irving Tabor, and Tabor's possession of the Kinney home, see *The Argonaut* (Feb. 14, 1991, p. 6, col. 1). For the legend of Santa Clara, see Patron Saints. Painting: "we did not shirk deprivation" from the *Testament* of St. Clare of Assisi, 1253; figure of Santa Clara based on a seventeenth-century painting by Baltazar de Figueroa, Iglesia Museo Santa Clara, Bogotá; face from a photograph of Irving Tabor's wife; central image based on a photo of Irving Tabor (both from *The Argonaut,* op. cit.).

Six: Over the Hills into the Valley

St. Edens Circle

Painting: this street name appears to commemorate St. Eden's Abbey, which is associated with one of two Irish saints named, variously, Aedan, Aidan, Aidand, Aiden, and/or Edan, of either Ferns (probably) or Lindisfarne. Both saints have additional names as well, including Maedoc, Maodhóg, Modoc, and Mogue: small wonder confusion arises as to absolute identity (see the various names, particularly Aidan of Ferns, on Saints O'the Day). As no record was found to conclusively wed one or the other to our tiny street, a retelling of St. Mogue's charming "fish story" seemed appropriate to honor this wee circular dead end.

All the Saints of Sylmar

This piece is informed by conversations in 2004 with staff of Santiago Estates. See also the map "Tentative Tract No. 35376 in the City of Los Angeles, approved as to design by the Cultural Affairs Commission, Jan. 9, 1986, Santiago Estates, Developer; Meuer Engineering, Engineer." For the history of Mountain View impacting the Poor Clares convent, see Dominic Berbeo's "Suburbia Moves on Peaceful Convent" (*Los Angeles Daily News*, May 20, 2001). For Mafia connection, ibid. and also see John Whiteside's "Capone arrives in Joliet to less than warm reception" (*The Herald News*, Dec. 29, 2001, from the archives of *Chicago Suburban News*). For conflict between estates and the "public benefits permit," see also "Los Angeles City Planning Commission Hearing," July 22, 2004. A pair of recent (Dec. 2006) offerings for homes in Mountain Glen and Santiago Estates illuminates some of the differences in properties: Mountain Glen had a two-story, four-bedroom home on a 6500-square-foot lot for $579,000; Santiago Estates had a two-bedroom "manufactured home" on land "owned by Santiago Estates and leased to the buyer of the home at approx $750 per month" for $140,000. Sister Magdalena Garay's quote comes from the end of Berbeo's "Suburbia Moves on Peaceful Convent."

San Miguel Street

This piece was inspired by seeing, in the street sign that marks the transition from San Miguel Street to De la Osa Street, the balance of St. Michael's legendary scales. I am indebted to Maria Helena Stewart for her many hours of dedicated research, in 1945 and thereafter, into the history of Rancho los Encinos. Because our goals were different, she did not connect the dots as I did; however, without her little book I would never have known such dots existed.

For the archangel's appearance to the Bishop of Siponto, see Butler's *Lives of the Fathers, Martyrs, and Other Principal Saints* (1780, vol. 5, p. 118 ff.). For a general history of José Vicente de los Reyes de la Osa, see Kielbasa's *Historic Adobes*, p. 33 ff., and a more detailed "Brief History of Vicente de la Ossa and Family," author unknown (ca. 1969), archived at Los Encinos State Historical Park (note that "De la Osa" can be spelled as "De la Ossa"). Four native men are mentioned by various authors, in various aggregations, as being the recipients of Pío Pico's largess: Francisco, Ramón, Tiburcio, and Roque: I selected the three I found most often named. The several transactions whereby Don Vicente squired ownership of Rancho los Encinos away from the native men and their female survivors are glaringly outlined in Stewart's *Los Encino's Past and Present* [sic] (1965, pp. 37-46). As Stewart herself states, "he was a pretty keen business man" (p. 46). Duly noted. For the significance of Don Vicente's middle name, "de los Reyes," ibid., p. 42 ff. Painting: face of Vicente de la Osa from his 1850 portrait in the collection of Rancho los Encinos State Park; faces of the natives from Kroeber and Heizer's moving *Almost Ancestors* (1968, pp. 94, 98, 105, 149); triptych based on the works of Lucas Cranach, Hans Memling, and Rogier Van der Weyden.

Santa Rita Street

For nineteenth-century devotion to Rita of Cascia in Mexico, see Frías' *Retablos Populares Mexicanos* (1991, p. 157). For Aguila and Rita Papabubaba's experiences with Don Vicente de la Osa and property taxes, see Stewart's *Los Encino's*, pp. 37-46. For the oily James Thompson, ibid., p. 48 ff., and especially pp. 13-16 of Alexander D. Bevil's "Santa Susana Pass State Historical Park Cultural Resources Inventory Historic Overview," California State Parks, March-April 2007: "Thompson's grief was extremely short-lived: he immediately married Francisca Sepulveda" (p. 14). From the same source, on the forced sale of Rita's ranch: "Thompson [ex-sheriff, ex-tax collector] may have manipulated the court to decide in his favor." In some earlier histories of Los Encinos, perhaps because they were created to convince legislators to establish and fund a state park, there is a tendency to gloss over Don Vicente's and Thompson's land acquisitions. But see, from the timeline "Title and Ownership of Rancho Los Encinos" in Los Encinos State Historical Park archives: "On March 6, 1867, Rita de la Ossa, widow of Vicente de la Ossa, pursuant to an order of court, conveyed to James Thompson." After her eviction, Doña Rita, then in her fifties, moved to the base of the Santa Susana Pass, where (as an employee) she ran a station supplying fresh horses for stagecoaches until moving to Mission San Gabriel in November 1883; in all, she soldiered on forty years after Manuela's death and Thompson's *traición*. To add to the epic family melodrama, Doña Rita Guillen de la Osa was a daughter of Eulalia Pérez de Guillen, the famed centenarian who had lost ownership of Rancho San Pascual some years before (See San Pascual Avenue, chapter 7, this volume). Painting: face of Manuela de la Osa from her 1860 portrait in the collection of Rancho los Encinos State Park; lyrics from traditional Mexican song "Cuatro Milpas."

Santa Lucía Drive

Lyrics "Tus ojos son dos luceros" taken from an anonymous song; "Malagueña Salerosa" by Pedro Galindo and Elpidio Ramírez; lyrics "Mis ojos me denuncian" taken from "Mis Ojos Me Denuncian" by José Alfredo Jiménez; lyrics "Tienen tus ojos un raro encanto" taken from "Ojos Tristes" by Guty Cárdenas and Alfredo Aguilar. The legend of St. Lucy taken from *The Golden Legend* (vol. 1, pp. 27-29).

San Blas Avenue

For images of an earlier Woodland Hills, see Cacioppo's *The History of Woodland Hills and Girard* (especially p. 58 for a panoramic photo from San Blas Hill). For quote about Blas Raho, see Newmark's *Sixty Years*, p. 293. For Blas Ordaz's questionable relations, see Geiger's *Franciscan Missionaries in Hispanic California, 1769-1848*, pp. 171 ff. For San Blas' charming legend, see *The Golden Legend* (vol. 1, p. 151 ff.)

St. Clair Avenue

The various saints named Clair (or Clarus) appear on the Patron Saints; Catholic Online Saints & Angels (www.catholic.org/saints, hereafter Catholic Online); and Saints O'the Day websites, as do their patronages. According to Patron Saints, the Clair whose feast day falls on January 1st was "sent from Rome to evangelize Aquitaine," the center of foie gras production. Quote about "feminine charms" from the online article "The Death of St. Clair," 1999, at the Sinclair Clan website, sinclair.quarterman.org/sinclair/who/hermit/index.html.

San Remo Way

For the basic *nada* known about this saint, see Saints O'the Day, "Romulus of Genoa." Additional information comes from the various websites associated with the Italian Riviera town of San Remo. Painting: image of San Remo from a painting by the wonderful José de Páez, ca. 1770, in Neuerburg's *Saints of the California Missions* (1989).

San Feliciano Drive

For Victor Girard and the questionable history of his city of Girard, see Cacioppo's *The History of Woodland Hills and Girard*, pp. 20-37. For agents reselling lots, ibid., p. 36. For Francisco Lopez, see Engelhardt's *San Fernando Rey* (1927, pp. 143-144), and for a photo of the site, see Hill's *La Reina*, p. 35. For Father Crespí and St. Catherine, see *Distant Roads*, p. 350 ff. For digging up San Fernando mission, see virtually any website about California missions; for example, "After the discovery of gold, vandals dug up the church floor looking for buried gold" ("San Fernando Rey," California Missions website, missions.bgmm.com). For St. Catherine as patron against temptation, see "Catherine of Bologna" on Patron Saints.

San Teala Court

St. Tecla/Thecla's story is told on the Catholic Online website, among others. (I don't know how I missed, however, the charming tale of St. Thecla and her chickens, from Frazer's *The Golden Bough* (1900, vol. 3, p. 25), which is quite worthy of looking up.) St. Tilo/Teilo, his skull, and his well are collected in various places, including Prof. J. Rhys' article "Sacred Wells in Wales," in *Folklore, a Quarterly Review of Myth, Tradition, Institution and Custom* (1893, vol. 4, p. 74 ff.) and Kemmis Buckley's "Llandeilo Llwydiarth—The Well and the Skull," people.bath.ac.uk/liskmj/living-spring/sourcearchive/ns2/ns2kb1.htm. St. Teilo's adventures with the dragon (and the multiplication of corpses after he died) appear on Britannia.com, www.britannia.com/bios/ebk/teilo.html, and on Saints O'the Day, "Teilo of Llandaff." St. Helen/Helena's recovery of Jesus' cross and related relics seems almost mundane by comparison: see Patron Saints, *The Golden Legend* (vol. 1, p. 277 ff.), and "La Invención de la Santa Cruz" in *Año Cristiano* (tomo 5, p. 39 ff.). Painting: the central image of a still-searching San Teala is based on Cima da Conegliano's portrayal of St. Helena, ca. 1495, coll. National Gallery of Art, Washington, D.C.

Santa Susanna Place

From Helen Treend's "Historical Review of *Quercus lobata* and *Quercus agrifolia* in Southern California," *Proceedings of the Symposium on Multiple-Use Management of California's Hardwood Resources* (Nov. 12-14, 1986, p. 16): "This area [Chatsworth Reservoir] supports both the *Quercus agrifolia* (the California live oak) and the *Quercus lobata* (the California white oak). Trees are estimated to be from two to five hundred years old." For Chinese workers see, among other sources, the websites of the Chinese Historical Society of Southern California (www.chssc.org/index.shtml) and the Santa Clarita Valley Historical Society (www.scvhs.org).

San Sebastián Drive

For the legend of St. Sebastian, see "Saint Sebastian" in *The Golden Legend* (vol. 1, p. 97 ff.). For the "porcupine" quote, ibid., p. 100. For information about native mortality and destruction, see, among others, Heizer's *The Destruction of California Indians* (1993); Barton's *The Tree at the Center of the World* (1980); and Johnson's "The Indians of Mission San Fernando," in Nunis' *Mission San Fernando* (1997). Painting: image based on Andrea Mantegna's *St. Sebastian*, ca. 1480 (Musée du Louvre, Paris).

Seven: The Old Saints

San Lorenzo Street

For whale bones in Tongva cemeteries, see Johnston's *California's Gabrielino Indians* (1962, p. 94) and Crespí's *Distant Roads*, p. 392 ff. For history of the Marquez cemetery and lands, see Ernest Marquez' self-published work, *Pascual Marquez Family Cemetery*. For Perseid meteor showers, see "The Discovery of the Perseid Meteors," by Mark Littmann, at www.skyandtelescope.com. For San Lorenzo martyrdom, see *The Golden Legend* (vol. 2, p. 63 ff.).

San Vicente Boulevard and Kuruvungna Springs

Thanks to Angie Dorame Behrns of the Tongva Nation for assistance. The *diseño* of Rancho San Vicente y Santa Mónica is on the Online Archive of California, www.oac.cdlib.org. For Crespí and his quotes, see *Distant Roads*, p. 344 ff. For St. Stephen's relics, see *The Golden Legend* (vol. 2, p. 40 ff.) and Butler's *Lives of the Saints* (vol. 7, p. 29 ff.). For Kuruvungna, see the Gabrielino/Tongva Springs Foundation website, www.onionskin.com/gabrielino/us.htm. See also Cory Fisher's "Before Columbus," *Los Angeles Times* (Oct. 11, 1998). For government work, see SB 1956 (Hayden; stats. 1998, ch. 439). Kuruvungna, also known as "Serra Springs" and "Gabrielino Tongva Springs," is California Historical Landmark No. 552. For soldiers' hunting of antelope, see Crespí, *Distant Roads*, pp. 344-345, 348-349. Image of Kuruvungna courtesy Angie Behrns; superimposed face comes from late-nineteenth-century stereo view "Boy, Cal.," "Popular Series," photographer unknown (author's coll.).

Santa Susana Pass and Old Santa Susana Pass Roads

This piece is informed in large measure by Ciolek-Torrello's *A Passage in Time* (2006); see also Alexander D. Bevil's "Santa Susana Pass State Historical Park Cultural Resources Inventory Historic Overview," California State Parks, March-April 2007. For stagecoach travails, see *A Passage in Time*, p. 174, and Pavlik's "From Rock Hopper to Park Ranger" in *CSPRA Wave Newsletter* (July-Aug. 2006, p. 10).

San Pascual Avenue

This piece is informed by Beebe and Senkewicz's transcription of Eulalia Pérez's memories of her early life, in *Testimonios: Early California through the Eyes of Women, 1815-1848*, pp. 95 ff. For San Pascual, see, among others, Giffords' *Retablos*, p. 104. For *manchamanteles* in nineteenth-century Californio cooking, see Pinedo's *Encarnación's Kitchen* (2005, p. 108). Painting: images of Eulalia Pérez are based on the widely disseminated portrait, ca. 1880.

Eight: The Island Saints

Sincere thanks to John R. Johnson, Curator of Anthropology, Santa Barbara Museum of Natural History, for continual assistance and advice on native peoples of the Channel Islands. These five essays are informed by the following scholarly articles: "Boats, Bones, and Biface Bias: The Early Holocene Mariners of Eel Point, San Clemente Island, California," by Cassidy et al. (*American Antiquity*, vol. 69, no. 1); "Site Chronology on San Clemente Island, California," by Goldberg et al. (*Pacific Coast Archaeological Society Quarterly*, vol. 36, no. 1); "Southern California Conifer Forests," by Minnich (*Terrestrial Vegetation of California*, ed. Barbour et al., 3d ed., ch. 18); "Timoloqinash: Incorporating Chumash Cultural Self-History into the History of California," by Ward (*Journal of American Ethnic History*, 2006); and by two master's theses: "Giving Voice to Juana Maria's People," by Cannon (Humboldt State University, Aug. 2006) and "The Specialist Next Door," by Dietler (University of California, Los Angeles, 2003).

Santa Catalina View

For Celestino Awatu's song as transcribed by Helen Heffron Roberts, and his explanation, see Roberts' *Form in Primitive Music* (1933, pp. 94-100). For St. Catherine's legend, see *The Golden Legend* (vol. 2., p. 334 ff.). Thanks to Cindi Alvitre, Culturalist, Department of World Arts and Cultures, UCLA, for advice on naming natives of Pimu.

Santa Cruz Street

For the legend of St. Helen, finder of the Holy Cross, see *The Golden Legend* (vol. 1, p. 277 ff.) and "La Invención de la Santa Cruz" in *Año Cristiano* (tomo 5, p. 39 ff.). For the Chumash legend of earth goddess Hutash, see "Limuw: A Story of Place" on the Channel Islands National Park website, www.nps.gov/chis/historyculture/limuw.htm. For the visit to Limuw by Father Juan González Vizcaíno and Spanish soldiers,

and the return of the priest's cross to the ship, ibid. and the Santa Cruz Island Foundation website, www.west.net/~scifmail. Native names of island and village from Santa Barbara Museum of Natural History website, www.sbnature.org (hereafter SBMNH), among others. All quotations in this story are poetic constructs. Painting: based on the fresco series *The Legend of the True Cross*, by Piero della Francesca, Church of San Francesco, 1452-66; crosslike images from Chumash pre-contact rock paintings.

St. Nicholas Avenue

For removal of St. Nicholas' remains to Bari, see the remarkable "Narration of the Recovery of the Relics of Our Holy Father and Wonder-Worker Nicholas," Appendix B in Whitmore's *Saint Nicholas, Bishop of Myra* (1944, pp. 28-36), available on Medieval Sourcebook; for invasion of Channel Islands by Aleuts and Kodiaks, see, among others, Johnston's *Gabrielino Indians*, p. 102 ff., and SBMNH. From the former, the words of Charles Frederick Holder stand out: "I found one spot...which must have been a battlefield...Skeletons were piled up, skulls crushed, and bones broken...a perfect golgotha" (p. 108). The story of the lost (or lone) woman of St. Nicholas Island, as she is commonly referred to, is widely diffused: see Johnston's *Gabrielino Indians*, among many others. For patronages of St. Nicholas, see "Nicholas of Myra" on Patron Saints.

San Miguel Avenue

This piece is informed by Schwemm and Coonan's "Status and Ecology of Deer Mice"; Susan Salter Reynolds' "Elephant Seals Make a Comeback," *Los Angeles Times*; Fred Gamble's marvelous "People on the Island," from an apparently unpublished book posted on www.channelcrossings.com/history; "Timeline of Cultural Change in South Central California," on SBMNH; Channel Island National Park website; and Johnston's *Gabrielino Indians*, 1962. For military use of missiles in the area around San Miguel, see also California Coastal Commission, "Staff Recommendation on Consistency Determination," www.laparks.com/commissionerhtm/pdf2006/jun21/06-185.pdf. For rats and San Miguel Island, see Schwemm and Coonan, op. cit., and the Wikipedia entry for the ship *Winfield Scott*. ("One of the lingering effects of the *Winfield Scott's* wreck was the introduction of black rats to the local ecosystem of the Channel Islands.") San Miguel's patronages, and the other patron saints of artists, taken from Patron Saints. Painting: portrait of San Miguel from the traditional portrait by Michelangelo, married to Picasso's 1920 painting *Seated Woman* (Musée National Picasso), set in a Hiroshige seascape.

San Clemente Avenue

Part i: This piece is informed by, and several lines taken from, the entries for St. Clement in Baring-Gould's *Lives of the Saints*, 1914, and Saints O'the Day; placement on map from *Thomas Guide*. Part ii: The island's pre-contact name suggested by John Johnson, SBMNH; see also Johnston's *Gabrielino Indians*, p. 89. Descriptive quote about the "treacherous sea" from Holder's *Life in the Open* (1906, p. 332); Vizcaíno's estimation of native boatmen from Johnston, p. 100 ff.; for Siberian traders' effects on the Alaskan Gulf and points south, see Vaughan and Holm's *Soft Gold* (1990, p. 4 ff., 17 ff.); for Vizcaíno's diarist's thoughts about the pelts, see Johnston, pp. 100, 102; for invasion of Channel Islands by Aleuts and Kodiaks, ibid., p. 102 ff.; "better part of mercy" quote, ibid., p.102; quote by Harrington's informant, ibid., pp. 112-113.

Nine: The Saints of Battle

San Juan Hill Avenue

Introductory quote from the poem "A Hero of San Juan," by Olivia Bush, 1899. This piece is informed by Gatewood's *"Smoked Yankees" and the Struggle for Empire* (1971), a collection of letters from black soldiers in the Spanish-American War: "deteriorating status of the black man" appears on p. 46, where Gatewood states, "Clearly, their perspective was shaped in large part by the deteriorating status of the black man in the United States—a condition which hopefully could be rectified, or at least ameliorated, by a display of loyalty and patriotism on the battlefield"; "recklessly destroy each other" is from a letter by John R. Conn, 24th Infantry, Aug. 24, 1898 (p. 69 ff.). Assessment of Davis as "Roosevelt's virtual publicist" is fairly widespread; see, for example, Yockelson's "I Am Entitled to the Medal of Honor and I Want It: Theodore Roosevelt and his Quest for Glory," *Prologue Magazine* (vol. 30, no. 1, Spring 1998): "Most responsible for the accolades was correspondent Richard Harding Davis, who tagged along with the Rough Riders and acted as Roosevelt's own press secretary." For Buffalo Soldiers' participation in the Spanish-American War, see *"Smoked Yankees,"* and also Frank R. Schubert's paper "Buffalo Soldiers at San Juan Hill," www.army.mil/cmh-pg/documents/spanam/bssjh/shbrt-bssjh/htm. For Roosevelt's opposing quotes, see "The Spanish-American War" at the Presidio of San Francisco website, http://www.nps.gov/archive/prsf/history/spanish_american_war.htm. Book of Revelation quote taken from Rv 22:8. "Benedictus" chant, arranged by Dr. Garrett, from *The Cathedral Psalter Chants*, ed. Jones, Troutbeck, Turle, Stainer, and Barnby, ca. 1900, p. xiv.

St. Mihiel Avenue

Introductory quote from "The Tale the Church Bell Told," by Grant and Lewis, 1918, a song about the Battle of St. Mihiel. Description of battle taken chiefly from *Final Report of Gen. John J. Pershing*, 1919, pp. 38-43. Quote from Book of Revelation, Rv 12:7, NAB. Reports of military and civilian war deaths for both "conflicts" vary from source to source. For example, FirstWorldWar.com estimates 8 million military dead for WWI (it gives no number for civilian dead); Wikipedia estimates 10 million military and 9 million civilian dead. SecondWorldWar.com gives 18 million military and 39 million civilian WWII dead; Wikipedia estimates 25 million military and 41 million civilian dead (plus 6 million Holocaust deaths). Certainly any estimate is necessarily incomplete and tragic. Painting: image of St. Mihiel based on the bronze sculpture *Seated Youth*, 1916-17, by Wilhelm Lembruck.

Ten: *El Sagrado Corazón de los Angeles:* Getting to the Heart of L.A.

San Ysidro Drive

Painting: central image is my portrait of an anonymous gardener I met and photographed as he worked on San Ysidro Drive, Bel-Air, 2003. Text is taken from the "Reflexiones" for the Feast Day of San Isidro, Labrador, from *Año Cristiano* (tomo 5, p. 319).

St. Moritz Drive

For the history of devotion to, and the range of portrayals of, St. Moritz, see Suckhale-Redlefsen's thorough *The Black Saint Maurice* (1986). For the legend of St. Moritz, see Murray's *The Oxford Companion to Christian Art and Architecture*, p. 316 ff., and "Saint Maurice and His Companions" in *The Golden Legend* (vol. 2, p. 188 ff.). The root word appears to be the Phoenician term *mahurin* (westerner), from which the Greek *mauro* (black) and the Latin *mauri* (African). Quote about St. Moritz comes from "SS. Maurice and his Companions, MM" in Butler's *Lives* (vol. 7, p. 183). For relevant context, see also Parry's *The Image of the Indian and the Black Man in American Art, 1590-1974* (1974).

San Pedro Street

The quote "a sharp Sunday blue" taken from Jeanne Wakatsuki Houston's description, in *Farewell to Manzanar* (2002, p. 3), of the morning life changed for her family. For Xuxungna, see Johnston's *Gabrielino Indians* (1962, p. 88 ff.). (Johnston, it must be noted, does not accept the story that Guinn, in *Historical and Biographical Record*, p. 20, and others narrate of natives hunting rabbits, proposing instead that the fires were "beacons to guide the fishermen.") For related descriptions of native land management practices, including burning fields to extract rabbits, see Kat Anderson's *Tending the Wild*. For "Bahía de los Fumos" (over "Humos"), see Bancroft's *History of California* (1886, vol. 1, p. 71) and Bolton's *Spanish Exploration in the Southwest* (1916, p. 7). For a description of nineteenth-century San Pedro harbor and trade, see Richard Henry Dana's *Two Years Before the Mast*. For quotes about hides and tallow, see Robinson's *Life in California* (1846, p. 38). For Japanese and Chinese fishermen in nineteenth-century San Pedro waters, see " The Abalone Fishery" on the Los Angeles Maritime Museum website, www.lamaritimemuseum.org/abalone.htm; histories of Chinese Americans and Japanese Americans on the National Park Service website, www.nps.gov/history/history/online_books/5views/5views3.htm and 5views4.htm respectively. For Sicilians, see Smith's "I Love L.A" interview with John Shannon in *January Magazine* (Aug. 2003) and Magagnini's "History Is Catch of the Day: Italy's Sons Mark Their Founding Role in State's Fisheries," *Sacramento Bee* (May 3, 1999). For Croatians, see Hansen's "Croatian San Pedro," *Los Angeles Times* (Oct. 27, 1999). For Terminal Island, see David Meltzer's documentary *Furusato: The Lost Village of Terminal Island*, 2006. For Little Tokyo (and Japanese internment), see Michael Several's "Historical Background" in the "Little Tokyo" entry on publicartinla.com. For Cabrera Bueno's renaming of Vizcaíno's Ensenada de San Andrés, see Bancroft's *History* (1886, vol. 1, p. 99, note 64). For patronage of St. Andrew, see "Andrew the Apostle," Saints O'the Day.

Santa María Road

I am indebted to historian Stafford Poole for sharing his research into *converso* history and for connecting it to the Santa María surname. For Jesus Santa María, see Gaye's *Land of the West Valley* (1975, pp. 116-120). The story of the *conversos* is tragically rich and complex: for a sense of restrictions under which Spanish Jews lived, see "Las Siete Partidas: Laws on Jews, 1265" on Medieval Sourcebook; for a more detailed history of Spanish Jewish travails, see "Spain" on www.jewishencyclopedia.com. For Santa María la Blanca, see Lynch's *Toledo* (1898, pp. 231-242). For the history of *conversos* (and the far uglier term *marranos*), see the entry "Marrano" on www.jewishencyclopedia.com or "Marano" on www.thefreedictionary.com. "It was the conversions, even more than the massacres and the emigration, that impoverished Spanish Jewry" (Pérez, *The Spanish Inquisition: A History*, 2004, p. 10). Painting: image of Jesús Santa María based on the depiction of Joseph in *Flight into Egypt* by the Master of Frankfurt, 1503-1506, in Mellinkoff's *Outcasts* (1993, vol. 2).

Santa Ana Boulevard

Inspiration provided by Veronika Waller and her lovely family; assistance provided by Rosie Lee Hooks, Director, Watts Towers Arts Center. Statistical data taken from "Watts Empowerment Zone Fact Sheet," compiled by the Los Angeles Youth Opportunity Movement of Watts (Source: 2000 Census of Population and Housing): "Per capita income was just $6800 in 2000 compared with $20,700 for the city"; "In all, 64 percent of adults in this community do not have a high school diploma"; "The 2000 census reflects 3 percent of area adults have earned a BA degree"; "50 percent of households in the empowerment zone report that Spanish is their primary language." Simon Rodia descriptive quote from the article "Towers of Power" by Sara Catania, *Los Angeles Times Sunday Magazine* (Oct. 23, 2005). The two italicized lyrics are taken from the song "Dear Mama" by Tupac Shakur. Description of Watts Towers as a "jazz cathedral" taken from novel *Underworld* by Don DeLillo (1997). "Concentrated poverty" and "informal economy" are common, current social science terms.

Afterwards: The Once and Future *Lobos Angeles*

This official explanation for the name of St. Francis' chapel is from the Catholic Encyclopedia entry "Portiuncula," www.newadvent.org/cathen/index.html. Crespí's and the Tongvas' "failure to comunícate" is taken from his *Distant Roads*, pp. 342-343: "que salió al camino al vernos, y al acercarnos, nos empesaron a ahullar como si fueran lobos." And so it goes.

BIBLIOGRAPHY

BIBLIOGRAPHY

(For information on additional, web-based resources, see Notes.)

Adams, Emma H. *To and Fro, Up and Down in Southern California, Oregon, and Washington Territory, with Sketches in Arizona, New Mexico, and British Columbia.* Cincinnati: Cranston & Stowe, 1888.

Alexander, Carolyn Elayne. *Venice.* San Francisco: Arcadia, 1999.

Anderson, M. Kat. *Tending the Wild: Native American Knowledge and the Management of California's Natural Resources.* Berkeley: University of California Press, 2005.

Bakeless, John. *America as Seen by Its First Explorers: The Eyes of Discovery.* New York: Dover Publications, 1989.

Bancroft, Hubert Howe. *History of California.* San Francisco: History Co., 1886.

Barbour, Michael, Todd Keeler-Wolf, Allan A. Schoenherr, eds. *Terrestrial Vegetation of California.* 3d ed. Berkeley and Los Angeles: University of California Press, 2007.

Baring-Gould, S. *The Lives of the Saints, by the Rev. S. Baring-Gould, M.A., with Introduction and Additional Lives of English Martyrs, Cornish, Scottish, and Welsh Saints, and a Full Index to the Entire Work.* Edinburgh: J. Grant, 1914.

Barraza, John. *Report of General Manager, No. 06-185, C.D. 9.* California Board of Recreation and Park Commissioners, June 21, 2006.

Barton, Bruce Walter. *The Tree at the Center of the World: A Story of the California Missions.* Santa Barbara, Calif.: Ross-Erikson Publishers, 1980.

Bauer, Helen. *California Rancho Days.* Sacramento: California State Department of Education, 1957.

Beebe, Rose Marie, and Robert M. Senkewicz. *Lands of Promise and Despair: Chronicles of Early California, 1535-1846.* Berkeley: Heyday Books, 2001.

——, trans. *Testimonios: Early California through the Eyes of Women, 1815-1848.* Berkeley: Heyday Books, 2006.

Beers, Terry, ed. *Unfolding Beauty: Celebrating California's Landscapes.* Berkeley: Heyday Books, 2000.

"Bel-Air: The Exclusive Residential Park of the West." Los Angeles: Frank Meline Co., 1923.

Bell, Alphonzo. *The Bel Air Kid: An Autobiography of a Life in California.* Private edition, 2001.

Berger, John A. *The Franciscan Missions of California.* Garden City, N.Y.: Doubleday, 1948.

Bevil, Alexander D. "Santa Susana Pass State Historical Park Cultural Resources Inventory Historic Overview." California State Parks, March-April 2007.

Bolton, Herbert Eugene. *Fray Juan Crespi, Missionary Explorer on the Pacific Coast, 1769-1774.* Berkeley: University of California Press, 1927.

——. *Spanish Exploration in the Southwest, 1542-1706.* New York: C. Scribner's Sons, 1916.

Bonfante-Warren, Alexandra. *Saints: Seventy Stories of Faith.* Philadelphia: Courage Books, 2000.

"Brief History of Vicente de la Ossa and Family." Archives, Los Encinos State Historical Park, ca. 1969(?).

Bush, Olivia. *Original Poems.* Providence, R.I.: Press of Louis A. Basinet, 1899.

Butler, Alban. *The Lives of the Fathers, Martyrs, and Other Principal Saints.* 12 vols. Dublin: John Morris, 1781.

Buxo, José Pascual. *Juegos de ingenio y agudeza: La pintura emblemática de la Nueva España.* Mexico: Universidad del Claustro de Sor Juana and Museo Nacional de Arte, 1994.

Cacioppo, Richard K. *The History of Woodland Hills and Girard.* Panorama City, Calif,: White Stone, 1982.

California's Mission San Gabriel Arcangel. San Dimas, Calif.: Photografx Worldwide, 1998.

The California Missions: The Romance and Drama of the Missions and the Mission Play at the San Gabriel. Chicago: American Autochrome, n.d.

Cannon, Amanda C. "Giving Voice to Juana Maria's People: The Organization of Shell and Exotic Stone Artifact Production and Trade at a Late Holocene Village." Thesis, Humboldt State University, Aug. 2006.

Carr, Harry. *Los Angeles: City of Dreams*. New York: Grosset and Dunlap, 1935.

Caughey, John Walton, ed. *The Indians of Southern California in 1852; The B. D. Wilson Report and a Selection of Contemporary Comment*. San Marino, Calif.: Huntington Library, 1952.

Cheng, Lucie, and Suellen Cheng, Judy Chu, Feelie Lee, Majorie Lee, Sus Ling. *Linking Our Lives: Chinese American Women of Los Angeles*. Los Angeles: UCLA Asian American Studies Center and Chinese Historical Society of Southern California, 1984.

Chervin, Ronda De Sola. *Treasury of Women Saints: The Stories of Over 200 Women, Including Mothers, Prophets, and Interior Women of the Spirit*. Ann Arbor, Mich.: Servant Publications, 1991.

Cini, Zelda. *El Valle de Santa Catalina de Bononia de Los Encinos, 1769-1975*. Sherman Oaks, Calif.: Dorothy Denny, 1975.

Ciolek-Torrello, Richard, et al., eds. *A Passage in Time: The Archaeology and History of the Santa Susana Pass State Historic Park California*. No. 87 of Technical Series. Tucson: Statistical Research, 2006.

Cohen, Chester G. *El Escorpion, From Indian Village to Los Angeles Park*. Woodland Hills, Calif.: Periday Co., 1989.

Conner, Palmer. *The Romance of the Ranchos*. Los Angeles: Title Insurance and Trust Co., 1939.

Cosa, Juan de la. *The Sea Diary of Fr. Juan Vizcaino to Alta California, 1769*. Trans. Arthur Woodward. Los Angeles: G. Dawson, 1959.

Coulson, John, ed. *The Saints: A Concise Biographical Dictionary*. New York: Guild Press, 1957.

Cowdrey, Kit. *Pacific Palisades*. Santa Monica, Calif.: United Western Newspapers, 1972.

Crespí, Juan. *A Description of Distant Roads: Original Journal of the First Expedition into California, 1769-1770*. Ed., trans. Alan K. Brown. San Diego: San Diego State University Press, 2001.

——— *Captain Portolá in San Luis Obispo County, 1769-1969*. Cambria, Calif.: Sivilla's Print Shop, 1968.

Croiset, Juan. *Año cristiano o ejercicios devotos para todos los dias del Año*, 12 vol. Madrid: Imprenta de la Real Compañía, 1804.

Dana, Richard H. Jr. *Two Years Before the Mast*. New York: The MacMillan Co., 1911.

Danforth, Susan. *Encountering the New World, 1493-1800*. Providence: John Carter Brown Library, 1991.

Daniels, Roger. *The Politics of Prejudice: The Anti-Japanese Movement in California and the Struggle for Japanese Exclusion*. Berkeley: University of California Press, 1977.

Davidson, Grace. *The Gates of Memory: Recollections of Early Santa Ynez Valley*. Solvang, Calif.: Santa Ynez Valley News, 1955.

De Bry, Theodore. *Discovering the New World*. Ed. Michael Alexander. New York: Harper and Row, 1976.

De la Ossa, Fabricio. "Diary." Trans. René Muñoz. Unpublished document. Los Encinos State Historical Park, 1975.

De Voragine, Jacobus. *The Golden Legend: Readings on the Saints*. 2 vols. Trans. William Granger Ryan. Princeton: Princeton University Press, 1995.

DeLillo, Don. *Underworld*. New York: Scribner, 1997.

Deverell, William. *Whitewashed Adobe: The Rise of Los Angeles and the Remaking of Its Mexican Past*. Berkeley: University of California Press, 2004.

Dietler, John Eric. "The Specialist Next Door." Thesis, University of California, Los Angeles, 2003.

Dippie, Brian W. *West-Fever*. Los Angeles: Autry National Center and University of Washington Press, 1998.

Drake, Sir Francis. *The Drake Manuscript in the Pierpont Morgan Library: Histoire Naturelle des Indes*. Trans. Ruth Kraemer. London: Andre Deutsch, 1996.

Driesbach, Janice T., Harvey L. Jones, and Katherine Church Holland. *Art of the Gold Rush*. Oakland: Oakland Museum of California, Crocker Art Museum, and University of California Press, 1998.

Duchet-Suchaux, Gaston, and Michel Pastoureau. *Flammarion Iconographic Guides: The Bible and the Saints*. Paris: Flammarion, 1994.

Echeagaray, José Ignacio, ed. *Album del 450 aniversario de las apariciones de Nuestra Señora de Guadalupe*. Mexico: Buena Nueva, 1981.

Elias, Judith W. *Los Angeles: Dream to Reality, 1885-1915.* California State University Northridge Libraries: Santa Susana Press, 1983.

Ellerbe, Rose L. *Tales of California Yesterdays.* Los Angeles: Warren T. Potter, 1916.

Encyclopedia of Discovery and Exploration. *The Conquest of North America.* New York: Doubleday, 1973.

Engelhardt, Fr. Zephyrin O.F.M. *Mission Santa Ines: Virgen y Martir and Its Ecclesiastical Seminary.* Santa Barbara: Schauer Printing Studio, 1932.

——. *The Missions and Missionaries of California.* San Francisco: James H. Barry Co., 1913.

——. *San Fernando Rey: The Mission of the Valley.* Chicago: Franciscan Herald Press, 1927.

——. *San Gabriel Mission and the Beginnings of Los Angeles.* Chicago: Franciscan Herald Press, 1927.

——. *Santa Barbara "Queen of the Missions."* San Francisco: James H. Barry Co., 1923.

Engh, Michael E. *Frontier Faiths: Church, Temple, and Synagogue in Los Angeles, 1846-1888.* Albuquerque: University of New Mexico Press, 1992.

First Los Angeles City and County Directory, 1872. Los Angeles: Ward Ritchie Press, 1963.

Frazer, James George. *The Golden Bough: A Study in Magic and Religion.* 3 vols. London: Macmillan Co., 1900.

Frías, Fernando Juárez. *Retablos populares méxicanos: iconografía religiosa del siglo XIX.* Mexico: Inversora Bursátil, Casa de Bolsa, 1991.

Frost, Jaime Soler, ed. *Los pinceles de la historia: El origen del reino de la Nueva España, 1680-1750.* Mexico: Museo Nacional de Arte and Instituto Nacional de Bellas Artes, 1999.

Garrigues, George. *He Usually Lived with a Female: The Life of a California Newspaperman.* Austin, Texas: Quail Creek Press, 2006.

Gatewood, William B. Jr. *"Smoked Yankees" and the Struggle for Empire: Letters from Negro Soldiers, 1898-1902.* Urbana: University of Illinois Press, 1971.

Gaye, Laura B. *Land of the West Valley.* Encino, Calif.: Argold Press, 1975.

Geiger, Maynard, O.F.M. *California Calligraphy: Identified Autographs of Personages Connected with the Conquest and Development of the Californias.* Ramona, Calif.: Ballena Press, 1972.

——. *Franciscan Missionaries in Hispanic California, 1769-1848.* San Marino: Huntington Library Publications, 1969.

——, trans., ed. *Letter of Luis Jayme, O.F.M., San Diego, October 17, 1772.* Los Angeles: Dawson's Book Shop, 1970.

Gesensway, Deborah, and Mindy Roseman. *Beyond Words: Images from America's Concentration Camps.* Ithaca: Cornell University Press, 1987.

Gibraltar Savings and Loan Association. *City of Beverly Hills: From Bean Field to Beautiful City.* Beverly Hills, Calif.: Gibraltar Savings and Loan, 1970.

Giffords, Gloria Kay. *Mexican Folk Retablos: Masterpieces on Tin.* Tucson: University of Arizona Press, 1974.

Goldman, Leslie, and Students and Staff of Sinaloa Jr. High. *Santa Susana: Over the Pass...Into the Past.* Chatsworth, Calif.: Santa Susana Mountain Park Association, 1973.

Graves, J. A. *My Seventy Years in California, 1857-1927.* Los Angeles: Times-Mirror Press, 1927.

Greenwood, Roberta S. *Down by the Station: Los Angeles Chinatown, 1880-1933.* Los Angeles: UCLA Institute of Archaeology, 1997.

Grubb, Nancy. *Revelations: Art of the Apocalypse.* New York: Abbeville Press, 1997.

Gudde, Erwin G. *1000 California Place Names: Their Origin and Meaning.* Berkeley: University of California Press, 1969.

——. *California Place Names: A Geographical Dictionary.* Berkeley: University of California Press, 1949.

Guinn, J. M. *Historical and Biographical Record of Los Angeles and Vicinity.* Chicago: Chapman Publishing Co., 1901.

——. *History of California and an Extended History of Los Angeles and Environs, also Containing Biographies of Well Known Citizens of the Past and Present.* Los Angeles: Historic Record Co., 1915.

Harpur, James. *Sacred Tracks: 2000 Years of Christian Pilgrimage.* Berkeley: University of California Press, 2002.

Harrison, Frederic, ed. *The New Calendar of Great Men*. London: MacMillan & Co., 1892.

Hayes, Benjamin. *Pioneer Notes from the Diaries of Judge Benjamin Hayes, 1849-1875*. Los Angeles: Private Printing, 1929.

Heizer, Robert F. *The Destruction of California Indians*. Lincoln: University of Nebraska Press, 1993.

Heldman, Marilyn, and Stuart C. Munro-Hay. *African Zion: The Sacred Art of Ethiopia*. New Haven, Conn.: Yale University Press, 1993.

Henstell, Bruce. *Sunshine and Wealth: Los Angeles in the Twenties and Thirties*. San Francisco: Chronicle Books, 1984.

Hill, Kimi Kodani, ed. *Shades of California: The Hidden Beauty of Ordinary Life*. Berkeley: Heyday Books, 2001.

Hill, Laurence L. *La Reina: Los Angeles in Three Centuries*. Los Angeles: Security Trust & Savings Bank, 1929.

Historical Society of Southern California Annual Publications: 1928. Los Angeles: McBride Publishing Co., 1928.

——: 1929. Los Angeles: McBride Publishing Co., 1929.

Historical Society of Southern California Quarterly, 1949. Los Angeles: Historical Society of Southern California, 1949.

Holder, Charles Frederick. *Life in the Open: Sport with Rod, Gun, Horse, and Hound in Southern California*. New York: G. P. Putnam's Sons, 1906.

Houston, Jeanne Wakatsuki, and James D. Houston. *Farewell to Manzanar*. Boston: Houghton Mifflin, 1973.

Jackson, Helen Hunt. *A Century of Dishonor*. Boston: Little, Brown and Co., 1903.

Johnston, Bernice Eastman. *California's Gabrielino Indians*. Los Angeles: Southwest Museum, 1962.

Jorgensen, Lawrence C., ed. *The San Fernando Valley Past and Present*. Los Angeles: Pacific Rim Research, 1982.

Keeler, Charles A. *Southern California*. Los Angeles: Santa Fe and Los Angeles Passenger Dept., 1899.

Kemperdick, Stephan. *Rogier van der Weyden, 1399/1400-1464*. Trans. Anthea Bell. Cologne: Könemann, 1999.

Kercheval, Albert F. *Dolores and Other Poems*. San Francisco: A. L. Bancroft & Co., 1878.

Kielbasa, John. *Historic Adobes of Los Angeles County*. Pittsburg: Dorrance Publishing Co., 1997.

King, Chester. *Prehistoric Native American Cultural Sites in the Santa Monica Mountains*. Santa Monica, Calif.: Santa Monica Mountains and Seashore Foundation, n.d.

Krása, Josef. *The Travels of Sir John Mandeville: A Manuscript in the British Library*. Trans. Peter Kussi. New York: George Braziller, 1983.

Kroeber, Theodora, and Robert F. Heizer. *Almost Ancestors: The First Californians*. Ed. F. David Hales. London: Sierra Club, 1968.

Lord, Rev. Daniel A. *Miniature Stories of the Saints*. Book 2. New York: William J. Hirten Co., 1943.

Los Angeles City Directory. Los Angeles: Los Angeles Directory Co., 1886.

Los Angeles Pioneer Society. *Historical Record and Souvenir*. Los Angeles: Times-Mirror Press, 1923.

Los Angeles Youth Opportunity Movement of Watts. "Watts Empowerment Zone Fact Sheet." Los Angeles, ca. 2002.

Lugo, Don José del Carmen. "Vida de un ranchero." Dictated to D. Tomás Savage for H. H. Bancroft, October 1877. (Original manuscript in Bancroft Library, University of California, Berkeley.)

Lynch, Hannah. *Toledo: The Story of an Old Spanish Capital*. London: J. M. Dent and Co., 1898.

MacMullin, Cynthia. *Shadows on Olvera Street: "El Pueblo" de Nuestra Señora la Reina de Los Angeles, The City of Los Angeles, 1769-2005*. Los Angeles: California State University, Los Angeles, 2004.

Marquez, Ernest, and Monica Marquez. "Pascual Marquez Family Cemetery: Rancho Boca de Santa Monica, Santa Monica Canyon, California." Canoga Park: Ernest Márquez, 2000.

McGroarty, John Steven. *California: Its History and Romance*. Los Angeles: Grafton Publishing Co., 1926.

—— *Los Angeles: From the Mountains to the Sea*. 3 vols. Chicago: American Historical Society, 1921.

—— *Mission Memories*. Los Angeles: Neuner Corporation, 1929.

McWilliams, Carey. *North from Mexico: The Spanish-Speaking People of the United States*. New York: Greenwood Press, 1968.

Meighan, Clement W. "Rock Art on the Channel Islands of California." *Pacific Coast Archaeological Society Quarterly* 36, No. 2 (Spring 2000).

Mellinkoff, Ruth. *Outcasts: Signs of Otherness in Northern European Art of the Late Middle Ages.* Vols. 1, 2. Berkeley and Los Angeles: University of California Press, 1993.

Minnich, Richard A. "Southern California Conifer Forests." In *Terrestrial Vegetation of California.* 3d ed. Berkeley and Los Angeles: University of California Press, 2007.

Miš č evi ć Dušanka, and Peter Kwong. *Chinese Americans: The Immigrant Experience.* Hong Kong: Hugh Lauter Levin Associates, 2000.

Mix, Miguel Rojas. *América Imaginaria.* Barcelona: Editorial Lumen, 1992.

Monroy, Douglas. *Thrown among Strangers: The Making of Mexican Culture in Frontier California.* Berkeley: University of California Press, 1993.

Moran, Tom, and Tom Sewall. *Fantasy by the Sea: A Visual History of the American Venice.* Venice, Calif.: Beyond Baroque Foundation, 1979.

Morgado, Martin J. *Junípero Serra: A Pictorial Biography.* Monterey, Calif.: Siempre Adelante Publishing, 1991.

Morgan, Genevieve, and Tom Morgan. *The Devil: A Visual Guide to the Demonic, Evil, Scurrilous, and Bad.* San Francisco: Chronicle Books, 1996.

Murray, Peter, and Linda Murray. *The Oxford Companion to Christian Art and Architecture.* Oxford: Oxford University Press, 1996.

Nadeau, Remi. *City-Makers: The Story of Southern California's First Boom, 1868-76.* Los Angeles: Trans-Anglo Books, 1965.

Neuerburg, Norman. *The Decoration of the California Missions.* Santa Barbara, Calif.: Bellerophon Books, 1991.

———. *Saints of the California Missions.* Santa Barbara, Calif.: Bellerophon Books, 1990.

Newmark, Harris. *Sixty Years in Southern California, 1853-1913, Containing the Reminiscences of Harris Newmark.* Ed. Maurice H. and Marco R. Newmark. Boston: Houghton Mifflin, 1930.

Nunis, Doyce B. Jr. *The Drawings of Ignacio Tirsch: A Jesuit Missionary in Baja California.* Trans. Elsbeth Schulz-Bischof. Los Angeles: Dawson's Book Shop, 1972.

———, ed. *Mission San Fernando Rey de España 1797-1997: A Bicentennial Tribute.* Los Angeles: Historical Society of Southern California, 1997.

O'Daniel, Victor F., O.P., S.T.M. *The First Disciples of Saint Dominic.* Somerset, Ohio: The Rosary Press, 1928.

Ord, Edward, O.C. *The City of the Angels and the City of the Saints, or A Trip to Los Angeles and San Bernardino in 1856.* San Marino, Calif.: The Huntington Library, 1978.

Packman, Ana Begue. *Leather Dollars: Short Stories of Pueblo Los Angeles.* Los Angeles: Times-Mirror Press, 1932.

Painter, Charles Cornelius Coffin. *Studying the Condition of Affairs in Indian Territory and California: A Report by Prof. Charles Cornelius Coffin Painter, Agent of the Indian Rights Association.* Philadelphia: Indian Rights Association, 1888.

Parry, Ellwood. *The Image of the Indian and the Black Man in American Art, 1590-1974.* New York: George Braziller, 1974.

Pérez, Joseph. *The Spanish Inquisition: A History.* Trans. Janet Lloyd. New Haven, Conn.: Yale University Press, 2005.

Perry, Claire. *Pacific Arcadia: Images of California, 1600-1915.* Oxford: Oxford University Press, 1999.

Pershing, John J. *Final Report of Gen. John J. Pershing, Commander-in-Chief, American Expeditionary Forces.* Washington, D.C.: U.S. Government Printing Office, 1920.

Peters, Harry T. *California on Stone.* Garden City, N.Y.: Doubleday, Doran & Co., 1935.

Pierce, Donna, Rogelio Ruiz, and Clara Bargellini. *Painting a New World: Mexican Art and Life, 1521-1821.* Ed. Marlene Chambers. Denver: Denver Art Museum, 2004.

Pinedo, Encarnación. *Encarnación's Kitchen: Mexican Recipes from Nineteenth-Century California.* Ed., trans. Dan Strehl. Berkeley: University of California Press, 2005.

Pitt, Leonard. *The Decline of the Californios: A Social History of the Spanish-Speaking Californians, 1846-1890.* Berkeley: University of California Press, 1971.

Pitt, Leonard, and Dale Pitt. *Los Angeles A to Z: An Encyclopedia of the City and County.* Berkeley, Los Angeles, and London: University of California Press, 1997.

Plummer, Charles, ed., trans. *Lives of the Irish Saints.* 2 vols. 1922. Reprint, Oxford: Clarendon Press, 1997.

Poole, Jean Bruce, and Tevvy Ball. *El Pueblo: The Historic Heart of Los Angeles.* Los Angeles: Getty Publications, 2002.

Powell, Ruth. "Chester Place." Los Angeles: Historical Society of Southern California and the Southern California Chapter of the American Institute of Architects, 1964.

Proceedings of the Symposium on Multiple-Use Management of California's Hardwood Resources, Nov. 12-14, 1986, San Luis Obispo, Calif.

Pucelle, Jean. *Hours of Jeanne d'Evreux, Queen of France.* New York: Metropolitan Museum of Art, 1957.

Ray, MaryEllen Bell. *The City of Watts, California: 1907-1926.* Los Angeles: Rising Publishing, 1985.

Rios-Bustamante, Antonio, and Pedro Castillo. *An Illustrated History of Mexican Los Angeles, 1781-1985.* Los Angeles: Chicano Studies Research Center Publications, 1986.

Roberts, Helen Heffron. *Form in Primitive Music: An Analytical and Comparative Study of the Melodic Form of Some Ancient Southern California Indian Songs.* New York: W. W. Norton, 1933.

Robinson, Alfred. *Life in California during a Residence of Several Years in That Territory.* New York: Wiley & Putnam, 1846.

Robinson, John W. *Mines of the San Gabriels.* Glendale, Calif.: La Siesta Press, 1973.

Robinson, W. W. "Beverly Hills: A Calendar of Events in the Making of a City." Los Angeles: Title Guarantee and Trust Co., 1938.

———. "The Forest and the People: The Story of the Angeles National Forest." Los Angeles: Title Insurance and Trust Company, 1946.

———. "Los Angeles from the Days of the Pueblo: A Brief History and a Guide to the Plaza Area." North Hollywood: California Historical Society, 1981.

———. "Panorama: A Picture History of Southern California." Los Angeles: Title Insurance and Trust Company, 1953.

———. "Ranchos Become Cities." Pasadena, Calif.: San Pasqual Press, 1939.

———. "Santa Monica: A Calendar of Events in the Making of a City." Los Angeles: Title Guarantee and Trust Co., 1955.

———. "The Spanish and Mexican Ranchos of San Fernando Valley." Los Angeles: Southwest Museum Leaflets, 1966.

———. "The Story of San Fernando Valley." Los Angeles: Title Insurance and Trust Company, 1961.

———. "What They Say about the Angels." Pasadena: Val Trefz Press, 1942.

Roderick, Kevin. *The San Fernando Valley.* Los Angeles: Los Angeles Times, 2001.

Rojas Mix, Miguel. *América imaginaria.* Barcelona: Editorial Lumen, 1992.

Sanchez, Nellie Van De Grift. *Spanish and Indian Place Names of California: Their Meaning and Their Romance.* San Francisco: A. M. Robertson, 1922.

Sandmeyer, Elmer Clarence. *The Anti-Chinese Movement in California.* 1939. Reprint, Urbana: University of Illinois, 1991.

Schreckenberg, Heinz. *The Jews in Christian Art, An Illustrated History.* New York: Continuum Publishing, 1996.

Schiller, Julius. *Coelum stellatum Christianum.* Augustae Vindelicorum: Praelo Andreae Apergi..., 1627.

Secrest, William B. *When the Great Spirit Died: The Destruction of the California Indians, 1850-1860.* Sanger, Calif.: Word Dancer Press, 2003.

Security-First National Bank of Los Angeles. "The Story of the Murals of the Beverly Hills Branch of Security First National Bank of Los Angeles." Los Angeles: Security-First National Bank of Los Angeles, 1934.

Security Trust & Savings Bank. *A Daughter of the Snows.* Los Angeles: n.d.

Smith, Anna Deavere. *Twilight: Los Angeles, 1992.* New York: Anchor Books, 1994.

Smith, Icy. *The Lonely Queue: The Forgotten History of the Courageous Chinese Americans in Los Angeles.* Trans. (Chinese) Emily Wang. Gardena: East West Discovery Press, 2000.

Smith, Otis, Kiilu Anthony Hamilton, and Richard Anthony Dedeaux. *The Rising Sons—Wisdom and Knowledge.* Los Angeles: The Watts Prophets, 1973.

Spencer, James. "Concentrated Poverty in Los Angeles County and the Geographic Distribution of Economic Change." Dissertation, UCLA Institute for Labor and Employment, n.d.

Stanley, Jerry. *Digger: The Tragic Fate of the California Indians from the Missions to the Gold Rush.* New York: Crown Publishers, 1997.

Starr, Kevin. *Embattled Dreams: California in War and Peace, 1940-1950.* Oxford: Oxford University Press, 2002.

Stewart, Maria Helena. *Los Encino's Past and Present.* Encino, Calif.: Quality Printers, 1965.

Suckhale-Redlefsen, Gude. *The Black Saint Maurice.* München: Schnell & Steiner; Houston: Menil Foundation, 1986.

Swett, Ira L., ed. "Los Angeles Railway." Interurbans Special No. 11. *Interurbans: The National Electric Railway News Digest,* 1951.

Thayer, William M. *Marvels of the New West.* Norwich, Conn.: Henry Bill Publishing Company, 1890.

Thomas Guide, Los Angeles County. 2000-2006 eds. Irvine, Calif.: Thomas Brothers Maps, 1999-2005.

Time-Life Books, ed. *The Indians of California.* The American Indians Series. Alexandria: Time-Life, 1994.

"Title and Ownership of Rancho Los Encinos." Archives of Los Encinos State Historical Park, n.d.

Tomlinson, Charles. *Thunder-Storm or, an Account of the Nature, Properties, Dangers, and Uses of Lightning in Various Parts of the World.* London: Society for Promoting Christian Knowledge, 1848.

Vaughan, Thomas, and Bill Holm. *Soft Gold: The Fur Trade and Cultural Exchange on the Northwest Coast of America.* Portland: Oregon Historical Society, 1990.

Vernon, Edward W. *Las Misiones Antiguas: The Spanish Missions of Baja California, 1683-1855.* Albuquerque: University of New Mexico Press, 2002.

Von Euw, Jack, and Genoa Shepley. *Drawn West: Selections from the Robert B. Honeyman Jr. Collection of Early Californian and Western Art and Americana from the Bancroft Library.* Berkeley: The Bancroft Library and Heyday Books, 2004.

Wagner, Henry Raup. *Juan Rodriguez Cabrillo.* San Francisco: California Historical Society, 1941.

Walker, Phillip L., and John R. Johnson. "For Everything There Is a Season: Chumash Indian Births, Marriages and Deaths at the Alta California Missions." in *Human Biologists in the Archives,* ed. D. Ann Herring and Alan C. Swedlund. Cambridge: Cambridge University Press, 2005.

Warner, J. J., Benjamin Hayes, and J. P. Widney. *An Historical Sketch of Los Angeles County, California.* 1876. Reprint, Los Angeles: O. W. Smith, 1936.

——— *An Illustrated History of Los Angeles County, California.* Chicago: The Lewis Publishing Company, 1889.

Watson, Douglas S. *The Founding of the First California Missions under the Spiritual Guidance of the Venerable Padre Fray Junipero Serra: An Historical Account of the Expeditions Sent by Land and Sea in the Year 1769 as Told by Fray Francisco Palou.* San Francisco: Nueva California Press, 1934.

Wax, Marvin. *Mystique of the Missions.* Ed. Patricia Kollings. Palo Alto: American West Publishing, 1974.

Weaver, John D. *El Pueblo Grande: A Non-Fiction Book about Los Angeles: Los Angeles from the Brush Huts of Yangna to the Skyscrapers of the Modern Megalopolis.* Los Angeles: The Ward Ritchie Press, 1973.

Wells, Harry L. *California Names Pronounced and Defined.* Los Angeles: Kellaway-Ide-Jones Company, 1934.

White, Kristin E. *A Guide to the Saints.* New York: Ivy Books, 1992.

White, Stewart Edward. *Old California in Picture and Story.* New York: Garden City Publishing, 1939.

Whitmore, Eugene Rudolph. *Saint Nicholas, Bishop of Myra.* Self-published, 1944.

Wilcox, Del. *Voyagers to California.* Elk, Calif.: Sea Rock Press, 1991.

Williamson, R. S. *Report of Explorations in California for Railroad Routes Near the 35th and 32nd Parallels of North Latitude.* Washington, D. C.: A.O.P. Nicholson, 1856.

Wilson, J. Albert. *Reproduction of Thompson and West's History of Los Angeles County, California, with Illustrations.* Berkeley: Howell-North, 1959.

Wolf, Kenneth Baxter. *The Poverty of Riches: St. Francis of Assisi Reconsidered.* Oxford: Oxford University Press, 2002.

Wolfe, Maynard Frank. *Rube Goldberg: Inventions!* New York: Simon and Schuster, 2000.

Wood, Raymund F. *The Saints of the California Landscape.* Eagle Rock, Calif.: Prosperity Press, 1987.

Young, Betty Lou. *Pacific Palisades: Where the Mountains Meet the Sea.* Pacific Palisades: Pacific Palisades Historical Society Press, 1983.

——. *Rustic Canyon and the Story of the Uplifters.* Santa Monica, Calif.: Casa Vieja Press, 1975.

——. *Santa Monica Canyon: A Walk through History.* Pacific Palisades, Calif.: Casa Vieja Press: Pacific Palisades Historical Society, 1997.

Young, Stanley, and Melba Levick. *The Missions of California.* San Francisco: Chronicle Books, 1988.

HEYDAY INSTITUTE

Since its founding in 1974, Heyday Books has occupied a unique niche in the publishing world, specializing in books that foster an understanding of the history, literature, art, environment, social issues, and culture of California and the West. We are a 501(c)(3) nonprofit organization based in Berkeley, California, serving a wide range of people and audiences.

We are grateful for the generous funding we've received for our publications and programs during the past year from foundations and more than three hundred individual donors. Major supporters include:

Anonymous; Anthony Andreas, Jr.; Barnes & Noble bookstores; BayTree Fund; B.C.W. Trust III; S. D. Bechtel, Jr. Foundation; Fred & Jean Berensmeier; Book Club of California; Butler Koshland Fund; California Council for the Humanities; California State Library; Candelaria Fund; Columbia Foundation; Compton Foundation, Inc.; Federated Indians of Graton Rancheria; Fleishhacker Foundation; Wallace Alexander Gerbode Foundation; Marion E. Greene; Walter & Elise Haas Fund; Leanne Hinton; Hopland Band of Pomo Indians; James Irvine Foundation; George Frederick Jewett Foundation; Marty Krasney; Guy Lampard & Suzanne Badenhoop; LEF Foundation; Michael McCone; Middletown Rancheria Tribal Council; National Audubon Society; National Endowment for the Arts; National Park Service; Philanthropic Ventures Foundation; Poets & Writers; Rim of the World Interpretive Association; River Rock Casino; Riverside-Corona Resource Conservation; Alan Rosenus; San Francisco Foundation; Santa Ana Watershed Association; William Saroyan Foundation; Seaver Institute; Sandy Cold Shapero; Service Plus Credit Union; L. J. Skaggs and Mary C. Skaggs Foundation; Skirball Foundation; Swinerton Family Fund; Thendara Foundation; Victorian Alliance; Tom White; Harold & Alma White Memorial Fund; and Stan Yogi.

For more information about Heyday Institute, our publications and programs, please visit our website at www.heydaybooks.com.

The Autry National Center is an intercultural history center that celebrates the American West through three important institutions: the Southwest Museum of the American Indian, the Museum of the American West (formerly the Autry Museum of Western Heritage), and the Institute for the Study of the American West. Through its extensive collection of art and artifacts, archival materials and books, innovative exhibitions, and a broad range of programs, the Autry National Center explores the distinct stories and interactions of cultures and peoples, and their impact on the complex, evolving history of the American West.

The Southwest Museum has one of the world's most extraordinary collections of Native American art and artifacts, including 250,000 objects that span more than 10,000 years and represent Native American cultures from Alaska to South America, as well as Spanish Californian, New Mexican, and other cultural artifacts, furniture, paintings, and ephemera. The Southwest Museum's founder, Charles Fletcher Lummis, was one of the first to champion the idea of Los Angeles as a multicultural city.

Through its collection of 72,000 artifacts and works of art, the Museum of the American West tells the comprehensive story of the American West and the multiple cultures, perspectives, traditions, and experiences—real and imagined— that have made the West significant.

The Institute for the Study of the American West is a research and publishing enterprise that produces and supports scholarly work in Western history and the arts. The Institute includes the Braun Research Library, which is home to over 200,000 books, periodicals, photographs, sound recordings, and other objects, and the Autry Library, a research collection of more than 64,000 items including rare books, maps, photographs, and manuscripts. Unique among museum libraries, the Braun and Autry libraries offer researchers access to both library and museum materials.

For more information on the Autry National Center, please visit our website at AutryNationalCenter.org or call (323) 667-2000.

Autry National Center

4700 Western Heritage Way, Los Angeles, CA 90027-1462
323.667.2000 • AutryNationalCenter.org